Learn
Digital
Photography

Sunrise Midday Sunset

In a Weekend ®

Sunset Sunrise Evening Sunrise

Send Us Your Comments:

To comment on this book or any other Prima Tech title, visit Prima's reader response page on the Web at **www.primapublishing.com/comments**.

How to Order:

For information on quantity discounts, contact the publisher: Prima Publishing, P.O. Box 1260BK, Rocklin, CA 95677-1260; (916) 632-4400. On your letterhead, include information concerning the intended use of the books and the number of books you wish to purchase. For individual orders, turn to the back of this book for more information or visit Prima's Web site at **www.primapublishing.com**.

Learn
Digital
Photography

In a Weekend

Brad Braun
Marc Braun

PRIMA
TECH

A Division of Prima Publishing

For Virginia, Laura, and Quinn

—BTB & MLB

 A Division of Prima Publishing

Prima Publishing, In a Weekend, and colophon are registered trademarks of Prima Communications, Inc. Rocklin, California 95765.

Publisher: Matthew H. Carleson

Managing Editor: Dan J. Foster

Acquisitions Editor: Jenny L. Watson

Project Editor: Kim V. Benbow

Technical Reviewer: John Popp

Copy Editor: Hilary Powers

Interior Layout: Shawn Morningstar

Cover Design: Prima Design Team

Indexer: Emily Glossbrenner

Adobe, PhotoDeluxe, and Photoshop are registered trademarks of Adobe Systems, Inc. PhotoSuite is a registered trademark of MGI Software Corp.

IMPORTANT: If you have problems installing or running PhotoDeluxe or Photoshop, go to Adobe's Web site at **www.adobe.com**. For problems with PhotoSuite, go to **www.mgisoft.com.** Prima Publishing cannot provide software support.

Prima Publishing and the authors have attempted throughout this book to distinguish proprietary trademarks from descriptive terms by following the capitalization style used by the manufacturer.

Information contained in this book has been obtained by Prima Publishing from sources believed to be reliable. However, because of the possibility of human or mechanical error by our sources, Prima Publishing, or others, the Publisher does not guarantee the accuracy, adequacy, or completeness of any information and is not responsible for any errors or omissions or the results obtained from the use of such information. Readers should be particularly aware of the fact that the Internet is an ever-changing entity. Some facts may have changed since this book went to press.

ISBN: 0-7615-1532-1

Library of Congress Catalog Card Number: 98-65966

Printed in the United States of America

98 99 00 01 02 DD 10 9 8 7 6 5 4 3 2 1

CONTENTS AT A GLANCE

Introduction . xii

FRIDAY EVENING
Getting Started . 1

SATURDAY MORNING
Starting Your Day of Digital Photography 57

SATURDAY AFTERNOON
Starting to Shoot Inside 115

SATURDAY EVENING
Shooting at Night and in Low Light 175

SUNDAY MORNING
Going Beyond Great Pictures to Get Great Images 189

SUNDAY AFTERNOON
Introduction to Advanced Image Processing 275

APPENDIX
Digital Photography Web Resources 353

Glossary . 359

Index . 367

CONTENTS

Introduction . xii

FRIDAY EVENING
Getting Started . 1

How to Use This Book ..3
What Is Digital Photography? ..4
Digital, Hybrid, and Conventional Photography5
Applications and Uses ...11
Where Digital Photography Does Not Work14
Types of Digital Cameras ..15
Take a Break ..38
Evaluating Digital Cameras ...38
The Digital Photographer's Software Tools45
Other Useful Hardware ...49
Buying a Digital Camera ...52

SATURDAY MORNING
Starting Your Day of Digital Photography 57

Plan, Plan, and Plan ...59
Preparing to Shoot Outdoors ...60
At the Ends of the Day: Sunrise and Sunset61
The Great Outdoors: Landscapes and Scenery72
Take a Break ..83
Architecture, Buildings, and Structures as Subjects83

Pets and Other Animals90
People, Children, and Portraits Outdoors99
Cars, Trucks, and Other Vehicles105
See What You've Got ...112
What's Next ...113

SATURDAY AFTERNOON
Starting to Shoot Inside 115
Control Freaks, Apply Here118
Indoor Shots of People118
Building Interiors & Architectural Appointments128
Shooting Still Life ...136
Take a Break ..145
Action and Motion as Subjects146
Taking Pictures through Glass156
Shooting Metals and Reflective Objects166
Back It Up! ...173
Take a Break ..174

SATURDAY EVENING
Shooting at Night and in Low Light 175
What You'll Need ..178
Digital Photography at Night178

SUNDAY MORNING
Going Beyond Great Pictures to Get Great Images 189
Transferring Your Photographs to Your Computer192
Scanning Basics for Hybrid Photography199

Using PhotoCD or Professionally Scanned Pictures206
Basic Image Processing: Software Overview210
Image Size versus Image Resolution................................221
Sharpening Your Photographs....................................226
Take a Break..233
The Basics of Digital Color....................................233
Color Corrections..237
Enhancing Your Photos with Simple Styling Effects................246
Changing Colors for Effect....................................258
Using Lighting Effects to Modify Your Photographs................267

SUNDAY AFTERNOON
Introduction to Advanced Image Processing **275**
Outlining Objects in Your Photographs............................277
Changing Scenes and Backgrounds285
Correcting or Distorting Perspective295
Other Effects to Try..300
Take a Break..312
Outputting Your Images.......................................312
Overview of Printing Options335
Using Service Bureaus and Professional Labs344
Special Concerns When Outputting Digital Files349

APPENDIX
Digital Photography Web Resources **353**
Hardware..353
Software Manufacturers......................................356
Magazines..357
Web Imaging..358

Glossary . **359**

Index . **367**

ABOUT THE AUTHORS

Brad Braun is a computer programmer and digital photographer with a background ranging from professional herpetology to laboratory digital data acquisition. He is currently the Director of New Media at Braun Productions where he is involved in Web Site Design and Interactive Media productions of all kinds. He is also a part time Instructor at the Cuyahoga Community College where he teaches Media Design. The course introduces students to multimedia authoring using Adobe Premiere, Macromedia Authorware, and Macromedia Director.

Marc Braun has been a professional photographer for more than a quarter century. His images have been winning local, national, and international awards throughout his career. Marc led his studio into the digital age in 1994 when Braun Photography was one of the first major studios to convert to true digital photography. Computing was nothing new to Marc, who had originally started his career as a computer programmer during the early 1970s and has continued at the leading edge of technology ever since.

ACKNOWLEDGMENTS

An incredible number of people contributed in some way to make this book possible. We have tried to list them all below, but we're sure we've missed someone. To that person we apologize and can only make the excuse that it is 4:58AM and the darn thing is due!

Folks who either were or provided photographic subjects:
 Models: Katie Murdoch, Dave Braun, Quinn Braun, Laura Braun
 Charles Ackermann, owner of the 1963 Morgan
 Scott Isquick, owner of the 1939 Rolls Royce Wraith
 Joseph Grizelak and the Cuyahoga Valley Terminal Model Railroad Club
 Roy Baine, Manager of the Quaker Hilton Hotel, Akron, Ohio

Special thanks are due the fine folks at Eastman Kodak. Their continued devotion to the advancement of excellence in digital photography is an inspiration to us all. Particular thanks are due W.J. "Gus" Radzyminski, Division Marketing Training, Digital & Applied Imaging. Gus helped us in a multitude of ways, but perhaps most by his enthusiasm and commitment to spreading the word about digital photography. Thank you, Gus.

Some of the many other Kodak people who provided so much assistance with material for this book:
 Michelle Zeller, Marketing Programs Manager, Americas Region
 Derek Doeffinger, Marketing Communications Manager
 Steven Spinelli, Inkjet Product Applications Specialist
 Ted Skomsky, Quality Engineer, Digital Cameras
 Kylie Peters, Marketing Programs Co-ordinator, Worldwide Marketing Digital and Applied Imaging
 Joseph Kurzweil, Worldwide Product Manager, Digital Capture Business Unit, Digital & Applied Imaging
 Christopher Cegelski, World Product Manager, Digital Imaging, Digital and Applied Imaging

We also wish to thank the following people from various corporations for their support and assistance with materials and information for the book:

Olympus Digital

Richard Pelkowski, Tech Support

Marlene Hess, Olympus Public Relations Department

Ken Barone, Product Manager, Consumer Digital & Imaging Systems Group

Colleen Clifford, Public Relations Coordinator

Steve Morgan, Director of Sales and Marketing, Harding Energy, Inc. (Quest Batteries)

Chris Taylor, MGI Software Corp.

From Fuji Digital:

Kelly Lesson, Public Relations Assistant, Corporate Communications

Jason Kule Edelman, Public Relations

We would also like to thank the dedicated team who worked on the book and made it all happen.

Dan Foster, Managing Editor

Jenny Watson, Acquisitions Editor

Kim Benbow, Project Editor

Hilary Powers, Copy Editor

John Popp, Technical Reviewer

Introduction

If any phrase in use today can challenge "the Internet" as the most-often-heard buzzword, it is *digital photography*. Like so many terms often heard and often used, the meaning of digital photography is not always clear. Too often people make too much of the technology, the digital prefix, and don't say enough about the photography. In fact, the secret of digital photography is to begin with solid principles of good photography, and only then turn to the limits and special concerns specific to using digital cameras and how they differ from conventional photography. With these principles securely in place, it becomes possible to use digital photography to take better pictures, and to have more fun while taking them.

Digital cameras are an exciting technology. They have an increasingly important role in the workplace, with new applications being created every day. Digital cameras can also contribute to a social event, they excite children and help bring people together in a way so surprising you have to experience it firsthand to truly appreciate it. Interestingly, the immediacy of digital cameras, with the ability to instantly review your shots, makes them a potentially invaluable tool for the photo student and serious hobbyist because they dramatically shorten the time involved in the photography learning curve.

What Is This Book About?

Make no mistake about it; this is a book about photography. It is about taking all sorts of pictures, and about doing so with a digital camera. The exercises in this book assume that you'll be using one of the newer consumer-level digital

cameras, which are currently retailing for between $500 and $900 (though, as you'll see in the Friday Evening session, you don't necessarily have to buy a camera in order to play). Cameras of this type are now of sufficient quality that they can produce acceptable images for a diverse range of uses, and the associated technologies are sufficiently mature that even the most jaded pro photographer can become excited about these handy little cameras.

Digital photography is based on the same principles as conventional photography, but the two are not the same. This book shows you how to shoot digitally, with a special emphasis on the differences between digital and conventional photography. Understanding some of these differences will help you use your digital camera to surpass your conventional shots, while others will help you avoid photo disasters that don't exist in the conventional photography world.

Secondarily, this book is also about software and computers; tools integral to digital photography. You'll learn about using software to improve your pictures, the options you have to output your photos, and even a bit about scanning so that your conventional photos aren't entirely left behind.

How This Book Is Arranged

The basic goal of this book is to help you to learn as much as possible about digital photography in a weekend's time. To that end, the book is arranged around an actual weekend, starting with Friday Evening and continuing through Sunday Afternoon. Half of the material consists of practical exercises that help you to learn by doing, while the other half is background theory and

reference information—stuff to read for general recall, knowing that you can check back on it when you need to apply it, which won't necessarily be during the weekend.

Friday Evening is about getting some terminology under your belt and helping you to understand the various hardware options, technologies, and principles involved with digital photography. There is very little in this section that is particularly tied to a time of day, so you could review it at any time prior to commencing the rest of the book. Because Friday includes information that can help you select a digital camera, but no time during the weekend is allotted for shopping, you may wish to look over at least that portion of the material in advance so that you are ready to do some digital photography.

Saturday Morning, Afternoon, and Evening are all about shooting. There are a total of 13 exercises that give you hands-on practice with digital photography. Some of the exercises, like those that assume certain levels of outdoor light, need to be tackled at specific times of the day; however, the majority can be done at your own pace, and in any order that suits you. It is possible to do all of Saturday's shooting, allotting an hour or so per exercise, if you are willing to use simplified practice settings instead of trying to get pictures you'll really like. If you wish to concentrate on a handful of specific exercises, that's OK, too. Each exercise has enough information to keep you busy for hours, days, or even a lifetime of shooting. The route you take is entirely up to you.

Sunday is about doing things with digital photos after they've been shot. The intent of the information throughout the day is to help you find approaches that will make the most of your digital photos, without providing too much detailed instruction in any specific software package. Sunday Morning introduces you to an overview of scanning, storage, and editing your images. The Sunday Afternoon session starts with a few more advanced software techniques and goes on to help you with getting the output you want, whether on home printers, in the form of electronic files for multimedia presentations and Web pages, and from professional service bureaus.

So, is a weekend enough to do it all? Absolutely yes, and no way at all. If you make the commitment of a full and busy weekend devoted to this book, you will be well rewarded. You can even do all the exercises. However, this book will continue to serve as a reference for a long time to come (at least until the release of the second edition), helping you grow and develop as a digital photographer.

Who Should Read This Book

Have you ever wondered what a digital camera is, and if it is different from other cameras? Are you excited about taking pictures, but frustrated by the delays when you try learning the nuances of better photography? Are you confused about the differences between digital photography and photographs that have been digitized by scanning? Have you bought or are you considering buying a digital camera? If any of these questions apply to you, you should read this book.

If you are already an avid photographer and are interested in learning more about digital photography, then you'll find this book was written with you in mind. First and foremost, this book is about taking great pictures, so if that is a goal of yours, you should also read this book.

This book is not just for the curious, or for the student of photography. Many exercises and tips explored in this book are targeted to professional graphic artists, small business operators, salespeople, and even investigators; all of whom can benefit by the regular inclusion of digital photography in their workplace. Most of the users of digital cameras targeted toward the consumer are actually professionals, with specific business applications for digital photography. If you are one of these folks, using your digital camera effectively can make a substantial difference in your job performance and satisfaction. By all means, if you use a digital camera in the workplace, you need this book. And if you aren't using a digital camera to get the pictures you take at work yet, you should be, and you *desperately* need this book.

What You Need to Use This Book

There are three important things you'll need when using this book. First and most important is a desire for better pictures. Your motivation could be work, play, study, or something entirely different. What matters is that good photographs matter to you.

The next thing you need is a digital camera. The Friday Evening session helps you understand the elements of a digital camera and will also help you select one, if you haven't already. You can even borrow or rent a camera, if you don't already own one. In fact, a borrowed camera gives you the opportunity to learn which features matter most to you before plunking down the full price

of a camera. However you come by it, you should have a digital camera in hand. This is, after all, a book about digital photography, and so most of the book is targeted to the use of digital cameras and the manipulation and output of digital photos.

Finally, you should have a reasonably up-to-date computer with image-editing software. Most digital cameras come bundled with basic but reasonably functional software that will get you through the software chapters. If you already have other software that you know you'll want to use in the future, be sure to use it during the weekend as a way to learn how to make the most of your digital photo tools.

Special Features

Several elements in this book will help you on your way:

TIP *Tips* offer insider information about a technology, a company, or a technique.

NOTE *Notes* provide background information and insight into why things work the way they do.

CAUTION *Cautions* warn you of possible hazards and point out pitfalls that typically plague beginners.

SIDEBARS

These special sections offer suggestions for using techniques like the ones you'll encounter in the exercises.

FRIDAY EVENING

Getting Started

- ✪ What Is Digital Photography?
- ✪ Types of Digital Cameras
- ✪ Evaluating Digital Cameras
- ✪ Buying a Digital Camera

This evening is about sitting back and planning for the weekend. Get cozy and plan for a night of reading and review. The information included in this section will help you buy a digital camera, but actually shopping for a camera really isn't part of this evening's activities. If you are able to borrow one or more digital cameras from someone, you may want to delay purchasing your own unit until you've had a chance to go through the book and discover what is most important to you about digital photography.

TIP Review the schedule for Saturday this evening. To get the most out of this book you will need to plan your time carefully tomorrow—for instance, you may want to get up before dawn to take advantage of the early light for the first exercise. Now is the best time to make sure you have everything you need for Saturday's exercises, including running to the store to get whatever you may be missing. It isn't possible to have too many batteries for your digital camera, so make sure you have at least twice as many as you think you'll need.

Get used to the idea of planning—you'll see it over and over throughout this book. As a digital photographer, you'll almost certainly be using some terrific equipment, but digital equipment can impose some unique limits on your shooting, making it essential to plan your shots and shooting ahead of time. The best form of planning comes from experience, so shoot every chance you get—it'll pay off when the shots really count.

How to Use This Book

The sessions in this book are arranged so that you can do everything in a weekend. Everything has been carefully planned to make this possible, but

that doesn't mean that the pace might not get hectic. Let what you hope to get from digital photography itself guide your approach to the weekend—and feel free to stretch the book out as long as you wish. Some sections may not appeal to you directly, and you can skip doing the shooting exercises they describe—but you should still review the text. Every section of the book includes general information along with the exercise-specific materials.

Looking at the book from the standpoint of the session headings, Friday Evening's information is a good general reference for choosing a camera and other equipment and software that will help with your digital photography. This session also gives you the basic definitions and terminology you'll need to be able to run through the book's exercises. You can come back to the information later for review if you need it, but it's a good idea to pick up the basics now.

Saturday is a day of photography. The exercises are set up lab style, with each session designed so that you can complete it in an hour or less. You'll get good hands-on practice using your digital camera Saturday. You may find yourself going back to the exercises again and again, both for the general information included with each exercise and to keep honing your shooting skills. You could spend an entire day or more on any one of Saturday's sections—or even a lifetime as a specialized professional photographer.

Sunday covers a lot of territory using software and your digital images, and in many ways is the most general in its application. Sunday's sessions can be used to improve your pictures and to begin to go beyond standard photography. You will even learn how to scan existing images from conventional photography, an exercise that is not digital photography at all but something that you'll probably find desirable if you have a large stockpile of conventional photographs stored away.

You will learn a great deal from this weekend's exercises, but this book is really only a start. The world of digital photography is just one part of the wider universe of digital imaging—a universe that gets larger and more exciting every year.

What Is Digital Photography?

Digital photography is part of the much broader field of digital imaging. It is likely that you have some experience with some form of digital imaging, although perhaps not digital photography itself. *Digital imaging* covers all

types of imaging that use computers at some phase or another of their development and application. So an entirely computer-generated image, an image created by an artist using a computer drawing tool, even an image photographed on film and scanned into a computer are all examples of digital imaging—but none are digital photography.

Digital photography is, specifically, using a camera to capture an image directly to digital form, without the use of film. A special sensor captures the light, much the way film does with conventional photography. So digital photography is first and foremost photography—and in many ways it has more in common with conventional photography than it does with other forms of digital imaging.

In spite of the similarities, there are many significant differences between conventional and digital photography. Much of this book is devoted to helping you understand and appreciate those differences. A small portion of this book also helps you to apply what we call hybrid photography. *Hybrid photography* is a form of digital imaging that incorporates scanned conventional photographs.

Many people confuse hybrid photography with digital photography, but because hybrid photography uses film it is very different from digital photography. The next session of this book will deal directly with the differences between digital, conventional, and hybrid types of photography. Understanding these differences will be important as you progress through the exercises in this book.

Digital, Hybrid, and Conventional Photography

Now that you know what digital photography is, you can begin to explore the question, Why digital photography? As with so many things in life, the decision to use digital photography has some advantages and some drawbacks. Every person and situation has unique elements, and so only you will be able to decide for sure if digital photography is right for you. For many, it is not a question of exclusively choosing either digital or conventional or even hybrid, but of knowing and understanding when each is most appropriate. Much of this evening's session is devoted to helping you make just that determination.

The way to compare different types of photography is to follow the story of the pixel as a component in different types of images. You are probably already familiar with the concept of a pixel in digital imaging; it is the tiny point that makes up one discrete element in a digital image. Film also has a discrete element, called a *film grain,* which is used to make up the conventional photograph. Although the term pixel is usually reserved for digital imaging, for the sake of clarity during this comparison we will use the same word to refer to both digital pixels and film grains.

Something to bear in mind is that conventional and hybrid styles of photography start out identical in all, or nearly all, ways. Hybrid photography is merely a bridge to allow images created using conventional photography entry into the digital-imaging world. The process by which hybrid photography is digitized is called *scanning,* and is identical in essence to any other scanning process. So hybrid photography bears about the same resemblance to digital photography that scanning a hand-painted watercolor does to drawing directly onto a digitizer tablet—which is to say, not very much.

Cost

The overall cost of digital photography is higher than that of conventional photography. Of course, the sky is pretty much the limit for spending on either type, but as a general rule a digital camera will cost at least two to three times as much as an otherwise similar conventional unit. If you do not already have a suitable PC and software to manage your digital photographs, that alone can be the greatest cost associated with digital photography. Although digital photography does save a bit in the long run because there are no film or film processing costs, for most people this saving will never equal the expense of the initial hardware investment.

OK, digital photography is more expensive than conventional, but where does hybrid photography fit into the cost scale? Actually, hybrid photography is potentially the most expensive form of all. What determines the expense of hybrid photography is the percentage of your total conventional photography that is scanned. For the conventional shooter who only occasionally makes use of hybrid imaging, it is probably not necessary to invest in a scanner (which can cost as much if not more than a digital camera), a high-end imaging PC, and other tasty gear. But for the devoted hybrid photographer, the cost will be as much as doing both conventional and digital photography combined.

Uses

Your intended use of an image will help you to determine which photographic method is best for you. The general categories include hardcopy output or prints, electronic images for a multimedia production or a Web site, and reproduction in printed media—all of which can benefit from the sheer ease of sending digital photographs from one place to another electronically. The difference between prints and printed media is that prints are what you normally think of as photographs, while printing is a much more complex process that you might encounter during the production of things like newsletters or magazines.

When it comes to getting prints of your images, there can be a trade-off in time and money in determining whether conventional or digital is most desirable. Film tends to be the most cost-effective and widely supported format for prints of your images. You just drop the film or negatives off at a photo shop and some time later pick up your prints. If you have the equipment handy, however, digital prints can be generated at almost the instant they are taken, being handier and faster even than Polaroid self-developing photos because you can make an unlimited number of prints from a single shot. But digital prints tend to be much more expensive than conventional prints; and if you haven't purchased the equipment necessary to do it yourself, it can take much longer to locate a service bureau, send in the image file, and wait for the prints to be produced. Hybrid photography really isn't a factor in this comparison, because you can simply get prints from your negatives without bothering to scan them.

If you intend to use a photograph in an electronic form, then you are limited to either digital or hybrid photography. There is no question that the very nature of digital photography usually makes it best suited to electronic forms. There can be quality issues, both pro and con, to using digital photography instead of hybrid photography for electronic media. Later this evening you'll learn about quality issues in the section titled "Evaluating Digital Cameras."

For all practical purposes, printed images today are produced digitally, and so—as with electronic uses—you'll be limited to digital or hybrid photography. Nearly all printing shops have in-house scanners, so this is one case where the problems of scanning will not fall on your shoulders. Many print houses today are happy when you bring them images for printing in digital form, but be aware that a few have difficulties with files that they do not scan themselves,

even if the files are digital photographs. So if you have a print house with which you often work, ask the staff about their digital capacities. You may actually get better results submitting photographic negatives or transparencies to them rather than shooting digitally.

The transmissibility of conventional photography is limited by your ability to physically transfer images to the required location. This can be fine, unless you need to get a picture around the world in a few hours. Electronic files, whether originally digital or hybrid photographs, offer far more methods and far faster transmission. Digital photography does have a great speed advantage, because the files can be transferred as soon as they are captured, versus the hours or days of delay required to prepare a hybrid file.

Production

Probably the best way to compare production is to see what happens to a pixel in each method of image production for different types of output. As you'll see later in the book, the steps in production can have a profound impact on image quality. Also, depending on where and how you plan on shooting, some types of production may be more or less well suited to your plans.

A conventional camera produces images by passing light through its lens onto a sheet of light-sensitive film. The film then goes through a chemical development process that eliminates the light sensitivity and thus stabilizes the image. During this processing, the film may suffer damage that reduces the image quality, but basically the original pixel (film grain) that responded to the light remains unchanged in the information it contains. If you are shooting slides, or transparencies, the processing of the image essentially ends with the development step. If you have ordered prints, the development step produces a negative image that goes through another set of lenses in a device called an enlarger, which exposes light-sensitive paper to create the print. The processes involved in creating conventional images have been largely automated, and in many cases you may be able to drop off film and pick up prints an hour later.

Digital photography production is essentially complete when light passes through the camera lens and falls on the light sensor. The camera has software that converts the raw data from the sensor into a usable computer file, and that is in many ways the equivalent of the negative or transparency produced in conventional photography. The image often gets some further processing on a personal computer or even by the software that runs a computer printer, but

it can be used for some purposes the instant it's recorded. For most uses, digital photography is much faster than conventional photography.

Hybrid photography is the most complex in its production, and is potentially the most time-consuming. All the steps involved in producing conventional photographs apply to hybrid photography, although it is generally recommended that you scan negatives or transparencies rather than photographic prints. During scanning, photographs are processed through another set of lenses and the resulting images passed to another light-sensitive device. Hybrid photographs are then sent through software like that used for a digital photograph. So hybrid photography requires the most processing during production and is the slowest to result in an end product.

Quality

Picture quality is where the story of the pixel really begins to come together. This section is devoted to the theory of image quality; in the upcoming "Evaluating Digital Cameras" section you will see the real-world application of the theory.

Once the pixel in film is exposed and processed, it retains its intrinsic quality. If all you ever want to do with a conventional photograph is to look at a transparency or negative, the issues involving quality would end there. When you decide to produce a print, however, new issues arise that affect image quality. The quality of the optics in the enlarger, for example, will cause some of the information in the pixels to blur and lose quality. It may surprise you to learn that photographic paper has a resolution associated with it, and that also causes image degradation.

Processes that cause a loss in image quality are called *lossy processes.* So the process of producing a print from a negative is a lossy process. But not very lossy—if what you want are photographic prints, conventional 35mm photography will give you better results than you'll get with consumer-level digital or hybrid techniques.

For hybrid photography, the processing will have a much greater adverse effect on the final image quality. When you scan an image, the sensor in the scanner has discrete pixels just like the film being scanned. Unfortunately, the pixels on the scanner can never match up to the pixels in the film exactly, so there is overlap. When pixels overlap, their edges get blurred and they end up approximating the information they are meant to represent. To counteract this effect

to some extent, hybrid photographs are often created using a method called *overscanning*, where the scanner uses a pixel size much smaller than that of the film. An overscanned image uses many pixels to represent a single pixel from the original, thereby getting a sharper image than if the scan were of the same resolution as the original. The upper limit for the true resolution of the scan is still the resolution of the original, however, no matter how much you overscan.

To compare conventional, digital, and hybrid images you must begin by considering image size in terms of pixels. The standard resolution for preparing digital images for print is 300 pixels per inch (ppi), so an image at three inches by five inches is 900×1,500 or 1.35 million total pixels in size at 300ppi. This is the reason you'll see so much emphasis on megapixel cameras, or those that produce photographs that have more than a million pixels in content. The actual size of the image will depend on the amount of color information and other factors, but for now consider these simple dimensions as a gauge.

From this example, you might assume that a 1.3-megapixel camera can make a pretty decent 3×5 print, and you'd be right. You might also begin to suspect that, in spite of what camera manufacturers might say, image quality begins to drop pretty quickly above 3×5 for a 1.3-megapixel camera, and again you'd be right. Using the reverse process, the theoretical target size for an 8×10 print is 7.2 megapixels, and about 3.2 megapixels for a 5×7. As a comparison, a 35mm negative is considered to have the information content of about a 4 to 8-megapixel image.

Fortunately for the digital photographer, pixels aren't everything in the issue of image quality. While it's true that if you simply wish to shoot and pump prints, a 35mm camera will give you better quality than a consumer-level digital camera, the amount of processing involved in conventional and hybrid photography mean that they are not as superior to our sample consumer digital cameras as you might expect. In fact, if you compare digital photographs and scans containing the same number of pixels, the digital photograph should be of higher quality because it has not been processed past the original capture.

Of course, not everything in the world revolves around prints. Electronic representations of images tend to be much lower resolution than prints, so the playing field is evened a bit for digital photographs. Even so, hybrid photographs that have been heavily overscanned are potentially of higher quality than a digital photograph, but the variables of scan quality can begin to play a big role. Also, because they tend to be sharper for a given number of pixels, digital photographs are often more efficient in terms of disk space for a given quality level.

Applications and Uses

Digital photography has a multitude of applications, as many as for conventional photography and then some. When considering consumer-level cameras, however, the scope of uses can become a bit more limited. Consumer-level cameras have some advantages over models designed for professional users, one of the most important being price (see Figure 1.1), but their lower image quality and point-and-shoot designs are definitely better suited to some applications than others. In this section you'll learn about some of the ways consumer-level digital cameras can work well; in the next you'll get a brief glimpse of their shortcomings.

If you intend to use a digital camera primarily for personal shooting, the applications are limited only by your imagination. Any place you might use a conventional point-and-shoot camera is likely to be suitable for a digital unit. As you will discover during tomorrow's shooting exercises, using a digital camera can be very different from shooting conventionally, but once you get a bit of experience under your belt you'll probably find yourself using your digital camera to try new and different types of shooting.

There are also many commercial users of consumer-level digital cameras. Many graphic designers, commercial artists, and public relations firms have replaced instant cameras with digital. Any number of industrial firms, ranging from

Figure 1.1

To seamlessly integrate digital photography into all applications requires a professional model, like this Kodak DCS-520, which can be yours for a mere $14,000. Photo courtesy of Eastman Kodak Company.

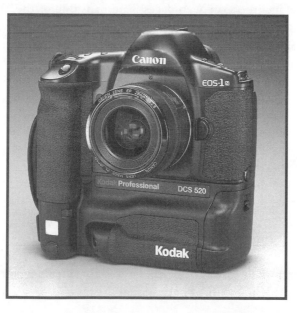

manufacturers to construction outfits, have found uses for digital cameras. Insurance adjusters, investigation firms, and members of law enforcement also use digital cameras as part of the job. The combination of flexibility and immediate results has led to digital cameras being used in place of conventional photography and anywhere instant cameras were traditionally found.

Ways to Use Digital Photography

There are many excellent applications for consumer-level digital cameras. Each of tomorrow's shooting exercises offers ideas for uses of digital photographs of the type being captured during that specific lesson. You can review those ideas, in addition to the points made in this section.

Digital cameras can be good at producing photographic prints as long as you stick to the smaller print sizes. Of course, if you do not desire prints and are satisfied with the lesser quality associated with consumer ink-jet or color laser prints, then digital photographs can result in a quick and easy way to get hard copies of your images. A common hardcopy use of digital photographs is in newsletters and fliers produced personally or semiprofessionally for clubs and organizations. The widespread availability of desktop publishing software and the ease of transferring digital photos to a computer make digital cameras ideally suited to this application.

Of course, inclusion on Web pages is perhaps one of the most common uses of digital photographs (see Figure 1.2). You'll find lots of other Internet-related applications, including sending images as part of e-mail. For instance, you can include digital photos of critical landmarks when you e-mail driving directions to people trying to find your house. In all, digital cameras often provide faster access to your images on the Internet, and many times result in sharper, more compressed images.

When Speed Counts

Many uses of digital photographs apply to all types of digital images. After all, in most cases it probably does not matter if your Web site features digital or hybrid photographic elements. But what about applications where consumer-level digital cameras have unique capabilities that allow them to produce images not normally possible with other types of photography? These applications appear when speed is everything; it is not surprising that most news organizations made the shift to professional digital photography long ago.

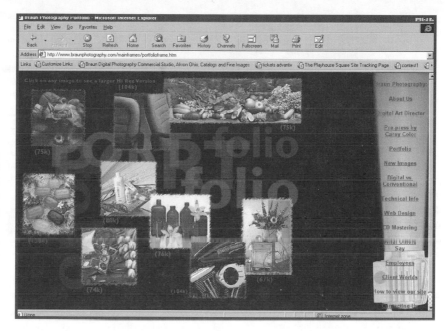

Figure 1.2

Digital photographs abound on Web pages, like this one from the Braun Photography Web site. Image courtesy of the Shameless Self-Promotion Department.

Because digital cameras make real-time or near-real-time uploading to the Internet possible, they offer electronic uses not possible with hybrid photography. It is possible to use a digital camera to post images of an event as it happens on a Web site for all to see. The applications of this are endless, from allowing long-distance relatives to be part of a virtual wedding reception to allowing shareholders to view the unveiling ceremony of your company's newest product (see Figure 1.3).

The immediate access to photographs made possible by digital cameras also helps in the teaching and learning of photography itself. While there are unique elements to digital shooting, many of the principles involved are the same for all photography. You will find that you are able to study your shots and correct your mistakes quickly as you try new and different forms of photography. Similarly, in a formal teaching setting, instructors can give students guidance and feedback while they shoot, greatly speeding the instruction process.

Storage and Retrieval

Digital photographs have great advantages over film when it comes to storing and accessing your images. An image database is vastly easier to search and use

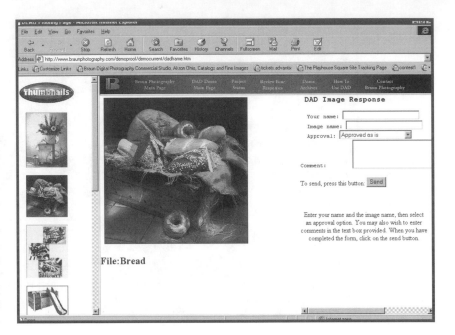

Figure 1.3

In another offering from the Shameless Self-Promotion Department, digital proofs of a photo shoot in progress are available to Braun Photography clients who are not able to be on site during a shoot.

than the traditional shoebox storage method. Copying images is as easy as copying any other computer file, and through the use of networks and other digital means of distribution, it becomes possible to make the same image available to many people at once.

Where Digital Photography Does Not Work

Consumer-level digital cameras have limits when it comes to some applications. Most notable is in the production of large photographic prints. You will find that the quality of the images these cameras produce typically is not acceptable above prints about 3"×5" in size. You will learn more about why this is in later chapters, but for now keep in mind that if large prints are important to you, you may wish to seriously reconsider venturing into the digital arena. As a general guide, you will probably have to wait until manufacturers start advertising that they've crossed the two-megapixel boundary before large prints become a viable option.

Another limit of most digital cameras is their poor performance under very bright light conditions. There is a section during Saturday Afternoon's shooting

exercises devoted to just this problem (see "Shooting Metals and Reflective Objects"), but the hints and tips suggested are mostly for the shooter who occasionally encounters these conditions. If it is your intention to shoot in very bright light much of the time, be sure to try out any digital camera you are considering before you make a purchase. Many cameras just will not give acceptable results under very bright light.

If you do a lot of action shooting that results in going through roll after roll of film in multi-frame bursts, a consumer-level digital camera is probably not for you. Some cameras now offer a burst mode, where several images are fired in rapid succession, but so far these modes are severely limited. You'd do better to wait until a digital camera within your price range can take many megapixel images in succession without sacrificing important camera functions like flash usage.

Types of Digital Cameras

Although digital cameras have only been around for about a decade, there may already be as many types and features for them as in all of conventional photography. Of course, the majority of tools used in digital photography originated in conventional photography; an excellent example of this is the Olympus D-600L digital camera, which is based on that company's popular line of point-and-shoot cameras. Still, just as digital photography can expand the creative possibilities available to the photographer, new tools and techniques are being developed to make the most of this exciting medium. This section will give you a brief overview of various types and features of digital cameras available so that you can evaluate your own needs when it comes to purchasing a digital camera.

The Pro Gear

Not surprisingly, most digital cameras remain in the realm of expensive professional-level gear. This is rapidly changing, as consumer demand has grown and advances in technology have made it possible to deliver reasonable image quality below the $1,000 mark. Still, most good information about digital cameras and their effective use has remained the province of professional photographers; even many pros who've tested the digital photography waters have failed miserably. As you look around for information, particularly on the Web, you are likely to encounter it in scrictly professional terms.

The majority of professional digital cameras are actually devices that attach to the back of traditional cameras and replace what is called the *film holder* or *film back* in conventional photography. This is why you may encounter the term *digital back* to mean digital camera (see Figure 1.4). Actually, most professional cameras can be digital or conventional depending on what type of back the user attaches to them.

One thing that will separate the successful digital pro from the wannabe is the use of digitally tuned optics, or lenses designed for shooting digitally. This is an issue unlikely to affect you, as you will probably not have a unit with interchangeable lenses, but is something to be aware of as you may encounter it when poking around for information.

You may also encounter debates on the Web between advocates of scanning backs and capture backs. A *capture back* uses a single large sensor to capture a digital photograph in a single instant, similar to film. A *scanning back* works like a flatbed scanner, passing the sensor slowly over the image area to capture the photograph. To the authors of this book, the debates over the two types of backs can be pretty silly and about as meaningful as trying to declare one film superior to all others and the only one you will ever need. Both types of backs can be used to get good images under the right conditions, and both have areas of weakness.

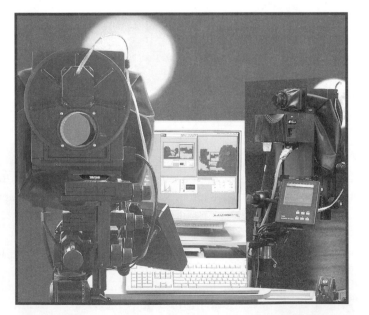

Figure 1.4

A digital self-portrait of the Leaf DCB on a Sinar p2 4X5 camera. If you find this jargon confusing, wait 'til you search the Web for information on digital cameras.

Another type of professional digital camera uses a professional single lens reflex (SLR) 35mm camera body and replaces the film plane with a digital sensor. The sensor is permanent, so the camera cannot use conventional film. These cameras allow the professional photographer to use an existing supply of lenses and other accessories to capture digital photographs. The images are stored on a standard-type hard drive within the body of the camera, or are saved directly on a computer via a cable. In many cases, the image quality available to the consumer is beginning to rival that of these cameras, and you may soon see cameras of this style available at a price point more reasonable for the average user.

Consumer Digital Cameras and Their Features

The most rapid growth in digital photography over the last several years has been in consumer-level digital cameras. As recently as 1996, to compare the image from a $1,000 digital camera to a picture taken with a disposable camera and scanned with a hand scanner would have been laughable—the junkiest hand camera would win every time. Those days are gone, and consumer-level digital cameras are beginning to rival traditional film photography in quality. It may take another year or two until affordable digital cameras truly reach the mark of 35mm film, but for many uses their quality is quite good already, and the flexibility and immediate convenience of the digital photograph simply can not be rivaled.

There are two basic forms of consumer digital cameras, the single lens reflex (SLR) and dual lens models. The primary difference between them is that the SLR provides you with a *viewfinder* (or *finder,* as we refer to it throughout the book—the thingy through which you look when taking the picture) that uses the same lens that takes the picture (see Figure 1.5)—often called a TTL (through the lens) view. A dual lens model has separate lenses for viewing and photographing (see Figure 1.6). An SLR has a slight advantage in that the TTL view is from the exact perspective of the photograph—basically, you see what the camera sees; in a dual lens camera, the viewing lens will be slightly off perspective, which can create a problem known as *parallax.* Many dual lens digital cameras also provide a TTL view on a small LCD preview screen, and thus it is possible to avoid parallax.

When it comes to using digital cameras, much of what you'll be able to do—or not—will depend on the exact set of features and capabilities of your particular unit. Several good cameras will be featured during the course of this book, but because models and features change so rapidly, you should survey

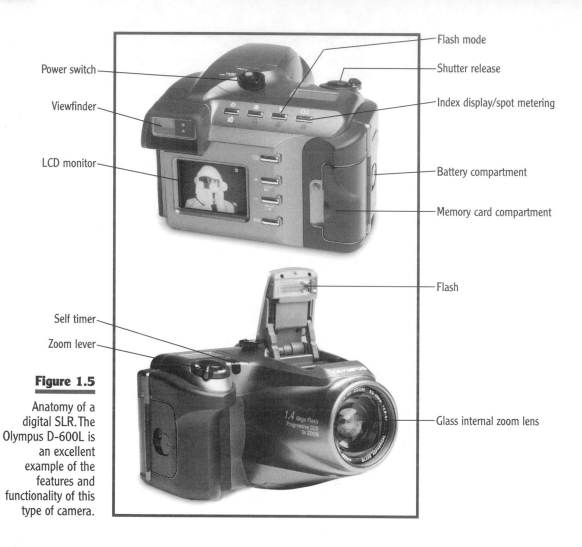

Power switch

Viewfinder

LCD monitor

Self timer

Zoom lever

Flash mode

Shutter release

Index display/spot metering

Battery compartment

Memory card compartment

Flash

Glass internal zoom lens

Figure 1.5

Anatomy of a digital SLR. The Olympus D-600L is an excellent example of the features and functionality of this type of camera.

the available cameras before investing in a rig of your own. The following descriptions of general features should help you cut through the fog of manufacturer marketing gimmicks and mega mart salesclerk hand waving.

Dipping into Chips

Just in case you've been napping so far: digital cameras do not use film. In a digital camera, a light-sensitive chip captures the photographic image. The camera reads the information on the chip and converts it into binary, or

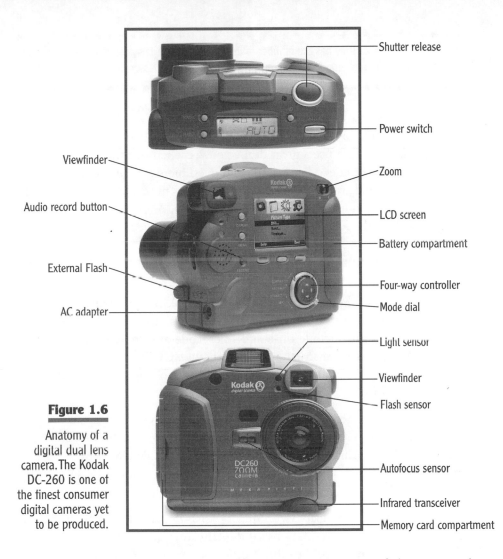

Shutter release

Power switch

Viewfinder

Zoom

Audio record button

LCD screen

Battery compartment

External Flash

Four-way controller

AC adapter

Mode dial

Light sensor

Viewfinder

Flash sensor

Figure 1.6

Anatomy of a digital dual lens camera. The Kodak DC-260 is one of the finest consumer digital cameras yet to be produced.

Autofocus sensor

Infrared transceiver

Memory card compartment

digital, information. There are two types of chips currently in use, and you should probably know which your camera features.

CCD

Most digital cameras feature light-sensitive chips of the type called CCD (Charge Coupled Device). CCDs are an array of light-sensitive units that correspond to the pixels in a digital image, so if a camera says it is a megapixel design that means that the CCD has more than a million units in the array.

◆ ◆

Be sure that a camera truly has the number of units advertised; a few manufacturers use a software trick called interpolation to claim a megapixel image from a lesser CCD.

◆ ◆

All high-end professional digital cameras use CCDs, as do all camcorders, but they are expensive to manufacture, have a high failure rate during the manufacturing process, and use a great deal of power when operating. On the positive side, CCDs offer excellent clarity and good picture definition. CCDs also have a good signal-to-noise ratio, which basically means your pictures won't have a bunch of smutz in them that doesn't belong. A low signal-to-noise ratio can be particularly beneficial when a photographic subject is moving or when the lighting is poor.

CMOS

The latest entry in the digital chip arena is the CMOS (complementary metal-oxide semiconductor). A CMOS bears a greater similarity to a classic computer chip, and can include on-board microcode and logic circuits. CMOS chips are much less expensive to manufacture than CCDs, and because of their ability to handle software type functions, begin to approach the idea of a camera on a chip.

So far, CMOS cameras have shown substantially lower image quality than cameras based on CCDs. However, it is highly likely that the first sub-$500 megapixel digital cameras will be CMOS units. As CMOS technology progresses, CCD cameras will probably survive only as mid-range and professional systems, where the price justifies the high production cost.

As a testimonial to the viability of quality CMOS cameras, Eastman Kodak, one of the innovators in CCD-based digital cameras, has invested heavily in CMOS technology. Also, the same group who developed the extremely high-quality Leaf Digital Camera Back for professionals is now working on consumer CMOS technology. Because CMOS allows so many computing functions on a single chip, the need for a massive computing system as part of the camera is alleviated.

● ●

Watch for the release of a CMOS-based digital "film roll" that allows you to shoot digital photographs using your current conventional camera.

● ●

Trip the Lens Fantastic

There may be no element of your camera that can have as much impact as the lens on final image quality. The quality of the lens is very important, as is the view the lens gives you of your subject. At the moment, no consumer-level digital camera allows changing lenses, so you're pretty much stuck with what comes on the camera.

Plastic

Plastic lenses are extremely lightweight and inexpensive to manufacture. Typically, little else good can be said about plastic lenses. Plastic lenses are often not manufactured to the exacting standards necessary to good image quality; they can introduce color aberrations, and may have soft areas where focus is not the same across the image. Technically, it appears that very fine lenses could be made from plastic, but they almost never are. Approach a camera equipped with a plastic lens with skepticism, at the very least.

Glass

The good news is, nearly all consumer digital cameras have glass lenses. Glass lenses can exhibit any of the defects common in plastic, but rarely do. One possible reason for this is that lens quality has long been a matter of pride with camera manufacturers, and digital camera lenses are often designed and manufactured according to the same traditions. Another factor so far in favor of digital camera lenses is that they tend to be very expensive compared to similar 35mm point-and-shoot units, and so seem to be constructed of high-end parts. After all, it may not be possible to produce a $40 camera with a glass lens, but at $850 the lens cost is a much smaller percentage of the total.

Zoom

If you are familiar with traditional photographic terminology, then you know that a *normal perspective* lens means a lens that results in a picture that approximates what a person would see standing at the point of the camera (see Figure 1.7). *Wide-angle* is a lens that shows more than what the person would see, and is similar, but not identical, to the view of a person standing farther back (see Figure 1.8). *Telephoto* is a lens that takes a small portion of the normal view and expands it to fill the image area, giving the impression that the subject is closer than it really is (see Figure 1.9).

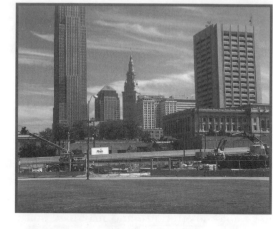

Figure 1.7

A normal view of the Cleveland skyline. This is about what the view would be for a person standing in the same spot as the camera.

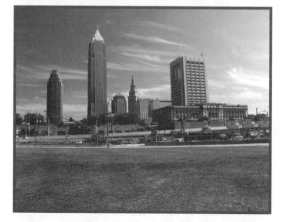

Figure 1.8

A wide-angle view of the Cleveland skyline. To see everything in this image, you would have to move back from the position of the camera or move your head from side to side.

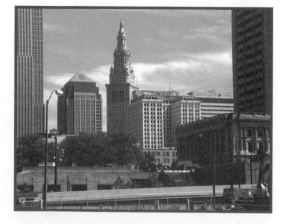

Figure 1.9

A telephoto view of the Cleveland skyline. This has the appearance of being much closer than the true location of the camera.

Most digital cameras are equipped with a zoom, rather than fixed, lens. A zoom lens has the ability to give multiple perspectives, typically a range from wide through normal to telephoto. A fixed lens has only one perspective, and in a camera without interchangeable lenses, it will typically have either a normal or slightly wide view.

Conventional 35mm lenses rate according to *focal length;* about 50mm is normal, 38mm and less typically the wide range, and above 55-60mm is considered telephoto. Digital cameras usually give the focal lengths of their lenses, too, but they aren't comparable either to film cameras or even to each other, because they have different chip sizes and so a different normal view. Most digital cameras rate their lenses as multiples of their own normal view, a system also used for camcorders. You might see a digital camera's zoom lens with a rating from 0.8× (wide-angle) to 3× (telephoto).

Many digital cameras have what is called a *digital zoom* capability, in addition to the optical zoom provided by the lens. Digital zoom is a software feature that merely enlarges the picture well past its native size. The image quality is extremely poor to horrible when digitally zoomed, so unless you have some artistic statement to make, don't use it. The good news is, you can always create the same effect yourself with software on the computer, so there's truly no reason to ever use this feature on your camera.

Lens Mounts

Now that you've already gotten the bad news that your camera will be stuck with one lens, here's the exception. You may be able to add filters or auxiliary lenses to your camera. There are two basic ways these work, either with a standard photographic threaded lens, or with a sort of spring-mounted clamp common to cheap camcorder lens accessories. If your camera has lens threads, you are fortunate, as you will be able to select from literally thousands of high-quality photographic filters and accessories that can boost the capabilities of your camera.

The most common lens accessories are wide-angle and telephoto adapters that can expand the range of your zoom lens or give a fixed-lens camera more versatility. Another common accessory is the UV-Haze filter that many photographers regularly use as a lens protector on all their lenses. A final filter you may want to investigate is a circular polarizing filter for high glare and aquatic settings. No matter what filter or lens accessory you choose, always make certain that it is of the highest quality available. There's nothing like a cheap filter to ruin the imaging properties of a good lens.

Can You Find It?

As you'll recall, a *finder* is the thing through which you look to get a preview of the picture you are about to take. Finders have always come in various forms, and with the advent of digital cameras, you have even more options from which to select. The important thing to remember about finders is that the better you're able to tell what's going on, the better your picture will be.

Optical

An optical finder, one that has you look through a lens at your subject, is an absolute necessity for all cameras, digital included. Optical finders can have various options, including whether they are TTL, as discussed earlier. Other options include a diopter correction (to allow eyeglass users to see through the lens) and various markings and displays that can give you information about the image without having to look away. You should be aware that no optical finder, including those with TTL, gives you exactly the view you will see in the picture. You will need to use trial and error to find out how they vary, but usually the actual picture will capture a bit more than what you see through the finder.

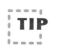

TIP

Check a camera's manual for the finder's percent coverage. Anything above 90% is pretty good for consumer-level cameras. While you're shooting, remember that your subject will be almost 10% smaller than it looks in the finder.

LCD

Having a liquid crystal display (called an LCD) on the back of a digital camera is great—it is simply one of the most important things that give consumer-level digital cameras their appeal. These displays allow you to view images in full color after they've been shot, run through the various options and settings for your unit, and even get a preview of what you're about to shoot (see Figure 1.5). Some LCD finders allow you to rotate and angle the screen, enhancing your ability to view the display at angles relative to the lens when you could not normally see the view. Another nice feature on some digital cameras is the ability to magnify the view seen on the LCD; this feature allows you to get a realistic view of the image, see if it is really in focus, check for red eye, and so on. LCDs can also give dual lens cameras a TTL view, often important in situations where parallax can occur or if you simply can't see through the optical finder (see Figure 1.10).

Figure 1.10

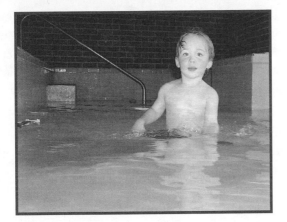

Figure 1.10

No, the photographer did not have to get in the pool to get this shot. The Kodak DC-260's LCD allowed the TTL view to be seen at arm's length with the camera held low, just above the water line, from pool side comfort.

LCDs are great, but they have a downside: they use tremendous amounts of power and thus drain batteries very quickly. Battery drain is not just a problem for your pocketbook—it can slow flash refresh time, reduce camera responsiveness, and generally degrade your shooting experience. An additional difficulty is that in bright sunlight many LCD displays are hard to view, which can make photography difficult. Because an optical finder, even if it is not TTL, will probably serve you very well for most of your shooting, you should avoid any camera that offers only an LCD for a finder.

Let's Get It in Focus

One of the critical elements of any photograph is how well it was focused. This is not as simple an issue as you may think, because in a surprising number of cases folks can disagree about the proper focus for a given picture. The key is options, and you'll probably have plenty.

Focus Free

A very limited number of cameras are focus free. While freedom sounds nice, this is generally a low-quality option, of the sort typically associated with plastic lenses. The entire image is in focus—sort of—but much of the picture will lack sharpness. The good thing about these systems is that they are fast, as there is no focusing delay prior to the picture being snapped.

Autofocus Systems

Nearly all consumer digital cameras have *autofocus*, meaning the camera determines the subject and adjusts the lens to focus. As a general rule, autofocus

systems are fast and work well. In some instances, however, autofocus will not work, or will not pick the correct subject. And autofocus can be extremely frustrating because under some conditions it can take much longer than the photographer would take to shoot the picture manually. The type of error and the circumstances where delays occur differ according to the type of autofocus system.

An *active* autofocus system uses a beam of light to measure the distance to the subject and make its focal adjustments. Active autofocus is often the most versatile, because it operates from its own light source and so functions in low light conditions, although it may take what feels like a long time to work. If you have observed a camera playing red light over a subject (this is technically known as an "alien death ray") before shooting, that camera has an active autofocus system.

Passive autofocus works by measuring differences in contrast to focus the lens. These units work from available light, and so may function poorly under low light—or not at all. They can be faster than active systems in good light. On the other hand, if you have ever heard a camera grind its lens in and out as it tried and failed to focus, it was probably a passive autofocus system in poor light.

Both passive and active systems can work by area or spot methods, in many cameras you have a choice. An *area autofocus mode* judges potential subjects within the entire active image area and will focus accordingly. Area has the advantage that if your subjects are around the perimeter of your image, it may well judge correctly and you will have the desired focus solution. *Spot focus* gives the photographer control over exactly what should be in focus by pointing an imaginary spot in the center of the finder at the subject.

Manual Focus

Manual focus is an option for many digital cameras, and one that you should get if at all possible. Most digital cameras offer manual focus, sometimes called autofocus override, via a user-selected distance range. While manual focus may seem difficult or annoying at first, you will probably find that to get the shots you want, it is the best mode a surprising amount of the time. For example, manual focus has the advantage of a nearly instantaneous shot without the wait for the autofocus system to find its solution. This added speed could make the difference between getting or missing a shot. In addition, manual focus is often necessary for shooting under low light using a camera with a passive autofocus system.

Close Focusing

Many digital cameras come with the ability to focus when very close to the subject. This ability can be either in a special close, or macro, focusing mode, or it can simply be a feature that's part of the camera's normal function. Be sure to find out how close your camera can be and still have the subject in focus, whether or not close focusing is an advertised attribute of the model. Close focusing can be a special way of shooting to get a different perspective on familiar objects, useful if the photographic subject is very small, or a necessity if you plan on shooting in close quarters. Whatever your intended use, close focusing is more important for digital cameras than for conventional units because it allows you to better fill the image space with the subject, conserving the limited digital image size.

Get Exposed

You have already read about the chip in a digital camera responsible for capturing the image and the lens that focuses and delivers the image to the chip. The camera's exposure system is what controls how all these elements come together successfully. There are different types of systems and ways they operate. While you may start off just using the automatic mode that works straight out of the box, you will undoubtedly want to explore more features and options as your understanding of your camera grows and your expectations expand.

The features in this section are probably the most technical you'll encounter. Don't worry if some of the terms are completely unfamiliar to you—as you go along things will become clear. You will learn more about the application and function of exposure during Saturday's shooting exercises. The ideas behind this section are definitely easier to appreciate in application.

Meter

The light meter of a camera is central to the exposure system. The meter measures the amount of light reflected off the subject and sets parameters that will usually give you a good picture. Most cameras out of the box will use either matrix or center-weighted metering. These metering systems measure light across the entire picture area. A *matrix system* sets exposure according to regions across the picture area, and has the advantage that the regions need not be contiguous. A *center-weighted system* places the greatest importance on a region in the center of the image, with metering trailing off the farther an object is from the center of the image area. Matrix metering can be the most

flexible when it comes to automatically getting good pictures under a variety of lighting conditions, but a center-weighted system can offer the photographer greater control.

A *spot meter* is an optional metering mode on many cameras. Spot metering can be tricky to get used to, but once you start to use it, you may find that you almost never use any other meter. A spot meter gives you the greatest amount of control, because it sets exposure from a precise point that you select.

Manual Modes

The simplest manual exposure is called exposure compensation. *Exposure compensation* allows you to make a picture lighter or darker without having to change metering modes or even knowing for certain exactly how the camera will make the change.

TIP

■ ■
Exposure compensation is an absolute must for consumer-level digital cameras—do not consider buying one without it.
■ ■

Manual exposure settings allow you to select shutter speed, also known as exposure time, and adjust what is called the *aperture* of the lens. You will learn how to use these options on Saturday; the thing to keep in mind while you're picking a camera is that the greater the number of manual settings you have available, the more flexible your shooting options will be. Look for these options even if you think you won't use them. The manual options in no way diminish the automatic functioning of a camera, and you may surprise yourself and start to use more features than you'd expected.

Another feature to consider in an exposure system is the range of shutter speeds available. If you plan on doing a lot of action photography, or any photography outdoors in bright sunlight, you'll want a camera with a shutter speed at least as fast as 1/1000 of a second. If you plan on doing a lot of low-light or nighttime photography, you'll wish for shutter speeds slower than 1/4 of a second. Unfortunately, neither the Kodak DC-260 nor the Olympus D-600L—two of the better consumer digital cameras currently on the market, and the ones discussed most often in this book—will let you cover both ends of the useful range. The Kodak is great for long exposures, allowing up to 4-second shutter speeds, but will shoot no faster than 1/400 of a second. The Olympus has exposures as fast as 1/10,000 of a second, but will only slow down to 1/4 of a second.

There in the Flash

In case you haven't already guessed, a lot of photography has to do with light. In fact, light is so important that nearly all cameras come with their own light source built in. This source, called the on-camera flash, provides a burst of very bright light for a very short duration. The flash can act as the sole source of light for a picture or can complement the ambient light. Almost all cameras come with an on-camera flash that will provide up to about 12 feet of illumination, so you probably will not have much choice in flash power. If a camera offers much greater or much lower range you might want to make flash power a factor in your consideration of models. Other features will probably matter more than power, but it's generally a good idea to make sure your camera has some kind of flash capability.

Flash Modes

Nearly all cameras with flashes will default to an automatic mode that will decide whether to use the flash and if so at what power output level. This mode can work pretty well a lot of the time, but you will be severely limited if your camera does not offer alternatives to the automatic setting. Ideally, you want to be able to turn the flash off—digital cameras suffer from special image problems if they get too much light. You also want to be able to force the flash to operate even when the automatic setting would not use the flash; this mode is often called *fill flash,* because the relatively low-powered flash burst fills in the shadowed areas of an image.

One highly-touted flash mode is called *red-eye reduction.* If your camera has any extra modes, this will likely be among them. Red-eye reduction can be annoying to use but beneficial in conventional cameras. With a digital camera, the portrait red eye problem can be solved in moments using software, so this mode is not worth using unless you intend to use or distribute the pictures *live,* or in real time. If you won't have an opportunity to process the pictures with software, of course, it'll be useful to have a way to keep them from developing that demonic glare.

External Flash

The most advanced form of flash photography makes use of external flash units, synchronized to fire when you take a picture. This is probably not something that many people will use, but is worth serious consideration if you have any interest in going beyond snapshots. External flash units can be many times

more powerful than the on-camera unit, allowing for much greater range, or *reach,* while getting pictures in low-light, nighttime, or high-speed action settings. External flash units also allow you to move the light relative to the camera, creating different perspectives and allowing much greater creative freedom. To date, the Kodak DC-260 and DC-120 cameras are the only consumer-level digital cameras to offer external flash sync.

Small, Medium, Large Capacity

Nearly all consumer digital cameras today feature removable high-capacity media cards for image storage. Previously, digital cameras stored images on internal memory—and once the memory was full, you had to stop shooting until you could transfer the files. This could put quite an annoying limit on your shooting potential. Removable cards are a great advantage over internal memory systems because they permit you to fill a card, remove it, and replace it with a fresh card. Of course, you can eventually fill all your available cards, but removable image storage lets you set your own shooting limits. Unlike film, cards are reusable. Several types of removable media are available, each with its own strengths.

Load up on the removable storage that's right for your camera. Most units come with a minimally sized device that'll get you started, but you will quickly find storage space is limited. At the very least, double up on what comes with your camera. Better still, buy enough cards of the right size to allow at least the conventional equivalent of a couple rolls of film.

Floppy Disk

Nearly all computers have floppy disk drives and the disks are dirt cheap, which has led one camera manufacturer to use floppies as its removable medium. While the idea might seem to have some advantages, floppies are about as useful in a camera as they are in your computer. Image files of reasonable quality are going to be about 500K, roughly half the capacity of a disk, so you have to carry a bushel of floppies for a day's shooting. In comparison, some other types of media come in sizes of 64MB or higher. Still, if the super high-capacity floppy disks ever catch on, they might turn out to become the medium of choice for digital cameras.

Smart Cards

Smart cards are tiny media cards that look something like gold-trimmed guitar picks (see Figure 1.11). These have to be about the coolest medium available, and they come in sizes up to 16MB. These cards do have the downside that they are susceptible to accidental erasure and are definitely very fragile. They also require a somewhat expensive interface to let a desktop computer read them, although the interface for laptops is more affordable. You will want to invest in an interface, though, as it will allow you to transfer files at near hard disk speeds.

Compact Flash Cards

Compact flash cards are essentially small PCMCIA (the doohickey used to add things to laptops) memory cards. They lack the neato factor of smart cards, but they are fast and durable. Compact flash cards are available in sizes up to 64MB. Some laptops require an inexpensive adapter to read these cards because of their size (see Figure 1.12). Desktop computers require a special reader that is about as expensive as the one needed for smart cards.

Figure 1.11

An 8MB smart card with the adapter necessary to use the card in a laptop PCMCIA slot.

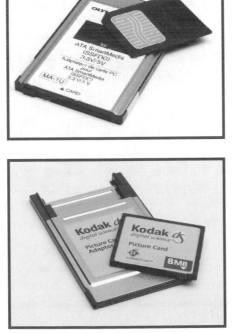

Figure 1.12

A compact flash card with the full-size PCMCIA adapter.

Other Media

The roll call of removable media is constantly changing as new products are introduced and older types are phased out. Some cameras still use standard-sized PCMCIA cads, like larger versions of the Compact Flash memory. Others even use small PCMCIA hard disk drives. Whatever the type, make sure that when evaluating media you find out exactly what is required to interface them directly with your PC.

Piles of Files

As you take digital photographs, the camera stores them as image files on whatever type of medium it uses. There are several forms in which the files may be stored, as well as numerous quality options that will influence final image quality. Probably the sales clerk made, or will make, quite a big deal about the pixel dimensions, or *resolution,* of the file that a camera produces. Minor details like the final quality of that image may have been made less clear.

Uncompressed

Unfortunately, few consumer-level digital cameras give you the option to store images in their raw, uncompressed form. Watch for a camera advertised as using TIFF (Tagged Image File Format) files—that tells you it supports raw files. Raw files will be very large, 3.5-4.5MB or more per megapixel image, but of the highest quality. You might not want a camera that supports only raw images due to the drawback of always having to use large files, but raw files are a terrific option to have available.

JPEG

JPEG images (pronounced "jay-peg") are high-resolution compressed files used by the vast majority of digital cameras. JPEGs have the advantage of being compatible with any image viewing or editing software package, and so you have a great deal of flexibility when using these images. JPEG compression is lossy, however, and the information discarded during compression results in various quality-lowering artifacts in the image.

Not all JPEGs are alike. Different cameras use different *algorithms,* or formulas, during compression and so can have higher or lower quality images. One important factor in image quality is the degree of compression; the greater the compression, the smaller the file but the more lossy the image. For example, an image with a native file size of 3.5MB would normally be considered of

lower quality than one with a native size of 4.5MB. However, if you JPEG compress the former file 4:1 to 875K and the latter file 8:1 to 560K, the file with the smaller native size may have less lossy compression, and so end up being of higher final quality. You will learn a great deal more about these issues during Sunday's session.

FlashPix

An image type less widely used than JPEG is the FlashPix format. FlashPix files compress to a degree comparable to JPEGs, but are less lossy. To date, few image software packages support FlashPix, so these files are of limited practical use. Because a consortium of major digital camera manufacturers supports the FlashPix format, you should expect to see more cameras offer this file format. Avoid cameras that only support FlashPix, but as an option it's nice to have.

TIP

Numerous other file formats exist and are supported by a few digital cameras. Most of these formats are proprietary and so are not usable by other devices or software packages. If a camera offers a proprietary format as an option, it might be worth trying, but avoid those that do not also offer a standard file type.

In Your Interface

You have already been warned that the preferred method of transferring images to your computer is via removable media. Bearing that fact firmly in mind, it is worth considering the other options available for file transfer. Sometimes it will not be practical to remove the cards, perhaps because you don't have the card interface hardware available. Other times, you may wish to use the file information utilities provided with many cameras, or even use your computer to control and program the camera. Whatever the reason, there are a variety of interfaces, and they are not all created equal.

SCSI

SCSI (Small Computer Standard Interface) is a terrific way to connect your computer to your camera, but one that's almost never used at the consumer level. The main reason for a lack of SCSI implementation is that few PCs have a SCSI interface. This lack is unfortunate, as a SCSI connection is one of the fastest and most reliable ways to connect any device to a computer. SCSI remains the method of choice for nearly all professional digital cameras.

Serial

Perhaps the most ubiquitous—and worst—interfacing option is to connect the camera to your computer via one of your computer's serial, or communications, ports. These connections are extremely slow, although they have the advantage of being reliably supported by almost every computer ever made (see Figure 1.13). Your camera should have a serial interface, just in case, but hopefully you'll never have to use it.

USB

A USB (Universal Serial Bus) connection (also shown in Figure 1.13) is the only direct connection method that allows reasonable connection speed for computers and cameras that lack SCSI. USB is so new that many PCs do not have either the hardware or the operating system support to use it. Nevertheless, you should get a camera with USB support, and if your computer does not support it, upgrade or get one that does. You will learn more about USB and how to implement it in Sunday Morning's "Transferring Your Photographs to Your Computer."

IrDA

Many laptops have the ability to communicate via an IrDA (Infrared Data Association) compliant infrared port. A few digital cameras have added this feature, and it could be a handy way to transfer images without the need for a cable or PCMCIA adapter. Unfortunately, most people find IrDA ports very slow and unreliable, so the true utility of these ports is questionable. A really nifty idea, implemented on the Kodak DC-260, is an IrDA port that allows data transfer between cameras. This is an extremely cool feature that allows you to share your shots with friends, family, and coworkers on the spot—no need to wait for double prints in the mail, you can go home with them saved on your camera.

Video

An on-camera video port lets you view your images on your TV screen. This really isn't a way to transfer images (although if you were so inclined you could videotape the output) but is primarily just a handy way to share your pictures. Having a video port isn't critically important for most folks, but you will probably find it a really nice feature to have—if nothing else, you can do your own local newscasts.

Figure 1.13

Two cables, near one another, but worlds apart. Almost every computer supports the very slow serial connection (left); USB (right) is less widely implemented but many times faster and growing in popularity.

Power Tripping

Something that all digital cameras share is an obscene need for power. Manufacturers do not help this matter much, as they tend to grossly underestimate their cameras' real-world power usage in their literature. There are a few ways to handle this need, but only two good ones. A digital camera without power makes a very expensive paperweight, so take the power issue seriously.

AA Batteries

The good news is that nearly all consumer digital cameras use the widely available AA standard type battery as their power source. The bad news is, forget alkaline batteries. A typical digital camera will suck down a set of alkaline batteries in between 5 and 20 shots. Yep, that's right, 5 to 20. It couldn't be a typo twice, so get used to the facts. Alkaline AA batteries will work in a pinch; after all, you can buy them just about anywhere, but don't count on them for serious use.

So, what kind of AAs do you want? Rechargeable AA batteries, and you should skip right over the standard Ni-Cd (nickel cadmium) rechargeable batteries and go straight for a few sets of NiMH (nickel metal hydride) batteries (see Figure 1.14). NiMH batteries cost about four times as much as alkalines, but will pay for themselves midway through their second use. These batteries are not only rechargeable but also seem to last about six to eight times as long as standard alkaline batteries. Get some, and then get some more.

AC Adapter

The bottom line to dealing with the power-mad digital camera is to use batteries sparingly—and only when necessary. If your camera does not come with an AC adapter as standard equipment, get one immediately (see Figure 1.15). The frustration you'll save yourself in just the first week of using the camera will be worth the price.

CAUTION

A few digital cameras use nonstandard or even proprietary battery types. You should avoid these units, as it is pretty easy to get stuck with a dead camera on a Friday evening 15 minutes after the sole local supplier of your camera's battery type has closed for the weekend. That's assuming you're fortunate enough to live somewhere with a local supplier.

Figure 1.14

Quest nickel-metal-hydride batteries are a must for all digital camera users.

Figure 1.15

An AC adapter is almost as essential to using your digital camera as the lens itself.

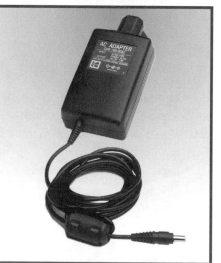

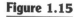

Other Features

It is simply not possible to even list—let alone comment on—all the features available or planned for consumer digital cameras. However, there are a few features worth mentioning that don't quite fit in any of the other categories.

Tripod Mount

A tripod mount is essentially just a threaded receptacle in the base of a camera that allows you to mount the camera on a tripod. Many types of shooting are very difficult without a tripod, so if you think you might ever want to take more than snapshots at the beach, make sure your camera can be mounted on a tripod.

Audio

Some digital cameras have the ability to save snippets of audio with an image file. This feature may not have a lot of appeal to you, but it is something that can come in handy for recording really vivid moments. Digital cameras with audio are out there, if you have the need.

Burst Mode

Most digital cameras shoot one picture at a time, often with a substantial time delay between pictures. A relatively new development is a burst-shooting mode that takes multiple images in rapid succession before stopping to save the images to the camera's card. This is a great idea, but one that so far has not been well implemented. For example, most cameras with burst modes do not fire their flash during burst mode; this severely limits the conditions under which the mode will get decent pictures. Also, these cameras either limit the burst file size to very low resolution or can only take a couple of shots before stopping to save. Consider this a technology to watch; you can expect good, useable burst mode cameras sometime very soon.

Scripting

A very recent and potentially quite useful addition to the digital camera feature set is the use of scripting to control how the camera takes pictures. A script is a set of instructions that you write, usually on a PC, and then upload to a camera. Scripts let you provide identical settings for multiple cameras. Right now they all have to match each other, but one day a standard language might emerge that offers compatibility between different models and manufacturers. Scripting can

allow you to record good shooting methods you find for particular situations or even help in training others to use a camera. The Kodak DC-220 and DC-260 units are the first to offer scripting, but as more cameras are based on open operating systems, expect more scripting-enabled cameras to follow. This is a very new arena with some exciting potential uses.

Take a Break

Well, right about now your head may be spinning a bit trying to sort out the difference between active autofocus and burst shooting mode. Don't worry—things'll sort themselves out as the weekend progresses. In the meantime, take this opportunity to stretch a bit, and maybe grab a refreshing beverage. If you are so inclined, a bottle of 1990 Châteaux Coufron is a pleasant, inexpensive Bordeaux that goes nicely with reading about digital photography.

Evaluating Digital Cameras

You've made it this far, so you're probably seriously interested in using a digital camera for something. The question now is, Which digital camera? You won't get an exact answer here—camera models and features change too rapidly for any specific recommendation to be of much value. This section will give you some tools and information to help you decide on the best camera for you.

There is one simple lesson in this section that bears repeating as often as possible. Only consider purchasing a megapixel camera. Period. Cameras with smaller image sizes simply do not produce acceptable images for any use. You may hear a lot of dreck from self-proclaimed digital photography experts who think a lesser resolution camera, say one that shoots at 640×480, is OK for certain uses. They may claim such cameras are suitable for the Web or for small prints. Yeah right, small like those little tiny rocks that float. Forget these cameras; they are a waste of your money—and in this section we'll show you exactly why that's the case. Avoid anyone who says otherwise—they are either only interested in laying claim to a bit of your wallet's contents, or have the imaging expertise of your average Windows NT device driver microcode programmer (not that we don't appreciate those folks when they do what they do best).

We ran a series of simple tests using a photographic test chart and several sample cameras. As a reference, we used a professional digital studio Leaf DCB on a Sinar p2 camera to produce the image shown in Figure 1.16. The Leaf has the ability to shoot at different resolutions, so we were able to match the resolution of the test cameras to allow a point-by-point comparison. Of course, we in no way intend to actually compare a studio camera outfit that costs many tens of thousands of dollars against sub-$1,000 consumer digital units; what the Leaf gives us is a neutral benchmark for the consumer units, which points up their advantages and disadvantages more clearly than comparing them to each other.

The consumer test cameras discussed in this section are the Kodak DC-260 and the Olympus D-600L. At the time of the tests, these were among the highest-quality consumer digital cameras available. Both have trade-offs in use and image quality, and there are of course other cameras of similar quality available, but these two provide excellent examples of what we consider to be the minimum acceptable level for digital cameras. By the time you read this book, newer cameras may well have replaced these models, but the principles involved in evaluating digital cameras will still apply.

Compression, File Size, and Image Quality

In the previous section, "Digital, Hybrid, and Conventional Photography," you learned about megapixel sensors and a bit about how they translate into final file sizes. What was not mentioned in that section is that to create a color image, digital cameras actually capture three times from the sensor. So, a

Figure 1.16

The sample used for the comparisons in our study. This image was shot using a Leaf DCB on a Sinar p2 4X5 camera.

camera with a 1.3 megapixel sensor creates a raw file three times that size, or 3.9MB. These captures represent each of the additive colors (red, green, and blue) to create what is known as an RGB image. You will learn more about digital color and types of images in Sunday Morning's session.

Consumer-level digital cameras do not generally store files in the 1MB or greater range. The convenient removable storage cards used by these cameras are generally in the 8MB to 30MB size range, and most folks would like to be able to take more than a couple of shots before having to change cards or transfer images. So the camera manufacturers use file compression techniques to store the images in much smaller, or compressed, formats—losing a certain amount of information in the process.

This lossy compression results in some *artifacts*—changes that degrade the quality of the image, especially when it's reproduced in larger sizes (see Figures 7.18 and 7.19). The samples you see are the equivalent of 11"×7", about the size that some manufacturers and overzealous reviewers claim you can get conventional photographic quality output from these cameras. Unless you have very low standards of quality, you'll doubtless agree that based on the sample shots here, these claims are without foundation.

The quality of a stored image depends largely on the *degree of compression,* which you'll see written as either a percentage or a ratio of the image's raw dimensions to the final image size. Most digital cameras have quality settings that represent greater or lesser degrees of compression. These settings are guides only; the actual degree of compression depends on how the camera's processor determines how much loss can be imposed on a given image.

When reviewing the test images, keep in mind that the raw Leaf image is an uncompressed 4.5MB file, the raw file size of the Kodak's sensor. The Leaf image is therefore the upper end of what an image of this size could be. The Olympus has a raw file size of 3.75MB, and at its highest quality level applies compression of approximately 4:1 to reduce the image to about 710K. The Kodak takes its 4.5MB file and compresses it 16:1 to about 280K at its highest setting.

Both the consumer test cameras were set to their highest quality setting. The Olympus compressed the file to about the predicted amount given the manufacturer's specification for the camera. The Kodak has about a 17 percent larger active image area, but uses greater compression when creating its files.

Figure 1.17

Comparing the Leaf image on the left with one shot at 640×480 on the right. There is so little information in the low-resolution image that there are almost no good uses for it.

Figure 1.18

The uncompressed 4.5MB Leaf image on the left compared to the 280K Kodak DC-260 photograph on the right. Notice the squiggly, worm-like compression artifacts in the Kodak image, particularly around the model's chin.

Figure 1.19

A side-by-side comparison of the Leaf's 4.5MB file and the Olympus D-600L's 710K image. Notice the compression artifacts, similar to those of the Kodak, and the loss of shadow detail, another common fault in consumer digital cameras.

WHY YOU SHOULD AVOID SUB-MEGAPIXEL CAMERAS

If the sensor in a digital camera uses more than a million pixels to capture the image, it's a megapixel camera; therefore, if a camera uses fewer than a million pixels it is a sub-megapixel camera. In practice, most sub-megapixel cameras capture images in the 800×600 to 640×480 range, which means their sensors are less than half a million pixels (480K to 307K) in size. Many people mistakenly believe that if their intended use for a digital photograph is the same size the camera provides or smaller, there is little purpose to purchasing a camera capable of higher resolutions.

The problem with sub-megapixel digital cameras is that the image quality at 640×480 is simply so poor to start with, it really does not matter how low a resolution you plan for your final intended use (see Figure 1.17). Digital photographs are like other types of data—the better the initial quality, the better the output of any kind. Of course, as with all types of photography, there are many issues other than the technology being used that determine final image quality, but with sub-megapixel digital cameras you are so severely hamstringing your images that the technological disadvantages overwhelm nearly any other consideration. If the $200 to $300 you save by purchasing these cameras instead of a better model is that critical to you, use an inexpensive conventional point-and-shoot camera and a scanner to do hybrid photography until the appropriate technology drops to your price range. In the long run, you'll be much happier with the results—and it'll probably be only a few months that you have to wait.

The typical compression level for the Kodak is about 9:1 at its highest quality level, but in the case of this test the camera's processor compressed the image to a much greater degree than you would predict. In other settings, we have seen a reverse of this effect, with the Olympus using much greater compression than the Kodak.

Manufacturers face a quality versus quantity issue when designing compression settings. More compression allows the photographer to place more images on expensive and always in short supply media, but it also introduces greater loss and more compression artifacts. The final degree of compression is an example of the camera's software making quality determinations largely out of the control of the photographer. You should probably always shoot at the highest quality level, and therefore lowest compression, because of the potential unpredictability of your camera's processor. Your goal should be to capture as much image data as possible while shooting. If you throw some image data away, let it be your decision—after you've had a chance to see what the best setting gives you.

Other Quality Issues

When you compare the sample images side by side (see Figure 1.20) several differences become noticeable. The first and most obvious to you may be the greater amount of compression artifacts in the Kodak shot compared to the Olympus. The remarkable thing about these images, however, is that the Kodak file is one-third the size of the Olympus and still holds up quite well. Under conditions predicted by the manufacturer's specifications, you would expect the Kodak-generated image to be about twice its size, and would therefore see fewer compression artifacts. Either way, you are getting comparable images with smaller file size, which nicely illustrates the advantages to megapixel cameras with larger active image areas in general.

The section "Digital, Hybrid, and Conventional Photography" introduced you to the issue of overscanning when creating hybrid images. A similar principle holds true for digital photography as well. When a digital photograph is resized for small image uses, perhaps the most common being for inclusion on a Web site, each pixel in the final image is built from several pixels of the original. As a general rule, the higher the resolution the original image, the sharper the final image at a given file size. If overall quality rather than file size is your criterion, you will be able to apply greater compression to the higher-resolution original resulting in smaller files at a given standard of quality.

Figure 1.20

The 710K Olympus D-600L image compressed 4:1 from its 3.75MB raw size, on the left, and the 280K Kodak DCS-260 image compressed 16:1 from it's raw 4.5MB file size on the right.

File size and pixel dimensions are not the only determinants of quality. Color accuracy is an important issue in all types of photography, but can be especially tricky for the digital photographer. You can use software to correct color problems, but too much processing of this kind can start to affect other elements of image quality. As with the true degree of image compression, different cameras tend to perform differently depending on the conditions. Both the Kodak DC-260 and the Olympus D-600L give very good to excellent color accuracy. Cheaper models tend to give poorer results, raising the possibility that higher-end cameras may be constructed to more exacting standards—and again making the case for purchasing a megapixel unit.

One of the most important elements of image quality, the dynamic range of the image, is often overlooked. The *dynamic range* is the ability of the light-sensing device, whether film or CCD, to capture a range of light and dark areas, and to distinguish between areas that have very small differences between their levels. Very bright areas are called highlights, and as you will discover during the shooting sections on Saturday, these tend to be problem areas for digital cameras. If a camera has the ability to create images that distinguish between dark areas, it is said to produce images with good *shadow detail*. Because of the electronics involved, digital cameras have much better potential than film to pull out shadow detail.

If you look again at Figure 1.20, you will see a difference between the shadow detail for the Kodak and Olympus images. If you compare the dark side of the bars at the bottom of the images, you can see that the Kodak pulls out much more shadow detail than the Olympus does. This is a characteristic of the

cameras' electronics, and so not subject to the same sort of variability from one shot to the next that you see with image compression. You can expect quality differences in shadow detail to be a reproducible element of image quality, and as you will see during tomorrow's shooting sessions, this is an element you will begin to depend on as a digital photographer.

It seems worth mentioning once again that after having run literally thousands of images through the Kodak DC-260 and Olympus D-600L, we have found them both to be excellent examples of sub-$1000 consumer megapixel cameras. If you are considering buying either camera, you can safely base your decision on subjective elements and peripheral options; in terms of basic image quality, both will get the job done. Yes, there are other similarly excellent offerings out there by companies such as Nikon and Fuji, but we have not had the opportunity to become familiar with these units, and so cannot comment specifically on their qualities.

The Digital Photographer's Software Tools

Just as a conventional photographer must make use of a darkroom for film processing and image output, the digital photographer needs tools beyond the digital camera itself to make use of digital photographs. Although most people who shoot film, including the pros, use the services of a professional film lab, things are different for the digital shooter. High-end digital service bureaus do exist, but you will probably handle most of your imaging needs yourself using a personal computer and software.

There are many categories of software useful to the digital photographer, and seemingly countless programs within each category. The software that came bundled with your camera may be adequate in some areas, but you will eventually want to replace many of the packages with more robust commercial applications. Some software is available via the Internet in a limited use, free, or demonstration version. You can use these versions to evaluate packages before deciding what to buy.

TIP

Often an inexpensive way to add to your software library is to take advantage of any upgrade offers that may be included with the "light" versions of software that come with most cameras.

File Acquisition and Transfer Software

You may not have much choice in the acquisition and transfer software that you will use, as it tends to be manufacturer specific for a given camera model or group of models. You should be aware of this software and its crucial role as a link between your digital images on camera and being able to use them with your computer. Because this software often includes drivers important to the ability of your computer and camera to communicate, you should check with your camera manufacturer for software updates and patches on a regular basis.

If your camera's software options include an offer to install an optional TWAIN driver for your camera, do so. The TWAIN driver will allow you to acquire images from your camera directly into a third party software package, such as Macromedia xRes or Adobe Photoshop. You may find that the custom software that comes with your camera is generally more useful for most file transfer tasks, but that does not mean the TWAIN driver isn't useful. For example, it is only by using the TWAIN acquire package with the Kodak DC-260 that you are able to get advanced information about how an image was photographed (see Figure 1.21). The TWAIN driver is also used to shoot directly from the computer in what's called *tethered shooting,* where you attach the camera to the computer and save the image files directly on your hard drive.

TIP Use the tethered shooting mode to take a lot of pictures in a single session. The images will be saved to your computer's hard drive, which is probably in gigabytes instead of megabytes. You can also use tethered mode with a laptop to take many shots in the field.

Saving and Conversion

Once you have an image transferred to your computer's memory, you are going to have to decide how and in what form you wish to save it. Again, your camera probably comes with a handy utility to get you started, but you will probably soon find that you want more features. An excellent example of saving and conversion software is Debabelizer by Equilibrium Software. Sometimes saving and conversion software is sold as an add-in, also called a plug-in, for another software package

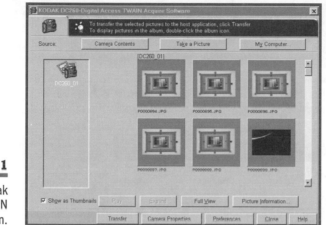

Figure 1.21

The Kodak
DC-260's TWAIN
driver screen.

Storage and Retrieval

Something you may have yet to consider is what to do with your images all the time you're not viewing them. As you get more images, it becomes increasingly difficult to manage them; even finding the one you want can become a challenge. You will need an image catalog or database that will organize your images, including managing them across multiple disks. The software should be able to display thumbnail views of your images and allow you to print these miniatures for storage with a disk (see Figure 1.22). One of the best—although certainly not the least expensive—is Kudo by Imspace Systems. Your camera may come bundled with image cataloging software, but most of the freebie programs do not support catalogs across multiple removable disks.

Editing and Manipulation

Probably the area of digital imaging that gets the most attention is the ability to retouch, edit, and manipulate images with software. Digital photographs make excellent subjects for software of this type, so much so that some people make the mistake of equating the software manipulation of photographs with digital photography itself. You do not have to manipulate your digital photographs to do digital photography, but you will most likely want to.

Manipulation programs come in a variety of forms. Some, like Kai's Photo-Bubbles, are simple utilities that automate basic image editing and correction

Figure 1.22

The thumbnail view in a Kudo image catalog. Print the catalog and store it with the disk as a hardcopy reference.

functions. Your camera probably comes with utility software that will function in this way. These simple programs have the advantage of being inexpensive and easy to use, but you will probably find that their limits restrict your creative potential.

Professional-level software packages are often expensive, but are well worth the cost if you become seriously interested in getting the most from your photographs. Adobe Photoshop and Macromedia xRes are perhaps the most popular tools in this category. Be on the lookout for special offers or upgrades that will allow you to purchase these packages inexpensively. Many cameras come bundled with Adobe PhotoDeluxe, a very limited version of the Photoshop image-editing software.

Output

The output devices you use to create hardcopy or specialized digital forms of your digital photographs use software to process your image for output. For many consumer-level devices, you may not have much choice when it comes to the software that your device uses. That's too bad, because this software is a critical element in determining the final quality of your hardcopy prints. As with the transfer drivers for your camera, be sure to keep checking for updates and patches for this software.

Other Useful Hardware

You will find that there's a slew of other things ranging from mere gadgets to a full-blown PC that you will either need or find useful as a digital photographer. As you run through the exercises tomorrow you will probably begin to create a list of things that might have been nice to have along while shooting. The gear covered in this section is a small sampling of the stuff reviewed in just one edition of a typical photo magazine. Most of the gear available is unnecessary or too specialized for most people to worry about, but there are a few things that will come in handy for just about everyone.

Personal Computer

A PC may not be standard equipment for a conventional photographer, but it is a necessity for both digital and hybrid shooters. You should have a fairly recent model, preferably with a fair amount of hard disk space and as much RAM as you can afford. In many cases, adding RAM to a system that's a notch or two below the most current model will result in a computer that's better at handling images than a PC with the fastest CPU but minimal memory. At this point, a system with 64MB is the least you should use; consider upgrading to 80MB or even 128MB or more for better performance.

A high-quality monitor and video adapter are also very important for working with images. You will need to be able to display a minimum of 24-bit color (16.7 million colors) at 1024×768 or higher resolution. This typically requires a video adapter with at least 4MB of display memory. Your monitor should support the desired resolution at a refresh rate of 75Hz or higher. Large monitor size is desirable because it helps you discern details of high-resolution digital photographs, but larger monitors can be very expensive. If your budget leads you to have to make a choice between a 19" monitor of mediocre quality or a 17" monitor of better quality, go for the high-quality monitor. In the long run, how well you are able to see your images will have a direct effect on your final image quality.

Removable Media

You are going to amass a lot of image files in a very short time. If you do not have a good removable storage solution, you are going to use up your hard drive very quickly. Low-capacity solutions, such as the Iomega ZIP system, can be OK for the short term, but you will likely fill up so many disks that they start becoming

a real expense, one that can make you reluctant to go out and shoot. Probably the best storage solution at the moment is to use a CD-R drive to write CD-ROMs of your files. You can probably purchase a CD-R drive for below $300, and media are available well below $2 a disc. Each disc is capable of storing 650MB of data, or about 1,300 raw images. That may seem like a lot, but once you begin manipulating and editing your shots you will find that your total number of images increases so dramatically that the discs begin to pile up.

Output

You will probably want some form of hard copy of your images, even if only of low quality and just to be used as a reference. Almost any computer printer can serve in this capacity, but if you don't have one you'll have to factor buying one into the price of going digital. There are many inexpensive color ink jet printers on the market that claim to be able to produce photo-quality output. Don't believe the claims—they can't, but for the price they can produce reasonable output for many home uses.

CAUTION

Manufacturers often use phrases like "photo-realistic" to describe output that "realistically" isn't a photograph. You might evaluate the device and decide that its quality suits your needs just fine, but be wary of claims that seem too good to be true.

Tripod

If you have any serious interest in getting high-quality photographs you will need a tripod (see Figure 1.23). Camera stability is an essential part of shooting, and a tripod is the traditional way of holding a camera steady. Avoid cheaply built tripods that can't hold much weight. A tripod should be able to hold a camera at a wide range of heights, preferably at least below knee level and above your head.

TIP

When selecting a tripod, you should be able to press your hand down and back and forth without causing the tripod to shake or its legs to wobble. Tripods of this quality typically run more than $100; if that's more than your budget will allow, consider a well-made monopod (essentially a walking stick with a camera mount) rather than a low-quality tripod.

Figure 1.23

A good tripod is an essential part of a complete photo outfit.

If you find a tripod cumbersome, there are other alternatives for stabilizing your camera. A *monopod* is something like a walking stick with a fitting on top for mounting a camera. It is not suitable for very long exposures, but can be used to greatly improve many photos. There are also variations on camera mounts suitable for mounting on car doors or designed for backpackers—or even to attach to trees or rocks. You'll also see beanbags used for holding cameras steady in a variety of positions.

Photo Gear Grab Bag

There is a seemingly endless list of gadgets that have been dreamed up in the hopes of helping photographers in their quest for great shots. Many of these devices only make shooting more complicated without helping the pictures that much. One bit of photo gear that you probably will find essential is a bag that can carry your camera and associated gear in relative safety from the elements. Photo stores sell photo bags, but there really is no need to buy a bag designed for shooting. In fact, the main reason photographers in the past were willing to pay a premium for photo bags was to get the built-in elastic loops to hold their film rolls. Digital photographers have yet to find a use for these loops.

Other things you may find useful include off-camera flash units to expand your flash photography capabilities. You can also buy expandable cards to help reflect light when shooting small objects. You will learn more about both of these items during tomorrow's shooting. If you already have them, great, you'll

get a chance to use them. If you do not, you probably should hold off buying them until after you run through this book and are better able to decide what accessories are most suited to your shooting needs. Figure 1.24 shows some of the ones you're likely to want first.

Buying a Digital Camera

To complete the exercises in this book you will need a digital camera. That does not necessarily mean that you will have purchased a digital camera before starting the exercises; in fact, if you can use one or more borrowed cameras as you work your way through the exercises you will be able to evaluate different systems and so ultimately make a better buying decision. Still, at some point it will come time to make the critical decision to purchase a camera. This section can help you in the buying process.

Cost

The first thing to consider is about buying a digital camera is cost. A high-quality camera with basic accessories is realistically going to set you back close to $1,000 (see Figure 1.25). For that amount of money in the conventional-photography world, you could get a pretty spiffy used SLR rig, including a reasonable starting film budget (see Figure 1.26). And used conventional gear will last you for years, while a used digital camera is likely to be obsolete right now, let alone a year or so down the road. So make sure that you have carefully evaluated the benefits of digital photography before you take the plunge.

Figure 1.24

A good bag, external flash units, and light cards are some of the most useful of the many photo gadgets available.

Figure 1.25

The Kodak DC-260 and a handful of essential accessories that bring the total cost to about $1,000.

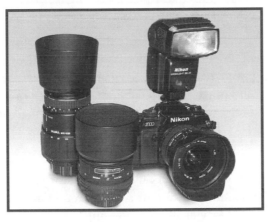

Figure 1.26

This used 35mm SLR body with lenses and high-powered flash would probably cost about $600, leaving enough money from a $1000 budget for more than 20 rolls of professional-quality film with processing.

Where to Buy

The next thing to consider is where to buy your camera. This may surprise you a bit, but having a reliable contact with knowledgeable sales people is perhaps the most important element in the process of buying a digital camera. The best place to buy a digital camera is at a better camera shop, particularly if you have one in your area with which you are already familiar. Camera shop clerks can usually give you well-informed advice on the features of cameras—often based on their own shooting experience. Computer stores and mega marts may save you a few dollars on the purchase price, but there is often a long-term cost to their typically poor advice that is greater than the few dollars you save up front.

The only way better photo shops can afford qualified staff to help you with your questions is if you actually purchase from that shop. While it's tempting to take their advice then buy from a catalog, in the long run you'll find that approach can cost you more. A good local shop will help customers with loaners during repairs, possibly trial hardware, and general hands-on support that you can't get from a mega mart or catalog. One prevented mistake will more than offset the few extra dollars charged by a better shop.

Make sure that the stores you are considering carry a full line of models from a wide range of manufacturers. You will want to have cameras in hand, preferably with an opportunity to use them in the store, as you come close to reaching a purchase decision. Avoid stores that carry models from only one or two manufacturers, as they will want to sell you what they happen to carry, as opposed to what best suits your needs.

If you do not have a local camera store that you can trust, consider using one of the major mail order camera suppliers instead of an electronics mega mart. Many reliable photo retailers sell by mail, and their telephone advice and support is typically much more reliable than from a nonphoto retailer. Refer to the Appendix for a list of a few of the many good mail order photo dealers.

Try It

The best way to know if a digital camera is right for you is to try it. Many local camera stores will allow you to rent a model for a day or two to get a feel for the camera. Often they will allow you to apply the rental fees toward the purchase price of a camera if you eventually buy. This is an excellent way to get your hands on a current model for evaluation.

TIP

Find out if a local shop will let you rent a digital camera for the weekend, or perhaps let you purchase the camera and return it for a small restocking fee if the unit doesn't live up to your expectations. Any way you can get a camera in your hands for serious evaluation is worth exploring.

Photo Clubs, Magazines, and the Internet

Be sure to check with the widest possible range of sources of information about current camera models before you buy. New models are being released

all the time, and the features and image quality keep changing. Look for reviews in magazines, but be aware that some commercial magazines take such a balanced approach to their reporting that it can be difficult to tell which models they think are good and which ones are losers. Talking to people who own and use digital cameras is an excellent way to add to your knowledge about various camera models.

Your Must-Have List

Use the section titled "Types of Digital Cameras," the other sources of information you've checked, and your shooting experience to come up with a must-have list of camera features. It is OK to have an "it would be nice" list, too, but it is the must-haves that will drive your shopping. Be brutally honest about the difference between must-have and nice-to-have, because you will not accept a digital camera that is missing a single feature on your must-have list. This is important, because if the consumer digital camera that has all your must-haves does not exist, you should pass for now on making a purchase or face looking at more expensive models marketed to professionals.

The reason you shouldn't settle for a camera that is missing one of your must-haves is twofold. First, you aren't going to be happy, so you aren't going to end up as a positive ambassador for digital photography. You won't get the pictures you want, and you'll have wasted a lot of time and effort in not getting them. Second, unless you have some very esoteric items on your list, there is probably going to be a camera with exactly what you need released reasonably soon. So wait a bit and get the right camera—you'll be happier in the long run.

SATURDAY MORNING

Starting Your Day of Digital Photography

- Sunrises and Sunsets
- Landscapes and Scenery
- Architecture and Buildings
- People and Portraits

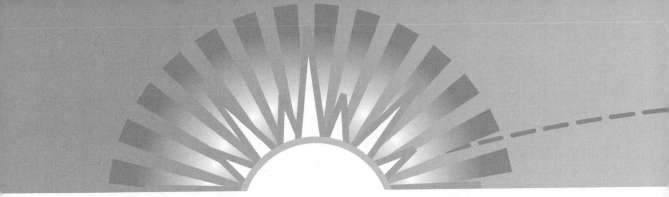

The essence of digital photography is shooting pictures with a digital camera. Today you will spend the day using and learning about your camera, its capabilities, and how to shoot digitally. Some elements of the day will be similar to what you may already know from conventional photography; others will be entirely new. Sunday you will have the opportunity to process, manipulate, and output your digital photographs.

Today is broken up into a series of shooting exercises. Now is a good time to briefly review the shooting schedule, as it could get hectic. You should be able to complete each exercise in an hour or less. Some of them may have greater appeal for you than others, and you might be tempted to spend more time on the subjects you like and skip a few of the others. Skipping the actual shooting for some exercises is OK, but you should still review the text for every exercise. Each exercise has its own tips and tricks, many of which will come in handy in a variety of contexts.

Plan, Plan, and Plan

The materials in the digital photographer's kit can be a bit more esoteric than what you'd need for a conventional point-and-shoot camera. Nickel-metal-hydride batteries and Smart Media cards don't have quite the same penetration in the drugstore market as do print film and alkaline batteries. Make sure that you have everything you will need, might need, and could even have the slightest possibility of needing before you leave your base. Today will be an excellent test of what you really should have when you plan to use your digital camera. Take notes on the stuff you needed but didn't have so you won't make the same mistake when it really counts. When you're on vacation in Cancun or Alaska, you'll be glad you did.

Something that's probably new to you when planning your digital shots is thinking about the final purpose of the shots you'll be taking. When shooting conventionally, you probably just used film that you dropped off at a processor and picked up later as prints. One of the great strengths of digital photography is the flexibility of uses to which you can put the photographs, but this can also complicate matters a bit. Different shooting methods create better results for shots intended for the Web from those that look best in a newsletter. Some mention of these differences shows up in the text, but ultimately you will have to be the judge of what works best for your particular subjects and intended uses. Watch for sidebars in each of the exercises.

TIP

You should resist the temptation to get more images on your camera media cards by skimping on image size. As you have already read, the final image will be of higher quality if you start with a higher quality source photograph. In some cases, you may be able to increase the compression of the image without noticeably sacrificing image quality. On most cameras, this translates into setting the resolution to the highest value and setting the quality to something less than the highest value. This will allow you to squeeze a few more images on your cards.

With most conventional cameras, it is possible to use a rapid shooting mode that allows you to shoot many frames per second for as long as you have film. Digital cameras tend to be slower, both in response to the initial shutter depression and between frames. This slowness means that you have to pick your shots more carefully for many types of shooting. Planning your shots ahead of time—and understanding your camera and how to use it to take great digital photographs—will give you the edge you need to compensate for your camera's performance drawbacks.

Preparing to Shoot Outdoors

This morning's session has been set aside for outdoor shooting. For most outdoor photography, the periods right before and right after midday have the best overall light. Early and late-day light can cause long shadows and make certain angles difficult; although, as you'll learn in the "Sunrises and Sunsets" section coming up next, that slanting light can be used to create very dramatic images. Midday light is often glaring and harsh, making it difficult to get good pictures. Indeed, for some digital cameras glare can cause extra

problems. In fact, although you might be disappointed at a slightly overcast day, your pictures will love the even, soft light.

Most of the pictures you take in your lifetime may well be shot outdoors. Many professional photographers loathe outdoor shooting because much of the creative control in the studio escapes them when outdoors. In fact, many pros will go to elaborate lengths to create virtual outdoor settings in the controlled environment of the studio. Does this mean there's no hope of getting great photographs outdoors? Not at all, but it does mean that you will have to approach outdoor shooting with an open mind and a willingness to work with the available light and subjects because in many cases they can't be moved or changed.

So, get your photo gear ready and get going on an outdoor shooting expedition. You'll probably find that with a bit of effort and concentration you will be getting better shots than you ever thought possible. Enjoy.

At the Ends of the Day: Sunrise and Sunset

The dramatic light and sometimes spectacular colors associated with the ends of the day often provide the setting for some of the most memorable of all photographs. Many times, the unique elements present during these fleeting moments can transform ordinary, even dull, subjects into the fantastic and exciting. The ephemeral quality associated with twilight enhances the magic of light and color. Digital photography allows you to capture these moments and transmit them globally almost instantaneously, transforming forever the way you can share this romantic time of day. And even if you're not out to create great art, sometimes you will find yourself faced with having to take a picture during twilight out of necessity. Shooting during these times of day can be challenging, especially during sunset when you're in a race against time to get a picture before the light fails completely. The tips in this section will help you with all sorts of shooting during twilight, not just with dramatic skyscapes.

How Dark Is It?

Before you jump right into shooting you'll need to understand something about how the camera sees the world compared to the way your eyes see it. When you learn to predict the effects of a situation on your photographs you will begin to see your pictures improve. This can be a difficult issue for some people, but you will find that shooting with a digital camera can help tremendously.

Figure 2.1

One of the authors diligently exploring the special outdoor lighting issues associated with walleye fishing on Lake Erie. This snapshot was taken using the Kodak DC-260 beta revision 06 camera.

How Will You Use It?

Twilight can have such a positive impact on photographs that some professional nature and wildlife photographers almost never shoot during any other time of day. These are individuals whose livelihoods depend on getting terrific, memorable shots that grab the attention of the viewer. If you really want to capture a special moment or mood with a photograph, this is definitely the time of day to do it (see Figure 2.2).

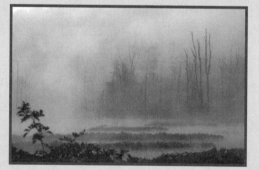

Figure 2.2

There is nothing like the mood and light of the early morning or late evening to enhance a photograph.

Sunsets are some of the most popular subjects for travelers. The feeling of being away from the world as you know it is magnified during twilight, and having pictures helps to preserve those moments forever (see Figure 2.3).

Similarly, for the early riser sunrises often have a rebirth or renewal quality that is reminiscent of springtime (see Figure 2.4).

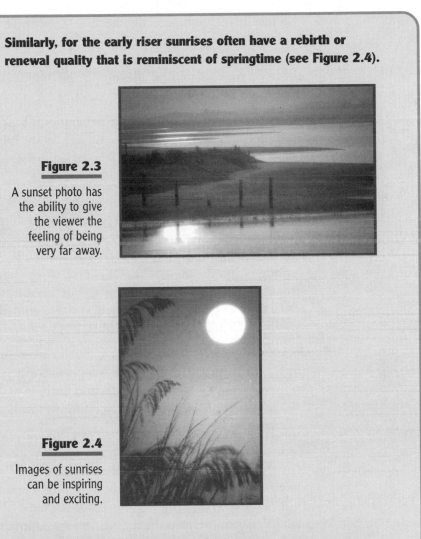

Figure 2.3

A sunset photo has the ability to give the viewer the feeling of being very far away.

Figure 2.4

Images of sunrises can be inspiring and exciting.

There are all sorts of people, from insurance investigators and real estate agents to car dealers and graphic designers, who occasionally take pictures as part of their profession. If you are one of these people you will in many cases not be able to select the time of day a picture is taken. You can combine the information in this section with the tips in other sections of today's shooting exercises to get better pictures more reliably.

You may have purchased a digital camera for many reasons, but the potential for it to help you get better pictures is the one that will be most meaningful today. You can take a picture and review it immediately, seeing at once the effects of your techniques, making the photographic learning process a cycle of minutes as opposed to days or weeks.

Each exercise today will add a little more to your basic understanding of becoming a digital shooter. The first exercise will lay the foundation for photographic exposure by explaining that what you see and what your camera captures can be worlds apart.

As you are no doubt aware, your eyes have a tremendous ability to adjust to different lighting conditions and still allow you to see clearly. Your eyes often do this so well that, except for when you are in very bright or extremely dark surroundings, you may not even realize just how different many day-to-day lighting environments can be. Of course, as you will see later today, the difference is not only in light intensity but in other characteristics—even the actual color of the light. But for now, concern yourself with comparative levels of light and darkness.

As a general rule, indoor settings are much darker than the outdoors. This can often surprise people, particularly when comparing very well-lit interiors with an overcast day. You may move back and forth, in and out, between a relatively low-light interior and much brighter outdoors without ever realizing the great difference between the two.

Twilight is another setting where you may not realize just how dark or bright it is at a given moment. Your problem is made more complex because you can simultaneously encounter both the very bright and the very dark in a single field of view. This can get tricky photographically, because of the way your camera's meter interprets the setting. You were introduced to the light meter in Friday Evening's "Types of Digital Cameras" section. Sunrises and sunsets can pose greater troubles for digital photographers than for conventional photographers, because many digital cameras are substantially more sensitive to extremes of light than are conventional units with film. There are special problems associated with digital cameras and spots or areas of brightness—which can even fry the camera if the contrast is too intense. These unique concerns are covered this afternoon in the "Shooting Metals and Reflective Objects" section.

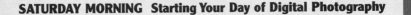

The relative darkness of a setting can jeopardize the quality of your pictures. The darker the setting, the more your camera will have to compensate with what is called a *slower exposure.* A slow exposure makes your camera more vulnerable to interference from movement of the camera or the subject. A moderately slow exposure requires that you support the camera using a tripod or some other stable platform; an even slower exposure and people will not be able to stand still enough to avoid blurring your pictures. You'll get the details on how the meter interacts with other elements of the camera to make up the entire exposure system this afternoon in the "Shooting Still Life" section; for this exercise, the main idea is simply to point the camera so as to make the most of your meter and make sure you get the picture you expected.

What You'll Need

To complete this exercise you'll need to shoot within about half an hour of sunrise or sunset. Which you choose does not matter for the exercise, although you should consider the angle of the subject to the sun to select dawn or dusk as the preferred time. Dawn is often better when shooting toward the east, as it places the sunrise behind your subject. For this reason, many shots of the Atlantic from the eastern seaboard of the United States are sunrises. Similarly, western subjects are often better shot at sunset.

If you have an opportunity to plan your shot, you can notice ahead of time if the angle of the subject will better capture light from a sunrise or sunset. Time of year can have a great impact upon this selection, as the angle of light varies greatly with the seasons unless you're in the tropics. No matter what the time of day, having an aesthetically appealing subject or setting for the photograph is always to your benefit.

If you have a tripod, bring it along. You will find that many times the shot you want will be much darker than you'd expect, so having support along can be an invaluable aid in keeping things sharp.

Camera features you are most likely to find useful when shooting at dawn or dusk:

- ✿ Exposure compensation
- ✿ Manual flash settings
- ✿ Spot or center-weighted meter

Digital Photography of Sunrises and Sunsets

The essential ingredient as you begin shooting is mobility. You are going to move your camera as you point it at different elements of the scene to see the effects of different levels of light, and you are going to move yourself to see the effects of the angle and direction of light on your photos. Take as many pictures with as many variations as you can—remember, you aren't going to be wasting film.

You may find that your camera's flash will fire when shooting during twilight. This is your camera trying to illuminate the entire horizon: a job for the sun, not your small on-camera flash. If your camera fires its flash during these shots, you will get a nice picture of the space immediately in front of you, with everything else near blackness (see Figure 2.5). So disable your on-camera flash; you won't need it for this exercise.

Pointing the Camera

If your camera uses a matrix meter, you will probably get nice, even, and somewhat dull pictures of the twilight sky. There are several methods you can use to get better pictures, although these can depend on the specific features of your camera.

A general principle for skies is to shoot with the sky dominating the image area (see Figure 2.6); this often results in the happy coincidence of your camera's meter reading enough of the sky that you get a better picture rather than if ground and sky were roughly balanced in the image. The difficulty with this approach is simple: it does you little good to get a nice picture of something other than what you want to photograph. So if you aren't interested in a photograph of the sky but hope to have the sky accentuate your true subject, you'll have to change your approach.

If your camera has alternate metering modes, specifically spot or center weighted, now is the time to experiment with them. The "Cars, Trucks, and Other Vehicles" exercise (scheduled for later this morning) will give you detailed instructions on how to use your spot meter when shooting a very specific subject, and you can combine that technique with this section; but for now it is probably enough that you just get some basic experience using different metering modes.

Figure 2.5

Using a flash at twilight makes the foreground appear as if in daylight and loses the rest of the image.

Figure 2.6

Shooting with the sky dominating the image allows good exposure of the dramatic sky and reasonable illumination of the foreground highlights.

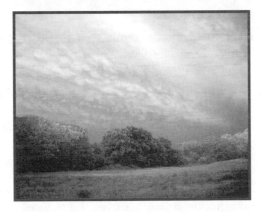

TIP

Try shooting in spot or center-metering mode with the center of the image a bit below and then a bit above the horizon. The dramatic differences between the two images may surprise you, particularly because you probably can't see any difference through your camera's finder (see Figure 2.7). Seeing these differences firsthand and immediately through your digital camera's LCD will help you understand how your view of the world and your camera's can differ.

During Sunday's software sessions, you will learn how to combine multiple images into a single picture. If you find that there are things you like about some of the images you get while shooting using spot metering and some that you do not like, you can start shooting with the plan of combining elements of images in later processing. For example, the shot with the center below the horizon probably has things about the foreground you appreciate, while the other shot probably has a better view of the sky. You can experiment further with this basic principle, trying different angles and extremes.

Figure 2.7

Two very different views of exactly the same scene during sunset. The left image was produced by metering off the ground, the right by metering off the sky.

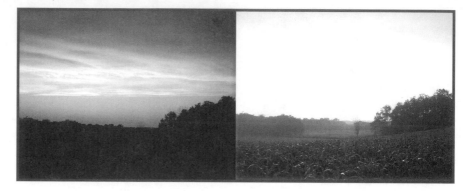

If your camera only offers matrix metering, your shooting options are far more limited. You can implement some of the tactics used for spot metering, but you may find that only very extreme changes in camera angle will result in significant changes in the picture. Another problem with matrix metering, particularly when combined with the difficulties many digital cameras experience with very bright light, is that when your images include the sun you may find a muddy appearance to the entire image. To an extent, you will learn how to correct this using software, but this effect can potentially ruin your pictures.

If your camera has exposure compensation, you can use it to darken the entire image to assist when the sun is in the image. How to use the exposure compensation setting is covered later today, in "Cars, Trucks, and Other Vehicles." If you already know how to use it—or feel comfortable skipping ahead—that's great. If you are covering this chapter first in the book, you may want to press on, noting for future reference that you can use this feature when experiencing metering problems at dawn and dusk.

Keeping the Light to Your Back

You always need to be aware of the position of the sun when shooting outside, and this is never truer than when shooting in twilight. As long as the sun remains above the horizon, it can have an enormous impact on the appearance of your photographs, including making itself an uninvited part of the image. With the sun low in the sky, you will find yourself constantly moving and orienting with respect to its location. Begin to practice this now, so that it becomes automatic when you are taking pictures that really count.

If you keep the sun to your back, the light will fall forward, illuminating your subject. You will not have to worry about the sun becoming part of the photograph, and in many cases you will be able to shoot using the automatic or default metering for your camera. Although the sky will probably appear dark and colorless, the light itself will be colored, giving a warm glow to your subject unlike any other kind of light (see Figure 2.8).

Shooting into the Light: Silhouetting and Other Options

An approach opposite that of keeping the sun to your back is to shoot into the light. This tends to create a halo effect of warm half-light around your subject. Your subject will probably appear acceptably bright if you shoot with your camera held so that the sky is not included in the image; if you include the sky, you will probably find that your subject is completely dark, or silhouetted against the sky (see Figure 2.9).

Silhouetting your subject can be dramatic—definitely something with which you should experiment (see Figure 2.10). However, many times you will find that you want a better view of your subject, with a good view of the sky as well. You have two approaches to this, the first photographic, the second with software.

Shooting into the light is a case where you may wish to use your flash to illuminate your subject. But just enabling the flash isn't enough, as there's a good chance your flash will not automatically fire now—the sky may be so bright that your camera's automatic mode will determine that it is not necessary. If your camera has a fill flash mode, this is an excellent time to try it out. As long as your subject

Figure 2.8

This montage of images shows how the special light near sunset illuminates an outdoor subject. Keeping the sun to your back lights the subject and is often the simplest way to shoot at twilight.

Figure 2.9

This cactus is silhouetted against the much brighter sky at sunset. Keeping the sun slightly to the side created a dramatic halo effect.

Figure 2.10

Silhouetted on a desert ridge at sunset, these images of a deer were only possible for a few moments out of the entire day.

is within range of your flash (for most cameras about 12 feet), you may be able to use fill flash to balance the back lighting of the sky and have both subject and background properly lit. You may still want to move around when using this method, particularly if the sun itself is in your picture. It may turn out that the better picture is possible with the sun just out of the image area.

TIP

There is a software solution to back lighting. Start by taking two pictures—one with a well-illuminated subject, and one with a great sky. You can then use software to combine these pictures after the fact, as you will see on Sunday. You can use this method when shooting with the light to your back as well, but it will appear more natural if the light is to the subject's back.

A secondary advantage to shooting toward the light is that it often results in faster exposures, allowing you more latitude in the subjects you can shoot. This gets around the problems with blurring that you run into if you do not have enough light to let you shoot fast enough to overcome camera shake or subject movement. Because the general image area is brighter when shooting into the light, the picture will often be less susceptible to blurring. If you are shooting using fill flash, even better.

When the Sun Is to the Side

You can get a very dramatic look if you shoot with the sun to the side. This creates images with long shadows and high contrast between light and dark areas. If the sun is relatively high, this can create a very bright effect, accentuating your subject (see Figure 2.11). If the sun is lower and the sky vividly colored, your subject will be bathed in warm light (see Figure 2.12), with a far more dramatic effect than the soft haloing of other angles (see Figure 2.13).

In some cases, you might not want drama—you might want a simple picture of your subject, and not have the option of waiting for the light to change or of shooting with the light to your back. The first thing to try in this situation is to get as close to your subject as possible. Getting closer can even out the lighting on your subject and create a more balanced effect, particularly when using matrix metering. You can also try using spot or center-weighted metering to compare the effects.

Figure 2.11

Shooting about an hour before sunset resulted in long shadows against a white picket fence.

Figure 2.12

The soft shadows of near sunset help create an otherworldly effect in this image.

Figure 2.13

The sun setting to the immediate right created the sharp contrast between light and dark in this image.

TIP

When shooting in low-light conditions, it isn't always a problem if your photos are dark. The most important thing is the *detail*—the photographic information—in the shadows. If the shadows are 100 percent black, you have nothing with which to work. If they are merely dark, then you can always lighten them using your image-editing software.

Something to Try

A really nice effect can be found by shooting the sky indirectly, as seen reflected in buildings, glass, or other objects. While you can try this at any time of day, it can be most appealing when the reflected sky has the color and drama of a sunset or sunrise. You can try this with almost any potentially-reflective object, even the glossy paint or windows of your car.

The Great Outdoors: Landscapes and Scenery

Photographs of landscape and scenery encompass the majority of history's most famous and memorable images. Ansel Adams, one of photography's first and greatest scenery photographers, made his reputation by capturing breathtaking landscapes on film that will be marveled at for generations.

Introduction to Photographic Composition

A central issue throughout all of photography is that of *composition,* or how the major graphical elements of the image are placed in relation to one

> ## HOW WILL YOU USE IT?
>
> Even if it is not your goal to produce works of art for the ages, you will probably have plenty of occasions to want pictures of outdoor scenes.
>
> In addition to travel scenes and snapshots, landscape photography has many commercial and professional applications. Landscape designers and greenhouse keepers can use digital photographs of their work for use in newsletters and on Web pages. Almost any application of photography can include a landscape to provide a sense of scale and dimension to a person, place, or product. The landscape gives perspective and can make even the harsh and industrial seem natural and in sync.
>
> Whatever your intended use for landscape photographs, you will find that using a digital camera adds a new dimension to shooting. Situations that have frustrated you in the past will become easier to manage when you can quickly preview your shots. The excitement of the immediacy of a digital image combines with the ease of sharing and flexibility of uses to which you can put a digital photograph to help make the great outdoors come alive.

another. Good composition cannot make an extremely dull subject exciting, nor can horrid composition entirely suck the life from a subject that has high intrinsic interest to the viewer. The unfortunate fact is, however, that most of the world's potential photographic subjects lie in a huge gray area between the very exciting and the very dull, so composition is critical to making the most of an image's potential.

The Rule of Thirds

Perhaps the best-known rule of composition is the rule of thirds. Using this principle, two graphic elements are kept from dividing the image area equally;

one dominates and comprises two-thirds of the space, and the second is made subordinate and occupies one-third. The rule of thirds also applies to images with three strong elements. In this case the three elements are classically given equal weight, although variations on this are possible where, for example, two parts are given a third of the combined area and the third element occupies an entire remaining two-thirds.

The rule of thirds does not apply only to the horizontal range of the image but to all directions and orientations. In fact, it can even apply to a central subject, allowing either a third of the image space on either side, or perhaps two-thirds to one side with the subject occupying the other side of the image.

In some respects the rule of thirds is a negative—its primary function is to prevent the very artificial and uncomfortable aesthetic effect that occurs when an image is divided equally in two. A classic application of the rule of thirds is in outdoor pictures that include the horizon. In many cases, it seems natural to place the horizon in the center of the picture, but this tends to create a sharp division and prevents any portion of the image from having a dramatic impact on the viewer (see Figure 2.14). Composing the photograph so that the horizon is about a third of the way from the top gives favor to the foreground and its elements, placing the horizon about a third from the bottom gives greater impact to the sky.

The rule of thirds is often successfully broken. The fact that it is really a negative rule makes breaking it easy, because many pictures manage to break the literal rule of thirds to great effect while keeping the rule in spirit by avoiding uncomfortable breaks or evenly dividing the image area. In spite of the fact that the rule can be broken, however, if you keep it in mind when shooting you will get consistently better pictures.

Where's It Going?

Another important principle of composition is that many objects show movement, even if it is just in potential or shape, and need room in the picture to allow for that potential movement. Animals, faces, and vehicles all clearly have directions associated with their forms, and if they are facing a portion of the image, you should allow them room in the image to move. This principle can be combined with the rule of thirds; you can use the implied direction of the subject to dictate how the thirds should be divided.

Figure 2.14

The horizon evenly divides the upper image, creating a look that is too balanced and therefore relatively uninteresting. In the lower image, the dramatic sky dominates, resulting in a better photograph.

Inanimate objects often have direction, even though they cannot actually move. The viewer's eye will follow any definite line across the picture and derive a sense of motion from it. As a result, a tall tree reaches upward and thus appears cramped and restricted if the image is cropped to the precise top of the branches. Mountains, buildings, and even roads can demand extra space, sometimes called *negative space,* to give their size room for expression (see Figure 2.15). In fact, anything with a strong directional content—a field of grass, some patterns in weavings and textiles, even a pile of wood—should be considered as having graphic motion and given room for that motion (see Figure 2.16).

An extreme break with this rule can also be very effective. Shooting close in and allowing lines to enter and leave the image can make for striking graphic content. In this case, the implied motion is magnified, creating the impression that the subject has even greater motion. This rule should only be broken with caution, however, as some people never overcome the almost claustrophobic effect of tight lines when viewing images of this type.

Figure 2.15

As the railroad tracks disappear into the distance, the empty top of the image implies space for motion.

Figure 2.16

The composition of this picture gives room to the stalks of the flowers and corn in the field.

What You'll Need

The setting for your practice shots of landscapes can be as simple as your back-yard or neighborhood park. Of course, if you already know of an area that interests you, try to use it as your subject—or at least find some place with graphic similarity to your intended subject. If you hope to finish today's exer-cises in one day, though, you should try to make your scene convenient to home or to settings suitable for other exercises. You might even be able to combine this exercise with one or two others—"People, Children, and Por-traits Outdoors" or this afternoon's "Architecture, Buildings, and Structures as Subjects" are potential candidates.

Being able to shoot the horizon during this exercise is a plus. You will often encounter the horizon when taking pictures, so shooting it now is good practice. If possible, choose a setting with elements that have strong graphic content to place in some of the images. Practicing balancing subjects now will pay off with better photos when it really counts (see Figure 2.17). Subjects of interest up close, whether flowers, rocks, or something else of interest, can also fit in well with this exercise.

Camera features you are most likely to find useful when shooting landscapes:

- Zoom lens with wide-angle and telephoto settings
- LCD review screen
- Manual flash off
- Spot meter

Digital Photography of Landscapes and Scenery

Landscapes are perhaps the best place to start applying the basic elements of photographic composition. As you photograph, be sure to use your LCD review screen as often as is practical. You will begin to understand and anticipate how what you see through your finder translates into the actual image.

Figure 2.17

The two images in this figure show very different ways of balancing the horizon and graphical elements to get two different perspectives of the same scene.

Try to take another picture of essentially the same subject immediately, adjusting your composition for a more appealing picture. Use your zoom lens at various settings, but be sure to try the effect of going very wide and seeing what the big picture gets you (as in Figure 2.18). Thinking and planning, as well as plain old looking around, are always important elements of photography. The more you practice the more good composition will become automatic and second nature.

Look for elements of the landscape with strong graphic potential. Fences, trees, buildings, bodies of water, and rock outcroppings are common features of landscape and scenery shooting that add interest and balance to an image. Try shooting these elements as many ways as possible, placing different emphasis on the features and the rest of the landscape (see Figure 2.19). Even with a preview screen, sometimes it won't be obvious to you just what works until you get home and can review your work at leisure. That's OK—no matter what the results, at least you're outdoors with a camera in your hand and nature all around.

Many scenes will have an obviously strong theme that almost leaps out and begs to be photographed (see Figure 2.20). Shooting a scene from the obvious angle is OK, particularly at a time when it seems so much attention is given to the bizarre, but you should try to look for the less obvious as well. Many times a slightly different way of looking at an object, particularly one that's familiar, will make the difference between a photograph that's a winner and one that's a snooze.

In landscapes, the horizon and the sky almost have to play a role in the picture.

Figure 2.18

You can use your zoom lens to get different compositions of the same subject.

Figure 2.19

Subtle differences in camera position can make a huge difference in the appearance, and quality, of the final image. Try different views of the same subject to find the photo you like best.

In many cases, the sky might even dominate the scene. This can pose a challenge for your camera's metering system similar to the problems with sunrises and sunsets discussed in the "At the Ends of the Day" section. If you have already done that exercise, then you know how to point your camera to get the most out of a sky that's much brighter than the foreground. If you got up too late to complete that section this morning, then at least review the tips on pointing the camera to help you with shooting the sky in this section.

Figure 2.20

The drama of a scene like this one can be enhanced by use of an extreme angle. Shooting with a telephoto lens helped to increase the effect.

Winter and the Challenges of Light

Winter scenes—a landscape draped with snow—are a common subject for outdoor photography (see Figure 2.21). Often the results are disappointing, and if you have experienced difficulties with these shots in the past the reasons may have eluded you. In most cases, the wonderful white-clad landscape will show up as a scene of dismal gray. The problems are not necessarily limited to snow scenes, but they are most pronounced when the picture is predominantly either white or black.

The problem is caused by the tendency of your camera's meter to seek what's called neutral gray. *Neutral gray* is a shade of gray that reflects 18 percent of the light that falls on it. It is called neutral because it falls between black, which is considered to reflect 9 percent light, and white, which reflects 36 percent. Before you reach for your calculator to double-check, yes 22.5 percent is the arithmetic halfway mark between 9 percent and 36 percent, but 18 percent is the real-world measure of the reflectance of gray. And if you think this definition is somewhat circular, it is.

NOTE OK, even if you aren't happy with it, you now know the definition of neutral gray, but what does this have to do with snow and other things that don't look right in many of your pictures? Well, as you are aware, it is the job of the meter in your camera to measure the amount of light in the image. Now that you know that different colors reflect different amounts of light, it should dawn on you that designing a meter is difficult because it has to be relative to some set amount of reflectance. A meter designed to measure light from neutral gray will make white too dark, because white reflects more light than the meter is designed to anticipate, thus the meter will register the scene as brighter than it actually is. When black is the predominant color, the reverse is true. It is therefore possible to take a picture of nothing but white and another of pure black and get two images that appear essentially identical. This is called *gray shift*.

Figure 2.21

Snow scenes make attractive but often challenging landscapes to shoot.

So far, all of this information about metering and reflectance applies equally to digital and conventional shooting. Here's where they part. In conventional shooting, the solution is to use the exposure compensation feature of your camera to lighten the scene, making white look white. Now, read the following many times over and imprint it in your brain: Do not use exposure compensation when shooting predominantly white scenes digitally. Never, not ever. Get it?

Well, almost never. If you are using a digital camera like a conventional camera and shipping the images off for immediate use without any software processing, you will have to use the exposure compensation feature just as you would with conventional photography—the "Cars, Trucks, and Other Vehicles" section later this morning will show you how to do this. Ignoring the exception to the rule, it is not necessary to use the exposure compensation feature to lighten white snow is because it is child's play to correct this with software. OK, so it's not necessary, but why the strong prohibition? The digital photographer faces a much greater threat when shooting bright scenes than gray shift: something called *bloom*. This afternoon has an entire exercise devoted to this challenge, called "Shooting Metals and Reflective Objects." In the meantime, follow the general principle of digital photography and accept a moderate amount of *underexposure* gladly—it's OK if your pictures appear too dark as long has they have enough digital information in them to let your software correct the problem.

CAUTION

Just in case you weren't paying attention, exposure compensation in the +EV range may be helpful in conventional photography, but tends to be a dangerous habit for the digital photographer. Fix your images with software, and avoid creating the dreaded "CCD bloom" problem that plagues overexposed digital shots.

Getting Close

An alternative to the wide, sweeping landscape is a scenery shot that gets in close, featuring small details like the ones in Figure 2.22. You may want a close-up for aesthetic reasons—because you like the abstract pattern the details make—or just because the details themselves are of interest. One way to get these shots is simply to get closer to the part of the scene that interests you (see

Figure 2.23). Do not plan on making major crops of your pictures; on even a megapixel camera the image size is too small to let you go around throwing away image information.

Another way to approach details is to use the *telephoto,* or long zoom, end of your lens. Telephoto tends to make some graphic elements stronger and more dramatic. This is particularly the case when the lines of the subject provide the interest, as with mountains and rocks. Of course, *close in* is a relative term, you may still be many miles from your subject when you zoom in close; in fact, for some subjects telephoto may be the only way to make them appear close (see Figure 2.24).

Figure 2.22

When shooting landscapes, don't forget the possibilities the details of the scene offer as subjects.

Figure 2.23

Getting close to the edge of the pond was the trick needed to separate these water lilies from the rest of the landscape.

Figure 2.24

The telephoto was the only way to fill the image with the rainbow in this scene.

NOTE Sometimes a subject is so large that trying to make it fit in one photo can make it appear smaller and less majestic, while zooming in on part of it actually enhances the feeling of size.

Take a Break

You've been running around grabbing digital shots outdoors for a good part of the morning; now it's time to shake the sand from your boots and break out the gorp. Today will probably be pretty busy, so take a deep breath and relax. Never forget that taking pictures is all about having fun.

Architecture, Buildings, and Structures as Subjects

As parts of the human landscape, buildings and other structures are often the most memorable features of travel and historical settings. Getting good pictures of the interesting buildings you encounter can be rewarding, besides helping to preserve your memories for posterity.

Introduction to Perspective

You are no doubt aware that more distant objects appear small relative to nearer objects of the same actual size. When photographing most subjects, this apparent shrinkage does not come into play, or if it does it merely inspires you

How Will You Use It?

There are many professional uses of architectural photographs, and digital cameras can be an excellent way to capture images for many of these instances. Work-in-progress documentation of new buildings and restoration projects (see Figure 2.26) is well suited to digital photography, particularly because of the speed and ease of sharing images. The explosion of real estate Web sites provides another example of architectural digital photographs being used to great effect (see Figure 2.27).

Figure 2.26

Digital photographs make compelling images of construction projects, like this one of the restoration of the Allen Theatre in Cleveland, Ohio.

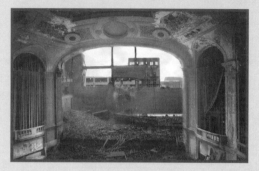

In addition to their convenience and immediacy, photographs shot with consumer digital cameras are great for use in rough manipulations for many professional applications. From digitally trying out paint colors to sketching in a new addition, digital photographs can be the foundation for improved communication between clients, designers, and contractors. On a personal level, you can use a digital photograph of your home to play with remodeling ideas and select landscape choices.

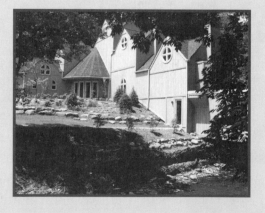

Figure 2.27

Digital photographs of houses have both personal and commercial uses.

to move closer to your subject or use a telephoto lens to make the distant subject appear closer than it really is. Large subjects can be distorted by perspective, but in most cases these are natural features of the landscape with irregular shapes, so the distortion is not obvious. For example, no one is likely to notice what perspective is doing to the true shape of a mountain. However, buildings and other man-made structures tend to have very regular shapes and parallel lines. As noted under "Where's It Going?" in the previous section on landscape photography, there is a tendency for the viewer to follow lines across a picture. Where the lines fall away into the distance they tend to run together, enhancing the distortion of the shape due to perspective.

Perspective can be used as part of the creative expression of an image (see Figure 2.28). You may be familiar with photographic uses of this fact—long fences stretching seemingly into eternity or roads leading off to the horizon. This can work with buildings, too. A tall building, shot from the ground, can seem to sweep away into the sky, creating a feeling of massive size (see Figure 2.29).

For some shots of buildings, perspective may be undesirable (see Figure 2.30). Conventional architectural photographers have long used expensive perspective-correcting lenses to allow a picture of a building from the ground to appear in proper perspective. As a digital photographer using a consumer camera, you will not have access to a perspective correcting lens, nor will you need one. As you will learn on Sunday, you can use software after the fact to correct the perspective of photographs.

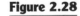

Figure 2.28

This image of the Quaker Square Hilton in Akron, Ohio, uses perspective to make the building almost seem to be an abstract sculpture.

Figure 2.29

The perspective used in this shot makes a large building seem even more massive and solid.

Figure 2.30

The effects of perspective can be undesirable when a straight shot is required.

What You'll Need

Buildings come in all forms, so it's great if you can plan on shooting a representative set of structures today. If you are traveling to do your outdoor shooting, you can even break this section up to grab subjects of opportunity throughout the other exercises. Of course, if you have a specific interest in shooting certain kinds of buildings, you should try to make your subject representative of your real interests.

Time your shooting so that it coincides with any activity typical of that associated with a structure. Often an important part of photographing a building is to tell its story: how it's used, who uses it, what the building is about. People are usually an integral part of that story, so don't be afraid to include them in your images.

Camera features you are most likely to find useful when shooting buildings:

- Zoom lens with wide-angle and telephoto settings
- LCD review screen
- Manual flash control
- Manual meter control
- Lens threads or adapters

Digital Photography of Buildings

Begin to shoot your subject from a distance, and work your way toward it. As you do, look for interesting angles or graphic patterns that relate to the building and its setting. You may be surprised, particularly if you are very familiar with your subject, to find that the position from which you take the picture can change the entire impression of the structure. Use your LCD preview to confirm this effect as you shoot.

It is likely that your camera's automatic flash setting will prevent the on-camera flash from firing. If it is firing and the image appears much too dark, turn the flash off. As you get closer to the structure, experiment with the effect of forcing the flash to fire using fill flash mode. Fill flash can improve pictures of smaller structures or those with interesting foregrounds that you hope to include in the image.

Try different meter settings as you shoot—you'll find there are special effects you can get with one setting that disappear with another (see Figure 2.31). Some structures can pose challenges for certain meter modes, so a bit of trial and error now can pay off in the long run. You may even find that one mode works best at one distance, and another is better after you move. Being able to predict what works best to give you the image you want can be a very difficult element of photography. For conventional photographers, figuring out metering problems can take a tremendous amount of trial-and-error learning; as a digital shooter you have the ability to learn as you shoot.

People can be a natural part of the picture when your subject is a building. After all, buildings tend to be full of people—you might not have the option of getting a people-less image, even if you want one. Look for ways that people can enhance the composition of the image. An interesting human element can make the difference between a fairly sterile image of brick and mortar (or steel

Figure 2.31

Different metering methods can produce dramatic results when shooting buildings. Spot metering off the sky made this church show up as a silhouette.

and glass!) and one that exposes the viewer to a worthwhile experience. Look for people to help convey a sense of time, place, perspective, and even emotional content.

The Wide Has It

Often one of the most useful features of your camera when shooting buildings will be the wide-angle range of your lens. Shooting wide may be a necessity in places where you simply cannot stand far enough back from the building to get the image you want; this often occurs in urban settings. If your camera does not have a wide-angle setting, or if you are not able to go wide enough for the shot you'd like, consider using a wide-angle adapter on your lens. (See Friday Evening's section, "Types of Digital Cameras.")

Using a wide-angle lens or adapter will increase the effects of perspective distortion. Buildings will appear more massive and can seem to almost surround the viewer. If you want that look, you should consider using a wide angle even if you could get the image without it (see Figure 2.32).

CAUTION If you intend to correct the image's perspective using software, use a wide angle with caution. Wide-angle lenses add curvature to lines that is much harder to correct using software than the effects of simple distortion due to distance.

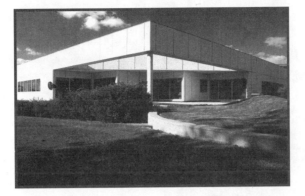

Figure 2.32

There was plenty of room to back up, but using wide angle for this building accentuated the lines and form.

It's In the Details

At the end of the lens range opposite wide angle is telephoto. Using telephoto to get a close-in view of building details is an approach that is often overlooked, and yet can produce some of the most memorable images of a structure. Many times even rather bland buildings can have interesting details, if you look close enough (see Figure 2.33). You can even use the telephoto setting of your camera to look at the building, slowly scanning the structure for potential images. You may be pleasantly surprised at what you discover.

Another advantage to telephoto is that if you simply cannot get wide enough to get the entire building in one shot, you can still get exciting images of a building (see Figure 2.34). There is even special software available to help you to stitch many shots together to get a realistic wide view of a building. If you're flexible in your expectations for your telephoto lens, you may find that you can get results that say more about the building than you'd realized possible.

Figure 2.33

A close view of this shed makes an interesting image.

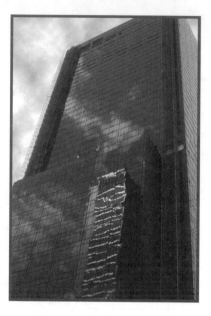

Figure 2.34

It was not possible to get far enough back to capture this entire building, but it was still possible to get a good image.

TIP Use your camera on a tripod to grab partial shots of your subject in sequence. You can use panoramic software to stitch these images together, creating a composite that shows your entire subject.

Pets and Other Animals

Taking pictures of animals is like playing golf—every now and then everyone can get a shot that's as good as anyone has ever taken. This is undoubtedly one of the reasons that pictures of animals remain a perennial favorite of amateur and pro alike. For many people, animals are an important part of day-to-day life, and so photographs of animals become important as well.

What You'll Need

If you have a favorite pet or other domestic animal available, then you already have an ideal subject at hand. In fact, like children, the animals you have in your home will probably be the subject of an inordinate number of photographs, so you might as well try to make them good shots. Even if a lousy picture of Spot the Cat is as dear to you as one of better quality, it isn't to anyone else. The fact that you force friends and coworkers to look at all your

photos of the insufferable little monster means you owe it to the world at large to at least make them good pictures.

Seriously now, find a shady place outdoors where you can make the animal behave (see Figure 2.35). A place that's relatively free of other animals is a good idea, as other animals can distract your subject. If you are more comfortable indoors, that's OK. While it is probably true that most animal photography is outdoors, there are enough opportunities to shoot indoors that this exercise can be completed in either setting (see Figure 2.36).

If you have an assistant who's willing to help, take advantage of the opportunity. Getting shots of animals is tough enough without having to worry about chasing after Fido every five minutes. In fact, shots of people and animals together can be terrific, so if your assistant is willing to be included in the pictures, your photo opportunities are multiplied (see Figure 2.37).

Figure 2.35

The relaxed comfort of home is combined with an attractive background to make this a nice snapshot of a pet cat.

Figure 2.36

It won't look very wild, but indoor pets are often more comfortable and thus pose for better pictures when inside.

Figure 2.37

Pictures of people with animals can last as treasured memories, or be put to more immediate practical use in the art of blackmail.

Camera features you are most likely to find useful when taking digital photos of animals:

- Wide-angle zoom or lens adapter
- Telephoto zoom or lens adapter
- Macro or close focusing mode
- Manual focus or autofocus override

Digital Photography of Animals

When taking pictures of animals, patience and flexibility are your greatest tools. Even a tame house pet will probably not take direction very well, and so you will have to wait until an opportune moment arrives to grab the shot you want (see Figure 2.38). In some settings, it will be necessary for you to move around quite a bit to keep the animal in view; in others you will have to wait patiently until the animal is in the right spot for your shot. You may not be able to plan exactly the shot you'll get when photographing animals, so keep your mind open—you might not get exactly what you'd wanted, but animals can surprise you with something even better.

To begin this exercise, use a pet or other animal over which you can exert a good deal of control. It will be to your advantage to be able to predict the animal's behavior and to position it as you would like. Also, if you know the animal it is likely that the animal knows you. An animal that is comfortable with you is less prone to alter its behavior in response to your presence. Having

this sort of home field advantage when you start out will help you get the feel for taking pictures of animals—and once you feel comfortable with a few basic principles you can venture on to more exotic subjects.

Taking pictures of animals shares many qualities with portraits of people. You want to focus on the eyes of the animal when you shoot, making sure that they are clear and expressive. Animal faces are typically of greatest interest to the viewer, and if the animal has a humanlike expression, so much the better. Most often the picture will look more natural if the animal is not looking directly at the camera, so leave some space in front of the animal's face to create a pleasing composition. Of course, if your shot has the animal with its eyes closed or otherwise making an awkward expression, as a digital photographer you will immediately know this when you review your shots and can reshoot to get a better picture.

Traditionally, animal photographers have relied on equipment that responds rapidly and can fire many exposures in succession. In this arena you will be at a disadvantage due to the relative slowness of your digital camera. All is certainly not lost, of course—you simply have to use the digital photographer's ultimate weapon and plan ahead for your shots.

Two tools you have in your digital kit to get great animal shots are compositing and prefocusing. *Compositing* is combining two or more shots into one picture—something that's much easier to do with software than with film. You will learn how to composite on Sunday; in the meantime you can collect multiple shots of your pet—or better still multiple shots of two pets that would never normally tolerate one another—to prepare for Sunday's session.

Figure 2.38

Good timing and readiness resulted in this fine shot of a cat being a cat.

> ## How Will You Use It?
>
> **Digital photographs of animals are great because they give immediate feedback on what you've shot. Time and again people have been disappointed when getting prints back from places like zoos and national parks because they didn't realize that some feature of their camera was continually causing them to miss a great animal shot by a fraction of a second. When you shoot digitally, you can recognize that you're making a mistake and correct it, saving the photographic day.**
>
> **Animal-related clubs, zoo newsletters, and even multimedia productions can all benefit from digital photographs of animals. The photographs can be about the animals themselves, or they can be used to express ideas of speed, ferocity, humor, and nearly any other human emotion. And because the shots are digital, they are ready for use in a variety of forms instantaneously.**

Prefocusing is a technique that involves setting up your camera and focusing it on a spot where you have a pretty good idea an animal will appear. The best way to do this is to use the manual focus setting on your camera, if it has one. If your camera does not have manual focus, you may be able to prefocus by partially depressing the shutter release button; the disadvantage with this method is that you will have to hold the button down until you are ready to take the picture. Prefocusing allows you to get a much faster response from your camera, because there's no time lag while the camera focuses.

The Jungle in Your Backyard

When you think of getting great nature shots, you probably think about great wild animals in exotic locales, or at least your local zoo or park. Actually, many of your best nature pictures can come from your own backyard. There are several reasons why you may find backyard nature photography rewarding and fruitful. First, you will be able to spend more time and have more freedom to do as you wish in your own yard than at another locale. Second, you know the area best, know what kinds of animals to expect and where to expect them, and can use your knowledge to plan your shots.

If you have a great deal of interest in getting nature shots, you can even create them in your backyard by planting specific flowers and other flora that will attract specific animals to your yard. When you combine all these factors, there are few tasks that can rival a great backyard nature shot for a feeling of pride and accomplishment (see Figure 2.39).

If you are interested in attracting birds to your backyard, try to buy or build a feeder that looks natural. You can also plan angles that will allow you to get a picture with more of the bird and less of the feeder for a natural look. When you learn outlining on Sunday you'll see how easy it can be to remove artificial elements from well-defined areas of a bird—its feet, for instance—and difficult from others, like wispy tufts of feathers. Knowing this in advance, you can plan your shots accordingly.

Animals found in your backyard might not be tame, but in many cases are more approachable than in the wild. This approachability can allow you to get pretty close, perhaps even close enough to use the close focusing or macro feature on your camera (see Figure 2.40). Getting close is an excellent way to make the most of the pixels available to you in your digital shot and can provide a different view of even quite common animals. Of course, whenever you approach any animal, use common sense to protect yourself and the animal.

Zoos and Animal Parks

Sometimes the only opportunity you'll have to see many exotic species is at a zoo. Zoos can be great places to get dynamite pictures of animals that interest you (see Figure 2.41), but they can pose certain challenges to the photographer.

Figure 2.39

The yearlong practice of setting out food for these geese has paid off in a fair-sized portfolio of digital images.

Figure 2.40

A praying mantis might not fit your idea of a cute critter, but being able to get close with the Kodak DC-260 resulted in the capture of what appears to be an almost human expression on this specimen.

Figure 2.41

This photo of a polar bear at a zoo might not look quite as natural as one taken in the Northwest Territory, but it involved much less travel time. As a bonus, the photographer did not end up as lunch.

To plan for taking pictures at a zoo or nature park, you can try taking pictures of a pet from a distance, even through a fence if you have one available.

Many zoos today have gone to great expense to make their settings appear as natural as possible; however, when shooting at zoos you will still be faced with a variety of artificial elements, from fences to water dishes, that can ruin some pictures or make a great shot mediocre. Removing smaller, less obtrusive objects with software can be easy, but other forms of interference can be more troubling.

Fences and screens are a common form of interference when photographing at zoos. One way to deal with mesh fencing is to get as close as possible to the fence when focusing on your subject. This can make a fence virtually disappear from view. With the limited controls available on most consumer digital cameras, you may not be able to force this to occur. However, you can use your camera's preview LCD to see if it works.

Another way to remove artificial features commonly found at zoos is to use the telephoto, or long zoom, setting of your camera to photograph only the face of the animal (see Figure 2.42). When you use telephoto, whatever background is visible will be out of focus, and so artificial objects will be indistinguishable. People often find photos of this type very appealing.

Animals in Nature

If you have ever set out to take pictures of animals in their natural habitat, you already know just how difficult it can be. Simply finding the animals can take hours or even days, never mind catching them doing anything interesting. To be successful at getting shots of animals in the wild, you must either have the necessary expertise and detailed knowledge of the animals and their habits or be very lucky. Most successful nature photographers may officially stress the former, but in private will probably admit that they tend to take large helpings of the latter whenever it's offered (see Figure 2.43).

One way to make your own luck is to spend a lot of time outdoors, especially in the company of people who know a lot about the animals in which you are

Figure 2.42

This lion shot was actually taken during a commercial shoot in the Ohio backyard of one of the authors, but getting close with a telephoto lens makes it indistinguishable from a photo taken on an African safari.

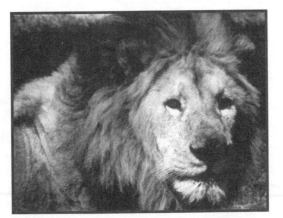

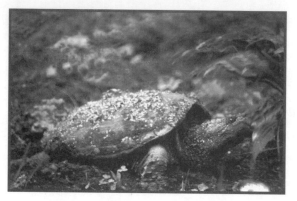

If you don't spend time in the right places, looking for the right things, you'll never get shots like this one. But it still helps to be lucky.

interested. If your interests lie in birds and bird watching, you can probably find a club in your area that has frequent outings and enthusiastic members, both of which can be of great help. Additionally, many avid bird watchers are quite proficient amateur photographers, and so may be able to provide you with invaluable assistance getting started.

If you have more exotic interests, there are numerous professional nature photographers who run workshops and photo safaris in the United States and around the world. With a little research, you can probably find one that specializes in the sort of animals you find interesting at a price you can afford. Of course, if you go to the trouble and expense of taking an animal safari, you will probably have a conventional rig along with your digital camera; however, the potential for almost instantly sending photos from the Serengeti via e-mail is something unique to the digital age.

To make the most of your time in the field, it is possible to practice while at home. You can use some of the tips in the "Jungle in Your Backyard" section as a basis and expand on them to suit the animals you find most interesting. Something to remember is that the wilder the animal, the farther back you will have to remain to get good shots without alerting the animal—and in some cases to assure your personal safety. To shoot truly wild animals will take long lenses, as long as you can get. If your digital camera has the ability to accept additional lenses, you should consider investing in a telephoto extender to bring the animals in closer. You can also try experimenting with the digital zoom feature on your camera, if it has one, but you will probably find that the degradation in quality is so great that it isn't very useful.

People, Children, and Portraits Outdoors

The most important thing in this exercise, as with all photography of people, is learning how to let the person in the photograph come alive. While this is a photographic talent that can only be demonstrated and can't really be taught, if you take the time to learn the basics you will find that after your next vacation, static, posed pictures have been replaced by interesting and exciting digital photos.

What You'll Need

Your subject for this exercise needs to be someone—or a few someones—willing to let you take their picture for an hour or so. Children can be ideal for this purpose, particularly because they can easily slip into outdoor activities and forget you're there, allowing you to concentrate on getting great shots without worrying about your subject becoming overly self-conscious. On the other hand, if you intend to combine this exercise with this afternoon's "Indoor Shots of People" section you may want an older subject, with the patience and understanding necessary for a couple of hours of photography.

The most important thing about the setting for this exercise is to avoid harsh, direct sunlight. While it may not always be possible to shoot in the shade when you are going for pictures that really matter, while you are learning and experimenting it is probably best not to combine too many challenges at once. Of course, if you can select a setting that has aesthetic appeal, it can only serve to enhance your shots. If you intend to use these shots on the Web, select a simple, unobtrusive background that will not complicate the picture when sized down.

Access to activities or sporting equipment can be a plus. Many of the best candid shots of people are when they are entirely absorbed in other activities. As a bonus, if you have an appropriate setting and some high-speed sports activities to shoot, it might be possible to combine this exercise with the "Action and Motion as Subjects" section scheduled for this afternoon.

Camera features you are most likely to find useful when taking people pictures outdoors:

- Exposure compensation
- Spot meter
- Fill flash
- Zoom lens
- Manual focus

How Will You Use It?

Digital cameras make ideal companions at family outings, company picnics, and vacation or business trips. The ability to instantly review and—as you'll see on Sunday—even modify and print images on the spot opens a world of exciting imaging possibilities at gatherings of all types. The only drawback might be that the interest digital cameras can generate has the ability to overshadow the event or gathering itself.

Digital pictures of people make great instant additions to newsletters and Web sites. They can also be a great way to include the disabled in outdoor activities normally closed to them. Of course, commercial uses of these pictures abound. Digital photography allows you to use photographs of events as they happen or soon after in promotional materials, enabling you to make the most of any event. In many commercial applications, digital photography is backed up by the long-term quality of medium or large format film.

Many people take the majority of their photographs on an annual family vacation. While any of the exercises covered in this book could form the subject of pictures taken on vacation, this one will mean the most for your vacation photos—after all, it is pictures of people outdoors that make up the bulk of most vacation photo albums. The practice you'll get in this exercise will help you understand how to take good pictures of people while making the most of the capabilities of your digital camera. Of course, you will also learn some of the limits of digital photography in these settings and how to overcome them.

Digital Photography of People Outdoors

Begin taking photographs with your subject relatively motionless, perhaps posed in an attractive surrounding and out of direct sunlight (see Figure 2.44). Even in shade, your camera's flash will probably not fire. For many subjects that would be OK, but most digital cameras do not reproduce skin tones as

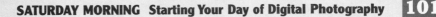
well as popular print film does. Skin tones tend to look best when slightly *warm*—with a slight red hue—but digital cameras tend to run blue, or *cool*. You will learn more about color on Sunday; for now concentrate on finding the best solution to get nice skin tones from your camera.

If you can force your camera's flash to fire, perhaps by selecting fill flash from your available flash modes, you will probably get better skin tones. If your camera has a spot meter, try using it to get a better balance of light for your pictures. You can also try using exposure compensation settings to get better exposure. For detailed instructions on using these features, refer to the "Cars, Trucks, and Other Vehicles" exercise, scheduled next in this morning's session.

Many people outdoors are going somewhere or doing something. You can make a better-looking picture if you can include the destination or activity in the frame. Even if that is not possible, you can give the person room to go somewhere by allowing for space in the direction they're headed or focusing on. For example, if your subject is looking or walking to the right, leaving a third of the frame open to the right of the main figure will help you tell the story of what the person is doing (see Figure 2.45). Photographing the same person tight, without the leading room, will give a claustrophobic look to the picture.

Going Wide for the Shot

If you have ever tried to take pictures of people involved in sports or other activities, you already know how difficult it can be to try to follow what's going on and get a picture without missing critical parts of the action. If your subject is a volleyball game, your camera will perpetually lag behind the ball. For children on swings, you are never able to match their exuberantly eccentric movements.

Figure 2.44

Taking pictures like this Kodak DC-260 image of Katie Murdoch in a shady garden will give you great practice at digital photography outdoors.

Figure 2.45

As Katie plays croquet, she is definitely concentrating on something out of the frame. The negative space in front of her gives balance to the viewer's natural tendency to follow Katie's gaze.

The solution in most cases is simply not to try to follow the action—just pick a spot and wait until the action comes to your lens. To increase the odds of success, zoom out as wide as your camera will go, with as much of the area of potential action covered in a single shot as you can get. For best results, use your camera's manual focus, or autofocus override, to preset the focus in the area of potential action. Using manual focus will improve your camera's response time. When you can see the action in your camera's finder, take the picture (see Figure 2.46).

This is a classic approach, but one with a couple of new twists when it comes to digital photography. First, even with a relatively high-end megapixel camera, this approach lends itself to a lot of wasted space and potentially the need to crop the final image. This wastes those valuable pixels. Unfortunately, it may be a case of waste pixels and get the shot, or don't get the shot. Still, if you are aware of the potential problem, you will be able to pick your shot carefully to allow as much subject in the image as is possible and still get the shot.

The second problem is that of camera response time. Even with manual focus engaged, digital cameras are slower than conventional cameras, both in response to a shutter release and between images. Many consumer-level conventional cameras are able to fire at a sustained rate of two or three frames per second for an entire roll of film, equaling 36 shots in as little as 12 seconds. Professional 35mm cameras are even faster, some able to shoot an entire roll

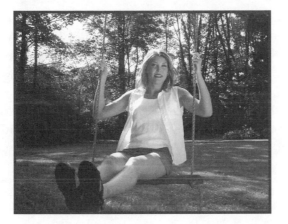

Figure 2.46

This Kodak DC-260 picture of Katie on a swing would not be ideally framed if she were standing still, but allowing more space made getting the picture possible.

of film in not much more than four seconds. Compared to these conventional speed demons, digital cameras are pokey indeed with some units requiring two to five seconds after you depress the shutter release button before taking the first picture and as much as five to eight seconds cycle time between shots.

The slowness of digital cameras does not mean that getting pictures of people engaged in outdoor activities is impossible, only that it can require a bit more planning and patience than with a conventional system. You probably can't afford to wait until you can see the action in the viewfinder—as you would with a conventional camera—before hitting the shutter release. Instead, you'll usually have to anticipate the activities of your subjects and start to take the picture well before you can see anything or anyone. This afternoon's "Action and Motion as Subjects" section deals with the general topic of using digital cameras to capture motion in greater detail.

Some cameras have a burst, or multi-frame, mode that you might think helpful in getting pictures of people outdoors, particularly when they are active. Unfortunately, most such systems will only operate at unacceptably low resolutions or have such limited firing capacity that they are of questionable value. For example, the Kodak DC-260 burst mode has a 1MB buffer for burst mode pictures, which translates into between two and three high-resolution images before the camera must stop and perform a lengthy file save. Of course, the ability to capture even two high-resolution pictures in immediate succession is a lot better than most digital cameras, so if your model has this feature it is worth trying to see if you like the results.

Pictures of Children

The best pictures of children outdoors are when they are wholly absorbed in activity or investigating something they find interesting. Anything from soap bubbles to toys can engage the interest of a child, revealing to the world and your lens the imagination and excitement within (see Figure 2.47). The great thing about shooting these pictures digitally is that you will immediately know if you got the picture you want or one that's a few moments off from perfect. So informed, you will proceed to get better and better pictures.

When taking pictures of children, it is a good idea to use the telephoto setting of your zoom lens to make yourself less obtrusive. If you supply a child with toys or interesting objects, you can hold back and get great shots without the child being aware of your activities (see Figure 2.48). Practicing this technique now will result in a readiness to take advantage of these priceless photo opportunities while on vacation, at the beach, or simply in day-to-day life.

Figure 2.47

This infant's rapt attention to the spray of bubbles has left him oblivious to the world around.

Figure 2.48

Two-year-old Quinn Braun is absorbed with the siren on this antique fire engine. Photo taken with an Olympus D-600L.

Cars, Trucks, and Other Vehicles

Most of the time you photograph cars you will be outside, so this chapter is written for shooting cars outdoors. When you do have an opportunity to shoot cars inside, as you would at a car show or an automobile museum, most of the material in the chapter will still apply. When indoors, also keep the points made in this afternoon's "Shooting Still Life" and possibly "Taking Pictures through Glass" in mind. Whether indoors or out, the suggestions in the "Shooting Metals and Reflective Objects" section scheduled for the end of the afternoon will be useful when you're taking automobile pictures.

How Will You Use It?

If you are one of the many people in love with your automobile, or at least some automobile, then it will be obvious to you why you'd want to take digital photographs of cars. In fact, some of the first and most ardent users of consumer digital cameras were car and motorcycle clubs. The twentieth century has been one long love affair with vehicles of one kind or another, and it is only natural that folks want pictures of the things they love.

If you are an automobile enthusiast, digital photography gives you immediate access to your photographs, and more ways to share your pictures than ever before. There are, of course, more mundane reasons that people are using digital photography to take pictures of cars and other vehicles. One of the fastest-growing ways to use digital images of cars is in automotive sales. With the explosion of automobile-related Web sites, using a digital camera has become the preferred method of capturing shots of vehicles for sale. Other uses include insurance investigation, preparation of promotional materials, and travelogues. Whatever the use, there can be little doubt that automobiles and digital cameras go together.

What You'll Need

If you have your favorite vehicle handy, choosing a subject will be easy. Even if you are less enamored of your wheels, if you've got 'em, use 'em for today. The practice you'll get will pay off when taking snaps at a car show or when it comes time to unload your city-limits special for a cooler ride. If you don't have a car at all, try using a friend's or neighbor's. Of course, your subject need not be a car at all. Any vehicle from a bus to a boat will work.

Most vehicles are shiny, so you should consider wearing clothing that's dark and won't show up in reflective areas. Similarly, a short drive may be in order to find a good place to shoot your car. An ugly background can be OK—on Sunday you'll learn how to outline and change backgrounds. But digitally changing what's reflected in chrome or shiny paint can be extremely laborious; it's much easier to just shoot the vehicle somewhere that the reflections will be reasonably nice. A field of grass in slight shade is an excellent choice. As is always the case with digital photography, a little planning can really pay off in better pictures.

TIP
Choosing the perfect setting, perspective, and lighting for shooting a car are all important factors, but don't forget to run your car through a wash if it needs it. Removing dirt with software is about as much fun as removing ugly reflections.

Camera features you are most likely to find useful when taking pictures of cars:

- Exposure compensation
- Spot meter
- Spot focus
- Manual focus or autofocus override
- Fill flash
- Zoom lens
- Magnification of review image display

Digital Photography of Vehicles

The first consideration as you begin to photograph vehicles is the composition of the photograph. By their very nature, vehicles are about motion. One way

to instill a feeling of motion when photographing a stationary vehicle is to compose the picture with negative space in front of the vehicle. A car shot so that the back of the car is near the edge of the photograph, leaving some room to move in front of it, looks like it is going somewhere (see Figure 2.49). You can increase the effect of this composition style by shooting the vehicle from a front angle so that it almost looks like the car is ready to come out of the picture. To increase the effect, try taking your shots from the level of the bumper or maybe mid grille. This height is the equivalent of eye level for a car and can increase the illusion of motion (see Figure 2.50).

One problem when allowing for negative space with a consumer-level digital camera is that you are using a lot of the limited pixel power for something other than your subject. This can lead to the vehicle not appearing as sharp, or reproducing as large, as you would like. One possible solution to this problem is to shoot the car so that it fills the frame of the image, and then shoot a second picture that includes the area in front of the car. If you have a zoom lens, you can do this without moving; take the picture of the car at

Figure 2.49

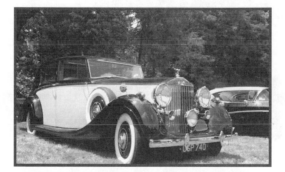

Through use of negative space, this Kodak DC-260 shot of Scott Isquick's 1939 Rolls Royce Wraith looks like the car is driving away.

Figure 2.50

This Toyota Camry was shot with an Olympus D-600L at headlight level to increase the illusion of forward motion.

greater than 1X, then take a second picture without moving at 1X (the widest setting). You will have two images, the first with more information stored about the car and the other with the setting and the car. In Sunday's sessions you will see how to bring these two pictures together.

Now that you've tried the basic view of a car, it is time to get interesting. All cars have interesting features that open exciting possibilities for pictures (see Figure 2.51). The ability to preview your images allows you the freedom to try different things and select what works. The many mirrors and shiny paint on most cars allow you to get multiple views of the vehicle in one shot (see Figure 2.52). Of course, if there are other people around while you're shooting you may have to wait awhile before you can get reflections free of interference. If you think you are getting some interesting reflections, you can always apply the multiple picture technique suggested in the previous paragraph as a way to store more information for a given portion of an image.

Figure 2.51

This somewhat different view of Charles Ackerman's 1963 Morgan can increase viewer interest. Shot with an Olympus D-600L.

Figure 2.52

This Kodak DC-260 shot makes the most of the car's many reflective surfaces. Views of the engine are displayed in the side mirror and the inside of the hood cover, while the front bumper reflects blue sky.

Car Trouble

The neat effects that mirrors and shiny paint can offer have their downsides. Reflections and glare can be a problem, particularly if what you really want is just a simple shot of a vehicle. For digital photographers, bright sunlight, chrome, and glare are far worse problems than for those who shoot with film. (See Saturday Afternoon's "Shooting Metals and Reflective Objects.")

Shiny objects with a great deal of glare can confuse some autofocus systems. If you have difficulty focusing on a car in bright light, try using your camera's manual focus or autofocus override mode. If your camera has a spot focus setting, that's even better. Spot focus allows you to pinpoint the exact place on the car where the camera should focus. If your camera's preview LCD has the ability to magnify review images, be sure to use it. The subtleties of reflection, glare, and focus can result in poor pictures that look OK at the size of most camera's LCD displays.

To use spot focus, choose a nonreflective, or at least little-reflective, spot on the car and center the camera's viewfinder there. If your camera is like most autofocus systems, when you partially depress the shutter button the camera will focus on the spot you've selected but will not take a picture. Keeping the shutter release button partially depressed, you can recompose the shot without losing focus. When you have the composition you want, just press the shutter release button the rest of the way and you capture the image—neatly beating the problem created for autofocus systems by glare and reflection.

Using Exposure Compensation

Long before the advent of digital photography, it was generally observed that many people prefer pictures that are slightly underexposed. In this section you will learn how to use your camera's exposure compensation feature to get better photos and to help overcome the tendency of many digital cameras to overexposure. See this afternoon's section "Shooting Still Life" for an overview of the primary elements of photographic exposure. After trying the exposure compensation technique, many digital photographers like the results so much that they permanently set their cameras to underexpose pictures.

> **NOTE**
>
> It is possible for a digital picture to contain all the information necessary to look good, even if it looks not so good in its raw form. As a general rule, overexposed pictures, or those that appear too bright, will contain less image information than those that look too dark. Of course, a solid black image has no more information than a solid white one; this rule only applies to images that are just a bit darker than what you would like.

A common practice in all photography is something called *exposure bracketing.* This is taking pictures at various exposure levels to increase the odds that at least one frame has good exposure. To take an exposure bracketing series, begin by consulting your camera guide to determine how to set exposure compensation. This is usually symbolized on cameras as EV (Exposure Value) +/−. To underexpose, choose (−). Take a series of photographs starting from EV 0, or normal (see Figure 2.53), to as low as your camera will allow, typically −2 or −3 (see Figure 2.54). If your camera has a spot meter, use it like the spot focus to select a point on your car as the reference point for the exposure. When you have completed the bracket series, you will probably find that you like the EV −1 or so setting best (see Figure 2.55).

Of course, if you were shooting conventionally, you would not know what looked best until you got your film back, so you would have to run the same bracket series for every picture to make sure you got the shot you wanted. Shooting digitally, you can delete all the images you don't like and just keep shooting at the preferred setting.

An advantage to using exposure compensation is that it may allow you to use flash while shooting your car. If your camera has a fill flash setting, you might find that it helps to reduce the shadow areas that are often present on the lower

Figure 2.53

A bright shot of the Morgan at EV 0, or normal exposure.

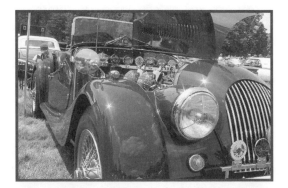

Figure 2.54

The same perspective as Figure 2.53, but at the Kodak DC-260's extreme of EV –2.

Figure 2.55

A third shot of the Morgan, at EV –1. Notice the nice balance of reflection and chrome highlight.

Figure 2.56

In this photo of the Morgan, the Kodak DC-260's fill flash mode was combined with an exposure compensation setting of EV –1.5.

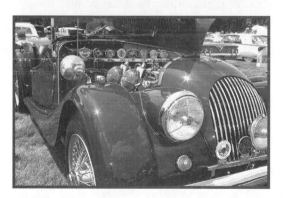

portions of vehicles, even in bright sunlight (see Figure 2.56). If you use your flash under normal exposure, you will probably get so much glare that the picture is worthless. Depending on the characteristics of your camera model and how prone it is to problems with glare and reflection, you might be able to use fill flash at EV –1 or –2 and get better pictures.

See What You've Got

You may have noticed that several of the exercises mentioned information to come. If you were too busy with the task at hand to skip ahead, don't worry. Things are probably starting to come together for you—and by the time you've completed Saturday Afternoon's session, you'll be a digital photo champ. Now is an excellent time to review what you've learned, especially if some of the instructions seemed a bit confusing. Sometimes, after you've actually done a thing, it's easier to understand how you should have done it.

Now is a great time to reflect on the gear you've used, and what you might have used if you'd had it along. As time passes, the things that irked you will fade from your memory, so the best time to learn from your mistakes is now. This weekend is about learning, so the more mistakes you make and figure out how to correct now, the better off you'll be in the long run. The really cool thing is, with digital photographs one hit of the delete button and your mistakes are gone forever, leaving no witnesses other than yourself.

If you have not been deleting shots as you go along, now is also a great time to discard some losers. You may not have confidence in your ability to tell the merely OK photos from the great ones using just your camera's LCD, but it's a pretty safe bet those images that appear all white or all black are goners. Delete those suckers with impunity—they're just taking up valuable media space that you'll need this afternoon.

Sunday morning is devoted to issues like moving images from your camera to your computer, and if you feel more comfortable waiting until then that's just fine. But if you are already familiar with the process, go ahead—that will save even more media space than just deleting the losers. If you do transfer the shots, be sure to use your camera's AC adapter to conserve its batteries during transfer.

TIP Use your rig's picture information utility to make a note of the data recorded for each shot (see Figure 2.57). Not all the information listed will make sense right away, but as you learn more about your camera and digital photography you will be able to make use of the data. Once you copy the picture files and delete them from your camera, you'll no longer have access to this information.

Figure 2.57

The image
information screens
from the Kodak
DC-260 TWAIN
acquire driver (top)
and the Olympus
D-600L image
import software
(bottom).

What's Next

OK, it's time to relax for a bit and take a much-deserved break. Kick up your feet and cool your toes if it's summer, thaw your mitts if winter. At ease, smoke 'em if you've got 'em. You'll be back at it in no time, so take this opportunity to have some lunch and recharge your wetware batteries a bit. Speaking of recharging, now is also a great time to swap out your camera's rechargeable batteries for a fresh set and recharge the ones currently in your camera. Dead batteries are the bane of the digital photographer.

When you're ready to go, there's a whole afternoon of indoor photography waiting for you.

Starting to Shoot Inside

- ✦ People, Building Interiors, and Architectural Appointments
- ✦ Shooting Still Life
- ✦ Action and Motion as Subjects
- ✦ Taking Pictures through Glass
- ✦ Shooting Metals and Reflective Objects

Now that you have spent half a day as a digital photographer, you are probably already comfortable with your camera and how it works. If you are an avid conventional photographer, you may have even seen some things about shooting digitally that surprised you. While the conventional photographer does have a few things to unlearn to become an effective digital shooter, ultimately the skills and attributes that lead to good photographs are the same for both mediums.

You will often have a wider array of tools available to help you get good pictures indoors than when you are outside. Whenever possible, you should use the AC adapter for your camera to improve response time and flash recycle, and to save batteries. If your camera has a *tethered shooting mode*—that is, the ability to take pictures when connected to a computer—indoor shooting is a great time to try that out, too.

As with all digital photography, shooting indoors can require a bit more planning than with conventional gear. You will need to take some care picking your shots and think about the planned use for your images. At the same time, you will have some advantages—at least when you're at your home or office—because limits on your media and file storage might not restrict you; you can always dump your images and go right back for more. Shooting away from your base will have ingredients of planning similar to outdoor sessions—in fact, if you plan on doing any indoor shooting away from home, now might be a good time to pick up the stuff you realized you forgot when you went outside this morning (see Figure 3.1).

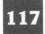

Figure 3.1

Now that you're using *Learn Digital Photography In a Weekend,* you'll be recognizing this guy all around you in the form of other digital photographers.

Control Freaks, Apply Here

One of the best parts about shooting indoors is the level of photographic control you'll enjoy compared to outdoor shooting. You will have more lighting options—and the ability to choose among them at will. For example, if it is a sunny day outside you can compensate for the sun, but there is nothing you can do to actually change the lighting. Indoors, you can often choose exactly what light and how much will illuminate your subject.

You will also have greater freedom to select your shots and arrange your subject when indoors. Usually, your primary limiting factor will be the size and dimensions of the indoor space itself—nearly everything else can be moved. Furthermore, because rooms don't tend to change much, if you know where and what you'll be shooting, you can always plan ahead. For example, if you're going to be shooting an indoor volleyball game, you can bring extra lights, cover parts of the background, and pick out the best angles for shots based on where you know the light will be best. For an outdoor game, you have to make do with the light and setting available, making quick decisions on the fly based on your photographic knowledge and experience.

Indoor Shots of People

If you are like most people, you probably take more pictures of people than of anything else. And while pictures at the beach or on a family picnic may be great, realistically most of us spend our time indoors so that's where we take

most of our pictures. The good news is that camera manufacturers know this; they make getting good indoor pictures with people as subjects a priority when they design cameras.

What You'll Need

The hardest part about these exercises, as with the ones in "People, Children, and Portraits Outdoors," is that you need someone else along to run through the exercise. You may wish to consider doing this section and the outdoor section together, so that you do not squander the goodwill of your subject. The person can be anyone; the only critical criterion is that you have a genuine *Homo sapiens* as subject.

HOW WILL YOU USE IT?

The ease of sharing digital photographs makes using digital cameras and people shots a terrific combination. You can send pictures of special events in your life across the globe as they happen simply by uploading digital pictures from your camera to a Web site or attaching them to an e-mail. This great advantage allows people who could not otherwise participate to become a part of weddings, graduation ceremonies, recitals, and other significant events.

Digital pictures of people are not just snapshots for use in photo albums. Photos of people get used for purposes as diverse as newsletters, press releases, and works of fine art. And there are even more novel uses—for example, barbershops and beauty salons are beginning to take advantage of indoor digital photography. These businesses have seen a decrease in stylist loyalty, with more customers scheduling with the stylist who happens to be available rather than the one who last did their hair. This tendency has led to some frustrated customers when stylist B is unable to replicate stylist A's haircut. As a solution to this problem, shops are using digital cameras to store client styles in a database. When the customer returns for another cut, any stylist is able to retrieve the previous cut as a reference.

A room with strong, indirect light is probably best for this exercise. If the room you plan on using has direct sunlight through the windows, you should consider hanging a light cloth over the window to prevent extreme overexposure of your pictures. This is a simple solution to a problem that ruins many indoor pictures, both digital and conventional.

TIP

Considering the simplicity of the solution, it is surprising that more people do not carry a couple of old gauze curtains when they plan to photograph parties and other indoor special events. Get better photos by planning ahead and using this technique at your next party or gathering.

If your subject is a child—or anyone whose height is greatly different from your own—make sure that you have a way to get to eye level. Children's expressions and facial features are wonderful when you can catch them straight on (see Figure 3.2). Similarly, if you are taking shots of a tall person you will need to give yourself a rise, or at least provide a chair or something to bring your subject to your level. Unless, of course, it is your goal to capture stunning images of nose hair. . . .

Digital shots of people indoors can require as much planning as those outdoors. As is always the case with digital photography, you will have to make the most of your shots. As you have already seen, the slow image cycle time common to digital cameras can be a great disadvantage when taking pictures of people outdoors. Although people indoors tend to move about less than when they are outdoors, you will find that people are actually in motion most of the time. Besides, many of the most memorable life events happen quickly

Figure 3.2

Caught in the act! Pictures like this of children have to be shot from the child's perspective. Photo taken with a Kodak DC-260.

and involve motion as well as emotion. You may be tempted to lower the resolution of your images to decrease image cycle time, but if you do you will undoubtedly be disappointed with the final results.

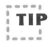

TIP If you're hoping to capture your one-year-old's first steps, use a video camera or a conventional 35mm camera with a fresh roll of film and a very fast continuous shooting mode—the current consumer-level digital cameras aren't up to the job.

Camera features you are most likely to find useful when taking pictures of people indoors:

- ✿ Exposure compensation
- ✿ Spot meter
- ✿ Fill flash
- ✿ Zoom lens

Digital Photography of People Indoors

When starting to take pictures of people, the first thing to consider is how to compose, or frame, the subject and surroundings. Pictures of people are generally about faces, and faces look at things and so can be said to have *direction*. It is the direction of your subject's face that will form the basis of your composition today.

In many of the best and most interesting photographs of people, the subject is not looking at the camera. Start by taking pictures of your subject near a window with the light illuminating your subject's face. Compose the picture so that the subject is looking away from the camera at an angle (as in Figure 3.3). Shoot with the camera at about the eye level of your subject. Try taking the same picture with and without flash. If your camera has a fill flash mode, try that, too.

Take more pictures of your subject looking in a variety of directions relative to the camera. As you shoot, notice the space in front of your subject's face. The more your subject looks away from the camera, the more of this negative space you need in front of your subject to create a pleasing picture. Practice moving while your subject moves so that you maintain a desirable composition at all times. In candid settings, this practice will pay off.

You may find that your subject's face looks washed out, or *overexposed,* even when shot without a flash (see Figure 3.4). This is a problem common to all point-and-shoot cameras that attempt to balance light and dark areas when shooting. The light from the nearby window is probably nearly as bright as outdoors, so your indoor subject will have bright areas and dark areas. The averaging method your camera's exposure system uses may result in bright areas that are too bright and dark areas that are too dark—and it may black out your subject entirely (see Figure 3.5).

To solve the exposure problem, try using your camera's exposure compensation setting at EV –1.5 or –2 to darken your subject's too-bright face. If your camera has a spot meter, use it to meter off your subject's face for better exposure (see Figure 3.6). For a summary of using exposure compensation and spot metering, reread this morning's "Cars, Trucks, and Other Vehicles" section.

Figure 3.3

This Kodak DC-260 picture uses natural light from a large window. Katie Murdoch is in a natural pose; absorbed in her book, she seems unaware of the camera and of being photographed.

Figure 3.4

In this picture the light from the window is washing over Katie's head and shoulders, resulting in overexposure, sometimes considered an aesthetically desirable effect.

Figure 3.5

In this shot, the camera's exposure system has tried to properly expose the bright outdoors, leaving Katie in the photographic dark. This image is too far gone even for digital rescue work.

Figure 3.6

This nicely exposed photograph is the result of spot metering off Katie's face and blocking off the worst of the sunlight with gauze.

When you preview these pictures, you will get an idea of what makes a simple yet interesting shot of a person. Although you may never be a portrait photographer, learn what works in the contrived setting of this exercise. With this experience, you will automatically move and adjust your composition when taking candid shots, getting better pictures as a result. Of course, understanding how your camera works under similar conditions will make the most of your model's capabilities.

So Close and Yet So Far

One of the classic problems with getting nice shots of people is that people know you're there taking pictures, and this can make them self-conscious and cause them to behave unnaturally. This problem is far worse indoors than outdoors, because the limited space makes it far more obvious to your subject

what you are doing. Your best approach to getting natural shots is to use the telephoto, or zoom, setting of your camera to get more working distance to better compose the shot and to make your subject more comfortable.

Telephoto shots of people have long been preferred, even for formal portraits. The aspect of a face when shot using telephoto tends to be more pleasing, with protruding elements like the nose and ears becoming less obtrusive. Of course, as a digital photographer, this advantage and the ability to get working distance from your subject are both bonuses when compared to simply making the most of your pixels. When you use the zoom lens on your camera, you fill your image with valuable information about your subject rather than about the room's wallpaper.

Take several pictures of your subject using your camera at its longest zoom setting. Make sure your flash has enough reach to properly illuminate your subject. Many small on-camera flashes are not an adequate match to the lens, and it might not be possible for you to get adequate exposure of your subject from a reasonable distance in a dark room. Of course, now is the time to discover this limitation, rather then when it really counts.

If your subject is comfortable and able to act naturally, try making conversation while you shoot from a distance. Take as many pictures as possible like this, and without trying to pick your shots. The result will be a series of natural expressions that can run the gamut of emotions (see Figure 3.7). It is the ability to get such expressions in candid settings that make using telephoto such a powerful tool when taking indoor photographs of people.

Get the Red Out!

Everyone has seen it: a portrait of a cherubic child ruined by glowing, blood-red pupils. Red eye in flash pictures of people has been around for years, as have conventional methods of dealing with it. The great news for the digital photographers is that you have all of the conventional means at your disposal (although you probably won't want to use many of them), plus a new set of software tools as part of your digital toolbox.

The first step in dealing with red eye is understanding its cause. When light from your camera's flash enters your subject's eyes, it reflects off the highly vascularized (that's full of blood vessels to most folks) retina of the eye, making the pupil appear quite literally blood red. This effect is at its worst when the lens of the camera and the flash are very close together, as is the case with

Figure 3.7

These images of Katie conversing were almost all shot within moments of one another using a Kodak DC-260.

compact point-and shoot cameras like consumer-level digital units. The more direct the view of the subject into the lens, the greater the problem. Also, the darker the room, the larger the subject's pupils and the stronger the flash output—both factors that add to red-eye problems.

The most obvious solution to avoid red eye, not using a flash, is unfortunately less viable an option when the room is darkest and the problem most likely to occur. If your camera supports off-camera flash sync, using it to place the flash farther away from the lens might be an option; but this solution really makes photography much more complicated, and so is probably not viable for most snapshot situations—exactly the ones where red eye is likeliest to be a major problem. Perhaps the best way to eliminate red eye is to take a picture where the subject is not looking directly at the camera; unfortunately, this is not always possible when folks are hamming it up for a photo.

The best solution available to conventional photographers is something called red-eye reduction flash mode. This is an optional flash mode that fires several mini flash bursts prior to taking the actual picture. The mini bursts cause the subject's pupils to contract, thereby reducing the reflection from the retina. Most point-and-shoot digital cameras also have this option, and it can work quite well to reduce red eye under certain conditions.

There are two major problems that face all photographers when shooting using red-eye reduction flash. When you have them posed for a shot, people will often mistake the initial mini flashes for the actual picture, and so break pose and begin to move right when the shutter snaps (this can be the source of some interesting candid shots). Second, if you have your camera set to red-eye reduction mode, there is always a substantial delay between depressing the shutter button and taking the picture due to the time it takes the initial flash bursts to fire; these delays can lead to many missed photo opportunities.

As a digital photographer, you already have to deal with unavoidable delays between shots, so adding to the delay by using red-eye reduction mode may seem like too much of a burden. Probably more important is the added drain on your valuable and limited battery time created by adding extra flash bursts to your shooting. If you are shooting under conditions where red eye is likely to occur, you are probably making heavy use of the flash as it is; this is the worst possible time to shorten battery life.

TIP If your camera has a red-eye reduction flash mode, don't use it. The negatives associated with this mode are significant, and anyway it won't always work. The good news is that you'll be able to use software to fix red-eye problems in your images after the fact and without negatives.

Fortunately for you, the digital photographer can handily remove red eye using software. To compare the conventional hardware method of red-eye reduction flash and the software method you'll use Sunday, get some sample pictures of your subject today with red-eye reduction on and off. You may need to go to a dark room, or even a closet, to be sure to force red eye in the shot without red-eye reduction flash. Have the subject look right into the camera to exaggerate the effect (see Figure 3.8).

Getting Children Involved

A common trick in photographing kids is to give them some task or game that distracts them from the presence of the camera and elicits spontaneous emotion and expression. What is unique to digital photography is that the act of taking pictures itself can serve as this distracting element.

Children love digital cameras. The immediacy of being able to view a picture off the back of the camera excites and intrigues most children. You can use this excitement and desire to get great digital shots of your kids—and start your children off on a photography hobby that can enrich their lives for years to come.

A great digital photography game to play with children is to take turns taking pictures of one another. The excitement of seeing the pictures can allow you to get good shots of the child, and you might possibly get one or two fun shots of yourself in the bargain (see Figure 3.9). It certainly can impress grandparents to be given a picture taken by their young grandchild.

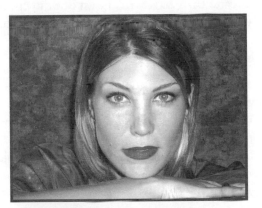

Figure 3.8

As Katie gazes directly into the camera's lens, the red is sure to follow.

Figure 3.9

At two, Quinn is already enamoured with digital photography. He snapped this image of Katie using the simple-to-use Fuji DX-9.

Building Interiors & Architectural Appointments

A favorite photographic subject for travelers is the buildings and structures they have visited. At times, whether you grab a shot indoors or outside may be a simple matter of chance; at others you may have a specific interest in features of a building's interior. Whatever prompts you to take a shot indoors, you will find that the photographic exercise is entirely unlike shooting the exterior of structures.

What You'll Need

The essential ingredient for this exercise is an interior space, preferably one with dimensions greater than 20 feet in at least one direction. This space could be a room in your home or in any convenient public building. Of course, if you already have a favorite spot that you'd like to catch in some digital photographs, then finding a place will be easy.

The ideal space to use for this exercise has a variety of appointments, wall hangings, sculptures, or other interesting interior features. For today's practice, these features could be almost anything, but the closer you can come to your own long-term interests, the better. When evaluating the suitability of the feature you intend to use, make sure that it is similar to subjects like gargoyles, plaques, plaster ornamentation, or other items you might actually one day want to photograph.

The more variable the light in the room, the better. Alternating areas of dark and light will help you learn how your equipment functions under these challenging conditions. Lamps and windows of various types and sizes, preferably over which you have control, can be an ideal way to challenge yourself and to try some of the tips mentioned in this exercise.

Camera features you are most likely to find useful when shooting building interiors:

- Wide-angle zoom or lens adapter
- Telephoto zoom or lens adapter
- External flash
- Manual focus or autofocus override
- Spot meter
- Manual white balance

Digital Photography of Building Interiors

When shooting building interiors, try to compose pictures that are in some way a little bit different from the expected. Interiors that are photographed at eye level in what is called the normal view (neither wide nor telephoto) end up appearing flat and uninteresting. Even the most intriguing interiors are made up of too many ordinary objects for the simple documentary approach to work well. Of course, you may well have a professional reason to attempt to document the appearance as faithfully as possible—as an insurance adjuster or an interior designer, for example (see Figure 3.10).

If you want interesting photographs rather than simple records of the interior, try shooting from very low or very high. Varying the camera height from eye level can create viewer interest and perhaps reveal surprising elements of a structure. Use the wide-angle setting of your zoom lens, or a wide-angle lens adapter if you have one, to really open up the space. This approach often successfully captures a feeling of size and majesty in buildings (see Figure 3.11).

Figure 3.10

This interior shot is simple and has a nice feel, but lacks anything to give it strong photographic interest. Digital photograph shot with an Olympus D-600L.

Figure 3.11

This wide-angle interior shot uses a skewed below-eye-level perspective to add interest to this photo, which was taken with an Olympus D-600L.

Getting up close in shots of building details is another essential part of shooting interiors (see Figure 3.12). Take a picture of a detail close up at wide angle, filling the image space with the subject, and then take a similar photo from farther away using telephoto. Comparing these images will demonstrate the subtle and interesting ways you can get very different images of the same subject (see Figure 3.13).

People can add interest to building interior photographs, not as subjects but as accents to the building as subject. Because people change more rapidly than buildings do, they can serve to add interest by contrast. For example, a photograph of a lone Elvis impersonator kneeling in the third row of an ancient

Figure 3.12

Close up of a fresco detail in the Allen Theatre, Cleveland, Ohio. The subject, angle, and lighting all add interest to this Olympus D-600L digital photograph.

Figure 3.13

A comparison of using wide (left) and telephoto (right) views of the same subject. The telephoto shot appears relatively flat, while the wide-angle view exaggerates roundness.

cathedral is more intriguing than a shot of just the cathedral interior itself. And if you're not lucky enough to hit on that sort of contrast, any human presence will make a pictured room more interesting. As a general rule, people used to enhance photographs in this way should occupy a relatively small percentage of the image (see Figure 3.14). As a digital photographer, you have the great advantage of being able to appreciate these effects as they are shot. You also have the opportunity to decide what is interesting—and what is merely different.

How Far a Flash

Most on-camera flash units are designed to be used at relatively modest distances, perhaps 10 to 15 feet, and under lighting conditions no darker than is

comfortable for people to interact with one another. This design philosophy results in units that are compact, lightweight, and fairly easy on their batteries. Unfortunately, these units are not capable of lighting large indoor spaces for photographs.

There are two ways to judge the limit of your camera's flash. The first is to check your manual, to see what the manufacturer claims as the power output of the flash. For digital cameras, this may just be expressed in feet. This is fine, as long as you do not wish to use your camera's manual exposure features and you aren't shooting in a very dark setting.

Probably the best way to learn the limits of your on-camera flash is to simply start shooting in a large area and see where the light drops off (see Figure 3.15). Because every area will have different levels of ambient light, no two occasions will give you identical results from a given setting; however, experimenting a bit now will give you a feel for how your camera functions and the limits of the flash.

When the area you wish to shoot is larger than your flash will illuminate, you have a few options. The first thing to try is shooting with your flash turned off. In very dark settings your autofocus might not function, so you may need to use manual focus or the autofocus override feature of your camera. You will probably need a sturdy base on which to rest the camera, as you may not be able to hand-hold the unit with sufficient stability.

TIP

If your camera has a spot meter, you can improve the way your picture turns out by pointing the spot meter at the darkest area of the room. If this still gives you areas that are overexposed, try taking three pictures, spot metering off a very light, a moderate, and a dark area. On Sunday when you learn how to use image-editing software, you might find that your images combine into an interesting and appealing result.

If your camera has an external flash sync, adding flash units to your rig is a way to get more light in the room for better illumination. This can be a very useful approach, particularly because most external flash units are substantially more powerful than the typical on-camera flash. Even if your camera does not have an external flash attachment, small mini-slave flashes can be strategically placed throughout the room to great benefit.

Figure 3.14

This digital image of the Allen Theatre rotunda reconstruction features one of the authors to give a sense of scale and interest to what otherwise would be a fairly flat, empty photograph.

The Color of Light

As a consequence of the limited reach of your camera's flash, many pictures of interiors you take may be lit by multiple sources of light. This is usually OK if the sources are of similar type, but can create color problems if they are different. For example, a room lit by a row of windows might have varying light and dark areas, but all the light is still from the sun and so of the same type. A room with a window at one end and a large incandescent lamp at the other has light of two different types (see Figure 3.16).

Your interior close-ups will often include light from assorted sources, particularly if you use a spotlight or accent lighting to bring out the detail in your subject. So what's the big deal about different sources of light? Well, other than sunlight, every type of light has a color associated with it, and this color can

Figure 3.15

If your camera's flash is not powerful enough to reach your subject material, you can end up with interior building photographs that appear indistinguishable from outdoor nighttime pictures.

affect your pictures. For example, standard incandescent bulbs give *warm* light—that is, they cast light with a slight yellow/red hue. Most fluorescent lights tend to be green, although there are different types of fluorescent lights with different color characteristics. Camera flash units are more or less equivalent to daylight. Most consumer digital cameras have a white balance feature that compensates for the color effects of light, but this only works when all the light is of the same color. When multiple colors of light are present simultaneously, the different colors will show in your pictures.

The best way to deal with light of different colors is to try to avoid them, or to minimize their effects by moving around so that one of the sources of light predominates. If you can make one of the sources dominant, the white balance of your camera will correct for it, and hopefully the effect of the secondary source will be minimal (see Figure 3.17).

Sometimes you can use the color of light for effect. In conventional photography, this is a simple matter of using film balanced for a type of light other than what predominates. If your camera offers a manual white balance feature, you can mimic this effect by setting the white balance of your camera to a type of light other than that of the dominant light (see Table 3.1). As you can see from the table, when you shoot a pure white card under a pure light source with the appropriate white balance, you do not get white, but gray. In most practical shooting situations you will not face this dilemma. This morning's "Landscapes and Scenery" section introduced you to the notion of 18% gray, and this is the effect in action here.

TABLE 3.1 WHITE BALANCE AND THE KODAK DC-260					
Light	**White Balance Setting**				
	Auto	Daylight	Tungsten	Fluorescent	Off
Daylight	Gray	Gray	Blue	Blue-Purple	Gray
Tungsten	Gray	Red-Yellow	Gray	Red	Red-Yellow
Fluorescent	Gray	Green	Blue-Green	Gray	Green

Figure 3.16

This photograph features daylight from the left foreground. Secondary lighting from tungsten work lights and fluorescent hanging strips complicate the overall light balance.

Figure 3.17

The lobby wall of Akron's Quaker Square Hilton had an almost even match of tungsten directly overhead and daylight from the upper right. A powerful Nikon SB-25 off-camera flash synched to the Kodak DC-260 was able to dominate the image, giving an overall flash/daylight color.

Something to Try

If you are interested in exploring the effects of white balance, try making a version of Table 3.1 for your camera. You can then use your table as a guide to experimenting with the color of light. For example, when you use the tungsten white balance setting to shoot a room with sunlight predominant but tungsten accent lights on a painting hanging on the wall, the painting will look normal, but the rest of the room will have an eerie blue cast to it. What happens when you shoot the same room using the fluorescent white balance setting?

Shooting Still Life

Still life is the broadest photographic category of all. In this section you will learn tips for shooting small objects of all kinds in a variety of ways. As a digital photographer you will find great advantages to the flexibility afforded you by your digital camera, and you will have a chance to push your camera beyond what you ever thought it could do.

You might be an auto-all-the-way shooter under other circumstances, but now is the time to find out what all those seldom-used features can do. Whatever you decide to use as a sample subject won't run away and isn't going to do something precious in a fleeting moment, so you don't have to worry about making mistakes and losing a photo opportunity forever. Once you gain confidence in your abilities by exploring your camera, you might even decide to improve your pictures by using some of these features in settings that are more candid.

Understanding Exposure

The more you know about what's going on as you shoot, the more you can take advantage of the flexibility and creative control still life photography allows. And once you get used to applying these concepts in the controlled still life setting, you will probably find yourself taking advantage of them every time you shoot—so it's worth spending some time on the basics before you jump in and start shooting your still life.

All photography is essentially about controlling light. All cameras have an element, either film in conventional cameras or the sensor in your digital camera, that is highly sensitive to light. They all also have a shutter that opens for a short period of time to allow light to reach the light-sensitive element. When light passes through the lens the sensor is exposed in a certain way for a certain period of time based on the setting of the shutter. The particulars of the way and period of exposure encompass all of shooting.

As you might imagine, not all light sensors have the same sensitivity to light. Film comes in various levels of sensitivity, reflected in its International Standards Organization rating, also known as *ISO* or just *speed*. Conventional cameras can accept a wide range of film speeds, from slow (25–64) to medium fast (400–1000) to extremely fast (1600+) film. Although there are some sacrifices in picture quality, faster film allows the photographer to shoot under a wider range of ambient light.

How Will You Use It?

Digital photography is a powerful tool to enhance your enjoyment of other hobbies and activities. Your pictures can be an excellent aid in instructing others in your methods and techniques—or just showing off your handiwork. Because the photographs are digital, they are ready for use in a diverse array of applications beyond simple prints; newsletters, Web pages, e-mail attachments, and digital enhancement are all just a mouse click away.

Graphic designers and fine artists alike are increasingly using still life digital photography in their daily work. Digital photographs are superior to Polaroids for use in graphic design, layout, and art direction. With today's tight deadlines, digital cameras are invaluable to help speed storyboarding and layout development. They also make great templates for painting, sculpture, and industrial designs. Fine artists even find that digital photographs themselves make excellent elements in larger projects.

Even if you aren't into macramé or model railroading and you only paint with a roller, being able to shoot small objects can pay off. As insurance companies tighten their loss payments, having an accurate record of your valuables can make the difference between receiving proper compensation and being forced into a settlement at a substantial loss. Although a photograph is not a substitute for an expert record such as a jeweler's appraisal, if you read such records carefully you will probably agree that while they may accurately reflect the quality and general value of an item, they would not allow you to identify your ring or locket from among many other similar items. Probably the most popular method of making home records of property these days is with a video camera—but a video camera can have as few as 200 lines of resolution, compared to more than 1,000 for today's megapixel digital camera. Videotape simply won't give you the detail you can get with a digital camera.

The light sensitivity of digital cameras is rated according to the same scale as conventional film. Unfortunately, digital cameras lag behind conventional photography in this area—most digital cameras have a fixed ISO rating, typically between ISO 100 and ISO 140, a speed typical for portrait and snapshot photography.

TIP

Because your digital camera's light sensitivity is fixed, you are more dependent on external light sources to get your shot. If you are accustomed to using fast film when shooting conventionally, you'll find that your digital camera is limited in range and far more prone to blurry pictures during low-light shooting.

The most important element in exposure is the lens (in cool photog circles, *glass*), the vehicle for the light as it travels to your camera's sensor. The quality of your lens is critical; any distortion or irregularities in it can ruin your pictures. It is the lens that determines the aspect of the light as it exposes your sensor. *Aspect* is another word for the coverage of a picture—to recap what you've seen in earlier sessions, this can be normal view (roughly the same as what you see standing at the position of the camera), or wide angle (more than you can see without turning your head), or telephoto (a closer view than you could get from that position with your own eyes). The opening in the lens that allows light to pass through is called the *aperture* of the lens. The aperture is a variably-sized iris that opens and closes to allow more or less light through the lens. The size of the aperture traditionally is referred to as the *f-stop* of the lens, with smaller stops meaning a larger aperture and more light—and thus a *faster* setting.

The final element in the exposure system is the shutter. The *shutter* is essentially a door that quickly opens to allow light onto the sensor. The shutter does not always open for the same length of time, but for a duration, typically expressed in fractions of a second, referred to as *shutter speed*. Shutter speed and aperture size combine to control how much light passes onto the sensor. Good exposure is when these elements are in balance with the light sensitivity of the sensor.

So why all this emphasis on speed? The basic derivation of the term *speed* is the speed of the shutter; it moves faster when there is more light and when the sensor is more sensitive to light. The way to think of speed is to reference the speed of the object that can be shot without producing a blurred image—

what's called *frozen motion*. Shutter speeds of 1/250th of a second or higher are required to freeze people moving quickly—and you need faster speeds than that for quicker subjects. This topic is covered in greater detail in the next section, "Action and Motion as Subjects." Another consideration is the speed of the camera itself. Although you may not often think of it, whenever you hold the camera it is moving slightly as your hand imperceptibly shakes. At shutter speeds slower than 1/30th of a second you probably cannot get sharp shots while hand-holding the camera. This is why tripods are so often used indoors.

So, are you still awake? Good! Believe it or not, you will be using these terms in the exercise to come.

What You'll Need

The list of things to bring along for still life photography is both simple and endless. You should begin with a sample subject that is either of some intrinsic interest to you, such as a hobby item, or something with interesting shape and color. Children's blocks, fruits and vegetables, even a coffee mug can all make suitable subjects for a still life.

A table at about waist height is typically a good stand on which to place your subject. It's a good idea to put the table in the middle of the room so you can get as many views of your subject as possible. The height of the table will allow you easy access to views from above, the sides, and possibly below. If the table itself is interesting, you might want to consider it part of the subject. If it is not so interesting, you should consider draping a plain white cloth over the table to serve as a background.

You will be playing a bit with light and different ways of lighting your subject, so windows in the room are fine. If you have drapes or shades for the windows, even better. The issue with still life is going to be control. This is your chance to shine, to make the subject and all elements of photography perform according to your instructions, so the more control you have over every element, the better.

Other accessories you might find useful are a tripod or other device for holding the camera steady and some small white cards or pieces of paper. You might even want to have a piece of aluminum foil handy. Modeling clay is useful to precisely hold your subject. Of course, if you have any filters, optional lens attachments, or other photo goodies, now is the time to haul them out and play.

Camera features helpful for still life photography:

- Any manual setting, such as focus, shutter speed, exposure or aperture, and flash
- Close focus or macro mode
- Mount for tripod
- External flash sync
- Lens threads for filters

Still Life Photography

Once you have collected your materials and put together a basic setup, it is time to start shooting. Start with the two basic approaches—first hold the camera in one spot while you make changes to lighting and your subject, and then move around with the camera to get different views of a single setup. Once you feel comfortable with each approach, you can begin to make multiple changes simultaneously for greater effect.

Lighting Still Life

Your first attempts at lighting should probably use your on-camera flash. For some subjects, your on-camera flash will be a real asset, but with most you will be too close and all the flash will do is create glare and harsh shadows (see Figure 3.18). If this is the case with your flash, try some of the alternate flash settings to see if you get better results. Many cameras have a fill flash setting that may produce more balanced illumination with the ambient light of the room. Do these shots with your camera on a tripod or otherwise fixed in position so that you can see the effects of lighting changes under the same conditions.

Position the pieces of paper and aluminum foil around the subject, out of view, so that the light from your flash bounces back and fills in the shadows, creating balance and softening glare (see Figure 3.19). The photographer's term for paper and other objects used in this manner is *fill cards*. If you have a white cloth under the subject, it can reflect light back up under the subject and fill in shadows, too. Figuring out how light bounces across these angles is sort of like playing photo-pool, but with a few trials you'll begin to get the hang of it.

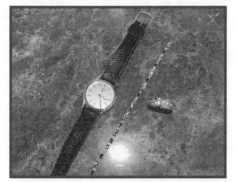

Figure 3.18

Glare from the on-camera flash has ruined this picture. The flash was too close to the subject.

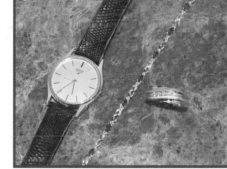

Figure 3.19

On-camera flash set to fill mode bounced off fill cards creates even lighting. Moving the camera and slightly zooming also helps to reduce glare.

One of the most useful ways to light a still life is to use varying degrees of *ambient light*—the light in the room, as opposed to what you get from your flash—to illuminate the subject. Again, fill cards can play an important role in evening out the light to produce a natural effect (see Figure 3.20). The addition of the light from a small clamp-on lamp such as you can purchase from a hardware store can help you fill an ambient light setup without creating the hard shadows of a flash. If you can get close enough to the cards that you can add and remove them with your eye through the viewfinder, you will be amazed at how much difference a few inches of white paper around a subject can make. Try aluminum foil and foil of other colors as a way to fill shadows with different colored light.

If you have an off-camera flash, try setting it up at a 45-degree angle to your camera's lens. Start shooting and move either the camera or the flash around a

few degrees at a time to see the effects of camera-to-flash angle on the illumination of your subject. Try pointing the flash away from the subject, at a fill card in various angles (see Figure 3.21). You may be pleasantly surprised at the effect of adding your on-camera flash in fill flash mode to the illumination of the off-camera flash.

One reason you might find you are unable to use your on-camera flash is that when you compose your shot, the flash is so close to the subject that it overshoots the subject entirely. You can try placing a fill card to bounce the light from your flash back onto the subject, but your best bet is shooting without an on-camera flash. If you don't have an off-camera flash, this will mean shooting your still life strictly with ambient light. Ambient light is fine—it can create some of the most dramatic and pleasing effects—but less light will mean slower shutter speeds and the probability that you will need a tripod or some other support for the camera to avoid giving your pictures the shakes.

Figure 3.20

Notice the soft, even light created with only ambient light and fill cards.

Figure 3.21

This shot was created using the Kodak DC-260 with two off-camera flash units and fill cards. Notice the detail and evenness that can be captured when the subject is well lit.

Thinking Ahead

As a digital photographer, you have an unparalleled opportunity to make the most of a little planning. If you know your intended use for your photograph and what sort of output you will want, you can alter the way you shoot to improve your camera's output. You might even be able to use your camera in a way that exceeds the manufacturer's specifications.

One area that often causes debate in photographic circles, particularly between advocates of digital photography and those conventional stick-in-the-muds who continually say "Not yet" to digital is the issue of size. Most professional photographers will limit the output of 35mm film to about 5×7—they use larger film and special cameras for those gorgeous shots you see framed in galleries. Some top of the line consumer digital cameras can approach 35mm quality in final output at the 5×7 size. But what if you want a high-quality 8×10 print? Or an 11×17? With digital, under certain circumstances, there might be a way.

You will approach the software side to the large-output problem on Sunday. Today, you can prepare by collecting the elements needed to make big digital prints. To prepare for this exercise, you'll need three subjects similar in size and shape, or at least of general type that you will photograph in the same spot, one after the other. Candles, toys, crafts, even clothing will work. If you have difficulty with finding three suitable subjects, try taking three shots of the same object, slightly repositioned. You could always copy a single shot into two new files, but by doing three separate shots you will create a more natural, less cloned look to the pictures.

Getting Close

One element of still life photography is that you will probably be taking close-in shots of small to medium-sized objects. Not only will the close-focusing ability of your camera come into play, but also you might realize that not all of the picture is in focus even when your camera's autofocus seems to be functioning just fine. This is called a depth-of-field problem, and is likely to be more pronounced when you are working without flash. This is when you put all that photo jargon into use.

The lens aperture and the quality of the lens optics determine the depth of field of an image. Remember how a larger aperture is a faster setting because

it lets more light through? Well, that increase in light travels through more of the radius of the curved lens, creating shallower focus. A smaller aperture uses less of the lens, and is thus flatter and has deeper focus. So the trade-off is speed versus focal depth. To make matters worse, your camera's auto exposure system is probably designed for the fastest shutter speed and therefore the largest aperture. This is great when taking pictures at a picnic, but not so great when you really want greater depth of field.

There are essentially two things you can do to solve a depth-of-field issue—either make the most of it or go manual. Of course, if your camera has limited manual options, you'd better figure out how to make the most of it. As a nod to the manually disadvantaged, you can start with ways to exploit limited depth of field.

One of the current trendy ways to shoot in commercial photography is with an extremely shallow depth of field so that almost the entire picture is out of focus. If your camera will not allow you to manually set shutter speed or exposure—congratulations, you're a trendy photographer. While the appeal of this approach is somewhat limited, you will find that by moving the camera back and forth you will be able to control which portions of your subject are in focus for a given shot. This technique allows you to make the most of the limitations of your camera—and you might find an effect that you really like (see Figure 3.22).

If your camera has a manual mode, you can adjust the depth of field by increasing the aperture setting of the camera (see Figure 3.23). Sometimes

Figure 3.22

The shallow depth of field in this model train shot (from an Olympus D-600L) helps make the setting look larger, almost real.

Figure 3.23

Proper use of flash helped bring this Kodak DC-260 shot of a model train layout into sharp focus from front to back.

your camera manufacturer won't come right out and admit that you have this ability, so you may have to poke around a bit to find the feature. For example, the Kodak DC-260 has an external flash sync mode that allows you to manually set the aperture all the way to f-22—even if you don't have an external flash attached to the sync! If you can manually set the aperture of your camera, have fun experimenting. This is the ultimate in photographic control.

Moving Around

The greatest part of shooting a still life is that you can move around—and move your subject around—at will (see Figure 3.24). Take advantage of this complete control to test the limits of your camera. What happens when you compare zooming in real close to actually getting real close? Is there some part, some angle, some perspective, from which you've never considered your subject? Now is the time to try things out. You will be amazed at how useful a different perspective on a common item can be, particularly for high-tech applications like Web site backgrounds or multimedia applications.

Take a Break

Indoor, studio-type shooting is definitely the more refined and civilized form of the art. Have Jeeves prepare high tea while you recuperate from your strenuous day of shooting. Of course, popcorn and a diet soda can work, too, in the unhappy event that today happens to be your manservant's holiday.

Figure 3.24

This montage of shots from the same setup shows how moving the camera to get pictures from different angles can make the same subject look very different.

Action and Motion as Subjects

Action and motion are a part of life—you'll run into them in almost any setting where you might want to take a picture. In some cases you will find yourself applying the techniques in this section out of necessity to deal with subjects that are moving when you wish they'd stand still and let you get a photograph. In other instances, it will be the movement itself that you want to feature in your photograph.

Movement can be used to tell a story, to realize the proverbial potential of a picture to equal a thousand words. In many ways, this use of motion is an extension of the candid photograph. Your subject has just done something, is doing something, or is about to do something interesting and you have caught them in the act. Photographs of motion can therefore be some of the most interesting to many viewers.

> ## How Will You Use It?
>
> Because digital photography is often used to get immediate images for rapid use, it is likely that the digital photographer will face a disproportionate amount of action shooting. The ability to be on the scene at an event, take a digital photograph, and transmit it electronically remains one of the most powerful uses of digital photography. The more exciting and immediate the event, the more desirable it is to get the images quickly, and the more likely that the event will involve action and motion of some type. Examples range from sporting events to scenes of disaster and newsworthy human suffering to real-time shots of a senior prom to the ground-breaking ceremony for the second store of the family business. All these examples involve action, and all involve the once-in-a-lifetime immediacy that simply will not allow waiting for posed prints days after the fact.

You have already seen some of the difficulties facing the digital photographer when trying to capture motion in the section "People, Children, and Portraits Outdoors." In that section, you learned how to prepare a preset shooting zone and wait for the motion to come to you. This idea was an expansion upon the preset focusing area described in "Pets and Other Animals" earlier in this morning's session.

The technique of setting a preset zone for shooting can work well for one type of action, and you should use it as part of your experimenting in this section. However, the preset-zone technique only works well when your subject is behaving predictably and you can plan ahead for your shot (see Figure 3.25). To understand general techniques for capturing motion, you must first get a more in-depth view of how a camera works.

Motion and Exposure

The exercises in "Shooting Still Life" introduced you to the fundamental elements of exposure. To get reliable and predictable results when shooting

Figure 3.25

This shot took a preset focusing zone and the Kodak DC-260's on-camera flash to capture the action. Katie was standing in one place while hitting the ball, and so was an ideal candidate for this method.

motion, you need to understand how the elements of exposure work in conjunction with a moving subject. You can use this information not just to shoot motion but to choose how you wish the motion to appear in the final photograph.

Blurring is the central issue for photography and motion. Anything that causes the subject and camera to move relative to one another can result in blurring, including hand-holding the camera with insufficient steadiness even when the subject is perfectly still. The trick to photographing motion is deciding when action should blur—and when it should freeze. Being able to decide what will blur and what will freeze is part of the photographer's craft (see Figure 3.26).

Figure 3.26

This photograph was taken from the window of a moving car to illustrate the almost surreal potential of showing motion.

It is ultimately the speed of the exposure that determines if an object will appear blurred in a photograph. For many pictures, this relates to shutter speed, but this is not always the case. When the subject is illuminated by flash, it is often the speed of the flash that determines how the subject appears, rather than the speed of the shutter. When the subject is partially illuminated by flash, and partly by ambient light, then the speeds of both the flash and the shutter interact to freeze some movements and blur others (see Figure 3.27).

NOTE

The flash unit on your camera will not be able to freeze all motion all the time. A flash freezes motion by rapidly illuminating the subject for a small fraction of the time the shutter is open. Because the flash-illuminated portion of the image is typically much brighter than what the shutter would capture without flash illumination, it is the flash that determines the true speed of the exposure. That works out fine to freeze motion, except in two instances. First, a flash is not infinitely fast even though it's much faster than most objects, so in the case of extremely fast objects (a hummingbird's wings, for instance), most flash units will not be fast enough to freeze the motion. Second, a flash is not necessarily the brightest light source around even though it's usually brighter than the rest of the environment, so it's possible that in extremely strong light the shutter's exposure setting might essentially overpower the flash.

The goal of this exercise is to learn the limits of your camera, its flash, and other features when taking digital photographs of motion. As you learn more about your camera and grow in your abilities as a photographer, you will find yourself pushing the limits of your equipment and expanding your photographic expectations.

Figure 3.27

In this shot, the fill flash setting of the Kodak DC-260 combines with the bright ambient sunlight to show a dash of motion.

What You'll Need

To learn about capturing motion and how your camera responds to shooting action the requirements are simple. You should try to find situations most like those you will encounter in actual shooting, if you already know you'll be running into motion. Because action and motion can occur in both indoor and outdoor settings, you should consider trying to get action shots both places. If it is not practical for you to shoot outdoors at the moment, you can always read the outdoor notes now and try shooting later.

For indoor motion, if nothing else comes to mind consider using an electric fan or water flowing from a faucet as your subject. Outdoors you have a wide range of options, from a running pet to a street full of traffic. The important element in your choice is to select something that will allow you to concentrate on the motion and the various features of your camera, rather than having to worry about the subject itself.

Camera features you are most likely to find useful when shooting motion:

- Exposure compensation
- Manual shutter or aperture settings
- Manual flash settings
- Wide-angle lens
- External flash sync

Digital Photography of Motion

The flash and shutter speed may determine if the object will be blurred, but only the photographer can decide if it should be blurred. For the shooting portion of this exercise, you should walk through all the pointers, taking as many shots as possible, and notice what does and does not lead to image blur.

As you grow accustomed to looking at shots of motion, you will begin to distinguish between motion in the subject and motion in the background. Many people concentrate on freezing all motion in a picture because a blurred subject with a clear background can often confuse the viewer, detracting from the subject. The simplest solution to this problem is to simply freeze all motion. Unfortunately, this often leads to artificial-seeming, even boring, pictures.

Motion Indoors

One predicament you might face when shooting a moving subject indoors is having difficulty shooting without a flash. Flash photography is great if all you want is a frozen snapshot, but it can ruin some pretty spiffy motion effects (see Figure 3.28). Try shooting your moving subject with and without a flash, assuming you have the ability to control your camera's flash. You might need a tripod or other support aid when shooting without flash to avoid unwanted camera shake and to allow you to shoot from the same spot. If there are things about each image that you like, it might be possible for you to combine the images using software. If you hope to combine the images, be sure to take each shot from exactly the same place.

For some indoor action, it is very desirable to completely freeze the motion of the subject. Indoor gymnastics competitions or diving trials make excellent subjects for flash photography. Although it is possible to get some artistic use of an image with a blurred competitor, you will almost always want completely frozen motion. The problem you face in these settings is that your on-camera flash is probably not strong enough to reach the competitor and freeze the motion.

When your on-camera flash is not powerful enough to freeze the motion at an indoor event, you might be able to improve your results by setting the exposure compensation of your camera to underexpose (see Figure 3.29). Depending on your camera, this might result in a fast enough shutter speed to freeze the action. Of course, if your unit has an external flash sync, adding auxiliary flashes can extend the reach of your camera as far as your budget will allow.

Figure 3.28

In the photo on the left, the flash froze the fan blades and crepe paper in midair. On the right, shot in low ambient light, the slow shutter speed produced an artistic blurring of the motion.

Figure 3.29

The Kodak DC-260's on-camera flash used in conjunction with exposure compensation set to EV –1.5 was able to stop the action of Quinn Braun leaping into the pool.

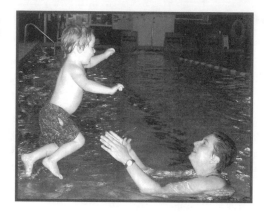

You should note that most mini-slave units are not very powerful, and so may not improve the range of your flash unless you can get them close to the action. Mini-slave flash units are described in "Taking Pictures through Glass," coming up next in this afternoon's session.

 TIP If you're simply not able to use your gear to get the shot you want, consider some alternatives. Sometimes a picture of a competitor on the bench or being chastised by a coach can have as much human interest and drama as an actual action picture. Shots during preparation or cool-down can demonstrate implied action, without the all-out burst of speed exhibited during competition.

Motion Outdoors

In many cases, the problem you will face outdoors when shooting motion is exactly opposite that of indoors. You may well find that your camera will not use its flash, or if it does it will be at such low power relative to the ambient light that it does not stop action. In the case of relatively slow-moving subjects such as joggers, you may like the result. The motion may be mostly frozen, with just a hint of blur to create interest. For faster subjects, you probably won't be satisfied—and it is usually outdoors where you encounter the fastest subjects.

Before you get too wrapped up in freezing motion, take a moment to consider the potential aesthetics of showing at least some of the blurring inherent in movement and action. Blurring can help tell a story and increase the dramatic effect of a photograph (see Figure 3.30). The benefits can be simple, such as

letting the viewer know if a ball was just hit or is about to be hit, or if water is falling down or splashing up. Other elements of showing motion include making the motion itself the subject, transforming ordinary objects into intriguing images.

As when indoors, to get a faster shutter speed in an attempt to freeze motion, you can try using the exposure compensation setting on your camera to deliberately underexpose the shot. You can even try to use a flash, or external flash sync, to freeze motion. For faster subjects, this may not suffice. In fact, there may be external shooting situations where you simply will not be able to freeze the motion.

A creative way to combine blur and stop action is a technique called *panning*. Panning is simple in principle—you just follow the action of your subject with your camera as you shoot the picture—but it's not quite so simple in practice. You can get some idea of what's involved in panning on any street corner near moving traffic. Hold your camera with your left hand under the body and cradling the lens, your right with the index finger on the shutter release button and palm around and under the camera. Twist at the waist and follow your

Figure 3.30

Two very different views of the same falling water. In the upper view it is clear that you are seeing water fall. In the lower view the water has been stopped by flash and it is not obvious if the picture shows a waterfall—or the splash from a thrown rock.

subject all the way to one side. When you have matched speed with the subject, depress the shutter release.

Moving subjects shot while panning will have some blur, primarily at their fastest moving parts, and some stop action. The main advantage of panning, however, is that the motion of the camera will blur the background. This can make subjects that move at even modest speeds appear to move very fast (see Figure 3.31). Try varying the panning technique by forcing fill flash and manually setting your camera's aperture.

You can get an effect similar to panning if you have multiple subjects, one moving and another relatively static. You permit the moving object to blur while keeping the static subject sharp. The still subject will serve to increase the effect of the motion, and the blurring of the moving subject can make the still subject stand out. A bus or elevator that has stopped to disgorge and load passengers could create this effect.

Sometimes moving to a different angle will let you stop, or at least control, motion blur in your photographs. The notion behind changing position to capture motion is based on the fact that objects tend to move in only one dimension at a time. For example, a racecar moving at 200mph might create a blur when shot from the side because it flies by at full speed. Facing the front or the back of the car is different; although the car will change apparent size due to perspective, it is not really moving in that plane, and so it is possible to get sharper shots by shooting from the ends of the object (see Figure 3.32).

While it may be OK to stand in front of some moving objects, many others can be hazardous. Fortunately, you can slow the perception of motion by standing to the side of a moving subject and shooting toward the front without having to actually be immediately in front. This method can have the benefit of showing a modest amount of motion for effect (see Figure 3.33).

Something to Try

If your camera has the settings available, try taking photos of movement at very long exposures. In most cases, this will mean selecting an area with many moving objects as a subject, instead of a moving object itself. A revolving doorway or a city street may work. This evening's session, "Shooting at Night and in Low Light," explores the idea of long exposures in greater depth.

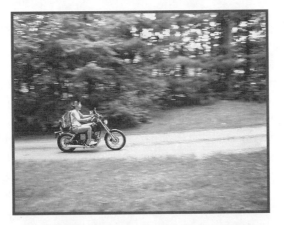

Figure 3.31

Panning with the camera made Katie and her motorcycle appear sharp in this picture while the background blurs with motion.

Figure 3.32

Katie is caught facing the camera mid-turn. Although her motorcycle is moving, it looks still because it is headed right toward the camera.

Figure 3.33

In this shot of Katie and her motorcycle, the angle is sufficiently in front of the action to help reduce blur, but far enough aside so as to not pose risk to life and limb.

Taking Pictures through Glass

Probably one of the most challenging circumstances under which you will ever try to take a photograph is through glass or some other potentially reflective transparent medium. Because so much trial and error is involved, it often takes beginning photographers dozens—if not hundreds—of rolls of costly film to perfect the techniques described in this section. Of course, as a digital photographer, you will be able to evaluate your work on the spot and simply delete your mistakes. By quickly reviewing your progress and immediately applying what you've learned, you will be able to make rapid progress where a conventional photographer would have to wait hours or days between trials (for the film to be processed and returned) to learn what works.

HOW WILL YOU USE IT?

If you have started to wonder "Why bother?" then stop and take a look around. Most of the world, including most of the more interesting things in it, is often on the other side of glass or something similar. While many times the easy way around this situation is to simply go outside and not take your photograph through a window, that can be a bit uncomfortable if it happens to be 10 degrees below zero outside at your birdfeeder, or if you are on the 45th floor of a scenic tower and don't happen to be wearing a parachute. It just so happens that there are often some pretty good reasons for keeping glass between you and your subject!

You may well want to try these techniques while visiting a public aquarium, a museum, or any other place where interesting or valuable things are secured behind glass. The skills you pick up here will also come in handy anytime what you want to photograph is outdoors while you're indoors, or vice versa, and when you're riding in a car or a plane when it's impractical or impossible to open the window. And even when you and your subject are not separated by glass, these exercises will help you deal with other transparent barriers, as when something you want to shoot is wholly or partially immersed in water.

What makes shooting through glass so difficult? Well, sometimes it lets you see through it and acts transparent, and sometimes it doesn't and behaves like a mirror. This might not be so bad, except for the fact that the same piece of glass can behave both ways simultaneously. When glass does this, you will get a picture of what you want, plus a bonus of potentially picture-ruining reflection. It does tend to spoil a wintertime scene of birds feeding on berries in the snow when a reflected view of your living room is superimposed on the image.

The incredible advantages offered by digital photography in learning to shoot through reflective materials should not make you too complacent. There are definitely some tricks involved in getting good shots no matter what kind of camera you use. Plus, it is really important for you to learn how to use your camera's specific features and deal with performance issues associated with your specific model of camera. If you are planning a trip to the local public aquarium, or perhaps an expensive trip to some exotic location with crystal-clear ocean waters, an hour or two of more mundane practice now will save you much frustration later.

What You'll Need

Other than your camera, the most important thing you'll need to complete this exercise is a subject separated from you by glass (to keep things simple, from now on the general term glass will refer to any potentially reflective material through which you wish to take a photograph). If you have a particular setting or application already in mind, then selecting a suitable subject should be easy. If you intend to complete the majority of today's exercises today, of course, it may not be practical for you to make a trip to a zoo, museum, or even a lake to get practice. That's OK, your subject can be as simple as a tree in your yard, shot from inside your house through a window. If you want practice shooting into water, a setting as simple as a child's play pool or a bathtub will work.

Of course, if this is a subject of particular interest to you, you might want to invest more time and go to a zoo or public aquarium. If you do, it is a good idea to call ahead to get their policy on photography and what equipment you may use. Most facilities will allow you to use any equipment other than tripods, but it is always a good idea to check to be sure.

After you've gotten everything else right, one of the most intractable sources of reflection can be the camera itself. Bring along a dark cloth that you can use as a drape when shooting to help eliminate these reflections of the camera. This will be particularly helpful if your camera has a silver or chrome body. You should also wear dark clothing to prevent reflections from the photographer (that would be you).

There are several camera features that you are most likely to find helpful when shooting through glass:

- Single lens reflex (SLR) style camera or a through the lens (TTL) LCD
- On-camera LCD to preview your shots (most new cameras have this)
- Manual focus or autofocus override mode
- An internally focusing and zooming lens
- Close focusing or macro mode (15 inches or less)
- Lens with threads for filters

Shooting through Glass

The ideal scenario for shooting through glass is to place the lens of your camera directly against the glass and take the picture. With your lens against the glass, it is not possible for reflections from the glass to interfere with your picture, and photography becomes virtually the same as when there is no glass at all.

If all you need to do is place the lens against the glass then problem solved, go on to the next section, right? Wrong! It turns out that it is almost never possible to place your lens directly against glass when shooting. Most public places where you will encounter glass do not permit you to touch the glass—and if you are allowed to touch the glass, your camera may not function properly. Perhaps most importantly, when your lens is against the glass, you are very limited in what you can shoot because the camera is held perfectly parallel to

the surface of the glass. You probably do not want to take a picture of just anything on the other side of the glass; you want something specific, and that something might not be visible with your camera held up to the glass.

How Close Can You Go?

You are going to have to experiment with your camera to find out how it functions when shooting close to glass. Start by shooting straight into the glass, with your camera held a few inches from the surface. If you don't already know this, determine if the front of your lens moves as the camera focuses and as you zoom in and out. If the front of the lens does not move, you have what is known as an internally focusing (IF) or internally zooming (IZ) lens. With an IF or IZ lens you do not have to worry about moving your camera as you focus or zoom.

The next consideration is if your camera can focus at all when held close to glass. Some autofocus cameras use systems that will insist on focusing on the glass itself. This might be OK, if the thing you want to shoot is itself very close to the glass. If your camera will not focus on the subject through the glass, you will have to use manual focus or autofocus override mode, if your camera has one. Cameras that will not focus through glass and do not have a manual focus mode probably cannot be used to shoot through glass.

Ideally, your camera will work through glass from about one inch away from the surface. At this distance, you escape many reflection problems about as well as if you were holding the lens directly on the glass—and still have the freedom of movement to get the shot you want. To work at this range, a camera needs to be able to focus properly, and also to give you a reliable view of the subject through the finder.

Unfortunately, when you hold the camera very close the glass, in many cases it is also quite close to the subject. If your camera is not able to close focus, you might not be able to get close to the glass and properly focus on the subject. Similarly, when your camera is close to the subject, small differences between the view in the finder and the actual subject as seen through the lens will make a big difference in the final picture. This difference between finder view and lens view is called *parallax*. Cameras such as the SLR Olympus D-600L that have a TTL view are best for close-in work, because the view you get through the finder is virtually identical to the final picture. When using a

dual lens camera, the photographer sees the subject from a different viewpoint than that of the lens used to take the picture. These cameras exhibit a great deal of parallax when taking close-up pictures (see Figure 3.34). Some dual lens cameras, such as the Kodak DC-260 solve this problem by allowing you to display the view through the lens on the LCD (see Figure 3.35).

Working the Angles

Once you know how close you can get, you'll need to try shooting with the lens held at different angles to the glass. It is quite possible that you will not be able to shoot straight into the glass because your flash will reflect back into the lens and ruin your shot (see Figure 3.36). There are two basic solutions to this problem: shoot without flash, or don't shoot directly into the glass but at an angle. You will work on shooting at an angle now, and cover working without flash next.

Figure 3.34

The effect of parallax. This fish appeared centered in the finder of the Kodak DC-260 used to take the picture, but the difference in lens positions caused it to be off center in the final photograph.

Figure 3.35

Parallax corrected by using the TTL display capabilities of the Kodak DC-260's LCD monitor.

Figure 3.36

Example of shooting straight into glass with flash. The on-camera strobe of the Olympus D-600L is glaring back in the image, spoiling the picture.

Take sample shots through glass at various angles. If your flash is directly above your lens, you will probably find that about 45 degrees works well to illuminate your subject while minimizing flash reflection (see Figure 3.37). It is important to think digitally as you experiment: Your software will let you remove minor reflections that do not directly interfere with your main subject, so you don't have to strive for perfection. Of course, better photography always results in better pictures, but when it is a choice between accepting minor interference and not getting the picture, the digital photographer enjoys much greater latitude than the one shooting with film.

One complication of angling your shots is that other sources of light in the room can send reflections into the lens (see Figure 3.38). This sort of reflection is called *incidental reflection*. The solution to this problem, if the reflection interferes with the picture, is to vary the angle slightly or to move. When shooting through glass, it is a good idea to review your shots often and make sure that your techniques are working. Sometimes a very small change in angle or moving even an inch or two can be enough to escape an interfering reflection.

TIP

A cloth, or even your coat, can be used to cover the camera and the glass to block interfering reflections. Hold the cloth over the camera, with the edges of the cloth against the glass. Your goal is to create a cone of cloth with the camera at the apex, preventing ambient light from ruining your shot. This trick is easiest to accomplish if your camera is on a tripod.

Figure 3.37

Example of shooting through glass at a 45-degree angle with flash. There is no glare from the Olympus D-600L's on-camera strobe.

Figure 3.38

Incidental reflections from the room ruined this Kodak DC-260 shot.

Another factor to consider is the thickness of the glass. All glass will distort your picture in proportion to its thickness, so very thick glass can distort your picture a great deal. When you hold your lens parallel to the glass, the distortion will tend to even out and the effect will probably not be noticeable. However, when shooting at an angle through very thick glass, the light from the subject will have to cross a much greater distance at the outside angle than at the inside, resulting in a great deal of distortion. If you were shooting conventionally this would be a disaster—but as you'll learn on Sunday, the digital photographer can often adjust this distortion using perspective correction.

Lights, Glass, Action

Whenever possible, use your flash when shooting through glass. Your flash will illuminate your subject and help to compensate for whatever irregularities may

exist in the ambient light. If you have a moving subject—say, a fish in an aquarium—the flash will freeze the motion and allow you to get a sharp focus on your subject (see Figure 3.39).

Sometimes you can't use your flash while shooting through glass. Many museums and similar institutions don't permit flash photography; also many living subjects don't like the flash and will leave if you try to use it. If you are shooting through glass into a large body of water, as is often the case at a public aquarium, your flash may not be powerful enough to reach your chosen subject. In this case, your picture will have some areas properly illuminated while others (containing whatever it was that inspired the picture in the first place!) aren't visible at all (see Figure 3.40). Of course, you simply might not be able to get the shot you want without reflective interference from your flash.

Whatever the cause, shooting into glass without flash will result in slower shutter speed and make your pictures even more susceptible to minor sources of reflection from the room. Probably the only way to avoid incidental reflection is to move around to find a better angle. The slower shutter speed can have a greater effect on your pictures; the stop-action effect of the flash is eliminated in this scenario, so you may end up with a blurred image of your subject if it moves. You might be able to manually set the aperture on your camera or even use the exposure compensation options to increase shutter speed and thus stop the action a bit. This is a case where you might initially end up with a

Figure 3.39

The Olympus D-600L's on-camera flash was able to stop the motion of this swiftly swimming shark.

Figure 3.40

The relatively low power of your camera's flash can combine with the light-restricting properties of water to lose the subject of your picture in darkness.

photograph that does not look useable, but as long as there is information in the image the digital photographer has a chance of salvaging the picture. You can refer back to "Action and Motion as Subjects" for more ideas on solving this problem.

Water Wonders and Worries

Taking pictures of a subject immersed either partially or wholly in water is a lot like shooting through glass, but with none of the advantages. For obvious reasons, not only do you not want to hold the lens of your camera directly against the surface of the water, you probably don't want to get your camera anywhere near the water. And if you have to stay away from the surface of the water, most of the tricks you've learned from working with glass are probably not going to work.

Depending on the time of day and your position relative to the sun, water can become a mirror of the world around but not to what lies under the surface. You can think of the sun as a giant flash, and one that you are going to have to find a way to work around because you can't move it. The simplest solution to shooting into water is to be flexible. If you can be flexible about the angle and composition of your shot, move around the body of water as much as you are able to find an angle on your subject that will reduce the surface glare to an acceptable level. If you can be flexible about the way your subject will look, you can accept certain amounts of reflection off the surface as artistic elements of your photograph.

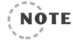

NOTE

If you can't pick the time of day that you shoot, use the techniques in this section to reduce reflections while shooting into water. If you *can* pick the time of day, simply choose a time when reflection isn't a problem for your subject.

If you can't be flexible, you might turn to a circular polarizing filter to solve the glare problem. This filter is like giving sunglasses to your camera. The filter works by cutting out all of the light that's bouncing off in all directions and restricts light entering the lens to a single plane. This restricted light is called polarized light. The polarizing filter cancels out reflections that can turn the surface of water into a mirror (see Figures 3.41 and 3.42). If you wish to use a polarizing filter, your camera lens must have threads to accept a screw-on filter. If you look at the end of your lens and see small threading, like the inside of the lid of a jar, your camera can use a filter. You'll find out more about using filters and dealing with glare in the "Shooting Metals and Reflective Objects" section later this afternoon.

Figure 3.41

Glare and reflections off the water surface interfere with this picture of breeding sunfish.

Figure 3.42

Attaching a polarizing filter to the lens of the Olympus D-600L cut back the glare and surface reflections to allow this view of sunfish nests.

Things to Try

If you are really interested in getting the most out of shooting through glass at places like your local aquarium, you will get the best results with a camera that is able to use an off-camera flash via a flash-sync cord, such as the Kodak DC-120 and DC-260. If your camera does not have this capability, you may be able to get some of the same effects by purchasing a small flash unit that triggers optically when your camera's flash fires—called a *mini-slave flash*. Either way, with some experimentation you will probably find that an off-camera flash is the way to get the best pictures with the most shooting flexibility.

As a starting point for using off-camera flash, hold your camera with the lens parallel to the glass and the flash off to one side at a 45-degree angle to the glass. What you're doing is separating the camera angle necessary to get a good picture from the flash angle necessary to keep the flash out of the picture. You will be able to find a pretty consistent flash-to-camera angle that will reproducibly keep the flash out of the image while providing good subject illumination. In fact, in the case of fish swimming parallel to the glass, this method allows you to get pictures of fish illuminated from the front while maintaining the advantages of holding the camera close to the glass with none of the incidental reflections that you often get when you hold the camera itself at an angle to the glass.

Shooting Metals and Reflective Objects

Whether you're a conventional or a digital photographer, reflective surfaces can make it harder to light your subject properly, and they can introduce unwanted bonus images as reflections in your main photograph. Of course, challenges like these can also be a means for creative expression. The fundamental issue addressed by this section does not relate to the general issue of reflectivity, however, but to the specific challenge posed for the digital photographer by metallic and reflective surfaces. You are about to be introduced to an issue with digital cameras that is probably entirely new to you, *CCD bloom*.

Blooming is a topic that the salesperson who sold you your camera was probably not inclined to mention—in fact, it is doubtful if many salespeople have ever heard of it. If you have read other popular books on digital photography,

the subject was probably either ignored or glossed over. A quick search of several popular computer magazines' Web sites failed to result in a single accurate hit on the topic (see Figure 3.43). For what it's worth, camera store sales clerks and photo magazines are more likely to have at least some information on this topic than computer mega mart personnel and computer literature in general.

Professional digital photographers have been dealing with the issues covered in this section for more than half a decade. Interestingly, the same camera manufacturers who boast about their pro units' abilities to deal with the problems covered in this section mention nothing about the issue in their consumer-level marketing.

What You'll Need

This exercise is one that actually applies equally indoors and out. If you have a specific subject you suspect or even know can cause reflectivity problems, then you have a good starting point. Look for starring or streaking on the images you shot today; this is CDD blooming and will help you to understand the situations where blooming can arise.

Although it's not likely, if you were to go to too great an extreme to reproduce blooming, you could damage your camera's sensor. Because of the potential for damage and the other difficulties of this section, you might even decide to sit this one out as a spectator. For this option, an easy chair, a good reading lamp, and a snack and your beverage of choice are recommended accessories.

Figure 3.43

Digital cameras aren't baloney, but a lot of information from mega mart sales clerks can be. As an informed digital photographer, you will be able to tell meat from filler.

Camera features you are most likely to find useful when shooting metallic and reflective objects:

- Exposure compensation
- Lens threads
- Spot meter or manual exposure
- On-camera LCD screen with zoom or magnify capability
- Manual shutter speed or aperture settings
- Off-camera flash sync

Digital Photography and CCD Bloom

Wherever you shoot using a flash or in bright sunlight, bloom is possible. In fact, although bloom is more likely when shooting subjects with metallic and other reflective surfaces, it can happen with nearly any subject if the conditions are right. Furthermore, if you have a camera based on CMOS rather than CCD technology, you may not be exempt from problems like bloom; early CMOS cameras have demonstrated plenty of quirks of their own. For a reminder about the different kinds of digital camera sensors, you can review the Friday Evening section titled "Types of Digital Cameras."

So what are the conditions that lead to bloom? Essentially, bloom occurs when the exposure settings for the photograph are such that one or more areas of the picture end up extremely overexposed. This is most common when much of the subject is dark but it has some very light or bright areas that will be overexposed when the picture is shot at the exposure most of the subject needs. Metallic and reflective areas are most prone to this phenomenon because they tend to reflect back great amounts of light, thus appearing much brighter than the rest of the subject.

Other than metallic and reflective surfaces, areas that are much lighter than their surroundings will make a subject tend toward bloom. So will subjects with lights—artificial or natural—as intrinsic parts of their composition (see Figure 3.44). Some of these conditions can create a dilemma for conventional photographers as well, but the special nature of the digital sensor makes the problems far worse. To understand why, strap yourself into your chair and get ready for a bumpy page or so.

Figure 3.44

The sun acts as a source of light to create bloom in the image on the left. The simple act of moving, in this case by the sun itself, has created an angle that has removed the bloom in the second image.

What Is a CCD and Why Does It Bloom?

There can be a bit of confusion in the use of the term *Charge Coupled Device (CCD)*. In fact, many sources will use the term in different ways simultaneously and without explanation. CCD usually refers to the entire sensor array used in most digital and video cameras; however, it can also mean the individual devices that make up the array. The latter meaning is actually more precise, but in general CCD means the entire chip, or array, and often the term *pixel* is used to refer to the individual devices that make up the array.

Each pixel in the CCD records the amount of light that hits it during photographic exposure. Other electronic circuitry in the camera reads this record, or charge (the first C in CCD), from each pixel and compiles all of them to make up the picture. In fact, for some consumer digital cameras the description of the exposure system in the section "Shooting Still Life" is not entirely accurate; the shutter in some digital cameras is not a physical device but a sort of virtual shutter created by the speed at which the camera reads the charge off the CCD. The basic principles of exposure still apply—this is just a different way to set the speed of the exposure.

Depending on how your camera operates, the individual pixels in the CCD and in the resulting digital photograph may correspond 1:1, or there may be some software shenanigans that go on to create the picture. One way that cameras with digital zooms can work is to interpolate, turning one CCD pixel into several pixels in the image. Of course, you can also do this with software after the fact and quite possibly with better effect.

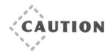

CAUTION

♦ ♦

A digital zoom feature can seem handy at first, but it doesn't do anything that you can't do with software after the fact. The downside to digital zooming is that the camera throws information away—information that you'd have, if you waited and did the zoom yourself. As a general rule, avoid taking pictures with digital zoom.

♦ ♦

The trouble with pixels is that they have a finite amount of charge they can hold before they get saturated. Those of you who like to bore people at parties by trying to sound impressive might be interested in dropping the term *quantum potential* at your next gathering—this is the technical term for the limit of each pixel in a CCD. Once a pixel gets saturated, no amount of light above its saturation point will register as anything different from the light at saturation, so an entire range of light intensity can register as white.

So far, the entire CCD-versus-film issue does not seem to be all that great. After all, film has small light-sensitive particles—film grains—that respond when exposed to light. Film grains can be saturated by exposure to too much light, as can the pixels in a CCD, so you might begin to wonder how this whole blooming issue comes into things. They work almost the same in practice, right?

Well, what happens to pixels on a CCD when they are saturated can be quite a bit different than what happens to film grains. A pixel that is only marginally saturated is not likely to misbehave, but the more saturated the pixel the more likely it is that it will spill charge over into adjoining pixels and create bloom. The greater the separation of the pixels on the chip, the lower the probability of bloom but also the less sensitive the CCD to light, and so the slower the exposure system. The engineers who designed the CCD in your digital camera knew about the problem of bloom when they designed the chip, and so your camera will incorporate their best attempts at balancing the propensity for bloom with the need for light sensitivity.

What to Do about Bloom

The best approach to dealing with bloom is prevention; moving the camera a bit is the simplest way to do this when it's possible, which unfortunately isn't all the time. A digital photograph that exhibits much CCD bloom is probably not useable, depending on the degree of bloom and where it occurs. Bloom

can obscure details of your subject and may trace lines across the photograph far from the source of the bloom (see Figure 3.45). Many times, the photograph can not be salvaged with software—and even for those photographs that can be saved, the time and effort required are far greater than you'd spend simply avoiding bloom to start with.

One difficult issue with bloom is that most on-camera LCD screens are not sensitive enough to let you see bloom in the field. This can lead to some major disappointments when you arrive home, transfer the images to your computer, and find that CCD blooming has ruined your shots. If your camera's LCD screen has a magnify option, use it often to review your pictures in bloom-prone shooting situations. The Kodak DC-260 has about the best LCD screen we've ever seen on a consumer digital camera—its magnify feature will reveal nearly all problematic instances of bloom.

You can use your camera's spot meter, if it has one, to help prevent or reduce bloom. Meter off of the brighter areas of your subject, which will give you a dark image with the bright area properly exposed. Some areas may be too bright for your camera to properly expose; that's OK as long as you can reduce the overall light in the image. As noted in previous sections, as long as a region in the image is not pure black or pure white, you can use software to pull out the digital photographic information (see Figure 3.46).

Exposure compensation settings can also be used, alone or in conjunction with a spot meter, to darken the image and reduce bloom. Manually setting the aperture to a smaller setting (a larger f-number) or your shutter speed to a shorter exposure time will also have this effect. You can use the off-camera

Figure 3.45

This Olympus D-600L shot is completely ruined by bloom. The hot spot in the far corner of the vehicle caused the problem, and moving the camera slightly solved it.

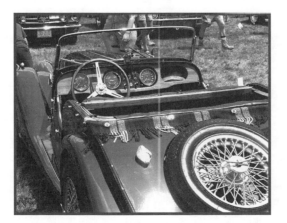

Figure 3.46

This Olympus D-600L shot was exposed by spot metering off the bright chrome. The original image was very dark, but was then corrected with software.

flash feature of your camera, if it has one, to angle light into the lens to create less glare—as illustrated in Figure 3.47 and described in the "Taking Pictures through Glass" section. Whatever method or methods you use, remember to bracket your shots as described in the this morning's "Cars, Trucks, and Other Vehicles" section to make sure you have a useable shot. Because of the limits of on-camera LCDs, you might want to consider not deleting images until you are able to review your shots on your computer.

If your camera's lens has threads for filters, you can use accessory filters to help deal with CCD bloom. The "Taking Pictures through Glass" section introduced you to using a circular polarizing filter to reduce glare and allow you to see into water, and the same glare-reducing capacity can also help prevent or minimize CCD bloom. A neutral gray (or neutral density) filter may also help

Figure 3.47

The highlight areas on this jewelry, particularly on the watch, would tend to bloom. To prevent it, the off-camera flash capability of the Kodak DC-260 was used to angle the light from the flash in conjunction with an EV –2 setting.

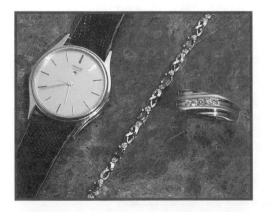

reduce bloom; this filter works simply by reducing the total amount of light let through the lens without affecting the color of the picture. Of course, you can combine filters and camera settings in a variety of ways to find a solution to bloom that works best for you, your style of shooting, and your particular subjects.

Back It Up!

You've now spent almost an entire day as a digital photographer. Feel any different? OK, maybe that's a bit much to expect, but you should be feeling much more comfortable with your camera and its features by now. In fact, just as some photographers never delve into the darkroom, if all you cover in this book is today's exercises, you will have learned digital photography. For most people, tomorrow's exercises—which involve actually doing something with the images—are as important as taking the pictures to begin with, but if you are the exception to the rule, that's OK. You've earned your digital shooter wings.

As with the end of your outdoor shooting exercises, now is an excellent time to prepare yourself, body and camera, for the ordeal ahead. Got some cruddy shots lousing up your media? Kick the bums out! Recharge your batteries and those of your camera. Did you ever think that an alkaline battery could be drained in minutes? (See Figure 3.48 for some of the debris from setting up these exercises for you.) Welcome to the world of consumer digital cameras!

You may be surprised at everything that can go into digital photography. You may even want to consider running through some of today's exercises again, perhaps next weekend, to go into more depth now that you have a wide base

Figure 3.48

The dead soldiers of digital photography. These are the actual batteries consumed during a mere two days of shooting for this book.

behind you. If you are interested in learning more, you should probably consider looking at a few excellent books on conventional photography, and adapting the techniques to digital shooting.

Here's a handful of the many excellent popular books on photography:

- *The Photographer's Handbook* by John Hedgeco, published by Knopf.
- *Understanding Exposure* by Bryan Peterson, published by AMPHOTO.
- *The Professional Photographer's Guide to Shooting and Selling Nature and Wildlife Photos* by Jim Zuckerman, published by Writer's Digest Books.
- *Night & Low-Light Photography* by Bob Gibbons & Peter Wilson, published by Cassel.

Take a Break

But don't pack up everything quite yet! Get some dinner, then hit this evening's session to take advantage of yet another set of lighting conditions.

Shooting at Night and in Low Light

- ✿ Using a Flash at Night
- ✿ Shooting with Long Exposures

You will probably never have to shoot at night or in very low light unless by choice. The conditions described in this section involve light levels too low for most people to see, and so there usually isn't much going on that most people will want to photograph. This is actually unfortunate, because there are many interesting things to see at night and many great pictures to be taken.

If you are willing to give this exercise an hour or two, you may be surprised at the enjoyment you get from shooting at night. You will have a chance to see things in a way quite different from the usual way you view them, and possibly encounter things you've never seen before. You may also feel the pride and sense of accomplishment that comes from doing something a bit difficult and different from what most other people have done.

Most consumer-level digital cameras are not designed to function well at night. Most conventional SLRs have features that are better suited to night-time photography, but in spite of this many people who try to use them to shoot at night give up in frustration. For many folks a night or two of entirely wasted shots is enough to make them throw in the towel. In this arena, as a digital photographer you will have an advantage because you'll know if what you are doing is working as you shoot.

This section touches on many nighttime shooting situations, most of them briefly. It is assumed that you are familiar with your camera and the techniques described in the day's shooting exercises. It would be possible to write an entire section on shooting at night for each of the scenarios you've covered today, so the purpose of this section is to point you in the right direction and to give you tips that build on what you've already learned.

What You'll Need

Your subject for this exercise can be practically anything. If you have a nocturnal subject in mind, by all means pursue it. You may also wish to look over the various subjects suggested later in this exercise for ideas and potential places to shoot. Ideally you will find at least one subject for flash and one for long exposure nighttime photography.

In addition to a subject, some form of portable light like a flashlight is often handy when it comes to nighttime photography. A strap-on headlamp is even better than a flashlight for many subjects because it will keep your hands free and automatically illuminate your subject whenever you look in the subject's direction. Finally, if you have a tripod now is definitely when you want to have it along.

Camera features you are most likely to find useful when shooting at night:

- Exposure compensation
- TTL LCD monitor
- Spot meter
- Off-camera flash
- Manual shutter speed or aperture settings
- Shutter timer
- Active autofocus or manual focus override

Digital Photography at Night

As you begin shooting at night, realize that nearly everything that's present during the day is still present at night. This may seem self-evident, but many people find it hard to recognize that the shooting opportunities of the night are often identical to those of the day. Of course, nighttime shooting is definitely more challenging than during the day, but that can be an advantage to the adventurous photographer.

The main challenge you will face is getting enough light for a decent photographic exposure. Surprise! OK, so maybe you were expecting that. The good news is that all day you've been learning that the digital photographer often

prefers to underexpose photographs, and during the night underexposing pictures isn't much of a challenge. The not-so-good news is that when you underexpose your shots you still need to get some photographic information for there to be a shot at all. Many times, you won't be able to tell if you have information just from your on-camera LCD viewer, so you'll just have to cross your fingers and wait until Sunday to see what you've captured (see Figure 4.1).

The other problem with extreme underexposure is that of contrast. Even if your image has some photographic information, there will be a very small range between nothing (the areas with no information) and something (the areas with information). This small range results in images that are lacking in detail and sharpness. This can at times have an interesting aesthetic effect, but may not be the picture you wanted. The good news is that under identical shooting conditions, a conventional camera would simply have no picture at all.

Figure 4.1

Here's a preview of pulling a decent image out of a seemingly lost digital photograph. The upper image is the original Olympus D-600L photo, the inset is a histogram—a graph that shows the distribution of information in the image. If the image were pure black, the histogram would be essentially empty. The lower image demonstrates stretching out the information in the photo to save the image.

Assuming you can get enough light for a decent exposure, you will still be dealing with long exposure times. You may have already encountered slow exposures in some of the indoor exercises and the first outdoor exercise in the Saturday Morning session. (Did you get out there at sunrise?) Tonight you will be dealing with the extremes of exposure lengths, and will have to face the situation where you simply will not be able to hand-hold the camera.

Another challenge may be with your camera's autofocus system. If your camera has a passive autofocus system (see Friday's section, "Types of Digital Cameras," for a review of autofocus systems) there is little chance that it will function during these exercises. You will have to use manual focus or autofocus override. Even active autofocus systems may not always function, they often have range limits in the dark and may also require manual focus.

If your camera's LCD screen has a TTL display, use it. Seeing subjects at night or in low light through an optical finder can be very challenging; you will probably find that the LCD makes it much easier to see your subject and compose the picture.

There are basically two types of nighttime shooting. The first uses flash illumination of your subject and can be much like shooting indoors. The second uses long to very long exposures to actually take pictures of the night itself. Both are distinct approaches to shooting, and there can be overlap where two photographers might elect to follow opposite courses under the same circumstances.

Shooting with Flash at Night

Your on-camera flash will probably have a very limited range when shooting at night. For most cameras, the manufacturer's listed range for the flash unit assumes modest levels of ambient light; in near-absolute darkness the range will be far lower. If you have external flash units, either via on-camera sync or external mini-slaves, you may find them useful during this exercise.

Shooting with flash at night has the most inclusive potential for subjects because anything you might shoot during the day can be shot with flash at night (see Figure 4.2). You can freeze motion just like during the day and may be able to proceed in many ways just as if you were in daylight. The only practical limit to your shooting is the limited range of your flash.

Figure 4.2

The on-camera flash of the Olympus D-600L caught this flower and seed pod at night as though they were displayed on black velvet—without the confusing and cluttered background that would have intruded on the picture during the day.

One way to increase the range of your flash is to use your camera's exposure compensation setting to deliberately overexpose the picture. This will typically result in a slower exposure, allowing more of the precious ambient light to assist your flash and reveal more of the flash's range (see Figure 4.3).

People

In many respects, flash photography of people at night resembles indoor flash photography. Get as close as possible to the people being photographed and use the wide-angle range of your lens. Be sure to avoid using red-eye reduction

Figure 4.3

Overexposure and the on-camera flash brought out the detail in these weeds while capturing a good range of tones in the sky as well.

at night; all of the disadvantages to this mode previously mentioned apply at night, possibly to even greater detriment to your shooting.

Flash photography of people at night will often result in well-illuminated candid shots of people on a black background (see Figure 4.4). Sometimes there is nothing you can do about this effect, but if you prefer to have some background detail, try overexposing using your camera's exposure compensation feature. Mini-slave flash units set out in the background area might assist as well. Although a more powerful flash might help, in many cases actually using less flash can be more effective at exposing the background by creating a better balance between flash and the low ambient light. If your camera has extensive manual flash controls and exposure settings, play with your options to see what works best.

Figure 4.4

Using a wide angle and flash it was possible to take this photograph on a moonless night, but the background of the campsite is lost in darkness.

Figure 4.5

Calling frogs are one of spring's great natural joys. A headlamp was used to see the frog in the finder; manual focus and two powerful off-camera flash units helped to finish the job.

Animals and Nature

From calling frogs (see Figure 4.5) to spectacular moths and nocturnal flowers (see Figure 4.6), there are some subjects in nature that can only be seen at night. If you have the ability, or luck, to find animals at night you will probably be rewarded with some of your most treasured photographs. In most cases, the best way to photograph animals at night is to use a flash (see Figure 4.7). Animals at night are active, and so you will get a blur or even miss them entirely if you try for a long exposure. And nocturnal animals often stop moving when the light from a flash hits them, allowing you to get more photographs.

TIP

A flashlight can be your most useful accessory when photographing nocturnal animals. In addition to allowing you to see where you're going, a flashlight held on your subject can help your camera focus and help you compose the picture properly. As a bonus, many nocturnal animals will stay motionless while you hold a flashlight on them, allowing you to get as many shots as you'd like.

Figure 4.6

Discovering flowers that bloom at night can make for a wonderfully different photo opportunity.

Figure 4.7

This swimming frog was shot in the middle of the night using flash photography and a headlamp.

Long Exposures at Night

Long exposures can be desirable as a way to actually photograph night as the night. Simply enough, if you are shooting at night without flash, you will be using long exposure. With cameras that have manual settings, you can force really long exposures for certain spectacular effects (see Figure 4.8). Of course, if you do not have adequate flash coverage, long exposures may not be a choice but a necessity. Either way, many people find shooting using long exposures quite challenging. This is the side of shooting at night that tends to discourage most people who attempt it.

Something common to all long-exposure photography is the need for a good stable platform for shooting. Of course, a tripod is an ideal camera platform, if you have one handy. But it's worthwhile to find other alternatives—even if you own a tripod, you will probably not always have it with you, and so run into the problem of finding a way to stabilize your camera without a tripod.

Perhaps the easiest way to stabilize a camera without a tripod is to place it on some other stable surface. Chairs, rocks, the hood of a car (see Figure 4.9), anything that is solid and relatively movement free. The longer the exposure, the more stable the platform must be. Moreover, if you are shooting in an area that is near vibration-causing elements, anything from footsteps to a highway with trucks roaring by, you will have to choose your platform with great care.

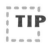

TIP Whether on a tripod or any other platform, long exposures are susceptible to shake from the very act of depressing the shutter release button. For some digital cameras this may not be a problem—the annoying delay between pressing the button and taking the picture may be long enough for the vibration to cease. But you can't count on your camera's slowness when you need it, so it's better to use the timer delay feature. You probably think of this feature as a way to let you start the camera and then run to get into the picture, but you can also use it to get a vibration-free long exposure.

The Moon

The most important thing to realize about the moon is that it is bright, the brightest thing out at night. In fact, because the sun illuminates it, the moon is as bright as other things illuminated by the sun during daylight. The moon therefore poses a metering problem common to all photographers, and a bloom problem unique to digital photographers.

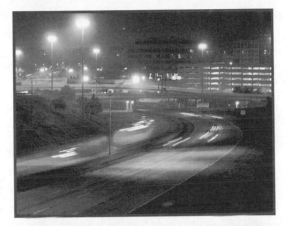

Figure 4.8

These blurred lights of passing cars at night were captured using the Kodak DC-260's long-exposure capability.

Figure 4.9

A car roof made an effective support for this shot of the nighttime skyline of Akron, Ohio. The reflections and shapes of the roof make an interesting addition to the image's foreground.

The best way for you to meter the moon is to use a spot meter off the brightest part of the moon. This will probably result in a reasonably exposed moon but a solid black, starless sky. Take two pictures, one metered off the moon and the other off the sky using a long exposure (basically, photograph the stars as described in the exercise after next). On Sunday you'll see how to combine multiple digital photographs into a single image.

Fireworks

Perhaps the most often attempted long-exposure photograph is that of a fireworks show. These are probably not the best situations to try to learn nighttime photography, particularly because most of us only see fireworks once a year, and if you shoot conventionally that can make for a very long learning curve. It is little wonder that most people give up after only one try.

As a digital photographer you can pack what would take a conventional photographer several years to learn into a single night of fireworks. You will have to do a lot of experimentation as you shoot because every camera is very different when it comes to capturing these images. As you review your shots on your LCD screen, do not be discouraged if you only see a few dots of light where you'd expected an entire burst. In many cases, you will be able to pull out a lot more image that you would expect from what you see on the screen (see Figure 4.10).

When shooting fireworks, be sure to bracket your exposure times. Use your manual exposure settings if you have them, or use exposure bracketing if you do not. Set your camera to manual focus at the "infinity" setting; even if your camera is capable of focusing during these low light conditions, it will be too slow to grab a burst of fireworks.

Stars

Use as long an exposure as your camera will allow for capturing the night sky. Be sure to direct the camera to an area of sky that has neither moon nor areas of brightness from other light sources. You may be amazed at how many stars your camera can capture compared to what you can see with the naked eye (see Figure 4.11). While you may not want these images for themselves, they can make interesting elements or backgrounds for other pictures you assemble with software.

Figure 4.10

These fireworks bursts were captured using the long exposure setting on the Kodak DC-260. On the LCD preview screen they appeared to be a few faint points of light.

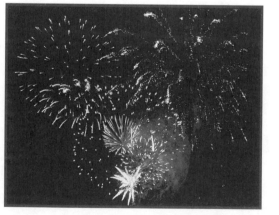

Figure 4.11

A relative handful of stars were visible the night this Kodak DC-260 shot was taken using a 4-second exposure time. The number of stars visible in the resulting image was remarkable.

Lights, Structures, and Motion

Long exposures of various human objects and activities at night can be some of the most dynamic and interesting of all images (see Figure 4.12). This is an entire field of photography, with many books devoted to just this topic. You can begin to experiment with capturing these images using your digital camera set to its longest exposure time and on a very stable platform. Depending on the brightness of the structure or objects, you may have to bracket your way down to find an exposure setting that's right for your particular subject.

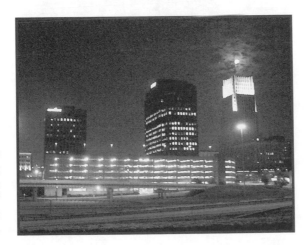

Figure 4.12

This moonlit cityscape shows a great deal of evidence of human activity.

Going Beyond Great Pictures to Get Great Images

- ✪ Transferring Photographs to Your Computer
- ✪ Scanning Basics for Hybrid Photography
- ✪ Using PhotoCD or Professionally Scanned Pictures
- ✪ Basic Image Processing: Software Overview
- ✪ Image Size versus Image Resolution

OK, so you spent all day yesterday putting your spiffy digital camera through its paces and now you have some really dynamite pictures, right? Well, wait a minute, what you probably have is a pile of removable media full of image files. That's a long way from getting a packet of prints back from the lab, so what next? Unless you are some sort of bizarre purist who has no interest in images beyond actually capturing them, you probably have all sorts of things that you hope to be able to do with your digital photographs. In fact, it may well be that some of those things are what led you to think about getting a digital camera from the start.

Today you'll be exploring what can be done with digital photographs. It's pretty basic stuff, but valuable—ways to make your great pictures even better. Yes, there are even two sections on using scanners and scanned images so that you can do some hybrid photographic work as well.

This is a day of a lot of software use, but you won't be spending a lot of time worrying over specific tools and tricks in specific software packages. If you hope to become an expert user of an image-editing package, you'll need to get a book devoted to that application. Software is too variable, and the goal of this book is to help you get great digital photographs no matter what setup you've got; concentrating on one software package would leave you out in the cold if you didn't happen to have that package. Of course, you do need some basic software—but whatever came with your camera will do. Chances are, that's Adobe PhotoDeluxe, which is packaged with the majority of digital cameras today. If the software on hand doesn't let you deal with today's exercises, you have many options available to help you, including demonstration versions of excellent tools like MGI PhotoSuite that can be downloaded from the Web.

After running around a bit yesterday, today you will be able to put your feet up and relax a bit (see Figure 5.1). A bunch of today's content is theory, or at least less strenuously hands-on, and so the pressure is off in terms of what you'll be doing. You will need a comfortable place to read, and you will need a computer with all the software that came with your camera—plus some sort of image-editing program if one was not bundled with your unit. Oh yes, some digital photographs will come in handy, too!

Transferring Your Photographs to Your Computer

The first step in using your digital photographs is getting them off your camera and onto your computer. This may be something you've done before, or it may be entirely new to you. Either way, take the time to review all your various options for transferring images.

CAUTION

It's important not to lose any data when transferring your images. Some software offers to change the resolution or otherwise edit your images during the transfer process. Don't let this tempt you to cut corners—you should always save an original, or raw, file from which to work, allowing you to revert to an original photograph should some of your editing go terribly wrong. Ignore this if, and only if, you don't care that future generations think Aunt Melba was green.

Figure 5.1

Relax and get comfortable. You did a lot of running around yesterday, but today will be a breeze!

The only processing you should allow during file transfer is a change in file type. If your camera uses a proprietary file format, you will have to change that format to a standard type if you wish to process and edit using third-party software. Even if your camera uses a standard file type, it probably uses a form of lossy compression. To avoid further image degradation during subsequent saving and editing, you will have to expand the file to a raw, uncompressed form such as TIFF. This will not remove the compression artifacts already present in the image, but will avoid adding more artifacts. You'll find a summary of common file formats in this afternoon's session called "Overview of the Most Useful File Types."

What You'll Need

Start with your digital photographs in their native form on camera. Collect and install all the software that came bundled with your camera, and assemble all the transfer hardware that you have as well. You will try transferring your photos using every method available and compare the results. There will certainly be differences in transfer speed, and you might find effects on your images as well.

TIP If you have an AC adapter for your camera, it's a good idea to use it when transferring images directly to your computer. Taking pictures is hard enough on your battery usage, so in a setting such as this where there's no need to use batteries, don't!

Transferring Via Cable

The most common form of image transfer involves attaching, or *tethering*, your camera to your PC. Check out "In Your Interface" in the Friday Evening session if you need a refresher on the various technologies associated with cabled transfer. Cabled transfer tends to be the slowest form of image access, but usually is the only way to view camera functions and photographic file information. Some cabled solutions allow you to actually control your camera, including taking pictures directly to your computer. Cabled transfer requires that your PC interface with your camera's electronics and software, and so depends on proprietary transfer software provided by the manufacturer.

Some forms of transfer software may even work like other device drivers for your computer, making the camera show up as a device alongside your hard disk, CD-ROM drive, or printer (see Figure 5.2). Software of this type allows the greatest flexibility, because it allows you to transfer your photographs without otherwise processing the images.

Other types of transfer software act like system utilities, automating the process and allowing you to set or preset various transfer options (see Figure 5.3). The utility form of software is the most convenient, particularly because it will perform various functions in a single step, but use it with caution. Be sure to compare the results of transfer software with other forms of file transfer. Some manufacturers process your images without telling you—and in ways you can not control—when you use their transfer utilities.

If you have third-party image-editing software and your camera comes with a TWAIN driver, be sure to try out this very handy mode of file access. Transferring files using TWAIN, or *acquiring* them (the term for use of this software), is

Figure 5.2

Here a tethered Kodak DC-260 camera appears as a device on a PC. You can copy images and other files to and from the camera as you would any other storage device.

Figure 5.3

Olympus Digital Vision file transfer utility. Software like this offers convenient, automated file transfers plus other image information and camera controls.

usually the slowest method because it typically requires that photos be accessed one at a time; however, TWAIN tends to offer the most information about the file and the most control over how the image is transferred (see Figure 5.4). Furthermore, when you use TWAIN you can place the image directly into the image-editing program of your choice.

Using Direct Media Transfers

If your camera uses removable media to store photographs, you can directly access the files as you would any other type of disk. Depending on the type of medium used and the features of your computer, you will very probably need additional hardware to accomplish this form of file transfer—and this adapter hardware can run from $20 to several hundreds. On the other hand, this is the only method that allows you to transfer files at near hard disk speeds, so even if the cost of the adapter seems high, you will probably consider the expenditure well worth it in the long run. Of course, if your camera writes files in a proprietary format, you don't gain as much from the speed advantage of this method because you are still going to have to turn the photos over to the manufacturer's software for processing.

Figure 5.4

The TWAIN acquire interface for the Kodak DCS-315 professional digital camera. This mode gives the greatest amount of control and image information.

◆ ◆

CAUTION Be sure to check your camera's instructions on using direct media transfers. Many cameras use very specific files, formatting, and directory structures when writing to media. If you make changes to the structure of the card, you may force your camera to reformat the card—a potentially time-consuming process.

◆ ◆

Digital Photos Are Not Forever

You may not encounter the phrase *copy artifact* in many places, but to people who regularly work with digital images, it is all too real. Just as other types of computer files can be corrupted as they are saved, read, written, and altered, so too can digital photographs. It is true that digital photographs are probably better protected under most circumstances than conventional negatives, but that does not mean you can be complacent about their storage. Copy artifacts ruin an image forever (see Figure 5.5).

Back It Up!

As with any other computer file, backing up digital photographs is an essential part of the process. Always store a raw file from each photograph as an archive, even if you think you'll never want an unprocessed version of the image. You should borrow a trick from the old days of personal computing and make backup and working copies of all images. If possible, store your backup copies in a secure place, away from your work area. This will help protect against copy artifacts—while removing the temptation to use an

Figure 5.5

The tragedy of copy artifact, or copy error, has introduced the vertical lines in the image that ruined the photo. These can crop up anywhere, any time the file is accessed, so be sure your files are backed up.

archive version when you just can't put your hands on the working copy at the moment. Save the backups for real emergencies.

Removable media types abound at the moment, so you'll have plenty of short and midterm storage solutions available (see Figure 5.6). The market for these devices changes constantly, so deciding on the drive best suited for you will be a function of what's available and affordable when you look. Be sure to allow for a generous number of disks when selecting a drive—it's easy to underestimate this as it often turns into the most expensive part of the investment, but if you later want more disks when the technology is obsolete and off the market, you'll be sorry. Depending on the speed of the type you select, you may be able to work directly off the disk, or may find it desirable to temporarily copy the image to your hard drive for editing and processing.

Probably the best long-term storage solution at the moment is CD-R, or Recordable Compact Disc. Your discs should be good for a decade or more, and the cost per megabyte for storage is fractions of a penny. Inexpensive, fast, and dependable drives abound and have the added advantage of providing you with a second CD-ROM reader for your computer. If you do a lot of digital shooting, give purchasing one of these drives serious consideration.

Storing and backing up your images can collectively be considered *archiving*. There are software solutions available to help you with this task. Many of these software packages will automatically make thumbnail versions of your images for printing and quick viewing and will track images across multiple drives (see Figure 5.7). Start using one of these software packages now, and keep in the habit of using it. Having convenient and reliable access to your images can

Figure 5.6

A comparison of three popular ways to store 4GB of image data. From the left, CD-R media with a cost of $15, Iomega Jaz magnetic disks for about $320, and Iomega Zip disks with a total cost of about $480.

Figure 5.7

A screen capture from Digital Arts & Sciences software's ImageAXS image storage software. Use programs like this to keep track of your image archives.

make the difference between being satisfied and successful in your digital photography adventures and being frustrated and losing files. The Appendix lists software resources where you can find more information about the many types of image-archiving programs available.

Several services exist that allow your images to be distributed across the Internet. In some cases, these are limited to processors of film who will scan your images and place them on the Internet for viewing, but these services have grown to allow other possible uses, including the storage, distribution, and retrieval of digital photographs. The Kodak PhotoNet Web site allows you to upload and store images for later retrieval. These services may be of limited use now, considering the time that it takes most home users to transfer 4MB files, but expect them to grow in utility as high-speed lines become more widely available.

Alternatives to Processing Your Images on a PC

It may not be necessary for you to transfer your images to a PC to get hard-copy output. Kodak has begun adding a media adapter to its Picture Maker kiosks so that you can transfer files, process them, and generate output instantly. You should expect to see more products like this develop as digital cameras increase in popularity.

Scanning Basics for Hybrid Photography

If your primary interest is hybrid photography, then you doubtless figured out a while back that this book was not written for you. Still, even the most ardent digital photographer will occasionally need to make use of a scanner. After all, you may shudder now to think of it, but there was a time when digital photography didn't exist and your only choice was to shoot film. It'd be a shame to waste all those grand old photographs, simply because they were shot during a technologically benighted epoch.

If you find yourself doing a lot of hybrid photography, you'll want to get a book on the topic. The techniques of scanning are very different from those of photography, but are themselves sufficiently technically challenging to warrant their own separate specialty in the field of digital imaging. This section will help get you started with your own scans, and most of the techniques described today can be applied to both digital and hybrid photographs equally.

How Good Is It Really?

One common source of misunderstanding when it comes to hybrid photography, made equally by novices and professionals, is confusion about the difference between photographic and digital information. *Photographic information*—also called image information—is the useful, unique information in an image that distinguishes each part of the photograph. *Digital information* is simply a collection of bits that may or may not contain photographic information. A failure to understand the difference between these types of information leads some to erroneously conclude that the size of a computer file, which is a pure measure of the amount of digital information, is equivalent to the amount of photographic information it contains. Because megapixel consumer digital cameras are typically limited to raw file sizes of about 4MB, and many scanners can easily capture files in excess of 30MB, these folks then go on to assume that there simply can be no practical comparison between the images each method provides.

One way to illustrate the error in assuming that computer information equals image information is to consider a 30MB computer image file of pure black. This file has the digital equivalent of the word "black" written over and over, 30 million times. From the standpoint of the computer, this file legitimately

has 30 million perfectly good data points to consider. However, from a photographic standpoint, the information is about what you'd get if it were written or spoken—black is black, no matter how many times you say it! Of course, there will be sticklers out there who will point out that there are some circumstances under which you can have 30MB of all-black image information, but those folks undoubtedly miss the point in most things in life, and so aren't worth your time.

As a general rule of thumb, it is probably safe to assume that a digital photograph has as much information as a hybrid image of at least three times its size, so that a 4MB example image would be equal to at least a 12MB scan. Of course, in each case there will be images of quality and potential problems like compression artifacts on the digital photo side and scratches and blemishes on the hybrid side that can complicate matters. Still, this is a conservative estimate—in some cases digital photographs surpass scans more than ten times their file size.

Types of Scanning

There are two basic types of scanners designed for home or office use. A *flatbed scanner* is a device that looks and in some ways functions something like a photocopier. Flatbed scanners are found in many homes and offices these days, as well as in print shops like Kinkos. When you think of a scanner, you probably are thinking of a flatbed.

Flatbed scanners are good for scanning printed materials, including photographic prints, and many can scan very large originals. Materials of this type are called *reflective,* because they are scanned by reflecting light back into the scanner. Some flatbed scanners can also be equipped to scan transparent media, such as film negatives or positive transparencies (slides). In most cases, consumer-level flatbed scanners cannot scan film directly as well as the other popular kind of scanner, called a film scanner or a slide scanner.

Film scanners are much smaller than flatbed scanners, because they have an active area suited to the smaller size of negatives or slides. If you have access to original film, these scanners give better results than scanning prints made from the film. If you will recall from Friday evening's comparison of the types of photography, conventional photographic prints have undergone image degradation due to the lossy process of producing the print. So a film scanner has the potential for a much higher quality scan because the original, being a negative or a slide, is typically of better quality than a print—it hasn't been processed as much.

What You'll Need

If your primary interest in this book is digital photography, you may decide to skip this section today. This exercise may someday come in handy as a reference, but unless you know that hybrid photography is going to be important to you on a regular basis there may be no need to futz around with a scanner now. On the other hand, if you have specific conventional images that you know you plan on scanning, running through this exercise will provide you with more images to use as samples for the processing and editing sections.

If you don't have a scanner, you can probably use one at a local copy shop or office supply store. A half hour rental should be enough to run through these hints and to save a few files. Be sure to check that the scanner you intend to use matches the medium (reflected or transparent) of your image. Some stores now offer image stations for walk-in use. Image stations such as Kodak's can be great resources, but tend to use proprietary software that makes using them different from other scanning projects. These kiosks are really designed to give optimal hardcopy output from devices more advanced than you may be able to afford for personal use, rather than to acquire images for further editing. See "Overview of Printing Options" in this afternoon's session for more about these potentially useful devices.

You should also check that the software you use today will be the same or similar to whatever scanning software you plan on using on a regular basis. Scanning software typically comes in two forms, either a proprietary program used only to acquire images from one kind of scanner or a TWAIN driver that allows acquisition when using an image-editing software package. Most scanners come with both types of software, and although they tend to offer similar features, you should try both to see what works best for you.

Basic Scanning

The first step in scanning is to acquire a prescan or preview image. A prescan is essentially a very fast, low-resolution scan that allows you to preview how the scanner software's setting will affect your final image quality. A prescan also allows you to work on the image, adjusting the scanner's settings to optimize the final, true scan (see Figure 5.8).

You should set your scanner to its maximum number of colors, or *bit depth*. For photographic uses, the minimum acceptable bit depth is 24, which will allow you to work with about 16.7 million colors. You may be familiar with

Figure 5.8

The preview screen from a Polaroid flatbed scanner. You can use the information from this prescan to crop and correct the image prior to committing to a large full-resolution scan.

this color depth as "16 million color mode." You should also set the scanner to its maximum optical resolution, which may be substantially lower than the listed maximum scanning resolution. Optical resolution is the only true resolution of the scanner, anything beyond optical is interpolated resolution. In some cases, interpolation may be desirable, or even necessary, but you should do it yourself after the scan using image-editing software.

Assuming that you may not need the full optical resolution of the scanner for whatever use you intend to make of a hybrid image, you will undoubtedly begin to wonder at what resolution you should scan. One general rule of thumb is that scanning at about twice the final intended use of your image, called overscanning, will give you freedom to crop, edit, and otherwise process your image without having to worry about losing image quality. Images intended for print, even when using a very high-resolution printer, work from a basis of 300 dots per inch (dpi), so a scan at 600dpi and the set output size should work well (see Figure 5.9). Because these inches get squared, an image like this can get very large. For example, a 5"×7" scan at 600dpi will be about 40MB, compared to just 10MB for the 300dpi final form.

Using film scanners can be confusing, because the optical resolution will seem much higher. Remember to size according to output size, not the size of the

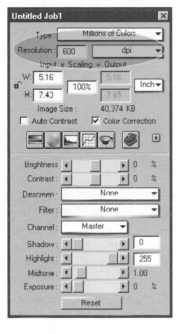

Figure 5.9

A fairly typical scanner software control panel with the scan resolution setting highlighted. All scanners use their own software, but some of their fundamentals like color correction and file size are constant.

film input. If you are scanning 35mm film, you would have to scan using the size of the film at about 3,600dpi to get 600dpi at 5"×7". Few film scanners go that high, but fortunately there is little need to. Remember that film loses less resolution than prints during processing, and so scanning closer to final image size will produce good results.

If you don't have the computing horsepower to handle 40MB files, consider only slightly overscanning to gain some benefits without sandbagging your PC. You will need computer system RAM of at least three or four times a file's size to be able to process it effectively. The good news is that while overscanning has some nice advantages, the more you overscan, the less you will gain. The quality of the original, especially the amount of good photographic information it contains, will be the true determinant of how much you can gain from overscanning. So if you are only able to overscan by a bit, don't sweat it.

Scanning for images you intend to use in electronic forms can be at resolutions much lower than for print. Most electronic displays are fine at 72dpi, so scanning at 144dpi can provide you with small initial files that still afford the advantages of overscanning when you process them.

Setting Image Tone

Once you have set your bit depth and resolution and acquired your preview scan, the first step in preparing your scan is to set the tone, or tonal range, of the scan. *Tone* is the range between bright and dark areas of an image, essentially the amount of illumination without regard to color. Getting this right is important to keep the image from appearing too dark or too light. In many ways, the problem associated with proper scan tone is similar to the problems of photographic exposure discussed during various sessions yesterday. Tone is also commonly called *image density.*

The scanner equivalent of a camera's light meter is usually a pair of tools, commonly called and shaped like eyedroppers, which let you set the white and black parts of an image (see Figure 5.10). Use the black dropper to pick a very dark or black region, and the white dropper to select a white region. One problem with using these droppers is that you often can't find a pure region to select, if the region you select has any color information (is not pure white or black), any other regions with that much information or less will also drop to white or black. This will create a very flat, poor-quality scan, with poor shadow detail and some regions that appear overexposed. You can use your scanner's software to set the point selected by the eyedropper tools.

TIP

If your attempts at setting white and black points during scanning results in a flat appearance or poor exposure, try offsetting your black and white points by a smidgen or two. This feature will let you set the *almost* white and the *almost* black points, allowing for tonal range beyond what you're able to grab with the eyedropper. Often, setting white and black three or five points off will give better results.

Another way to set the tonal range is to use the histogram tool. The *histogram* is just a graph of the distribution of image density (see Figure 5.11). You can adjust the histogram so that the tonal range of the captured image better fills the scanner's range, resulting in better reproduction of tones. It is a mistake to try to get too involved in histograms at this point, but most software will have an autoadjust function associated with the histogram that will work well with many images. Compare the effect of auto setting the histogram to what you got using the eyedroppers.

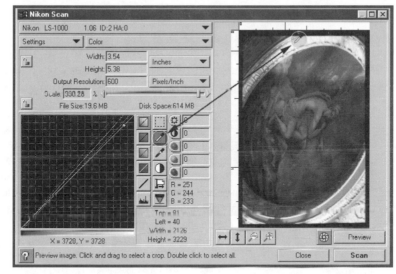

Figure 5.10

The control panel for the Nikon Super Coolscan LS-1000 film scanner in white eydropper mode. Notice how the dropper is used to pick a white point to properly expose the scan.

Figure 5.11

The Nikon LS-1000 control panel in histogram mode. Notice that when the photo is underexposed, or too dark, the histogram shows all the information clustered at one end of the tonal range.

Scanning Color

In the best of all worlds, the colors captured during scanning will be what you see in the final image—or at least close. You will have to process the scanned image's color using image-editing software no matter how good the scan, but the better the initial scan and the less required postscan processing, the better.

Some scanning software has eyedropper tools similar to the white and black tone-setting tools to help adjust color. Probably all scanning software offers the use of color curves (see Figure 5.12). Curves in scanning software work like curves in image-editing software. For more info, refer to the explanation of curves in "The Basics of Digital Color" later in this morning's session.

CAUTION

Some scanners offer to sharpen the image during scanning. In most cases, this is a poor choice. The "Sharpening Your Photographs" section later in this morning's session explains how to use image-editing software to sharpen your images under your direct control. In comparison, scanner-based sharpening offers less control. Furthermore, there is a limit to the amount of sharpening that can be applied to an image—and if you have already added sharpening via a scanner you may not be able to sharpen further.

Using PhotoCD or Professionally Scanned Pictures

In addition to scanning conventional photographs yourself, you can have your images scanned commercially by a photo-processor or professionally by a person who specializes in scanning images. Your images can be delivered to you in a variety of ways ranging from removable media that you supply to having your photos delivered on CD-ROM. You can even have your photos delivered on a special form of CD-ROM called a PhotoCD (see Figure 5.13), which is a format of CD developed specifically for use with photos.

The two basic ways of having your photos professionally scanned each have their advantages and difficulties. Having your images scanned during processing tends to result in images that need a lot of fixing up with editing software, as there is no way to specify how you'd like each image to be handled. This approach does tend to have tremendous advantages in terms of speed and cost; many photo-processors will scan images when they develop your film for a few dollars more than the cost of basic processing, and in many cases there is little or no time delay to have your images delivered.

Professional scanning provides a personal touch to your imaging needs. You can have your images scanned one at a time, and at very high resolutions. The

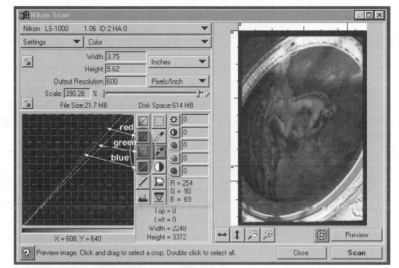

Figure 5.12

You can display and adjust color curves during scanning. This can be a great way to get the best working image possible from your raw image.

Figure 5.13

A PhotoCD is a common and quite useful method of having your images scanned. The cover of the jewel case includes thumbnails of your images for easy reference.

cost associated with this can be quite high, and the person or service you use may request several days or even more than a week to deliver the scan. In spite of the cost, if you have a very special image that you wish to use in hybrid photography, using a professional scanning service may be the way to go for the very best results.

PhotoCD

All PhotoCDs are CD-ROM discs with photos on them, but not all CD-ROMs with photos are PhotoCDs. In fact, PhotoCD is an entire system developed by Eastman Kodak to help commercial photo-processors deliver hybrid

photographs to their processing customers. PhotoCD is also a format, or type, of CD-ROM called Photo CD Image PAC, that is different from standard CD-ROMs and requires that your CD-ROM drive support the format. Although not all CD drives support the PhotoCD format, it is a pretty safe bet that if you bought your drive within the last five years you can use a PhotoCD. If you are unsure about your drive's compatibility with PhotoCD, check your system documentation before you stock up on discs.

The images on PhotoCDs are not standard file types, and so can not be read by all imaging software. Most major photo-editing packages either support PhotoCD directly or have separate plug-ins that allow you to import PhotoCD images for use (see Figure 5.14). If your software does not support PhotoCD images, you can always get free software from Kodak's Web site to export the images to a file format that you can use.

There are three types of PhotoCDs, each with different features and uses. They all provide users with images scanned in multiples and fractions of the base size of 512×768, or a little over 1MB file size. The style of PhotoCD that you will probably use is called the *Master,* which will hold scans of 100 photos at five different levels of resolution each (see Figure 5.15). The range of resolution levels runs from the highest of 2048×3072 (about 18MB) to the smallest 128×192. The *Pro Master* is identical to the Master, except that it adds a higher-resolution scan of 4095×6144 to the mix, resulting in a maximum number of images of only 25 per disc. The final format is the *Portfolio II* and stores images only at the base resolution but allows the addition of sound and

Figure 5.14

Many popular software packages include the ability to directly import PhotoCD images. This Adobe PhotoDeluxe screen is a basic part of the program's functionality.

The two worlds of digital color. The CMY (Cyan-Magenta-Yellow) color space (a) used in digital printing is subtractive because the three colors combine to form black, the absence of all color. The RGB (Red-Green-Blue) color space (b) of digital photography and scanning is additive because the colors combine to form white, which is the combination of all colors. Learn about both worlds of color and how to use them in Sunday Morning's section "The Basics of Digital Color."

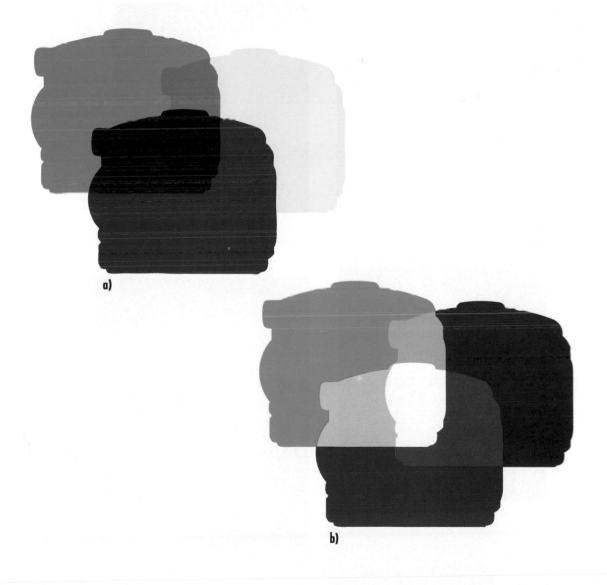

a)

b)

Color Plate 2

Starting with an original Kodak DC-260 digital photograph (a), use Sunday Morning's "The Fundamentals of Color Correction" to compare auto enhancements from the free software distributed with your camera (b), with PhotoDeluxe's automatic image variations function (c) and basic color fixing capabilites (d). Complete color correction using professional software and curves (e) is also discussed.

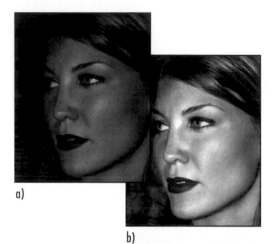

a)

b)

c)

d)

e)

An important part of shooting better digital photographs is understanding the fundamentals, like the color of light and proper use of your camera's white balance feature. The practical shooting exercises found in Saturday Morning's session will help you understand how to use your digital camera so that a standard daylight shot (a) does not end up looking fluorescent colored (b) or having the yellow tungsten light look (c).

a)

b)

c)

Color Plate 4

Learn how to use manual long exposure and spot metering to get great low light, sunset (a), and sunrise (b) shots like these. The sections "At the Ends of the Day: Sunrise and Sunset" and "Digital Photography at Night" are devoted to these dynamic and exciting shooting conditions.

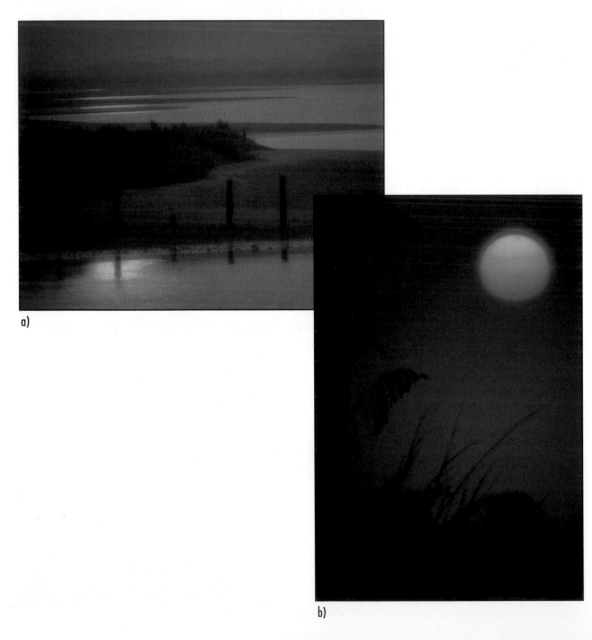

a)

b)

Saturday Morning's "The Great Outdoors: Landscapes and Scenery" includes practical advice on composition (a) and simple ways to get the best pictures possible by demystifying complex issues like photographic exposure metering for digital cameras (b).

a)

b)

Color Plate 6

Saturday Afternoon's "Action and Motion as Subjects" gives tips on capturing exciting action shots, including special techniques like panning (a). It also discusses when and how to capture, or avoid, motion effects for practical and aesthetic reasons (b). You can combine motion techniques with the methods in "People, Children, and Portraits Outdoors" and "Indoor Shots of People" to reliably use composition and flash photography to freeze motion for clarity while maintaining a dynamic subject (c).

a)

b)

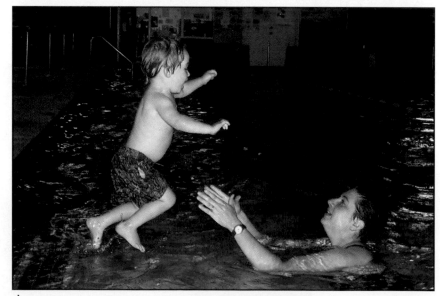

c)

Understanding exposure and composition, knowing your digital camera, and planning ahead will greatly expand your shooting possibilities. Slight differences in shooting technique, position, and your camera's advanced metering modes can result in very different images (a and b). Sunday Afternoon's "Outlining Objects in Your Photographs" helps you combine images to get the image your eye saw but the camera couldn't capture (c).

a)

b)

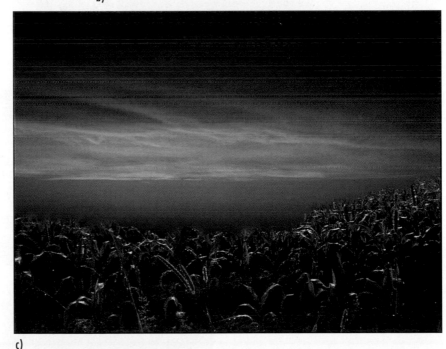

c)

Color Plate 8

See the sections "Cars, Trucks, and Other Vehicles" and "Shooting Metals and Reflective Objects" to learn techniques for getting great digital shots of cars, even when facing the special digital photography challenge of CCD bloom (a). Use techniques from Sunday Afternoon's "Outlining Objects in Your Photographs" to combine your pictures with scanned conventional images (b) to produce dynamic and exciting hybrid images (c).

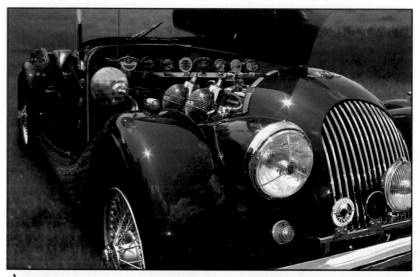

a)

b)

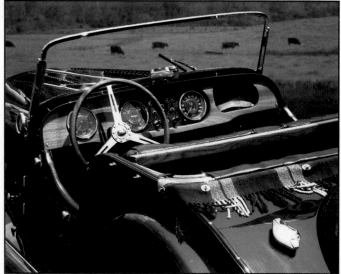

c)

Digital cameras give you the freedom to play as you shoot, allowing you to experiment and see the results immediately. The bottom line is getting better pictures and having more fun while you take them. Saturday Afternoon's "Shooting Still Life" describes how to use flash, composition, and the close focusing function of your camera to see the familiar in unusual ways.

Color Plate 10

Digital cameras allow you to make the most of fleeting photo opportunities by giving you instant feedback on how your shot looks and allowing you to make any required adjustments quickly, before the moment is lost forever. It was necessary to substantially underexpose this shot to capture the rainbow, but only years of photographic experience, or the instant review mode on a digital camera, would tell you that. (See Saturday Morning's "The Great Outdoors: Landscapes and Scenery.)

Color Plate 11

The instant feedback of a digital camera can help you in tough shooting situations, like shooting at night. Is your flash powerful enough to get the shot? Have you set your manual exposure to an appropriate distance? See Saturday Evening's session, "Shooting at Night and in Low Light," for hints on low light and nighttime use of digital cameras and to help you get the most from your equipment.

Color Plate 12

Digital cameras can be one of the most exciting and useful ways to document memorable or newsworthy events. Using the Internet, an image like this one can be transmitted across the globe within seconds of taking the picture, allowing you to communicate as it happens. Sunday Morning's "Transferring Your Photographs to Your Computer" mentions some of the possibilities for sharing your work.

Color Plate 13

Special events, like fireworks displays, require manual focus and long exposure modes. Many of the shooting exercises help you with using these features, culminating in special instructions for shooting fireworks in Saturday Evening's "Long Exposures at Night."

Color Plate 14

Nature, scenery, and travel are all a part of digital photography. Combine techniques in the section "Action and Motion as Subjects" with the composition hints in "The Great Outdoors: Landscapes and Scenery" to make the most of a scene, make moving water look like it's moving, and other tips that make the difference between nice pictures and great shots.

Color Plate 15

Don't be afraid of shooting through glass. It takes getting close and understanding how your lens and flash can be used effectively in this challenging shooting environment. See Saturday Afternoon's "Taking Pictures through Glass" to get the shots you want.

Color Plate 16

Do you use your camera or editing software to remove annoyances like red eye? See "Indoor Shots of People" and Sunday Afternoon's "Other Effects to Try" to find out the best ways of doing both.

Color Plate 17

Digital cameras are a great way to capture people and places. See Saturday Morning's "People, Children, and Portraits Outdoors" for tips on using your digital camera to capture great shots of people outdoors.

Color Plate 18

Processing and editing your pictures using your computer opens new possibilities and new ways of seeing the familiar. Simple color effects and adjustments, available in software programs like MGI PhotoSuite and Adobe PhotoDeluxe allow you to manipulate the appearance of your images using color. See Sunday Morning's session, "Going Beyond Great Pictures to Get Great Images," for pointers on how to get there.

a) Original image

c) Sepia appearance using PhotoDeluxe's Old Fashioned special effect

b) An almost surreal landscape produced by adjusting Brightness/Contrast and Hue/Saturation

d) Get this effect by adjusting Tint and Hue/Saturation

e) One of many automatic Variations presented by PhotoDeluxe

g) The more changes you make, the more dramatic the effect. For this image, adjustments were made to Brightness/Contrast, Color Balance, and Hue/Saturation

f) Another special effect called Solarization in PhotoDeluxe

h) Some of the most appealing effects are the simplest. This image was created just by adjusting the image's Color Balance

Color Plate 19

Wondering what kind of camera you need? See Friday Evening's session, "Getting Started," to understand the quality issues associated with digital photography, including why full-size megapixel images (a) are superior to VGA resolution cameras (b), no matter what your intended use of the image.

a)

b)

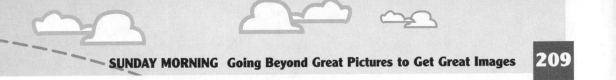

Figure 5.15

A PhotoCD import screen with preview area. Note the ability to select file size for use.

other types of media to the disc. While you may occasionally wish to experiment with the Pro Master level for the creation of hybrid images if you have photographs that warrant such high resolution, the Portfolio II format is really for use in video, and so outside the realm of hybrid and digital photography.

Professional Scans

In some cases you will find that you want to have an image scanned, and either simply want to get the most from the scan or are unhappy with your own attempts at scanning the image. This is a time to turn to a professional who can assist you with personalized service and high-end hardware well beyond what you can find at the corner copy shop. Probably the best way to find such a professional is by word of mouth—ask friends or colleagues who have used the service before. If you can't get a recommendation, try the Yellow Pages under headings like "Graphic Artist" and "Printer."

If you are trying to evaluate an unknown service, begin by asking if they do small fine art and consumer jobs. Some shops are only interested in working with certain types of clients like advertising agencies or catalog houses, or will only accept large work orders. Next, you will want to visit the shop and get a feel for the people who will be handling your work. Do they seem like creative and enthusiastic individuals with a commitment to quality? You might be surprised to find that some services bear a greater resemblance to factories or sweatshops than progressive and innovative creative houses. Be sure you're comfortable with the shop, and make sure that the person with whom you are dealing is the person who will perform the actual work.

The best scans come from a device called a *drum scanner*. Drum scanners are the opposite of flatbeds; instead of a moving scanner platen passing by a stationary subject, the subject moves past the scanner beam at a very high rotation speed. Unfortunately, drum scanners are so expensive that in many cases the sort of creative and responsive professionals who will give you the best service may themselves not be able to afford a drum scanner.

TIP If you must choose, select a competent artisan with a flatbed scanner over the technological advantage of the drum scanner.

Basic Image Processing: Software Overview

An important goal of the digital photographer is to use technology to get pictures superior to what is possible with film. The current crop of consumer units won't always give you results of this level, but there are situations where one of the better megapixel cameras will do the job. Whether you are using a pure digital photo or a hybrid image, what you do to the image with software can have a major impact on your success. Just as the processing technologies applied in a film lab can have a major impact on your conventional prints, what you do with your software tools is an important ingredient in producing dynamite digital photographs.

Improving pictures without letting the viewer know that improvements have been made is the true art of digital image editing and retouching. There are lots of software packages out that will let you "warp" and "morph" and do all sorts of wild things to your photos. You might have fun with those effects for a while, but ultimately if you are like most folks you'll get bored with making your boss look like a giraffe and settle down to figuring out ways to use software to improve your images. This section launches you toward that goal by introducing some of the common tools you'll find in almost any image-editing software package. You'll apply some of these tools in later sections today, and you'll have to explore others for yourself.

What You'll Need

The examples in this section use Adobe PhotoDeluxe software, but the tools described are common to all image-editing packages. If you have PhotoDeluxe, it will be easier for you to follow along if you open it up as you read. If you know that you plan on using some other package, use this section as a guide to help you locate your software's approach to the various functions described. Your software's Help system should be able to assist you, particularly if your package uses a slightly different name for the same tool. In some cases, having a digital photo handy may make it easier for you to locate the tool in question.

Basic Software Tools

Many of the tools described in this section can be found under PhotoDeluxe's Advanced Menu (see Figure 5.16). Click on Advanced and you will see an array of options listed. This section will not cover everything in the Advanced Menu, but will offer a brief explanation of the most useful tools. There are many tools that are not included in this section, so spend some time just exploring. Pushing buttons is often one of the best ways to learn how to use software.

Figure 5.16

PhotoDeluxe's Advanced Menu offers an array of very useful tools common to most image-editing packages.

Size and Related Tools

The Size Tab in the Advanced Menu gives you access to some very important tools for image editing. The choices under the Size Tab work in conjunction with some other tools to control both the true size of the image and the apparent size of the image on your computer screen.

Zoom Level and Display Size

When you open a digital photograph in an image-editing program, the photo appears at an onscreen size that the program has set to allow you to see the entire image and various program tools and menus. This typically means that the image is displayed at a reduced, or less than 100 percent, size. Most software programs will allow you to directly select or enter a zoom (greater than 100 percent) or reduction (less than 100 percent) level (see Figure 5.17). They also provide simple zoom tools to enlarge or reduce to the next predetermined level. A very useful zoom tool is the Magnifying Glass, which zooms to the next predetermined level but centers the display at a point where you click (see Figure 5.18).

It is important to remember that Zoom and Reduce do not change the image data, only the display on the screen. You can change zoom levels at will without altering the photograph. Reduced levels are most often useful to allow you to see the entire image at once, zoom levels often show only part of an image, but allow you to see fine details for editing. If you zoom to a point

Figure 5.17

You can use the drop-down size menu to select an appropriate zoom or reduction level for viewing your image.

Figure 5.18

The Magnifying Glass zooms in with the new image centered where you clicked the glass.

where the image extends beyond the limits of the image display box but there is room left on the screen, you can drag the edge of the image display box to allow you to see more of the image onscreen. In PhotoDeluxe, these tools are at the top bar of an image display.

Trim or Crop

The Trim option in the Size Tab allows you to crop your photo to create a smaller image (see Figure 5.19). When you trim your photos, the area outside of the Trim box is discarded. Trim permanently reduces your total image data, resulting in an image with smaller pixel dimensions and smaller file size.

Resize and Free Resize

This pair of commands creates a series of box "handles" that you can grab with the mouse pointer and use to change the size of either the entire image or a region of the image (see Figure 5.20). The two commands function identically, except that the corner handles under the Resize tool change the size while maintaining the aspect ratio of the image, while Free Resize allows you to grab the corners and change the ratio. You may change the aspect ratio using either tool if you grab the handles on the sides of the image rather than the corners.

Using this pair of tools introduces you to an important concept, that of the *canvas.* You may be accustomed to thinking of a photograph as the entire

Figure 5.19

You can use the Trim tool to select a region of the image to retain. The area outside of the selection is cropped away and discarded.

Figure 5.20

You can use the handles in Resize and Free Resize to reduce or enlarge the image area without changing the canvas size.

digital image, but actually as far as the software is concerned the photo is merely an object that sits on some or all of an underlying surface called a canvas. When you reduce your image using the Resize tool, the canvas size is not reduced, so the now blank canvas shows around the edges. Similarly, if you expand the image beyond the canvas size, the image data remain, but you don't see anything beyond the canvas.

Canvas Size

After reading about the notion of the software canvas in the preceding section, it should not surprise you to learn that image-editing software gives you the ability to change the size of the digital canvas. One way to do this is to select Canvas Size under the Tools Tab in the Advanced menu (see Figure 5.21). Canvas Size allows you to increase or decrease the size of the canvas, using one of several units of size. You can also select how you want the size change to be implemented relative to the current canvas. The default places the current canvas in the center of the new canvas, but you can place it to one side or another (see Figure 5.22).

Figure 5.21

The Canvas Size menu. You can increase or decrease the canvas size and select the orientation of the new canvas relative to the old.

Figure 5.22

The canvas size has been enlarged equally in all directions relative to the old canvas. Notice that the new area is blank.

The other way to increase canvas size is also the simplest way to increase the resolution of digital photographs. Rather than starting with an open image, select New from the File menu and create a blank image, effectively a new canvas, of a size of your choosing. You can then open existing images and copy their information into the new file. If you want to create an 8×10 print of some favorite objects, you could take a single picture of the objects and have your printer software stretch the image to fit the new size. The difficulty with this approach is that typical digital cameras create photos best suited for smaller prints, and thus your big print will be of degraded quality. As an alternative, start a new image that's 8"×10" in size with 300ppi resolution, the standard resolution for creating prints. You can then import and place multiple photos within the new file, creating a montage that will print at full resolution without having to stretch your individual digital photos.

Photo Size

The Photo Size command is the Size tool that does what you would expect a size command to do (see Figure 5.23). You can use this tool to change the size of the image, canvas and all. This command allows you to set the three primary determinants of size: resolution (in a variety of units), height, and width. As a reference, the tool displays the size of the file as well. You have the option to

Figure 5.23

The Photo Size menu allows you to reduce or enlarge the entire image with the option to constrain the image aspect ratio and total image size.

constrain the proportions, which links the width and height options so that a change in one causes a corresponding change in the other, maintaining the aspect ratio of the image. You may also constrain the entire size of the image, which links width, height, and resolution. Any change to any of the dimensions causes a corresponding change in the other two dimensions to maintain a constant file size.

The Tools Tab

The Tools Tab, found under the Advanced menu, gives you access to several important tools common to all image-editing programs. Once you become accustomed to the function of these tools in one software package, you will be able to quickly adjust to their use in another. To get really good with these commands, refer to the exercises in a book or manual for the software package of your choice.

The Clone Tool

The Clone tool, in spite of its hi-tech science fiction ripped from today's headlines sorta name, is pretty simple to use. However, like many simple tools, it can take some time to truly master. The general function of the Clone tool is to copy one section of an image to another section, creating a "clone" of the original (see Figure 5.24). The power of the Clone tool is that it copies in proportion as you drag the mouse. So you aren't likely to use the Clone tool to replicate entire objects within your photo—there are more direct ways to do that with Copy and Paste commands. Instead, the Clone tool lets you create subtle replicas of small areas of a photo. For example, if you are working to retouch a small blemish from a hybrid photo, perhaps a crease in an old photographic print, you can use the Clone tool to copy adjacent data over the imperfection. This works best for patterned areas, like grass or bricks, or for skies.

The Smudge Tool

Drag the Smudge tool across the photo to create blurred regions within an image (see Figure 5.25). The effect of the Smudge tool is in many ways similar to running a paintbrush across a wet painting, dragging and mixing colors and lines as you go. The Smudge tool can sometimes be used to simulate motion trails, but is more often used to blur unnaturally sharp edges created during editing.

Figure 5.24

Once you get the hang of the Clone tool, you'll find it handy for all sorts of retouching projects.

Figure 5.25

In this photo the Smudge tool has been used to soften the edge of the upper feather.

The Eraser Tool

Use the Eraser tool to (surprise) erase image data to reveal the canvas or other image data below (see Figure 5.26). As you will learn in the section later today called "Changing Scenes and Backgrounds," many image-editing packages allow you to place different image information on different layers in a single composite image. One way to selectively reveal an underlying image is to erase regions from an overlying layer.

The Line Tool

The Line tool is a generally useful tool that you can use to draw lines and shapes on your images (see Figure 5.27). You can use this tool to draw the viewer's attention to certain image details, or even to create a border around the entire image.

The Orientation Tools

The Orientation Tab under the Advanced menu contains several very important and related tools. These tools are used to flip and rotate your images. You can use them to create mirror images of your photos, or to simply correct the view of a horizontal photo (see Figure 5.28).

Figure 5.26

You can use the Eraser tool to remove portions of an image and reveal what's below.

Figure 5.27

You can use the Line tool to draw shapes in your image. In this example, a box frame has been added to the photo.

Figure 5.28

The Rotate Left tool set the mask right side up.

Other Useful Tools

Among the many wonderful and powerful image-editing tools at your disposal, the Undo and Text tools are two that deserve mentioning. In PhotoDeluxe, both tools are at the top of the image display box. The Undo tool is quite important, because you use it to catch your mistakes. When you invoke Undo, your image reverts to its state prior to the last command or tool you used. It is important that you remember that the Undo tool is only able to undo the very last thing you did—it does not remember several steps back. So save your images often, and use new names for your images so that you do not overwrite old files that you may later need, should you make an "un-undoable" mistake.

TIP As with all computer-related tasks, the rule with digital files is to save early and to save often. Be sure to use the Save As feature of your software to create new files as you edit, so that your original images are preserved.

The Text tool is simple, and it does pretty much what you'd expect. Use this tool to add text to your images, in various sizes and fonts. Something that may take getting used to is that the Text tool does not display your text on the image as you type. Instead, it puts the text in a small box within the Text tool dialog box (see Figure 5.29). Once you finish adding text, it appears in the

Figure 5.29

The Text tool appears as a dialog box for text entry and other options.

Figure 5.30

Once you have okayed the Text tool, your text shows up on the image.

image (see Figure 5.30). Like many image-editing packages, PhotoDeluxe does not offer text editing capabilities, so if you want to make changes to your text, you must delete the entire text object and start over with new text.

Image Size versus Image Resolution

The issue of image resolution is probably the one that causes the most confusion for folks first getting started in digital imaging. The digital imaging community does not help much, often using the term *resolution* in different

contexts and when another term would be more accurate. For example, resolution is often used in reference to the pixel dimensions of an image when actually pixel dimensions are a measure of size, not of resolution. Of course, there is more flexibility with images with larger pixel dimensions to create high-resolution files, and that is why the terms are so often used interchangeably.

Understanding the distinct but related issues of resolution and size is important. These issues have an impact on nearly all file processing, from elementary printing using your home ink-jet to complex multiple-file composites, so make sure you're comfortable with the material in this section before going on. This section isn't long, and the issues really aren't difficult, but there seems to be something about dealing with two so closely related topics that throws some folks off.

Resolution is an image characteristic that is given in units of "elements per linear dimension": dots per inch (dpi), pixels per inch (ppi), and lines per inch (lpi) are all units of resolution. What resolution is a 2,000 pixel × 2,000 pixel file? It is hard to say for certain; although it may have a lot of pixels, you don't have the linear dimension associated with the file to tell you its resolution.

The general notion of image size is simpler than that of resolution, but in practice it can be more difficult for some folks because you have to keep four different measures of image size straight. You will need to understand the difference between *file size, pixel dimensions, print size,* and *memory size* requirements if you really begin to manipulate your files. And once again, the issue is not simplified because the terms and the concepts they stand for are interrelated.

The pixel dimensions of a file give you the most straightforward measure of its size. From the pixel dimensions the other measures of size are determined. For example, a file with dimensions of 1,500×1,000 pixels has 1.5 million total pixels. If this file is a digital photograph, then the camera that shot the photo is called a 1.5 megapixel camera. To get the raw file size, you must remember that digital photos are RGB images, and the picture actually has 1.5 million pixels for each of the three primary colors. Conveniently, the image is also probably captured in 24-bit color, which is 8 bits per RGB channel, and since (as everybody learned in Computers 101) 8 bits is a byte, each pixel ends up being 3 bytes, one for each of the colors. Some basic arithmetic: 1.5 million times 3 is 4.5 million bytes, or megabytes. So, for a 1.5 megapixel camera that captures 24-bit RGB color, the raw file size is about 4.5MB.

Compression

When a camera uses a compression scheme to save digital photos, as nearly all consumer digital cameras do, the size of the photo on disk will be much less than the raw file size. For example, the Kodak DC-260 uses a 9:1 JPEG compression ratio for its highest-quality image; if the raw image is 4.5MB, then at 9:1 compression, the file saved will be 500K. That's dandy, but you must bear in mind that those 500K are still used to represent an image with dimensions of 1,500×1,000 pixels and 24-bit RGB color, and so the image size when displayed will still be 4.5MB. This means that the memory used by your computer to display that file is the same as if the image were not compressed, the only savings is in disk space. Furthermore, you actually use more computing power to work with a compressed file because every time you access one your computer must compress or decompress the file. So compression may be a handy way to save disk space, but since you already know that you can get compression artifacts from compressing files, and now you know that there is no time savings when it comes to using a compressed file, hopefully you are convinced that working with compressed files is to be avoided.

Different file types do not always make files smaller. For example, if you heavily edit a file and save it with many new elements in a proprietary format like Photoshop's PSD, the file might be several times 4.5MB in disk space and memory usage, but will still occupy a mere 1.5 million pixels in dimension. Similarly, a 1.5 megapixel image in a different color scheme like CMYK will be larger, in this example 6MB, to accommodate another channel. And some professional cameras capture color in as much as 48-bit RGB color, which corresponds to 2 bytes per channel, and so a 1.5 megapixel image is 9MB for those units.

So, how does all of this come together with resolution? Well, you can think of the uncompressed file size as the amount of information present in the file, no matter the resolution. Your 4.5MB file could be at the relatively low resolution of 72dpi (a common monitor resolution) or the higher 300dpi suitable for professional printing. If you use the file size as a guide, you can change the resolution and corresponding dimensions and retain the file size, thus you are not truly resizing the image, nor do you lose any information.

Looking at size and resolution another way, the pixel dimensions of the file determine the upper limit of resolution for a given print size. Print size is pretty simple, it is just the size of a print that you want. Common photographic print sizes are 3×5, 5×7, and 8×10. You can get good prints from a

digital photograph at 267dpi, with 300dpi often being the standard. Don't worry about the listed resolution of your ink-jet printer; that's something different and is covered in this afternoon's "Overview of Printing Options" section. Dividing the pixel dimensions of the file by the desired output resolution tells us that a 1.5 megapixel image is well suited for 3×5 prints and even slightly larger—but not up to 5×7s.

Try It!

The best way to get a feel for these definitions and how they interact is to try it yourself. To do this you can use an image from yesterday, or just test a purely digital file that you create now. Use your imaging software either to open a file or to create a new image. If you create a new image, make sure your image has dimensions of about 1,500×1,000 pixels in RGB color. If you are a purist, you will remember that a megabyte is 1,000×1,024, and so will use dimensions of 1,536×1,024. Once you have done that, use the resize function and verify that the image is 4.5MB total size (see Figure 5.31).

The image size display for most programs clearly distinguishes between pixel dimensions and resolution, often called print size. The options you will see should include the pixel dimensions of width and height, and corresponding print dimensions. The pixel dimensions will also be expressed in terms of total file size, and the print dimensions will have a resolution. If your image-editing software is like most packages, the file will have been created at the default resolution of 72dpi. If you go to change that resolution, you will probably find that the image size and pixel dimensions change, too (see Figures 5.32 and 5.33).

The Constrain Proportions option is used to make sure that an image stays the same shape. If you have a blank file the proportions may not matter, but if you are using a photo, try deselecting this option and change only one dimension. You should see that the image is distorted (see Figure 5.34). Another option, also selected by default in most software packages, is the Resample (or Resize) option. When Resample is checked, the program changes the dimensions of the image to match the new resolution, or vice versa. While this can be OK—even desirable, if you want to reduce the image dimensions for a specific purpose—it is not desirable if all you want to do is change the print size and resolution for outputting.

Figure 5.31

The Image Size dialog box from Adobe Photoshop displays the default file size, dimensions, and resolution for an Olympus D-600L digital photograph.

Figure 5.32

Notice the image resolution change from 144dpi to 300dpi with image resample off (left), on (middle), and 600dpi with resample on.

Figure 5.33

The Image Size screens that correspond to the images in Figure 5.32. Notice the dramatic increase in file size resulting from resampling.

Figure 5.34

The image distortion that can occur when you uncheck the Constrain Proportions box. Compare this image to the left image in Figure 5.32—the square window has become a vertical rectangle, and the angle of the water stream has changed dramatically.

Sharpening Your Photographs

An essential step in preparing your digital photographs for use is *sharpening*. A sharpened image has a crisp appearance that is appealing in most photographs. Although the sharpness you get is different from what you'd get from a lens, you can think of sharpening as digitally focusing your image.

There are different kinds of sharpening, but they all have in common the principle of processing an image so that the differences between the pixels are in some way increased. The different forms of sharpening merely use different methods of discriminating between those pixels that the software will treat as similar, and those that it will treat as different. The software then may make the dissimilar pixels less similar by increasing the *contrast*—the difference between light and dark—between the groups. Because the lines, or edges, of objects in an image tend to be distinguished by such contrasts, this process will tend to enhance the edges in an image, hence the term *sharpen*.

What You'll Need

Pick several images representing different exercises from yesterday's shooting. High-contrast images may be a good place to start, as it will be easier to see the effects of sharpening with these images. Be sure to copy the files to a working directory, and save them in TIFF or another raw file format.

Sharpening is ubiquitous in digital and hybrid photography, so nearly any software package will offer some form of sharpening. Try the basic software that comes with your camera (Kodak Picture Easy, for example), but be sure to take a stab with PhotoDeluxe or something on that order, too. More advanced software, if you have purchased it, may offer additional options, but you can probably get a good look at the fundamentals by using whatever software package that you received free with your camera.

Sharpening Digital Photographs

Raw digital photographs have a tendency to appear soft (see Figure 5.35). This is due to the technology involved in producing images. As you will find as you experiment with sharpening, most images need sharpening, but they need the *right amount* of sharpening (see Figure 5.36). No matter how fancy the algorithm, it is the human eye that is the final judge of the necessary sharpening an image requires, and because once sharpened, there's really no going back, camera manufacturers wisely leave it up to the photographer to sharpen digital photographs.

TIP

A point that bears repeating: Don't edit your original digital photographs; always work with copies. A sharpened image can never be returned to its original form, so always back it up!

The basic imaging software that shipped with your camera probably has some form of sharpening as part of an "auto enhance" type of filter (see Figure 5.37). You should try your software's enhancement option—but mainly as a point of comparison; you probably won't want to use it very often for real output. Automatic software enhancements are designed to allow you to quickly improve the appearance of most photographs, but lack the controls necessary to give your photographic eye freedom to truly get the most from an image.

Figure 5.35

A raw digital photograph from an Olympus D-600L. Notice that this image has a soft, almost fuzzy or muddy appearance before sharpening.

Figure 5.36

Too much of a good thing. This image has been sharpened too much, creating a harsh and unappealing photo.

Figure 5.37

Kodak's Picture Easy software provides rapid and automatic improvements to your images, including sharpening, but does not allow much in the way of user control over the process.

In a sense, the automatic sharpening is what the camera would do, if the manufacturer wasn't originally wise enough to leave the sharpening up to you.

Sharpening with PhotoDeluxe

The sharpening options offered in PhotoDeluxe's long menus are essentially identical to those available with professional software packages. Find Sharpen under the Effects menu in long menu mode (see Figure 5.38). There you will see an option simply titled Sharpen, one titled Sharpen More, and two more called Sharpen Edges and Unsharp Mask. These four menu options encompass all of photographic sharpening, so unless you need advanced features (like batch sharpening, which will allow you to quickly process many files in sequence), there really is no need to purchase software to sharpen your photographs.

For most of your images, you will probably find that using the Sharpen effect, or filter, does a fine job of sharpening (see Figure 5.39). This effect applies a relatively even amount of sharpening to your entire image, and is similar to the automatic enhancement found in more basic software. This filter is OK, but once you become accustomed to using the other options, you'll find yourself using it less and less.

Figure 5.38

The Sharpen submenu in PhotoDeluxe.

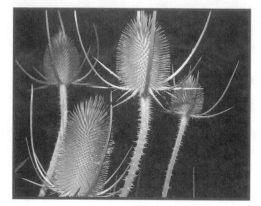

Figure 5.39

Applying the basic
Sharpen filter does
much to improve
the image over
the original.

The Sharpen Edges filter is more complex than the basic Sharpen effect. When you apply Sharpen Edges, the software examines the image for relatively high regions of contrast, or edges. When it finds such regions, the software increases the contrast by an appreciable amount, while it applies less sharpening to areas with less contrast. Try this filter and you'll see that the edges of your image become very pronounced, while most of the rest of the image appears unchanged (see Figure 5.40). This filter can actually make the edges appear too pronounced in many images, introducing a new problem. Sharpen Edges works best with images where you wish to create or accent highlights.

Sharpen More is sort of like applying Sharpen Edges to the entire image (see Figure 5.41). This effect will create very high differences in contrast within the photograph, even in those areas where such contrast may not be desirable. Images that have had the Sharpen More filter applied are usually obvious because of the grainy appearance typical of this filter. If you plan on dramatically reducing your images, however, you may find Sharpen More works well to pull out the main gist of the image.

Despite its name, Unsharp Mask is really the general form of sharpening, the other three effects being just specific cases of the Unsharp Mask. Using this filter effectively can take some practice, but once you are comfortable with Unsharp Mask you will probably almost never use any other form of sharpening. When you open this filter, you will see a small preview of your image. You can use this preview to get an estimate of the effect your choices will have on the appearance of your photograph.

Figure 5.40

The Sharpen Edges filter emphasizes those areas that are already high in contrast, increasing the effect. Use this filter sparingly, as most images do not take to it well.

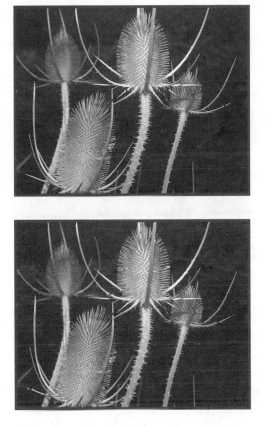

Figure 5.41

Sharpen More can be extreme for many images.

The main options offered under Unsharp Mask are Amount, Radius, and Threshold (see Figure 5.42). Amount is the percentage change you wish to apply to those pixels that are selected for sharpening; as a guide, the generic Sharpen has an amount of about 35 percent, while Sharpen More has 75 percent. *Radius* is the number of pixels out from the selected pixel to apply the percentage of sharpening you've selected in the *Amount* option. And *Threshold* is the level of brightness that will be used to discriminate those pixels selected for sharpening.

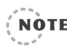

NOTE

Another way of looking at Unsharp Mask is to turn its options upside down, and recognize that Threshold selects pixels to be sharpened. Radius then may select additional pixels near the threshold pixels for sharpening, all to the degree selected in the Amount text box. Clear as mud? Don't sweat it—the more you play with these options, the more accustomed you'll become to the way they interact.

Figure 5.42

The Unsharp Mask interface. If you have the preview box selected, you will be able to see the effects of your proposed changes before committing to the settings.

Sharpening and Compression Artifacts

You were first introduced to compression artifacts way back during Friday evening's evaluation of digital cameras. You now also know that you need to process your images using an uncompressed format such as TIFF to avoid introducing more artifacts to your photographs. Unfortunately, the artifacts that are already in your photos aren't going anywhere by themselves, and they can make it harder for you to sharpen your images. You will probably find that Sharpen More and Sharpen Edges make the artifacts pop out at you more than the basic Sharpen tool does (see Figure 5.43). The lower the radius and threshold when using Unsharp Mask, the more pronounced the artifacts.

If you find that sharpening brings out the artifacts in an image, you may be able to reduce the effect by carefully selecting your options using Unsharp Mask. Try using a slightly larger radius; in some images this can allow you to get some general sharpening while preventing the edges of the artifacts from becoming too pronounced. Each image will respond differently, so your best bet will be to experiment. As a general rule, the best way to avoid problems with compression artifacts is simply to avoid compression artifacts. As has been said many times before, shoot at the highest resolution and quality setting your camera offers—you'll avoid a multitude of problems by following that simple rule.

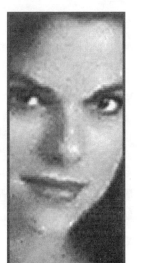

Figure 5.43

No, this woman has not been drinking milk—those white lines are compression artifacts that have been increased due to sharpening.

Take a Break

The coming section is not hands-on, so you can kick back a bit. There's no need to be in front of your computer now, so make comfort your first priority. You'll be spending a lot of time with software today, so enjoy this opportunity while it lasts. Stretch and get comfortable for a few minutes, and find yourself someplace relaxing to read.

The Basics of Digital Color

Color and associated concepts play a principal role in almost all digital imaging. The starting point for digital color is the human visual system, with its three types of color-sensitive cones. This section is not about human retinal anatomy, of course, it's just a brief introduction to digital color—but it is useful to remember that the entirety of digital color is ultimately directed toward stimulating the human visual system so as to replicate what it perceives when viewing nondigital material. Keeping this in mind should help you remember that these are methods to describe the human experience of color or to simulate it.

Color Space

Visible light, and for that matter even the rest of the light that we can't see, forms a spectrum. The human eye receives information from three slices of the spectrum (red, green, and blue) to see color. Because different colors have different percentages of these three colors, called primary colors, we are able to perceive literally millions of different colors within the spectrum by means of different amounts or percentages of the primaries. The human visual system is therefore said to be a red, green, blue, or RGB, color space. When you add the three primaries of the RGB color space together you get white, the sum of all colors, and so the RGB color space is said to be *additive*. You can see how this works in Plate 1 of the color insert.

NOTE

Color space isn't as futuristic as deep space, nor as likely to create personal harmony as inner space, but it is a useful concept nonetheless. Color is described as occupying a "space" that is plotted mathematically along coordinate axes. The RGB color space uses its three primary colors as axes; other color spaces use different axes.

The RGB color space seems special to us, because it is how we see. However, other color spaces do exist. It is important to remember that a color space is really a tool, a handy way to describe the colors, and so it is always possible to come up with a new color space if there is a need for a new tool. One such tool that is important to digital imaging is the cyan, magenta, yellow (CMY) color space. The primaries of this color space combine to form black, the absence of all color, and so this color space is said to be *subtractive* (see Color Plate 1). For practical reasons, black is added to this color space during application so it is usually referred to as the CMYK color space, the "K" representing black because "B" is already used in the RGB color space for blue.

Both the RGB and the CMYK color spaces are important to digital imaging for the simple reason that many devices used in digital imaging use one or the other color space to represent an image. The tricky thing is, when you want to transfer an image that exists in one space to a device that uses the other, you need to use software to convert the image to the other color space. The converted image may not look identical to its previous state, and therein lies the rub. It is at the very least a good idea to know what color space a device uses, so that you will know when a conversion is going to take place and anticipate having to deal with color shift. As a guide, digital cameras and computer monitors are RGB, but most color printers are CMYK.

NOTE You'll encounter CMYK often, and might even begin to confuse it as a true color space, but it isn't. CMYK color is a real-world practical creation for printing that uses the CMY color space plus the addition of pure black. Unlike theory, the real world often gives results a bit different from what you'd expect. In the case of CMYK color printing, the real inks used to represent the theoretical CMY primary colors subtractively combine to create a muddy brown, not black.

Other Color Concepts

As you work with image editing software, you will encounter other color terms and color-related tools. While trial and error has helped many folks figure out uses for these tools, knowing what they are ahead of time can help you to make the most of them. The following sections lay out the basics of these concepts.

Hue and Tone

Two terms that can easily cause confusion are hue and tone. *Hue* really is just a color, any color. The primaries of any color space are hues, as are the colors in between described by combinations of the primaries. *Tone* can be a bit trickier, because it too can mean a color, but actually means anything that isn't white. From a practical standpoint in digital imaging, think of tone and hue as working together to form a color image. If you have a photo of a car and make it grayscale, devoid of hue, the remaining shadows, grays, and so forth are tones. You could remove the red hue from the car and trade it for blue, maintaining the tone information but completely altering the hue.

NOTE A conventional black and white photo is all tone and no hue. If you think of details such as shadow and light in a black and white photo, you can recognize the considerable amount of information in an image that is not color related. Coloring a black and white photo adds hue to the tone.

Saturation

Saturation is the amount of a color, or hue, in an image. Colors can be highly saturated or desaturated using image-editing software to create a desired visual effect. *Brightness,* also called value, is the amount of light or illumination of a color. You can think of brightness as the amount of white mixed into a hue.

White does not change the color itself, but by brightening the color it reduces or dilutes the appearance of the color, causing it to be less saturated. A related topic is the contrast of an image. *Contrast* is not a specific value; it's an image-specific value that represents the relative brightest and darkest region of an image. High-contrast images will share the property of having very bright and very dark regions, but low-contrast images can be uniformly dark, uniformly bright, or somewhere in between.

Gamut

The *gamut* is the range of colors that can be represented or perceived, expressed as some portion of visible light, which is really the gamut of the human eye. The great news is that digital cameras and computer monitors tend to have large gamuts, the bad news is that your monitor and your camera will probably not have identical gamuts, and so your monitor will only be able to display those colors from your camera that the monitor shares. To make matters worse, output devices also have gamuts, typically more limited than either monitors or cameras, and it is therefore quite likely that you'll be excited by the colors in an image onscreen, only to be disappointed by the way they print.

Bit Depth

A final element critical to digital color is the *bit depth* of an image. The more bits used to store color information in each pixel, the greater the bit depth. Most consumer digital cameras today use the minimum bit depth for representing photographic images, 24-bit color. With 24-bit color, each color channel in the RGB image is represented by 8 bits of information, or 256 color levels. Multiplying 8 bits by the three channels results in the total of 24 bits of color, multiplying the three sets of color levels results in 16.7 million possible color combinations, the standard for printing.

Many professional-level scanners and digital cameras exceed 24 bits of color, even when they are creating images destined for 24-bit printing. Units that use 30, 32, or even 48 total bits of color are not uncommon. If you think back to the notion of color gamut, it's easy to see why this would be. A 24-bit raw image that is destined for a 24-bit output process has no range within which to work. The 24 bits as captured get represented in the output device. Using a greater amount of initial color information is sort of like overscanning for image resolution. The final image can use the best 16.7 million colors from an original set of a much higher number. Furthermore, during color processing

and image editing, if the higher color depth is maintained, the image will hold its color better, just as a higher-resolution image will withstand more editing without loss of sharpness.

You will see a simple example of this principle when you look at GIF images in this afternoon's "Photographs for Web Pages" section. GIF images have 8-bit color depth, but they also allow the user to select the 8 bits of color from the 24-bit gamut. When you select the best 8 bits from 24, you can often get quality nearly as good as the original 24-bit image. However, if you must limit the image to a specific 8 bits of color, the image is severely degraded. The same principle applies to capturing color with a device that has a larger color gamut than the final output device.

Color Corrections

One of the principal software fixes that can be applied to an image is color adjustment, or *color correction.* You may wish to adjust the color in an image because it does not match the original subject, or you may wish to use the principles of correction to improve an image beyond simply matching the image colors to those of the real world. Most consumer-oriented software programs come with automatic functions to fix images according to generalized preset notions of what is desirable. These auto fixes actually can work surprisingly well for a variety of photos, but there are plenty of instances where you will not be satisfied with the results. Perhaps more significantly, once you learn the benefits and creative control possible for color in your images, you will probably never look back at auto fixes again.

The techniques used in this section build on the general principles of digital color introduced in the last section. The examples feature specific image-editing packages, but the good news is that color is a matter of the physical world and not something a few software engineers invented, and so what you'll do is essentially universally applicable. One of the most important places you'll want to use these techniques outside of image-editing software is within advanced printer drivers, such as you find with newer high-end ink-jet printers. These drivers use some of the exact same tools to control the way a printer manages color, allowing you to correct for variances in output between different printers, inks, paper, and so on to get photographs that begin to approach traditional prints in quality.

What You'll Need

The basic requirements to run through this section are some software and a digital photograph. PhotoDeluxe is used as the reference software package during the first portion of this exercise, and is a good example of the level of controls available with basic image-editing software and most printer drivers. Adobe Photoshop, perhaps the most widely distributed professional image-editing software package, is used to describe the basic use of color tools in advanced software.

The Fundamentals of Color Correction

No matter the tool used, there are some principles common to all color correction tasks. Perhaps the most important is also one of the most difficult: learning how to tell what needs correcting. The best way to figure out what is wrong with the color in an image is to practice playing with color. Practice a lot. The tools you'll discover in this section will start you off with the necessary knowledge to get that practice, but you won't be able to get all of the experience you'll need just today.

The source of much of the difficulty in learning color correction comes from the applied consequences of the color space principles discussed in the previous section. When you take the additive RGB color space and the subtractive CMY color space in concert, you discover the principle of *complementary colors.* In a nutshell, complementary colors mean that an increase in a color in one color space results in a decrease in the complementary color in the other color space (see Figure 5.44). More difficult is the fact that both color spaces have somewhat similar colors, adjacent on the color space diagram, that can be mistaken for one another. For example, does an image show too much red, or too much magenta? If you refer to the color space diagram, you'll see that if you decrease magenta, you are increasing the complementary color green. If the image actually had too much red, you now have an image that has not been corrected at all—it's further off by virtue of now having too much red and green.

The next issue in application is that of additive or subtractive approaches to color correction (see Table 5.1). The principle of complementary colors implies that you can reduce the amount of a color in an image by increasing the amount of that color's complement. That is the additive approach. The subtractive approach works by decreasing the other two primaries of the complementary color space, in the case of this example decreasing cyan and magenta to decrease blue.

Figure 5.44

The relationship of the RGB and CMY color spaces, showing the complementary color sets using a color space diagram.

TABLE 5.1 WAYS TO GET THE COLOR YOU WANT

Color in Question	Problem	Desired Results	Additive Correction	Subtractive Correction
Red	Not enough red in image	⇧ Red	✛ Magenta & Yellow	— Cyan
Blue	Too much blue in image	⇩ Blue	✛ Yellow	— Magenta & Cyan
Blue	Not enough blue in image	⇧ Blue	✛ Magenta & Cyan	— Yellow
Green	Too much green in image	⇩ Green	✛ Magenta	— Yellow & Cyan
Green	Not enough green in image	⇧ Green	✛ Yellow & Cyan	— Magenta
Yellow	Too much yellow in image	⇩ Yellow	✛ Blue	— Red & Green
Yellow	Not enough yellow in image	⇧ Yellow	✛ Red & Green	— Blue
Magenta	Too much magenta in image	⇩ Magenta	✛ Green	— Red & Blue
Magenta	Not enough magenta in image	⇧ Magenta	✛ Red & Blue	— Green
Cyan	Too much cyan in image	⇩ Cyan	✛ Red	— Green & Blue
Cyan	Not enough cyan in image	⇧ Cyan	✛ Green & Blue	— Red

TIP Although both the additive and subtractive approaches to color correction can work, try the subtractive method first, as it often works best.

Color Correction with PhotoDeluxe

The simple controls in PhotoDeluxe are actually excellent for learning the basics of color correction, because they clearly show the relationships of the complementary colors in the two primary systems. Start by opening an image. Any image will do; if you're following along, just assume that whatever amount of blue it has is "too much blue" as specified in the exercise. In PhotoDeluxe's Advanced menu there is a tab called Quality; select it, then choose Color Balance from the selections in the tab. You will see a menu with three sliders, each representing the primary complements from the RGB and CMY color spaces (see Figure 5.45).

In the case of an image with too much blue, to use the subtractive method you must subtract cyan and magenta, the two CMY primaries other than blue's complement of yellow (see Figure 5.46). As you can see from the table this is identical to adding red and green, the other two primaries in blue's RGB color space. This method is called subtractive because you are removing colors in one color space, based on the principle of complementary colors. However, if you recall that all color amounts are relative to one another, you can see that by using the subtractive method to increase red and green, the same thing as subtracting cyan and magenta, you are actually reducing the relative amount of blue in the image in its own RGB color space.

To use the additive method, you simply add yellow, which has the direct result of decreasing blue (see Figure 5.47). When you view the sliders in PhotoDeluxe, how this works is pretty clear, but in some ways the names of what you are doing during color correction seem backwards. After all, to decrease blue you add yellow, so instead of being called the subtractive method (for subtracting blue), it is the additive method because you are adding the complement of blue. In a similar fashion, the subtractive method of color correction can seem to have a backwards name.

Once you have used both methods of dealing with too much blue, run through the other methods in Table 5.1 as a way to get a feel for the effects of the various

Figure 5.45

There are sliders
for each of the
three sets of
complementary
primary colors.

Figure 5.46

Using the
subtractive method
to decrease blue in
the image by
subtracting cyan
and magenta.

Figure 5.47

Using the additive
method to reduce
blue in an image
by adding yellow.

color correction methods. While the entire notion of color space and color correction may seem alien to you right now, if you are willing to spend a little time to play a bit with color, it will pay off with a greatly increased control over your digital photos and how they look.

One last point: think back to the section titled "The Basics of Digital Color," and you'll recall that there's more to color than just color space. The other dialog you'll use in PhotoDeluxe to adjust color is the Hue/Saturation menu, also in the Quality Tab. When you open this menu, it may at first glance look nearly identical to the Color Balance dialog box, although the properties Hue, Saturation, and Lightness have replaced primary colors in the three slider controls (see Figure 5.48). Although it was not mentioned last section, some folks actually use these three properties as a color space, which may not seem intuitive as there are no recognizable primary colors with which to work, but can be a quite effective way to adjust the color in an image nonetheless.

Figure 5.48

PhotoDeluxe's
Hue/Saturation
dialog box can be
an important tool
in color correction.

Moving the Hue slider shifts the entire color balance of the image through a spectrum based on the image's starting colors. The Saturation slider runs from a grayscale, essentially no color information, at the left, to greatly exaggerated color to the right. The Lightness slider controls the amount of white in the image, and can affect the properties of brightness and contrast.

For the most part, you will use the Hue/Saturation menu to make final adjustments that will fine-tune your image after you've used Color Balance. Play with both of these menus until you are comfortable with how they affect the appearance of your image.

Color Correction with Photoshop

The sample image shown in Figure 5.49 is probably like many in your own portfolio. It has a very bright sky as a background and a dark subject in the foreground. An image like this is often the result of using a matrix style meter that averages across the entire image, resulting in a relatively high-contrast image with nothing properly exposed. An image like this can be difficult to deal with—particularly for programs that apply an automatic fix—because although the image has high contrast, it really only has information in the high (bright) and low (dark) regions of the tonal range. It has an almost complete lack of midtones, and for most photos it is the midtones that are most desirable.

The first step in correcting this image is to go into the Image top line menu and select the Levels function from the Adjust submenu (see Figure 5.50). The most prominent feature of the Levels dialog box is a histogram that graphically represents the distribution of tonal information across the image. In the case of the sample image, you can see that the image almost has two curves, a lot of information at the far left that represents the information in the dark foreground, a dip where the midtones should be, and another peak representing the sky highlights. The sky must have dominated the meter when the image was shot, because its peak is too dark, dominating the center of the graph where the midtones should be.

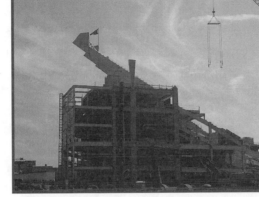

Figure 5.49

The original image has high contrast between background and foreground, but little in the mid range.

Figure 5.50

The Levels dialog box showing a histogram chart of the distribution of information in the image

For some images, the way to proceed would be to use the dropper tools to pick a white and a black point in the image, resetting the histogram according to your new reference colors. You can even use the middle dropper to select a midtone, if you have one available. If you really want to get fancy, you can use the central drop-down menu to adjust the histogram for each of the RGB channels independent of one another. You may not want to jump in quite that far yet, but pull down a couple of the channels just to see how different the information distribution can be for the different colors.

In the case of the sample image, the goal of a levels adjustment is to widen the histogram, pushing the highlights to the upper end of the graph and making room to open up the midtone region. The Auto button can do this quite well for most images (see Figure 5.51). You may be tempted to use the eyedropper tools, also called pickers, to select white and black points in the image. The difficulty with these tools is that unless you have pure white or pure black in an image—a rare event—you actually discard image information by forcing a range of high or low tones to go to the pure state. For the most part, avoid using the eyedroppers.

The next step is to open up the midtones. You can do some of this with the Levels function by sliding the black, midtone, and white pointers at the bottom of the histogram. The sliders change the reference point for the given level. Although the Levels function works, the Curves function is easier to handle and generally more useful for most folks. You select it from the same Adjust submenu where you found Levels. The Curves function is in some ways similar to Levels, although the graphical representation is merely a relative function of the current information in the image, without standard reference white and black points used for Levels.

To help you understand the difference between the Curves and Levels graphs, open the various color channels in the Curves function. In each case, the starting point in Curves is a straight 45-degree line—that is, a curve with a slope of 1. The Curves graph is relative to the data in an image, while the Levels histogram is an actual reading of the specific information in a given image. The Levels histogram is often the first stop in correcting an image because it lets you visualize the state of the image as it is. Curves are handier for actually applying most corrections, because you can apply a consistent degree of change to a region of the image without having to figure out the specifics for that image. So, in Curves you can make a 20 percent adjustment to something (don't worry about *to what* or what that might mean at this point) without having to convert the adjustment to the absolute values in the Levels histogram.

In the sample, the idea was to open up the midtones, making the information in the foreground lighter without causing the sky to appear overexposed. Adjusting the Curves function is easy; simply click on the region of the curve you want to adjust and hold the mouse button while you drag the curve in the desired direction. In the example, the middle of the curve is dragged down, making it lighter (see Figure 5.52). As you an see from a histogram of the final image, compared to the Levels even after the Auto adjustment, there is much

Figure 5.51

The information in the image has been spread out, pushing the sky up into the high key region and leaving plenty of room for true midtones.

Figure 5.52

The standard Curves display on the left compared with the adjusted curve with lightened midtones on the right

more information in the central region of the graph, and lower peaks at the left, which represents the black end of the tonal range (see Figure 5.53). Viewing the final image, the sky and the foreground are in much better balance, creating the impression of a pleasing, properly exposed photograph (see Figure 5.54).

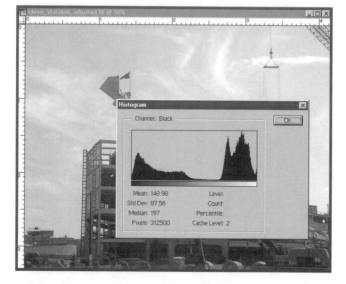

Figure 5.53

A histogram of the final image. Notice that even compared to the adjusted histogram in Figure 5.51, the dark regions on the left have been reduced and spread out toward the middle tonal region.

Figure 5.54

The final image, adjusted with a bright sky and well-developed midtones for the foreground.

Enhancing Your Photos with Simple Styling Effects

Your digital photographs are perfect—just the way you want them, right? If you are like many folks, it is the allure of making your photos jump through digital hoops that helped attract you to digital photography to begin with. It turns out there are a number of ways, ranging from simple to complex, to enhance your photos using software. Basic, fun, and easy-to-use software packages like MGI

PhotoSuite and Adobe PhotoDeluxe allow you to do all sorts of neat things to your photos, usually with not much more than a click or two of the mouse.

Styling effects change your photo by changing the image itself. These are different from other effects, such as the color effects covered in the next section, because when you change the style of an image you are really altering the fundamental subject information in the image. Most other effects keep the basic image the same while making it brighter, darker, greener, or whatever. Styling effects are a handy way to make your image appear to be something other than what it is, and most software packages come loaded with bunches of programmed effects for you to try.

What You'll Need

To compare the effects of the styling filters offered by the various software packages at your disposal, start with one or more simple images (like the one in Figure 5.55). An image with simple lines, moderate contrast, and even exposure will help you differentiate between the true effects of the filter and those that are peculiar to your image.

Try to use whatever software you have available, particularly any package that you think you might want to use on a regular basis. Most of the examples in this section were generated using MGI PhotoSuite, an inexpensive and flexible package with many other features such as greeting cards and calendars that you can use with your images. Other images were created using PhotoDeluxe. In many cases, there is overlap between the styling effects each package offers, although most software will offer at least a handful of more or less unique effects.

Figure 5.55

The original photo used for the examples in this section. The clean simplicity of this shot helps to make the effects of various filters clear and obvious.

Styling Effects from PhotoSuite

MGI PhotoSuite offers over 20 styling effects under five different menus (see Figure 5.56). These effects are simple to use, with assorted options offered in a menu area below the image display. The following sections summarize only a sampling of this program's many styling offerings; you should take the time to try them all.

Emboss

The Emboss effect is common to most software packages, and one that you've probably seen many times without realizing it. Emboss creates the appearance of a metallic surface with a raised imprint of the photo's subject (see Figure 5.57). The primary option for the Emboss filter is Height. When you move the Height slider you increase or decrease the shadow contrast in the emboss edges, creating the appearance of more or less depth to the embossing.

Negative

Another commonly found effect is the Negative filter. This effect transforms the photo into its negative image, just like a film photographic negative (see Figure 5.58). This effect is often used to create an otherworldly appearance, or even a frightening nighttime look.

Figure 5.56

A list of the effects available in PhotoSuite, with their respective menu headings.

Figure 5.57

PhotoSuite's Emboss effect gives your image the appearance of having been embossed on a metallic substrate.

Figure 5.58

Give your photo the appearance of a photographic film negative using the Negative effect.

Cartoon

PhotoSuite's Cartoon effect transforms your image from a photo to something you might see on a Saturday morning children's show (see Figure 5.59). This is a pretty neat effect, under the right circumstances. This is an excellent example of an effect that is easily accomplished with a programmed filter, but that would require real effort for even a pro to do by hand.

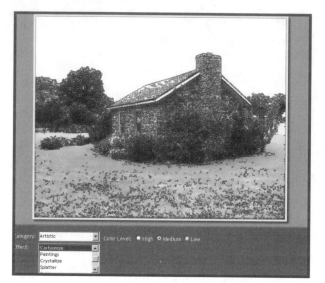

Figure 5.59

The simple and whimsical appearance of the Cartoon filter.

Mirage

PhotoSuite offers another cool effect called Mirage. This filter creates a shimmering mirrored image of your subject, as if reflected from a pool or a desert mirage (see Figure 5.60). It comes with controls that let you push and pull the effect from the one extreme of a reflection pool to the other of a wraithlike mirage.

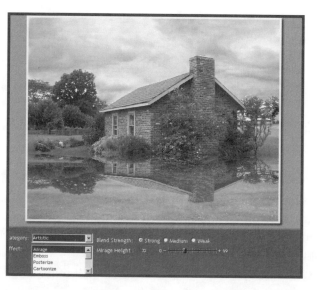

Figure 5.60

The Mirage filter adds a reflecting pool to the sample image.

Glass

The Glass effect in PhotoSuite gives the appearance of viewing your subject through a pane of glass. Of course, if it were a plain old pane being simulated, there'd be very little to show (unless it was very dirty). So the filter comes with a slew of options for types and style of glass to create interesting effects on your image (see Figure 5.61).

Ripples

PhotoSuite offers a handy example of another commonly found effect called Ripples. When you use this effect your image appears to be a reflection pool that has had a stone dropped in the center (see Figure 5.62). PhotoSuite gives you two simple sliders to modify this effect by increasing or decreasing either the size or number of the ripples.

Mosaic

Another commonly found effect creates a mosaic pattern in your image, giving the illusion that your photo is composed of tiles (see Figure 5.63). PhotoSuite gives you a slider to increase or decrease the amount of tiling the effect applies to your image. Other programs such as Photoshop will actually allow you to select the shape and pattern of the tiles as well.

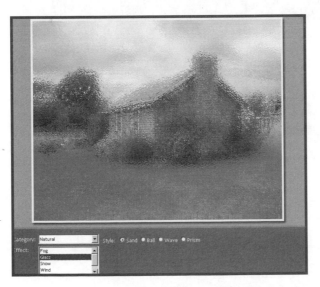

Figure 5.61

The Glass effect with the Sand filter selected

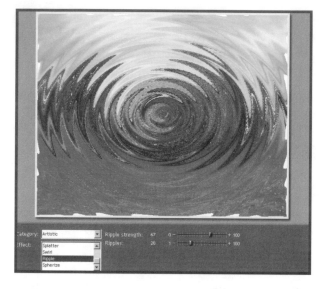

Figure 5.62

The Ripple effect in
action. Notice the
sliders that let you
control the use of
the filter.

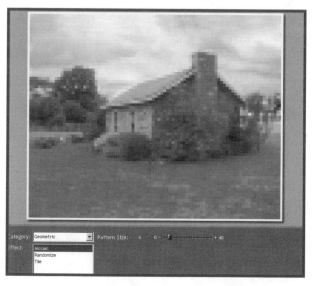

Figure 5.63

The Mosaic effect
in PhotoSuite

Randomize

One pretty spiffy effect found in PhotoSuite is the Randomize filter. This effect
gives your photo an almost smeared or blurred appearance by creating a speck-
led pattern in the image (see Figure 5.64). You can use radio buttons to select
the shape of the speckling and a slider to change the degree. One possible use

of an effect like this is to make the image less distinct—and therefore more suitable for use as a background in a composite image, as described in the section later today called "Changing Scenes and Backgrounds."

Spherize

The Spherize effect is pretty wild. When you apply it to your image, the central subject appears distorted, as if on the surface of a ball (see Figure 5.65). You can use this effect to simulate the appearance of an extreme wide-angle shot, or—with the techniques in this afternoon's section titled "Outlining Objects in Your Photographs"—to isolate the sphere and for use as part of a composite image.

Styling Effects from PhotoDeluxe

PhotoDeluxe also offers a number of styling effects that you can apply to your photos. Taken together, the selection can be somewhat daunting, with 28 total effects in four menu tabs (see Figure 5.66). These effects are combined under the Special Effects selection on the left side menu. If an effect has options associated with it, they are displayed on a floating dialog box that usually appears over the active image space. Previews, if available, are shown in a small window within the dialog box. As with PhotoSuite, some of the effects are pretty much unique to PhotoDeluxe, while others are commonly found in many software packages. Examples of a few of the best follow.

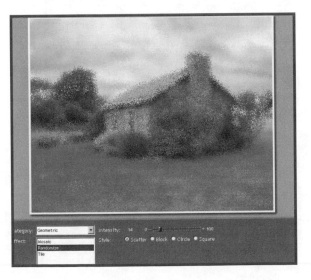

Figure 5.64

The Randomize filter, with options. Shown is the Scatter variant.

Figure 5.65

The wide-angle appearance of the Spherize effect makes your photo resemble a Christmas tree ornament.

Figure 5.66

PhotoDeluxe's Special Effects menus and selections

Sketch

The Sketch effect makes your photo appear as if it had been drawn in pencil or with charcoal, accenting the lines of the image (see Figure 5.67). This is a pretty nifty effect when you need it, although it tends to work better for images with strong lines, like the sample schoolhouse, than for more moody shots. You might try using this effect to create a printed coloring book. In fact, the results of this filter appear identical to the PhotoDeluxe Coloring Book effect before the program prompts you to add color.

Glowing Edges

PhotoDeluxe's Glowing Edges effect is one of the wilder filters to be found in any software package. Using Glowing Edges, you can transform your image into an eerie neon outline with wild squiggles of color (see Figure 5.68). Unlike many of the PhotoDeluxe options, this effect has a dialog box that gives you some control over the effect of the filter on your image (see Figure 5.69). You can see the effects of your changes to the presets in the preview box.

Page Curl

PhotoDeluxe's Page Curl effect is simple to apply, but would be quite difficult to do without the help of a program preset. When you apply the Page Curl filter, your image is displayed as if on a semi-transparent leaf that is being turned up, displaying an underlying solid color of your choosing (see Figure 5.70). This may not be an effect you'd want to use daily, but it can be handy at times.

Figure 5.67

PhotoDeluxe's Sketch effect transforms photos into pencil drawings.

Figure 5.68

The Glowing Edges effect menu with preview screen in PhotoDeluxe.

Figure 5.69

The results of the Glowing Edges options shown in Figure 5.68

Crackle

When you select the Crackle effect in PhotoDeluxe, a dialog box allows you to control three factors of the effect (see Figure 5.71). Depending on the selections you make, the Crackle effect can make your photo look as though it were printed on anything from crumbled paper or foil to concrete or a similar rough surface. It can also make it look cracked and marred like an ancient oil painting (see Figure 5.72).

Figure 5.70

PhotoDeluxe's Page Curl effect lets you turn the page on your images.

Figure 5.71

Options for the Crackle filter in PhotoDeluxe

Figure 5.72

The sample photo has been given the appearance of old, cracked paint using the Crackle dialog box.

Changing Colors for Effect

Simple changes in color can have a dramatic impact on the appearance of your photos, as shown in Plate 18 of the color insert. In later sections today you will have an opportunity to work with more complex examples of image alteration, but more complex does not necessarily translate into better results. The techniques you'll use in this section are simple to implement, and can have interesting and useful impacts upon your digital photos. Color effects can be most useful in adjusting the mood of an image, particularly when enhancing an already strong mood created photographically.

What You'll Need

The images in Plate 18 were all created with Adobe PhotoDeluxe. It is often easier to create effects with PhotoDeluxe or similar packages such as MGI PhotoSuite than with professional image-editing packages. The lightweight products have many of the effects built in, although most have sufficient settings and options to allow you some control. To follow along with this section, you'll find it easiest to use PhotoDeluxe and an image that you'd like to modify. A moody digital photo, perhaps one shot during yesterday's "At the Ends of the Day" exercise, is an ideal choice. The image in the figures features a foggy sunrise over a bog in the Cuyahoga Valley National Recreation Area (see Figure 5.73).

Enhancing a Digital Photograph with Color

Once you have selected your photograph for the exercise, open the image in PhotoDeluxe. Be sure that you are working with a backup copy of your image

Figure 5.73

The original photo used for the examples in this section. The photo already has a strong mood element just waiting to be enhanced.

and not the raw photo. Make sure your copy is in TIFF or a similar noncompressed format. If you have not already done this, you can save the photo as a native PhotoDeluxe file type using the Save As option under the File menu. If you need to, refer back to this morning's section, "Transferring Your Photographs to Your Computer," for help.

Sepia

The Sepia effect in Plate 18c is a standard effect in PhotoDeluxe. Begin by selecting Special Effects menu from the side menu, and choose Old Fashioned under the Art Tab (see Figure 5.74). This effect will walk you step by step through the process of simulating age in your digital photos. The first step the effect performs is to convert your image to black and white. This is a simple no-brainer; you merely click on the button and the program makes the conversion for you.

The second step is more interesting, and actually exposes some of the hidden power of this effect. The step is called Tint, and in it you are prompted to select a single color to tint the image. PhotoDeluxe prompts you to choose from the orange area of the displayed spectrum (see Figure 5.75), which will result in a simulated sepia effect. Orange is fine, but you can choose any color for your image, which is one of the potentially really cool things about this

Figure 5.74

The Old Fashioned effect under the Art tab in the Special Effects menu.

Figure 5.75

Add tint to your digital photograph, after first reducing it to black and white.

effect. You can choose to play with other colors, going beyond the limited Old Fashioned effect to others like Electric Blue or Horizon Red—wherever your creativity takes you. Try different combinations, using the handy Undo button to lose those changes you don't like.

The final step in this effect is actually the option to apply one or both of two options. The sample image shows the effect of applying the Noise filter to the image (see Figure 5.76). Noise creates a speckling effect like the crackling of a

Figure 5.76

Noise is added to the sample image as the final step in creating the appearance of an aging photo.

very old photograph. PhotoDeluxe does not offer any controls with this, or the other filter, Blur, so you may not always want to use them. In both cases, the changes can be so strong as to ruin a potentially nice image.

The Surreal Landscape

Not all color effects are entirely preset by the software. It is possible to use one or more general color adjustments to create an effect, as with Plate 18b. To create this effect, begin by opening the Advanced menu options from the side menu. Select Brightness/Contrast from the Quality tab to display a pair of sliders (see Figure 5.77). In the case of the sample image, both brightness and contrast were increased using the sliders. The hue, saturation, and lightness of the image were then adjusted using the Hue/Saturation menu under the Quality tab to create the final image (see Figure 5.78).

The Green Fog

The green fog seen in Plate 18d was another effect created by combining two simple color adjustment menus. The first step used was the addition of the overall tint to the photo using the Tint effect under the Art tab in the Special Effects menu (see Figure 5.79). Here the entire image was selected for tinting, but you can restrict the effect to some portion of the image that you've selected if you prefer. To complete the effect, Hue/Saturation was selected from the Quality tab, as shown in Figure 5.80.

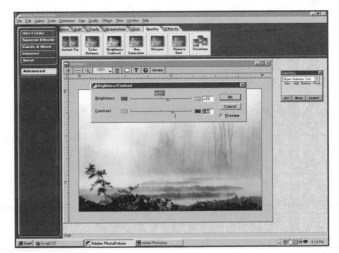

Figure 5.77

The first step in creating this effect is to adjust brightness and contrast under the Quality tab, as shown here.

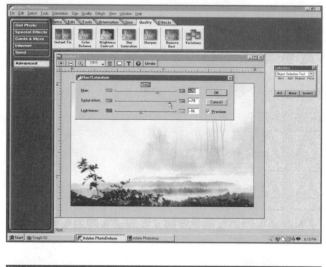

Figure 5.78

The effect is completed by adjusting hue, saturation, and lightness using the Hue/Saturation menu in the Quality tab.

Figure 5.79

Applying a tint to the image.

PhotoDeluxe Variations

Perhaps one of the handiest of PhotoDeluxe's effects is actually a series of effects, all centered on your original image. Plate 18e was created using this effect, called Variations. You can find Variations under the Quality tab in the Advanced menu. You will see six different versions of your image displayed around a central original (see Figure 5.81). Adding more of one color to the original creates each variation. You can select a variation—at which point it becomes the new "original," and the program spins off further variations from your pick.

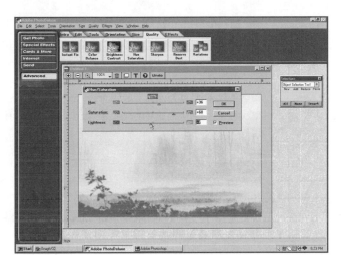

Figure 5.80

The Hue/Saturation menu with the appropriate settings for this effect.

Purple Haze

The dramatic color effect seen in Plate 18g is another example of combining simple effects to create a greater change. It probably won't surprise you to learn that the greater the change you hope to create, the more you must do to an image. In the case of this example, three simple color effects were used in combination. All three effects can be found under the Quality tab in the Advanced menu.

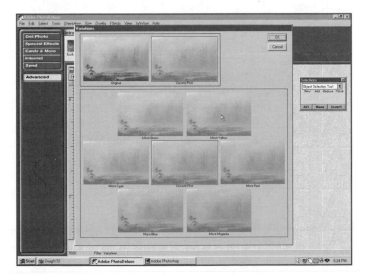

Figure 5.81

PhotoDeluxe's Variations effect offers you six alternatives to your current image.

Begin by selecting Brightness/Contrast (see Figure 5.82). These sliders change the brightness and contrast of the image while at least theoretically leaving the underlying colors, or hues, unchanged. As you can see from the figure, in the case of this example the overall brightness of the image was decreased slightly and the contrast increased. These changes were necessary because otherwise the later color effects would have wiped out much of the image detail.

The next step is to use the Color Balance effect to create the overall purple cast to the image. Red and blue make purple, so those sliders were increased, while the green in the image was decreased. Decreasing green also increases the magenta in an image, which suits our task just fine (see Figure 5.83). The final step is to use Hue/Saturation to make the image detail pop out under the new color scheme. The primary goal here is to increase the saturation in the image, with minor adjustments to hue and lightness to whatever looks about right (see Figure 5.84).

PhotoDeluxe's Solarize

Sometimes dramatic effects can be created automatically by a preprogrammed filter in a program. Under the Special Effects menu PhotoDeluxe offers a Cooler tab that introduces you to a number of wild effects. In Plate 18f, PhotoDeluxe's Solarize filter was used to create the extreme effect seen. This effect is similar to a standard gamut-reducing effect found in many software

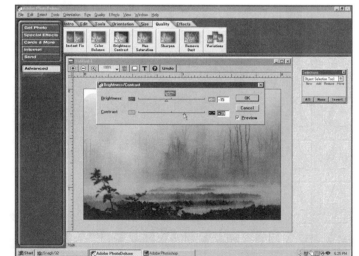

Figure 5.82

The Brightness/ Contrast menu.

Figure 5.83

Use the Color Balance menu to continue with creating this effect.

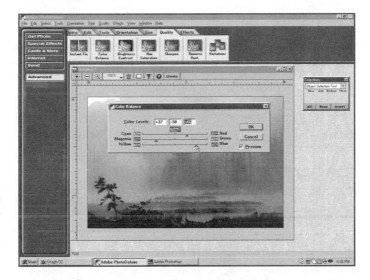

Figure 5.84

The Hue/Saturation menu finishes the job.

packages called *posterize*. PhotoDeluxe does offer a Posterize effect as well—it gives you results similar to the Solarize effect but nowhere near as extreme. Simply select Solarize from the Cooler menu (see Figure 5.85) and you're pretty much done, as there are no user settings for this effect.

Pink Skies

The very appealing image in Plate 18h was created quite simply. To emulate this effect, begin by selecting Color Balance under the Quality tab in the Advanced menu. You can create many terrific effects by simply moving the three color sliders back and forth until you like what you see. In the case of the sample image, red was increased dramatically, with a corresponding decrease in green and a moderate decrease in blue (see Figure 5.86).

Figure 5.85

The simple yet dramatic Solarize color effect in PhotoDeluxe.

Figure 5.86

Sometimes simple is best. To create this image, I made changes using only the Color Balance menu.

Using Lighting Effects to Modify Your Photographs

A fascinating and often handy way to enhance the appearance of your digital photos is through use of lighting effects. *Lighting effects* are virtual lights, added by software, that give your photo the appearance of having been shot in a darkened area with only a portion of the subject illuminated by one or more lights. From a photographic standpoint, this effect is one of the most difficult to create *in camera*—that is, by using traditional photographic methods of optics and light, whether shooting digitally or conventionally. The ability to shoot a more standard shot and create the effect after the fact using software is a great boon to all photographers.

Lighting effects have many uses above and beyond simply being something cool to do to an image. You can use lighting effects to bring the viewer's attention to particular portions of the image. Lighting effects are also useful to create mood or accent the photo. You can even use these effects as a simple and easy way to diminish the effect or appearance of some portion of your shot.

What You'll Need

Almost any digital photo is suitable for these effects. You might want to consider a small objects shot or an indoor people photo for this exercise, although it really isn't necessary. Think about the shots you got yesterday—if there is one that makes "Wouldn't a spotlight look great here" spring to mind, that's the one you should use. Once you get a feel for how to use lighting effects, in the future you'll be able to plan shots for which you know you'll want to use them. Figure 5.87—which you'll recognize from yesterday's "Shooting Still Life" exercise—shows the base image used for the examples in this section.

Figure 5.87

The original photo used for the examples in this section. Lighting effects can be used to enhance almost any picture if you so desire.

Bad news for PhotoDeluxe users: the package does not give you any lighting effects. There are several packages that do offer these effects, but none of them are free. Probably the most popular package to offer these effects is Adobe Photoshop, a trial version of which can be downloaded free of charge from the Adobe Web site. If you do not already have a package that offers lighting effects, get the Photoshop demo version to run through this section.

Enhancing a Digital Photograph with Lighting Effects

In Photoshop, the Lighting Effects menu is under the Render submenu of the Filters menu. The Lighting Effects dialog box (see Figure 5.88) can appear intimidating at first, but once you get the hang of it and learn that most of the time you can ignore most of the options, you'll find it easy and straightforward to use. The Lighting Effects menu has two submenus (see Figure 5.89): Style, which allows you to select from numerous preset starting points, and Light Type, which refers to the individual light with which you're working.

Flashlight and Floodlight Style

Begin by selecting the Flashlight style and the effect is immediately displayed in the preview window (see Figure 5.90). You can grab the dot in the middle of the displayed circle of light to move the light to a different location. Grabbing

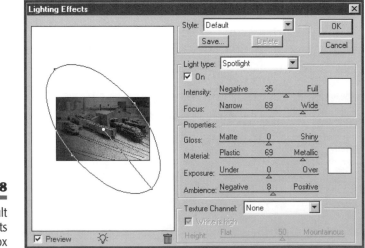

Figure 5.88

The default
Lighting Effects
dialog box

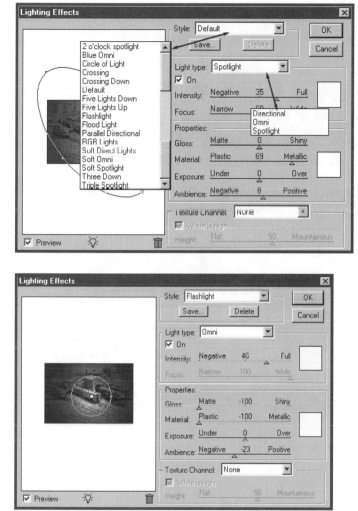

Figure 5.89

The Lighting Effects dialog box. Notice that three light types are used in various ways to create more than a dozen preset effects.

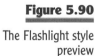

Figure 5.90

The Flashlight style preview

a handle on the perimeter allows you to adjust the size of the circle. You can experiment with the different slide bar settings, including changing the color of the light by clicking on the colored box under light type, but for the most part the default settings will be pretty close to what you want to create the effect of a small handheld flashlight playing a single diffuse beam across the subject (see Figure 5.91). Making too many changes essentially transforms the flashlight effect into another of the presets—so why bother?

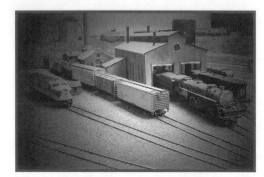

Figure 5.91

The Flashlight style lighting effect in action

Figure 5.92

The Floodlight lighting effects preview

The Floodlight style uses the same type of light, Omni, as the Flashlight style, but its settings are different (see Figure 5.92). Comparing the two nicely illustrates that the presets really are just generally useful saved effects, and that any preset can be altered to another by adjusting the settings. In fact, if you create a setting that you particularly like you can save it, adding it to the list of Styles. The Floodlight style creates a diffuse effect, illuminating the entire image with a focus at the central point of the light (see Figure 5.93).

Circle of Light Style

Selecting Circle Of Light creates four colored lights in a circular pattern within the center of your image (see Figure 5.94). The default Light Type for this style is Spotlight, which functions slightly differently from the Omni type you saw in the Flashlight style. You can grab the center of a Spotlight to move it, just as with the Omni type, but the center is not the focus of the light. Instead,

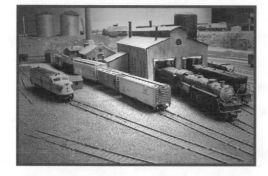

Figure 5.93

The Floodlight lighting effect in action—wider than Flashlight, but still with a strong central area of illumination

Figure 5.94

The Circle Of Light preview screen

there is a line drawn from the center to one of the perimeter boxes and that box serves as the source for the light, with the center merely a location along the beam of the spotlight. The default settings of the Circle Of Light style result in an image that appears as if the photo were shot while the room was illuminated by an old-style color circle (see Figure 5.95).

Soft Spot Style

Selecting Soft Spot from the Style menu results in a single, rather diffuse spotlight displayed in the preview window (see Figure 5.96). This single light is identical in function to the four lights in the Circle Of Lights style, but its attributes are different, resulting in a different effect. The default setting for this style gives you a soft wash of light that illuminates the subject from the foreground back (see Figure 5.97).

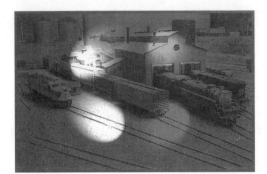

Figure 5.95

The Circle Of Light effect

Figure 5.96

The Soft Spot preview screen

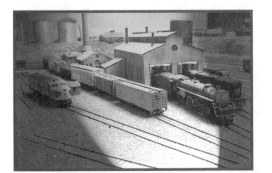

Figure 5.97

The Soft Spot lighting effect in action

Triple Spotlight Style

The Triple Spotlight style creates three spotlights that focus on the center of the image area (see Figure 5.98). You can select and manipulate each of these lights independently, including changing it into another type of light. The default setting for this style results in a dramatic stagelike effect, with multiple lights swooping down to illuminate a central point (see Figure 5.99).

Five and Three Lights Down Styles

The Five Lights Down lighting style—like the similar Three Lights Down—creates five spotlights focused directly down (see Figure 5.100). These lights are functionally identical to other spotlights and can be moved and spaced as you'd like. This style has an interesting effect, creating arches of light on the image that could serve as the basis of further enhancements (see Figure 5.101.)

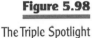

Figure 5.98

The Triple Spotlight style. Note that each light source can be moved and adjusted independent of the others.

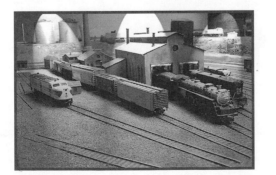

Figure 5.99

The Triple Spotlight effect in action

Figure 5.100

The Five Lights Down lighting effect preview screen

Figure 5.101

The dramatic arched lights that result from the Five Lights Down lighting effect

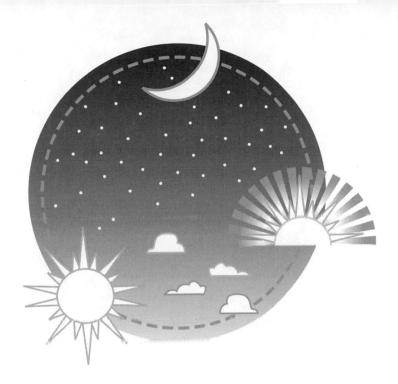

Introduction to Advanced Image Processing

- ✿ Changing Scenes and Backgrounds
- ✿ Correcting Perspective
- ✿ Outputting Your Images
- ✿ Photographs for Web Pages
- ✿ Using Service Bureaus

If you are jumping into this section right after the morning session, give yourself a break. Have a light lunch, and take a stretch. May we suggest strips of grilled chicken over Bib lettuce, mixed wild greens, Ohio tomatoes, and a Balsamic vinaigrette as an appropriate repast for midway through your second full day of digital photography? You'll be spending some serious time in front of the computer from now on, so be sure you're relaxed and comfortable. And remember, never use your computer for longer than is comfortable. Stretch often, giving your eyes and mouse arm a much-deserved break.

To start off the afternoon you'll be working with a few more advanced techniques using image-editing software. These sections are not about making a column of ants run out of Uncle Milquetoast's nose, nor are you about to learn intermediate laser death eye rays (see Figure 6.1). You will be working with ways to get the most out of your photos, particularly how to make a composite image out of two or more digital or hybrid photos. This is where your planning from yesterday will really start to pay off. Remember all the suggestions about taking multiple shots of the same scene using different camera settings? And the promise that it is even possible to increase the resolution of an image beyond what your camera will give you by planning your shots? Well, that's a good part of what the next couple of sections will cover. You'll also get tips on correcting problems with perspective and see some other neat effects to try.

Outlining Objects in Your Photographs

Outlining is the process by which the lines of an object and the data within a digital image are defined and isolated so that the object can be manipulated independently of the rest of the image. Of all the techniques for manipulating

Figure 6.1

We're saving the "World Domination: Photo Tricks and Techniques" section for the next book. So sorry.

digital photographs, outlining is perhaps the most useful. It might interest you to learn that outlining is such an important tool in the digital imaging profession that there are people who specialize in doing nothing but outlining images. While you may not find the idea of spending 40 hours a week outlining very appealing, you will probably discover that you can become very good at this technique without too much practice—and once you feel comfortable with outlining you will begin to find all sorts of interesting ways to use it to improve your photos.

For this section, you'll stick with the basic bread and butter of learning how to outline. The result will be what's called a *selection,* that is, an isolated portion of the image to which you may do all the things you've so far done with an entire photo. The next section, "Changing Scenes and Backgrounds," will introduce you to a few of the cool things that can be done with outlining by combining images into composites.

What You'll Need

To start off outlining, pick a photo with simple lines and high contrast between subject and background. The smoother and more regular the subject's border, the easier your outlining job will be. For most subjects, light backgrounds work best because dark backgrounds can become confused with shadow. Good subjects can usually be found in simple objects, buildings, and landscape shots that include the horizon. If your shooting yesterday didn't include anything that fits the bill, it would be a good idea to pick up your

digital camera and grab a quick shot of something simple like a piece of fruit against a plain light background.

You will at least need simple image-editing software like Adobe PhotoDeluxe or whatever similar program came with your camera. You will get better results if you invest in higher-end editing software like Adobe Photoshop. In the long run, the extra money spent on advanced software can pay for itself in time and fewer miscues in output, particularly when you get to more advanced editing topics. There are special programs for outlining that exist as either stand-alone packages or enhancements to full-blown editing software. For some applications these packages work OK, for others they do not. Your best bet is to learn how to do it yourself.

Outlining with PhotoDeluxe

To start off with (if you're using PhotoDeluxe) you need to realize that PhotoDeluxe comes with what it calls an outlining feature that has nothing to do with the subject of this section. In PhotoDeluxe, outlining is a function that creates a line around objects in an image to create colored or glow effects. There is nothing wrong with this function, it is just a difference in terminology. PhotoDeluxe uses the term *selection* for what we are calling outlining.

Start outlining by opening the Selections menu and choosing the Color Wand tool from the drop-down list (see Figure 6.2). The Color Wand works by selecting similarly colored pixels adjacent to the pixel where you clicked the mouse pointer. Use the Color Wand to select the background or other areas that you do not wish included with your main subject. You will probably find that the first time you click, the Color Wand picks up a relatively small area (see Figure 6.3). The selected area is easy to recognize by the series of moving pixels that surround it, called *marching ants* for obvious reasons. Don't worry

Figure 6.2

The Selections menu in Adobe PhotoDeluxe. Each tool in the drop-down list offers a different approach to the task of outlining.

```
Selections                    ✕
Object Selection Tool    ⬆
─────────────────────────────
✔ Object Selection Tool
  Polygon Tool
  Trace Tool
  Rectangle Tool
  Oval Tool
  Square Tool
  Circle Tool
  Color Wand
  SmartSelect Tool
```

about the limited size of the initial area—the tolerances for this tool are set low so that you do not inadvertently select too much.

The four choices that appear on the Selections menu once you select the tool determine how the Color Wand functions. From the left, the New option allows you to start over with a new outline; the Add option allows you to click on a second pixel and add new areas to your current outline; the Reduce option allows you to click on a pixel to remove similar pixels from your outline; and the Move option allows you to adjust the placement of the outline. Use the Add option to click around the background, increasing the area within the marching ants until most of the background is included (see Figure 6.4).

Figure 6.3

Use the New option under the Color Wand tool to select an area of the background.

Figure 6.4

Use the Add option of the Color Wand tool to expand your outline until it includes most of the background.

The next tool you want under the Selections menu is the Trace tool. The Trace tool allows you to draw loops around pixels that you wish to include, or exclude, from your outline. The Trace tool has the same four options for its function as the Color Wand. Set your image on an appropriate magnification setting, usually between 200 percent and 300 percent, so you can comfortably see the details of the image. Use the Trace tool to collect all the random pixel areas that the Color Wand missed (see Figure 6.5).

The Smart Select tool under the Selections menu functions similarly to the previous two tools, but allows you to set threshold and width for greater control. Experiment on your image with these settings, using Undo from the top line menu if you do not like the results. Use the SmartSelect tool to get in close to your subject (see Figure 6.6).

Figure 6.5

Next use the Add option of the Trace tool to collect the "stray" pixels that the Color Wand missed.

Figure 6.6

SmartSelect allows you to create a finer edge, closer in to your subject.

The Polygon tool is perhaps the most useful of PhotoDeluxe's Selections tools. You can use the Polygon tool to directly draw your outline, distinguishing the fine details and contours of your subject (see Figure 6.7). If you make a mistake, you can use the Reduce option of the Polygon tool to cut out your mistakes (see Figure 6.8).

When you have completed outlining, your entire subject will be surrounded by an outline of marching ants. Your subject is now what's called a selection, and is digitally isolated from the rest of the photo. This isolation lets you use all the processing tricks from this morning's session on your selected subject without affecting the rest of the photo.

Figure 6.7

The Polygon tool has the finest control of all PhotoDeluxe's Selections tools and can be used to get the finest edge detail.

Figure 6.8

The Reduce option of the Polygon tool is a handy way to clean up mistakes in your outline.

Advanced Outlining with Photoshop

In advanced image-editing software such as Adobe Photoshop, outlining is much more straightforward than in PhotoDeluxe. While the PhotoDeluxe methods get the job done, particularly for simple shapes, you do have to use a number of tools and the Reduce options quite a bit as shapes get more complex. In Photoshop you can just create a path, which is essentially an editable line drawn around an object, for outlining. In fact, you can use multiple independent paths for complex shapes (such as the spokes of a bicycle wheel) or to isolate multiple subjects.

Begin by selecting the Pen tool from the Tools menu and Paths from the Layers menu. You can begin to trace the outline of the object, leaving square selector boxes behind every time you click the mouse (see Figure 6.9). These selector boxes are the power of using the Pen tool for outlining; you can click and drag the boxes to change and edit the shape. Compared to the many steps you had to use in PhotoDeluxe, you should find it quick and easy to outline a simple shape with a very precise path (see Figure 6.10).

A path is an object in Photoshop, and is not used to select the shape. You can use the bottom control bar of the Paths palette to turn the path into the familiar marching ants (see Figure 6.11). The subject is now an outlined selection, and can be independently manipulated within the software.

The selection of the object essentially divides the photo into two parts. As it now stands, you have selected the subject. Sometimes it is desirable to make changes to the background rather than to the subject. Use the Inverse

Figure 6.9

Select the Pen tool and the Paths palette to begin outlining in Photoshop. You can click to create a selector box, which you can then grab and move to edit the outline.

Figure 6.10

A simple shape like this tomato can be quickly outlined using a Pen tool path in Photoshop.

Figure 6.11

Clicking the Selection option, third from the left on the bottom control bar of the Paths palette, turns your Path into a selection.

command under the Select menu to select the background instead of the outlined subject. You can tell if the outline selection has been inverted when the square borders of the photo also have marching ants (see Figure 6.12).

One handy thing to do with an inverted image is simply to remove the background information entirely. You can do this by pressing Delete while the background is selected. The result is an image without a background, also called a transparent background (see Figure 6.13). This image is ready for use in creating a composite image, as you'll read about in the next section.

Figure 6.12

The Inverse function selects the background and whatever else is not included within the outline. You can tell the image has been Inverse selected because the marching ants are now around both the subject and the border of the entire image (compare to Figure 6.11).

Figure 6.13

The Clear function under the Edit menu has removed the background, completely isolating the subject. Note the checkerboard appearance, indicating a transparent background.

Changing Scenes and Backgrounds

This section introduces the concept of layers and applying image layers to the outlining techniques you learned in the last section. You might find that you have a great shot of a subject that's important to you, but you may not like the setting or background of the subject. If you run into this sort of problem, you can do anything from changing the apparent weather or arranging for fewer people in a scene to showing your subjects in a completely different place from

the one where you shot the photo. With the techniques in this section, you can simply create the digital image you want from the digital photos that you have.

Several times during Saturday's shooting sessions we suggested that you take multiple pictures of the same subject, perhaps using different exposure modes or metering from a different region of the image area, and that this planning would pay off. In this section you learn how to make the most of your planning. In fact, once you try the techniques in this section and really start to get a feel for combining multiple photos, you can better plan your shooting in the future.

What You'll Need

The techniques in this section are all from Adobe Photoshop. There are other high-end image-editing packages that also allow you to perform the functions in this section—and you could even do a lot of this manipulation with PhotoDeluxe. However, the more advanced the techniques you wish to apply, the more advisable it is to purchase better image-editing software. The more complex the technique, the greater the difference the software makes—you've already seen how much easier it is to outline in Photoshop than in PhotoDeluxe, and that's only the beginning. The discussion in this section, although based on Photoshop, is general enough that you could use the tips to accomplish the same effects using other packages like Corel Photo-Paint and Micrographx Picture Publisher.

Try to find a more challenging image for practice than the one you used for the preceding section—or at any rate, more complex than the tomato featured in the figures. In the examples, you will follow along with the enhancement of an image you saw earlier in the book, the hood-open view of a spectacular Morgan at a car show (see Figure 6.14). There are several things about this image that make it suitable for this section. First and foremost, it is a nice photo of a car with a not-so-great background. It is also a subject with good, clean lines that are easily distinguished. And finally, it includes a glass windshield that adds an interesting complication to the photo and makes for good practice. Pick something like that if you have it. Alternatively, if you got a pair of sunrise or sunset shots yesterday, one with an overexposed sky and a properly exposed foreground and the other with a properly exposed sky and an underexposed foreground, you could use the techniques in this section to put them together.

Figure 6.14

Figure 6.14

The clean, well-defined lines and the less-than-appealing background both make this image an ideal candidate for a background change.

Changing a Photo's Background

Begin this project by redoing the preceding section's exercise—that is, create a path around the subject with the Pen tool, and make it a selection (see Figure 6.15). Your subject is now isolated from the rest of the image so you can manipulate it independently. Before you begin to work with the image, it is a good idea to check your path to make sure you have everything. The Paths palette includes a thumbnail outline of the path, but for complex outlines this can be difficult to make out (see Figure 6.16). Another way to check your outline for accuracy is to go to Photoshop's Quick Mask Mode by either selecting the mode from the bottom of the toolbar or pressing the letter "Q" on the keyboard. This is a toggle function, so you can switch back out of the mode the same way. The mask will show you a simple form of your outline selection (see Figure 6.17).

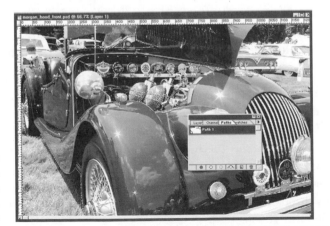

Figure 6.15

The sample image after outlining and selection in Photoshop

Figure 6.16

The Paths palette displays a thumbnail outline of your path.

Figure 6.17

Using an image mask, it is easy to check your outline for errors.

The next thing to do is to place your subject on a new layer to isolate it from the background. The simplest way to do this in Photoshop is to select the Copy command under the Edit menu to copy your selection to the Clipboard. If you immediately follow Copy with the Paste command, the image will automatically be placed in a new Photoshop layer (see Figure 6.18). This functionality is present in all intermediate and professional-level software, but check the package that you're using to see whether it automatically creates a new layer with Paste. In some software, you must create and select a new layer before pasting.

Layers are a very powerful and deceptively simple tool, and they can take a bit of getting used to. The basic notion is that you view an image from the top layer down, with objects on higher layers obscuring what's below. There are two exceptions to this rule. First, if an object has transparent regions, as with the selection in the preceding exercise, objects in lower layers will show through in the transparent areas. Second, layers have a property called *opacity.* Standard layer opacity is 100%, meaning that nothing of the underlying layers shows through; however, you may set the layer opacity from 1% (essentially invisible) to 100%.

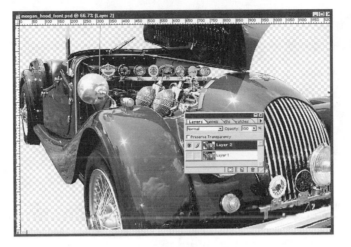

Figure 6.18

The selection copied to a new layer within the same Photoshop document

You may turn a layer off by clicking on the Eyeball icon at the left of the Layers palette. When you do this, the layer information remains part of the file but is not part of the image display. This allows you to retain your original image should you need to make further use of it, while not having it interfere with the display. This is why you do not see the original background in Figure 6.18. To work on a layer, click on it and it will be highlighted. Forgetting which layer is the active layer is probably the error most folks make who are new to working with layers. You can spend a lot of time editing the wrong layer, and in many cases this will result in lost work and a waste of your time. Get into the habit of checking the Layers palette for the active layer to avoid this mistake.

Photoshop will paste new layers immediately above the layer you currently have selected. What if you make a mistake? Simply grab the layer and drag it up or down the list in the Layers palette to the spot where you want it. If you end up with images that have many layers, getting a layer to the right location in the list can be an art in itself.

Getting back to the project at hand, you now have the subject isolated on its own layer. Where to put it? We used an old hybrid photo we had of a pasture (see Figure 6.19). Although a nice image, it lacks any sufficiently strong subject or lines to make it a good shot; however, images such as this one can make excellent backgrounds for other photos. Paste the background image into a layer and place it below your subject on the Layers list (see Figure 6.20).

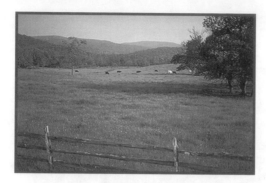

Figure 6.19

The pastoral scene, a hybrid image, used for the new background.

Figure 6.20

Simply placing the new background below your subject won't work in most cases. Notice the artificial floating appearance and how the car is generally misplaced.

The result is a subject that seems to float above the background, and is probably not well placed within its new setting.

To make the digital shot of the Morgan a better fit, the next step expands the background. You could opt to shrink the subject instead, but in the case of this sample that is not desirable, nor would it work very well because the subject goes out of the image area and is cropped. To expand the background, select Scale under the Transform submenu of the Layers menu. Be sure that you have the background layer selected, and not the subject! This will give you handles that you can click and drag to expand the background (see Figure 6.21).

Figure 6.21

Use Transform on the background layer to expand it to size.

Combine the Scale Transform and the Move tool from the toolbar to position the background the way you want it (see Figure 6.22). Once you are happy with the position and scale, you will have an image that's pretty close to what you want (see Figure 6.23). While you can probably think of a multitude of additional things you'd like to do to the image, this exercise will stick to adding a windshield and a realistic shadow to the car.

Select the layer with your subject and make an outline of the windshield area (see Figure 6.24). Make sure the foreground color is white in the toolbar, and

Figure 6.22

The background is expanded and moved to suit the subject.

Figure 6.23

The final background placement. Notice that the car still appears to float above the field.

Figure 6.24

Make the windshield area a selection to begin the process of adding the appearance of glass.

select Fill from the Edit menu. Fill your selection with white at about 15% opacity (see Figure 6.25). This simulates the glazing effect of a window, and adds just enough haze to the background behind the window area to give the illusion of the presence of a windshield (see Figure 6.26).

The final task in this project is to add a shadow to the image. Without a shadow, the car still appears to float artificially above the grass in the background. Shadows give the illusion of depth to an image and make the whole thing come together.

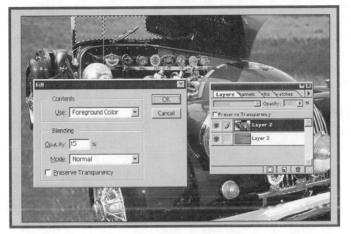

Figure 6.25

The Fill dialog box set to 15% opacity for the windshield.

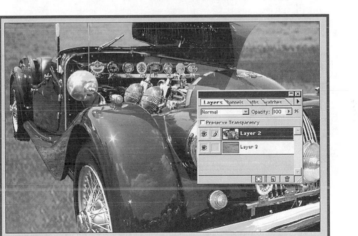

Figure 6.26

The finished windshield with a simulated glass look.

Too add the shadow, either select the layer of the object that needs a shadow or create a new layer just for the shadow. Select the Airbrush tool in the toolbar and the 100% diffusion brush from the Brushes palette (see Figure 6.27). Make sure that you have the foreground color set to black, and begin to paint from back to front in the image.

Use the Airbrush Options palette to select a pressure for the brush. The pressure option is similar to opacity: the higher the pressure, the less diffuse the brushstrokes. Select an option that looks good for your subject, typically starting at about 15% near the image and decreasing with successive strokes farther from the subject (see Figure 6.28). The final result is a composite digital image of the subject and background that looks like the real thing (see Figure 6.29).

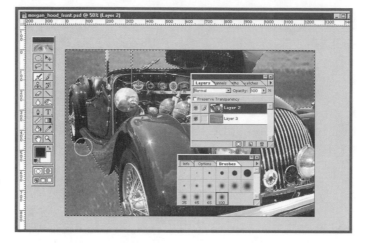

Figure 6.27

Selecting the Airbrush tool and the Brush style.

Figure 6.28

Partway through building the shadow. The first stroke is in at 15%, the next will be lower.

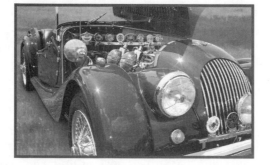

Figure 6.29

The final image with completed shadow. Now the car actually looks as though it belongs on the field.

Using Layers to Increase Resolution

One useful application of the techniques in this section is combining multiple shots to increase the resolution of a digital image. By adding components to an image, you can increase its total amount of information. Suppose you want to make an 8×10 print of three subjects on a background, but you already know that you aren't happy with the way your camera deals with prints that big. Follow these simple steps: Take a wide shot of your subjects and background the way you want everything to look in the final image. Then zoom in and grab a full-frame shot of each subject by itself. Open the wide shot and expand it to an image size of 8"×10". Outline each of your subjects from the close-up shots and import them into the big image. Place each individual subject over its lower-resolution counterpart in the main image. The result will be a sharp composite that will print better than the single original would have—the background may be a little vague, but that will just call attention to your subjects.

Correcting or Distorting Perspective

Saturday Morning's "Architecture, Buildings, and Structures as Subjects" pointed out that you don't need expensive perspective-correcting lenses with digital photography. In keeping with the tradition of Sunday delivering on Saturday's promises, now you'll see how to use software to correct perspective. Of course, what one may fix with software, one may also break, and so it is also possible to use the techniques in this section to create distorted images.

What You'll Need

Start off with a digital photo that has distorted perspective, perhaps a tall building (like the one in Figure 6.30) or some other subject shot from an unusual angle. A basic image-editing package like PhotoDeluxe will do just fine for this exercise, although the advanced features in a package like Photoshop can be to your advantage.

Correcting the Perspective of a Digital Photograph

The first and most fundamental step to correcting perspective is quite simple in PhotoDeluxe. You can select Perspective (or Distort) under the Size menu to get a set of handles that let you alter the photo (see Figure 6.31). Grab a

handle, any handle, and change the perspective of the image. With PhotoDeluxe you have to "eyeball" things to get the image the way you want it (see Figure 6.32).

Figure 6.30

The original image. Notice how the sides of the building slope in due to distance and the use of a wide-angle lens.

Figure 6.31

The Perspective handles in PhotoDeluxe. Grab a handle with your mouse to change the perspective of the photo.

Figure 6.32

The result of dragging the Perspective handles. It is necessary to move the handle the approximate amount needed and then apply the change to see if the result looks OK.

The image in Figure 6.32 is fine, as far as it goes, but notice the lower right and left corners. Correcting the perspective so that the building's walls appear straight also pushes the bottom of the image together, creating dead space. One possible fix would be to use the Crop tool to simply make the image smaller, cropping away the corners. But what if you don't want a smaller image, or if cropping the edges will lose some critical portion of the shot? Well, you can always recorrect the corners to fill the image space.

Use the Rectangle tool from the Selections menu to grab each corner of the image in turn (see Figure 6.33). Then use the partner to the Perspective tool—the Distort tool—to convert your selection to an active Distort box with handles (see Figure 6.34). Unlike the Perspective tool, the Distort tool permits you to change the perspective of the image or image selection in multiple directions, so you can use it to push the edges back to fill the corners (see Figure 6.35).

Figure 6.33

Use the Selections tool to grab each corner in turn.

Figure 6.34

The Distort tool in PhotoDeluxe. Use the handles to stretch the selected portion of the image back to fill the image area.

Figure 6.35

The results of the Distort tool, filling in the right corner. Do the same to the left side to complete the job.

Distort will not allow you to make a perfect correction. It does what you want, but it also makes part of the foreground extend beyond the active image area (see Figure 6.36). Use the Crop tool to finish off the image, creating a final photo that has correct perspective without lost corners or extra extensions (see Figure 6.37).

Correcting Perspective with Photoshop

The essence of perspective correction in Photoshop and other professional software is identical to the PhotoDeluxe demonstration. The more advanced software does offer tools to make your job easier, however, and to improve your results. Begin working with your image by dragging guides from the side

Figure 6.36

The effect of the Distort tool extends beyond the basic image area, creating excess information.

Figure 6.37

The completed image, trimmed using the Crop tool to remove the excess that resulted from the use of the Distort tool.

ruler to line up with your subject. These guides make it easier to know when you have corrected the perspective of your image, because you do not have to depend on "eyeballing it" as you did in PhotoDeluxe. Then select Perspective from the Transform menu to bring up handles (see Figure 6.38).

An additional advantage offered by Photoshop is the ability to review your changes in real time, as you make them (see Figure 6.39). This allows you to move your handles to create the effect you want, without having to create an effect by guessing and undo it if you don't like it. This makes changing perspective much easier, particularly when combined with guides. Proceed from here as with PhotoDeluxe.

Figure 6.38

Image guides in Photoshop help you fix the perspective of a distorted photograph.

Figure 6.39

Photoshop displays perspective changes in real time, allowing you to see the effect as you correct the image.

Other Effects to Try

So far today you have seen quite a lot of the tools and techniques available to you with image-editing software. Using these tools individually and in concert with one another will allow you to do some incredible things with your digital photographs. In addition to the basic tools and the prepro-grammed effects available with your software, various third parties make available supplemental tools and add-ons to image-editing software that greatly expand the functionality of the programs. Most of these supplements are designed for use with higher-end packages, and some can be almost as expensive as the base software itself.

The software supplements come in two basic forms. A *plug-in* is a type of program that expands the functionality of some other software package. The TWAIN driver for your digital camera is an example of a plug-in. The other type is a *macro*—a set of instructions that make use of features of the existing software in ways that would be difficult or tedious to work out from scratch (in Photoshop it's called an *action*)—which another user has developed and decided to share with others. You'll get a look at both styles of supplement in this section.

What You'll Need

The sample plug-in used in this section is Eye Candy 3.0, from a software company called Alien Skin. This plug-in is compatible with a variety of

higher-end software packages, including Corel Photo-Paint, Microsoft Image Composer, and Photoshop, which will be used for the exercises in this section. If you do not have an appropriate software package, Alien Skin also offers the stand-alone Eye Candy 2.1 LE that includes many of the same filters and effects found in the plug-in. If you do have an eligible software package, download the demo version of the Eye Candy 3.0 plug-in from **www.alien-skin.com** (see Figure 6.40). This demo version allows you to try the package but limits your ability to save the effects. Use an image with an outlined selection to run through the Eye Candy demo (see Figure 6.41).

Having a book or other resource on the use of your software is also useful. There are too many packages to cover them all here, but to do the examples in this section you will have to know how to use beginning and intermediate options in your image-editing software—things like playing actions and adding plug-ins. If you are not sure of how to do these things and don't have

Figure 6.40

The Eye Candy 3.0 demonstration version is available from **www. alienskin.com**.

Figure 6.41

Use an outlined selection to try out the Eye Candy demo. Deleting the background helps you appreciate the full impact of the effect.

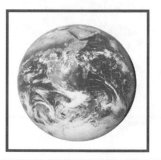

an appropriate resource available to help, you should consider merely reviewing this section as a reference for what you can do in the future when you are more comfortable with the image-editing software of your choice.

Eye Candy Effects

One of the terrific and most powerful things about Eye Candy is that it will operate upon selections. For example, starting with version 4.0, Photoshop has an automated drop-shadow capability that is limited to the entire image area. Eye Candy's drop-shadow function follows the contours of a selection, making it much more useful than the standard Photoshop function (see Figure 6.42). Photoshop 5.0 will do this, too, but has fewer options than the Eye Candy effect. You will also notice that the Eye Candy effects feature a great number of options and variants, so many that you could spend hours exploring them all.

TIP

To add a drop shadow to part of an image in Photoshop 5.0, start by outlining and selecting the portion you want to shadow. Copy your selection to a new layer and apply Photoshop's Drop Shadow effect. The shadow will be limited to the selection, resulting in a contoured effect.

Perhaps the most popular, or at least best known of the Eye Candy effects is the Fire filter. At its most basic, this filter makes your image selection appear to be engulfed in flames (see Figure 6.43). The really cool thing about this filter, though, is the amount of control it offers. You can change the inner and outer color of the flames, altering the appearance from a natural look to, for example,

Figure 6.42

The Eye Candy 3.0 drop-shadow effect. Notice how the effect follows the contours of the outline, making it ideal to add multiple shadows to a single image.

an other-worldly magenta fire. You can also change the other elements of the effect, from flame height to the degree the flame covers the selection (called *inside masking*). A series of presets are included to start you off, but you can create and save whatever sort of fire you like.

The next logical step from fire is water; more specifically the Eye Candy Water Drops effect. This effect scatters a series of round, nearly transparent water drops across your image (see Figure 6.44). Some of the controls, like refraction, may not be instantly intuitive to you, but if you play around you'll find this to be a fairly flexible filter. Certainly one of the nicest controls is the ability to adjust the direction of light reflecting from the drops, this allows you to match the drops to the real light in your image.

Figure 6.43

There are even nastier things in store for the world later on, but the Eye Candy Fire effect has started things off in the right direction.

Figure 6.44

The multitude of options available with the Water Drops effect makes it a versatile addition to your digital imaging toolkit.

Another cool effect is to use the Motion Trail filter to give a region of your image a simulated blur, as if moving (see Figure 6.45). If used carefully, this filter could be used to add interest to those motion shots from yesterday's shooting where your camera's flash froze the motion more than you like. You can control the direction of the blur, and whether the trails go just along the edges or over the entire selection for a dramatic effect.

We Just Couldn't Help It!

You may remember at the start of this afternoon's exercises we told you that we wouldn't reveal the secrets of world-dominating effects in this book. OK, we lied. What would you expect from two guys who'd come up with an image like that to begin with? Here goes, with the caveat that the techniques discussed here are not for the faint of heart, and best practiced with a Photoshop reference in hand as a backup. This section will quickly cover what was done and the general points to getting there, but if you aren't already reasonably comfortable with Photoshop you're better off treating this as a fun reference, rather than a blow-by-blow how-to instruction set.

Beginning with the end, the digital photo composite was built in Photoshop using a total of nine layers (see Figure 6.46). It took three different sets of procedures to prepare the total image: globe, eye beams, and the original photo with background. We'll give you the overview of each in turn. Combining the three elements just follows the procedures you've already learned earlier this afternoon in "Changing Scenes and Backgrounds."

Figure 6.45

You can create the illusion of all sorts of motion in your digital photographs using the Motion Trail filter.

Figure 6.46

The completed image, showing the arrangement of all the Photoshop layers.

TIP

The image of the globe came from a public domain NASA Web site. There are several governmental agencies such as NASA that have loads of images on line, and because we all own the government, they are free for use by all. Of course, always be sure to check the specific permissions from a site; sometimes images are produced as part of special programs that are not public property.

In keeping with the public domain spirit of the globe, the fiery effects were added by use of two publicly available actions from the Ultimate Photoshop Web site (**www.ultimate-photoshop.com**). You can use the actions from this site freely, but you may not pass the actions themselves on for anyone else to use.

The NASA globe was processed using an action called Fire and a second called Ice (see Figure 6.47). These actions create effects that go on new layers, but are based on the underlying image (see Figure 6.48). When layered with the original outlined image, the combined effect is typical of any puny world that dares to oppose the awesome might of your average death eye-beam-wielding intergalactic ogre (see Figure 6.49). This process is all automatic except for the few places where the program asks you to interact with it. The globe winds up combined but in a new layer—if you don't like what you got, you can start over easily.

Figure 6.47

Building complex
Photoshop actions
like these can take
hours or even days.
Fortunately, the
good folks at
**www.ultimate-
photoshop.com**
are willing to
share.

Figure 6.48

The results of the
Fire and Ice
actions, shown with
globe removed.

Figure 6.49

Real estate prices
are dropping
precipitously
throughout the
globe as the effects
of the combined
actions are felt.
Group the three
layers so that you
can move them as
a single unit.

To create the eye beams, start with a path drawn using the Pen tool. Make the path a selection, and then under the Select menu choose Feather to create soft edges for the path (see Figure 6.50). Enter Quick Mask mode using the Selected Area option, and under Filters run a Gaussian blur on the eye beam to give it that final diffuse look (see Figure 6.51). Leave Quick Mask mode, and under the Edit menu, choose Fill to fill the selection with the color or gradient of your choice. Make a copy of the eye beam layer so that you have one for both eyes. You will layer one beam above the globe, and the other below. In the case of this example, both will be above the ogre figure, so that the beams appear to emanate from his eyes.

Figure 6.50

The beginning of the end for the Earth. The laser eye beams start out Innocuously enough as a simple path with feathering.

Figure 6.51

The eye beam is masked and a Gaussian blur is applied. All that remains is to fill it with the globe-dissolving color or gradient of your choice.

To create the ogre with background, begin with an ordinary digital photo (see Figure 6.52). Use the outlining technique with which you are now thoroughly familiar to isolate your ogre wannabe and remove the old, boring non-inter-galactic background (see Figure 6.53). Selecting Clouds from the Render option in the Filters menu creates the new background based on the fore-ground and background colors (see Figure 6.54). Except for the colors, the Clouds filter has no options associated with it, and the "clouds" formed don't look much like anything anyone has ever seen in the sky unless you're really careful with the colors and make judicious use of the Fade command; still, Clouds is an effect that gets used quite a bit, and it does give our ogre a nifty hyperspace background.

Figure 6.52

It all starts with a more or less normal digital photo. Of course, all things are relative, and for Dave Braun this is about as normal as they ever get.

Figure 6.53

Outline the subject, select it, and delete the background. It's as easy as that.

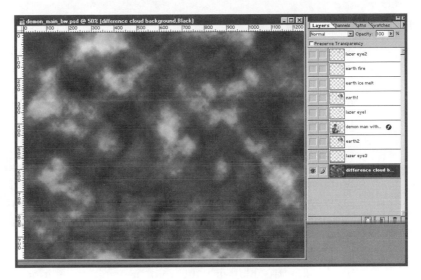

Figure 6.54

The background created using the Clouds effect. Layer everything together, and it's watch out, world!

There is a subtlety to the image that has yet to be covered. If you run the Clouds filter in its own layer, you can only place it above or below other elements. Reducing opacity can help, but to get the shirt-coming-from-the-ether look in our final image its necessary to do something else. One way to do this is to create a selection outline that includes only the ogre's shirt and fill it with a Clouds rendering, just as you filled the eye beams with a color gradient. If you are particularly adept at Photoshop, there's an even better way to do this using a tool called an Alpha channel, but that goes way, way beyond the scope of both this section and this book. If you want to get really good at creating photo composites using Photoshop or a similar program, get a good book on the subject and practice, practice, practice.

TIP

A good how-to on Photoshop is an excellent companion to this book. The techniques described here are a terrific start on improving your pictures with software, but if you are serious about great images, you'll want to get deeper still. Check out Prima's *The Essential Photoshop 5 Book* as a terrific way to take your digital photos to the next level.

Removing Red Eye

Well, enough hyperspace; it's time to get back to the mundane but useful world of digital photo processing. As you saw yesterday, the flash setup on a consumer-level digital camera makes it very likely that you'll get photographs that are just great except for the most important bit—your subjects' eyes blaze red instead of looking natural.

There are all sorts of ways to remove red eye, ranging from special flash modes to simplistic functions added to consumer-level software like Photo-Suite and PhotoDeluxe to elaborately elegant features in high-end image-processing programs. You've already seen the problems with using your flash to remove red eye—it eats batteries, and your subjects tend to move before the shutter does. But if you try most of the simple software solutions, you'll find that they blot out red eye with a uniform or nearly uniform splotch of black. The trouble with the splotch-of-black solution is that one of the things that puts life into photographs of people and animals is the glint of light typically visible in the pupils of the eyes. So these solutions give you a dull zomboid look in place of the original lively demonic glow. You can do better, and quite easily, with Photoshop.

To fix red eye without losing reflections, begin by entering Quick Mask mode and selecting the Airbrush tool. Zoom in on the image until the eyes appear quite large, typically at least a 200% setting. Pick an airbrush size that's about the same as the size of the pupils and click on each pupil, creating a mask for each (see Figure 6.55). Transform the masks into selections, so that you can

Figure 6.55

Use the Airbrush tool in Quick Mask mode to mask off the pupils.

work with the area of each pupil separately (see Figure 6.56). Now open the Fill menu and select Color Mode before filling with black at a moderate opacity (see Figure 6.57). The fact that you used the Airbrush tool to create the selections will make the edges of the fill soft and natural in appearance. The Color Mode in the Fill dialog box restricts the fill to the regions of the selection that have color information. Because reflections arc *specular*—that is, all white, which counts as *no* color information—Color Mode doesn't black out the reflection in the pupil.

Figure 6.56

Transform your pupil masks into selections.

Figure 6.57

Using the Color Mode in the Fill dialog box you can replace the red with black, while maintaining the reflection highlights.

Take a Break

So, do you feel like a bona fide digital photographer? The end of your training approaches, Grasshopper, and it is nearly time to send you out into the world. A short brisk walk might help clear out the cobwebs prior to the final push to the big finale. For libations, we can recommend quaffing a bit of Old Peculiar as an excellent way to finish the weekend.

Outputting Your Images

So far, you've managed to shoot great digital pictures and make them look just the way you want—on your computer monitor. That's wonderful; when you want to show friends your shots of your last vacation, you can all crowd around the old 17-incher and gasp with amazement at how great your shots look. Right, not such a swell scenario. You'll now want to do something with your photos to help you share them and to use them in effective communication.

There are basically four categories of things to do with your photos, and you'll get to all of them this afternoon (Figure 6.58). First off, you'll almost certainly want to make prints of your shots. You can make prints yourself, or you can use a professional service bureau to make the prints for you. Another option, and this may sound a bit confusing when compared to point one, is preparing your files to be sent to a print shop. This is a different printing process, known as halftone printing, and requires a different approach. You may also want to actually do the reverse of the hybrid photography process, and send your digital photos to be shot on film—say, to do a slide show or business presentation when you can't slave a monitor to a projection unit and use the digital images directly. And finally, you may wish to output your files electronically, as other files. Probably the most common reason you'll want to do this is for display on a Web site, although there are plenty of other potential multimedia applications as well.

A fair amount of the outputting topics will be in the realm of theory. Hopefully you have at the very least a computer printer with which you can make some sort of hardcopy prints, and of course you can use your editing software for electronic output. Still, many of the topics like using a service bureau are simply not something you'll be able to experience today—especially not if

Figure 6.58

It is hard to count the ways currently available to share your digital photos, and the number grows daily.

you're on schedule and it's Sunday afternoon. You can use the next couple of hours to practice working with your digital photographs and preparing them for these uses.

Overview of the Most Useful File Types

One often critical—and potentially very frustrating—element of sharing images electronically is that of the format of the image file. While most imaging software applications today can readily read and write a multitude of file formats, probably none will work in all types, which of course means that inevitably you will want to share your images or collaborate with someone who needs to work in a file format with which you'll have some difficulty. If you are preparing files for outputting by a service bureau, it is possible that they will have very specific requirements for the files you submit to them—and slap you with corresponding fees if you don't comply with their requirements.

If you do a lot of file sharing you will want to invest in software that specializes in making file transfers easier. If your sharing includes cross-platform support, you will want to make sure that you have that covered as well. Many fine packages exist, but personally we have great success using Equilibrium Debabelizer Pro for file conversions and DataViz Conversions Plus to move files between PCs and Macintoshes (see Figure 6.59). Whatever tools you end up using, the list of commonly occurring file formats and the challenges they present remains constant (see Figure 6.60).

Figure 6.59

File conversion programs like DataViz Conversions Plus are an essential software component of cross-platform file sharing.

Figure 6.60

A screen shot from Adobe PhotoDeluxe showing the list of file formats with which this program can work.

Cross-Platform Issues

Just as it appears that most of the computing world is devoutly PC based, most of the digital imaging world is equally devoutly Macintosh. Why that is, and if it's a good thing, is immaterial; what does matter is that if you end up doing a bit of digital photography you will sooner or later end up having to cross the PC-Macintosh barrier. In most cases, it is the person who saves the file for use by another who must bear the burden of making it work correctly.

Saving Mac Files for PC Users

Odds are, you are a PC user, and so are not likely to have to save files on the Macintosh yourself. However, if you work with a graphic artist or service bureau for outputting or scanning services you may find that they work on a Mac and will need to give you files. That's great, except that most graphics folks are so exclusively Mac oriented that they never quite get the rules right for saving files for PC use, so you'll need to know these rules to help them out; it'll make your life easier in the long run.

The good news is, most Macs today can read and write to PC-formatted discs out of the box. This seemingly great advantage does have a downside, though, because many Mac folks think that it alone is enough to allow PCs to read their files—which just isn't so. The big problem with files saved on the Mac for use by the PC, assuming that the file is saved in a mutually agreed-upon format (list coming up shortly), is the file name. There are two elements of misunderstanding when it comes to naming PC files: the characters that can be used in the name and the size and content of the file extension.

The issue of *legal characters* was made simpler with the advent of Windows 95 and 98, but that simplicity hides some increases in difficulty. In the MS-DOS days, every Mac user knew about the 8-character limit for the main part of a PC file name. Windows 95 dropped that limit, but made very few other changes. So while the space character can now be used in a PC file name, the following characters are still on the forbidden list: forward slash (/), back slash (\), colon (:), asterisk (*), question mark (?), quotes ("), greater than (>), less than (<), and the separator (|).

Furthermore, every PC file name should have one period in it, but only one, and that's to designate the file extension. PCs use a three-character extension following a period at the end of the main part of the file name to identify the type of file and the program that produced it (or can read it). That's a fine system, and one that has worked well in one form or another for a couple of decades now, but it is something that Mac users often find befuddling. If you're working on a Mac, make sure that you know the three-character extension for the file type you're using and add it to every file destined for use on a PC.

If you get a file from a Mac that is in the proper format but does not have the proper three-character extension, all is not lost. You have three options at this point. Probably the best thing to do is to simply change the name of the file so that it has the proper file extension. This is great, unless the file is on a read-only

medium like a CD, in which case you'll have to copy the file to another drive before you can rename it. Another option is to use the Windows 95/98 Open With dialog box (see Figure 6.61) to point the file to your application of choice. And finally, you can launch your imaging application, go to its Open File or perhaps an alternate Open As dialog box, and explicitly tell the software how to treat the file. Not all packages support this feature, so there's no time like the present to check your software to see if it does.

Saving PC Files for Mac Users

Creating files on a PC and saving them for use on a Macintosh tends to be even more challenging than the reverse operation. Do not count on the Macintosh's ability to read PC disks to solve the problem for you. Many Mac users will assure you that it shouldn't be a problem, only to have a problem arise. Your best approach is to take responsibility for the disposition of your files and see to it they get properly prepared in a Macintosh format.

CAUTION

◆◆

Most Macs can read PC disks, but that doesn't mean they can use the files stored on the disk. Use a file conversion program for best results, and whenever possible do a trial run before sending anything important across platforms.

◆◆

The first element to saving files for use on a Mac is to write the file to a Mac disk. To do this you will need a utility program that will allow you to read, write, and format Macintosh disks on your PC. Several good options are available; we use DataViz Conversions Plus (see Figure 6.62). This will get you halfway there, because you can write a file as if your machine were a Macintosh.

Figure 6.61

The Windows Open With dialog box. Start by right-clicking on the file, select Open With, and then select your software from the list of registered programs.

Figure 6.62

Using DataViz
Conversions Plus
you can format a
disk for Macintosh
computers on a PC.

For many purposes, this is in and of itself much better than simply sending a PC-formatted disk and will eliminate many potential problems.

To really be sure of your file, the second element of a Macintosh file is what is called the *resource fork*. Just as PCs use the file extension to identify a file, Macs use the resource fork to instruct the computer as to the file type and the program to use to open the file. Simply saving a file from an application to a Macintosh-formatted disk will not write the fork—when the Mac user opens the file the machine will see it as a Simple Text file. The Mac user will have to do some computational calisthenics to make the file usable.

The good news is that all is not lost with regard to the resource fork. If you use software with an export and convert function, it will not only let you write to a Macintosh-formatted disk, it will also write the resource fork for you, making the file fully usable on a Mac. Conversions Plus and another utility, MacDrive 98 by Media4, will do this. If you do a lot of this sort of file creation and transfer, you should get one of these utilities.

BMP

A BMP file is what is known as a Windows bitmap. It is a format designed for use on Windows and OS/2 systems and is hardly ever found in any other environment. The BMP specification supports color depth of 1, 4, 8, and 24 bits, so the format can be used to represent digital photographs (see Figure 6.63). BMP is a raw, uncompressed file format, and so like TIFF can be used for image editing—but in practice BMPs are mostly used for small files like icons and system resources or for inclusion in multimedia applications.

Figure 6.63

Options for saving a BMP image. Pick Windows and the highest color depth offered. Do not use RLE compression unless your recipient specifically asks for it.

CGM

CGM stands for Computer Graphics Metafile. In general, a *metafile* is a file that includes computer instructions and references to other files. There are many metafile formats, but only CGM is a standard for use on all computing platforms. Is it unlikely that you will ever need to create a CGM file, but you may find older computer images stored in this format. Most image-editing programs today can neither import nor export CGM files, so you will need to use a conversion utility if you want to work with a CGM file.

EPS

EPS stands for Encapsulated Postscript. Postscript is a page description language that was developed for use with high-end printers. You will find that many imaging professionals work with EPS files, and this may be one way that they deliver scanned files to you, or a service bureau may require an EPS file for output. If you have separated an RGB file to CMYK yourself, you will probably save it as EPS. The EPS format actually produces two files for each image, the high-resolution Postscript portion and a low-resolution thumbnail. This is handy, particularly in the case of a very large EPS file that may take a while to load even from a very fast drive. You can preview the thumbnail to ensure that you are opening the right file (see Figure 6.64).

Opening EPS Files

If an EPS file is all bitmapped information, then usually it can be opened by an image-editing program in the manner used for all other files. Many EPS files have non-bitmapped data, however, and so the editing software must convert them to bitmap form as part of the process of opening the file. Because vector information is resolution independent, the program will have to ask you for the dimensions of the image (see Figure 6.65). That's fine, as long as

Figure 6.64

An Open dialog box for an EPS file. The thumbnail file appears onscreen automatically, allowing you to evaluate the contents of the image before opening the file.

you know what they are supposed to be. Getting the dimensions wrong can distort the image. The good news is, most programs will start you off with a suggestion for the image dimensions. Usually, the proportions of the suggestion will be correct for the image, even if the suggested size is not what you want. If you have a Constrain Proportions option available, you can adjust one of the measurements to the desired size and the other will change to correctly correspond to the new size. And remember, as long as all of the information in the file is vector, you can make it any size you wish without loss of image quality. Once you rasterize the file to bitmap, of course, you are stuck with your choice of size.

Other options for opening an EPS file include resolution, color mode, and anti-aliasing. For the most part, you will want to match the size of the photographic images with which you are working. Digital cameras typically capture digital photos in RGB color mode and 72dpi or 144dpi. You should select the anti-aliasing option, as this will improve the image quality by smoothing curves and eliminating jagged contours.

Figure 6.65

The dialog box for opening a vector (or Generic) EPS into a bitmapped program. Choose an appropriate size and open the file in RGB mode.

Saving EPS Files

If you are transferring your files to be used by a designer or artist as part of a desktop publishing or page layout program, or if you are sending them to be printed by a service bureau, you will probably want to save your files in EPS. Most editing packages offer you a slew of options while saving an EPS file (see Figure 6.66), but you should ignore the majority of them. One element that does matter is the compression, often called encoding, you apply to the file. At the very least, you will probably be offered the choice of either ASCII, which is essentially uncompressed, or binary encoding. If you are sending the file to someone using a PC, select ASCII; Mac users can use ASCII, but will appreciate binary. The ASCII file will be much larger than with binary encoding, but you are assured of compatibility. If your program offers other compression methods such as JPEG, do not use them. Most devices do not support methods of encoding other than ASCII or binary.

◆ ◆

CAUTION If you try to open an EPS file on a PC and it just looks like an empty box, it was saved in a binary format, and thus only usable on a Macintosh. The ASCII version of an EPS is the most universally applicable form, so unless you know for certain that your recipient will be using a Mac, stick to the inefficient ASCII version.

◆ ◆

Figure 6.66

Options for saving an image as an EPS file. Be sure you know what encoding the recipient needs— and leave the other options for when you have more experience.

FPX

The FPX extension is for the FlashPix image format. In many ways, FlashPix is the successor to the Kodak Photo CD Image PAC format (PCD) and shares some common features. As with PCD, FPX files are saved in a tier of sizes. Unlike PCD, those sizes are not fixed but variable, sizing down from the full original. FPX files can be in the raw file size, or they can use JPEG encoding to compress the file. An increasing number of image-editing packages now have the ability to import FPX files, and a few can save them. Most applications simply load the highest resolution file and ignore the rest. If your software gives you an option as to the file size to load, stick with the full-size file.

GIF

Files in the Graphics Interchange Format are some of the most common you'll encounter. GIFs are indexed or 8-bit color and so are not suitable for using while editing. These files are a common output option, however, in spite of the limited number of colors. Don't confuse the limit to 8-bit color with what happens when you view 24-bit images on a 256-color monitor. GIFs can be made from the 256 best, or most suitable, colors out of the 24-bit color space, and so many images appear to be of near-photographic quality as GIFs. When saved, 256-color GIFs are smaller than raw files like TIFFs because of the reduction in color, but are larger than a compressed 24-bit JPEG. The good news for computer resources, however, is that while the GIF may take a bit more disk space, it does not need as much computing memory and horsepower as a JPEG when you display it. See the next section, "Photographs for Web Pages," for more information on GIF images.

JPEG

Another very common file format, JPEGs (the acronym stands for Joint Photographic Experts Group) are compressed files that may be in either 8- or 24-bit color. Because they are compressed, you should not edit a JPEG file directly, but use a TIFF file that then gets saved to JPEG as the final step in processing. JPEG images save disk space and are useful for transmission over a modem because of their small size, but require the same amount of computer memory to display as a raw file of the same pixel dimensions and color depth. Because the file must be decompressed for viewing, it actually requires more computer horsepower to display than an uncompressed file. These system

resource points can become an issue, particularly when using JPEGs in multimedia presentations, because accessing JPEGs can cause system delays during decompression.

PCD

PCD stands for PhotoCD and is the extension for Eastman Kodak's Photo CD Image PAC file format. You will probably never save files to this proprietary format, but if you use PhotoCDs you will need to import them. PCD images are 24-bit bitmaps and can be used in one of several sizes. The trick with PCD files is deciding which size to use. You may find that for many uses selecting the largest size available for processing is the best route—use the information it offers, then simply resize the image before you're done. If you intend to crop the image, always make sure that you do not end up having to enlarge the cropped area to get the final size you need. For example, if you intend to have a final image size of 500×400 pixels for electronic distribution, you might think that the PCD Standard file size of 512×768 is OK. But it doesn't leave much room for cropping—if you decide to keep only part of the image and you crop it to below 500×400 to get the piece you want, you will get noise and rastering when you expand to fit your final size.

◆◆◆

Whenever possible, avoid enlarging your digital images. Enlarging your images causes the "jaggies" and generally reduces quality. When using file formats like PCD that offer multiple resolutions, this often translates into using the highest resolution available if you plan on editing the image.

◆◆◆

PCX

The PCX format is an older type of Windows format that is 24-bit color capable. This file type seems to have some small compression associated with it, because files are a bit smaller than the raw form, although memory usage is identical to that of the raw file. The only place you are likely to want to use PCX files is if you export files for use with some desktop publishing, word processing, and greeting card programs.

PICT

The PICT format is the Macintosh format that corresponds to BMP on the PC. This format supports color depth up to 32-bit, and may also include vector information. If you work on a Macintosh, or share files with those who do, you may find yourself working with PICT files.

PSD

A PSD file is the native format for Adobe Photoshop image-editing software. Because of the popularity of the program, you are likely to run into this format even if you don't use Photoshop. PSD files have the great advantage of including all the information about creating the file, so you can get right in and make more editing changes. Of course, some folks see this as a disadvantage, because they don't want folks messing with their images. It is your call.

If you are a Photoshop user, creating a PSD file is as easy as using the Save command on the File menu. If you are not a Photoshop user, find out if your program can import PSD files, and if so, what version. The most recent version of Photoshop is 5.0, but many programs from other software vendors do not yet support this version. Know your software and how it functions before giving someone the go-ahead to send you a PSD file.

SCT

SCT stands for Scitex Continuous Tone and is a format used by Scitex devices, notably professional-level scanners and digital cameras, to save images. You may encounter this format if you send conventional images out to be professionally scanned. Check your software to see if you can import these images before you accept them.

TIFF

TIFF stands for Tagged Image File Format, and is one of the earliest of the standardized formats to be created. The history of TIFF files is not all rosy; there was a time when nearly every imaging program used TIFF files, but all in their own version called a TIFF "flavor" that often made it necessary to purchase a conversion utility to translate from one program to another. Those days are thankfully gone, and now TIFF files are a commonplace part of the digital imaging world.

Figure 6.67

Saving an image as a TIFF file. Select the format to match your recipient's computer, and leave the compression alone.

TIFF files may be up to 24-bit color, and are usually of the raw, full-sized form (see Figure 6.67). Technically, two forms of TIFF images exist, one for the Mac and one for the PC, although most packages on either system can read and write either type of image. You can apply a type of compression called LZW to TIFF images. Technically, LZW is considered lossless compression, as opposed to compression forms like JPEG that are lossy, but some people claim to be able to discern the difference between LZW and non-LZW TIFF images. The amount of file space saved by LZW isn't great, so there's probably little point in using it.

Photographs for Web Pages

The World Wide Web is perhaps the fastest-growing medium of communication, both now and ever in the history of humankind. One of the most appealing elements of the Web is the ability to share not just text but images as well. There are some tricks to taking your raw digital images and making them acceptable for Web use. As you might expect, several software packages—from high-end programs like Macromedia FireWorks to helper utilities that are intrinsic parts of basic software like PhotoDeluxe—have been developed to help you prepare your images for use on the Web. In fact, some photo processors will deliver files to you in Web-ready digital form.

In spite of the aids available, it is a good idea to understand the fundamentals of basic Web photo file preparation. Most of the simpler services and software packages make things so easy that you really don't have the options you'd like—and need—to use your images effectively. And as always, the more you know the more power you have to decide what you like and what to do when. This boils down to understanding the two primary image file types used on the Web, GIF and JPEG, and in particular how their application affects the

Holy Grail of Web Pages: minimized download time. It is worth noting that as a general rule, the principles in this section may be applied to any form of electronic publishing, not just Web pages.

What You'll Need

Start off with a raw digital photograph saved in TIFF or native PhotoDeluxe format. Any photo will do, but if you have an image that you intend to use on the Web, now is a good time to dust it off and get some practice. The examples in this section assume that you are using PhotoDeluxe to create your Web photos, although the principles are the same no matter what software you use.

Creating Web Images in PhotoDeluxe

You'll use the Send menu in PhotoDeluxe to create images for use on the Web (see Figure 6.68), but you'll find that there isn't much reason to use the To Internet option. The PhotoDeluxe menu built just for outputting images for the Web is the Web Page selection under the Send menu, in the To Internet tab. As a general guide, the steps that this function lays out are mostly OK. Follow along to see where it goes wrong, and why you should approach this menu with caution.

The first option in the menu is Trim, which is a reasonable thing to think about when preparing images for use on a Web page—or for any other use, for that matter (see Figure 6.69). Trim is PhotoDeluxe's name for a crop function, and if there's excess to trim, you should do it. One way to reduce your image

Figure 6.68

PhotoDeluxe's Send menu contains the tools for saving files in various formats.

to a more Web-friendly size is, well, to reduce your image's size! Crop away whatever elements of your image are unnecessary, and when it comes to the Web, if in doubt, cut it out. A really cool background is not likely to win you as many fans as a fast-loading page. In PhotoDeluxe, the Trim function is optional, so if you like your image the way it is, just skip ahead.

The next function is Size (see Figure 6.70), and although PhotoDeluxe considers it optional, it isn't. Your digital photos probably have pixel dimensions adequate to support quality hardcopy printing in the 3"×5" or higher range, which is way too much information for electronic display. The raw file size of your digital photos is probably about 4MB, perhaps 500K when compressed. For modem users, that can mean anywhere from five minutes to an hour or more to download. Not exactly snappy.

Typical Web image pixel dimensions don't exceed 320×240 and drop to well below that. Many images that you see on the Web are only a few pixels by a few pixels in size. One way to judge how large you'd like your image to be is to display your photo at 100%, which will probably mean that only a small portion is visible on the screen at any one time. If you shrink the image to a point that it is all visible at once on the screen, you have a reasonable starting point. It is still probably too large, but that's OK for now. You'll practice this many times until you get a feel for how large an image you'd like. As an alternative to this method, you could just go ahead and drop the image down to about 320×240, still very large for most Web applications, as a starting point.

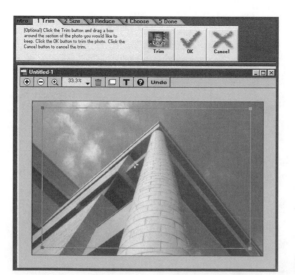

Figure 6.69

One of the first things to consider when preparing an image for use on the Web is if you can crop the photo to reduce its size.

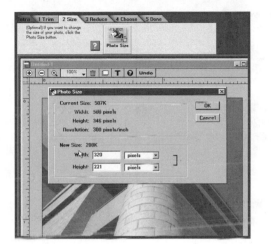

Figure 6.70

Use the Size tool to reduce your image to 320×240 or smaller. Usually much smaller.

So far so good, right? Correct, but it is with the next function that PhotoDeluxe goes horribly wrong. PhotoDeluxe makes the kind offer to reduce your image to conform to what it calls 72ppi resolution (see Figure 6.71). Remember the section you read this morning called "Image Size versus Image Resolution"? Well, the designers of PhotoDeluxe evidently need to read it. As you (being an astute reader) are already well aware, if you change the print resolution of an image with resampling on, you change the pixel dimensions of an image. Somehow, even as they change the pixel dimensions of your image, the folks at PhotoDeluxe seem to think they aren't. Try it with a file that has a print resolution other than 72dpi (or ppi) and see. PhotoDeluxe shrinks the pixel dimensions of your image (see Figure 6.72), which really is a pretty nasty thing to do after you just set it to the size you wanted in the previous step!

Figure 6.71

The simple response to the PhotoDeluxe Reduce function is to just say No!

Figure 6.72

Adobe claims
PhotoDeluxe won't
actually change the
size of your image,
but 76×53 sure
seems a lot smaller
than the 320×240
initial size. Don't
bother to check our
math—trust us,
it is smaller.

So how does this confusion get started to the point that the software engineers at Adobe, folks who should know better if anyone does, are entirely confused about pixel dimensions and print size? Well, it is a matter of digital imaging lore that a typical computer monitor has a resolution of about 72 dots (or pixels) per inch. Actually, there are probably few monitors in use today with resolutions that low, but traditions get started and they become hard to break. Now, when you look at the attributes of a digital file, there is a resolution setting, and it is so tempting to change it to conform to 72dpi, which everyone *knows* to be the resolution of a monitor, if you are only going to use the image for electronic distribution. All that extra resolution must mean extra pixels, and an unnecessarily large file, right? So the well-meaning but misguided folks in PhotoDeluxe's programming team evidently think.

Here's a secret that surprisingly few folks, even pros, seem to understand: When you display an image electronically at 100%, it is displayed so that each pixel of the image corresponds to a pixel in the monitor. Therefore, the only important factor is the pixel dimensions of the monitor; print resolution means nothing. Nada. Get it?

Consider an image with 640×480 pixel dimensions. If the file is 24-bit RGB color, its raw file size is about 922K. Does it matter if the image is scaled to print at 300dpi or 72dpi? Not a bit, it is still going to be 922K, the only size that matters when transferring the image across the Internet (see Figures 6.73 and 6.74). If the image is prepared at 1dpi, it'll print as a huge and foggy 640"×480" billboard. On the other hand, if it is prepared at 1,200dpi it will

print as something smaller than a postage stamp with very high resolution. The file size remains the same in both of these extremes. At all print resolutions, the file will be displayed electronically according to the dimensions of the monitor displaying it. So if the monitor is set for 640×480, the image will fill the display. If the monitor is at 1,280×960, the image will take up only one quarter of the screen, whatever its print resolution.

The good news with the PhotoDeluxe Reduce option is that you can skip over it and go right to the Choose option, where you select either GIF or JPEG as your file format. That's fine, but it is actually faster and easier to just resize the image and go directly to either GIF or JPEG in the Send menu, so PhotoDeluxe's To Internet function ends up being not all that useful —and given the possibility that you might forget what you're doing and mess up your image with the Reduce function, it is probably best that you avoid the Send To Internet path.

Figure 6.73

An image with pixel dimensions of 640×480, a print resolution of 300ppi, and a total file size of 900K

Figure 6.74

The image from Figure 6.73, having had its resolution changed to 72ppi. The information in the image has not changed— the 100% pixel dimensions are still 640 pixels by 480 pixels, and the file size for download is still 900K.

Using GIF Images

GIF images are called indexed color images because every color in a GIF image is indexed according to a specified palette, also called a Look Up Table (LUT). The maximum number of colors in a GIF image is 256, which may seem very limited when you are accustomed to the 16.7 million colors of the 24-bit world, but it is not as bad as it first seems. When you save a file as a GIF you have the option of using either a System palette or an Adaptive palette, and in this choice lies both the high-end potential and the low-end usefulness of the GIF image (see Figure 6.75).

The Adaptive palette option creates a unique LUT of the best 256 colors for the specific image, out of all the colors in the 16.7 million color 24-bit rainbow (see Figure 6.76). It might surprise you to learn that many images, even photographs, end up not needing all 256 potential color slots. This means that a 256-color GIF can look about as good as the full-color image, as long as the viewer is using a 24-bit color display. This is important to remember, because the viewer must have the full 24 bits of color available to be able to match them up to the Adaptive 256-color LUT. The bad news is that the GIF format is color-reduced but not compressed, so this will not be a particularly small file.

◆ ◆

Viewing an Adaptive palette GIF image on a 256-color display is definitely worse than using the System palette option. The results are unpredictable and depend on how much the image's LUT differs from the colors available on the user's display. Under the best circumstances, expect the image to look striped or banded, and as if it has fewer than the total 256 colors. At the worst, the image could appear unintelligible, with only a couple of blotched colors representing the entire image spectrum.

◆ ◆

The System palette option uses a reset LUT that alters the image so that its colors are replaced with the closest match from the predetermined set of 256 colors. This will greatly degrade image quality, and is generally not recommended for most photographs; its main use is for simpler art. Multimedia developers who need images that will look the same across a great number of different hardware configurations often employ the System palette.

Having evaluated the options, you should stick to the Adaptive palette choice when outputting digital photographs as GIF images. But what about file size?

Figure 6.75

The basic GIF export dialog box and options

Figure 6.76

A GIF image saved using 256 Adaptive colors. Notice the array of colors selected at the bottom of the image. This image will appear photographic on a 24-bit display.

Well, cutting back to 256 colors is only the beginning for effective reduction—many photographs will stand up well with even fewer colors. You can use the Colors dropdown list to pare the image down further. Use the preview mode to see the effects of the color reduction. For images with smaller pixel dimensions, 64, 32, and sometimes as few as 16 colors can look OK (see Figures 6.77, 6.78, and 6.79). These images aren't for full-screen viewing, but they end up being about as small as an image file can get, and they certainly have their uses. Try using Sharpen More as a way to improve the appearance of very small images with greatly reduced colors.

Figure 6.77

The sample image saved with 64 colors. Notice the degradation, particularly in the sky.

Figure 6.78

The sample image saved with 32 colors shows further signs of degradation. But if you can live with the appearance with 64 colors, 32 may be almost as good.

There are two more things you should know about GIFs. The first is about the Interlace option, and it's simple. Don't use it. An interlaced GIF is one of those horribly annoying Web images that appears in rows or lines, instead of all at once. They look bad, and fortunately the Web world at large appears to have almost uniformly rejected them.

The other option is the Transparency Index Color, and it is one of the potentially most useful things about GIF images on the Web. When you output an

Figure 6.79

As an 8-color GIF the image is starting to look pretty rough. If you make it small enough, however, you may find it does the job—and you can always go back to your original and cut only to 16 colors if this doesn't work.

image to a GIF file, you have the ability to make one color, or a mask if you've made one for the file, into a transparent color (see Figure 6.80). When displayed on a Web page, the areas with the transparency will not be visible, allowing the underlying information to show through. You can use a simple and familiar eyedropper tool to select the color. This has about a thousand and one Web design applications, which you'll have to learn about somewhere else, but the critical thing is now you know how to do it.

Figure 6.80

Use the eyedropper to select a color to be converted to transparent in the final GIF.

Using JPEG Images

JPEGs are about as different from GIFs as any two formats can possibly be, and yet together they work in concert to create almost all of the images on the Web today. JPEGs are compressed files that can be up to 24-bit RGB color. They are simpler than GIFs to use—and often look better, too.

The main feature of the dialog that comes up when you save a file as a JPEG is a slider bar that allows you to control whether you wish to save the file as a lower-quality, more highly compressed image, or go for higher quality with less compression (see Figure 6.81). Most programs won't tell you how much you get of each factor at a given setting, so you may find yourself saving the file multiple times with different settings to see what works best (see Figure 6.82).

Figure 6.81

The JPEG Options
dialog box.

Figure 6.82

A comparison of
the same image
saved as a JPEG at
the highest quality
level (10) on the
left, moderate
quality (6) in the
middle, and low
quality (3) on the
right.

There are other controls in the JPEG Options dialog box, and you'll need to address them as well to get the JPEG image that you want. First is the Format Options series of radio buttons. The Standard Baseline and Baseline Optimized options result in about the same image in terms of appearance, but the Optimized selection usually results in a smaller file size, so it is typically the better choice. The Progressive option is in essence identical to the Interlace option for GIF images. Progressive JPEGs and Interlaced GIFs are ultimately a matter of personal taste—if you have any, don't use 'em!

The final option is Save Paths. This results in a larger file size and has no practical use for the Web, so deselect this check box before saving.

Overview of Printing Options

There has been an explosion over the last several years in photographic and near-photographic quality output devices priced at a reasonable level for the home and small office user. This explosion is no accident—it coincides with the availability of reasonably priced scanners and higher-quality digital cameras that have created a huge demand for photo output technologies. With seemingly daily improvements to existing technologies and new technologies emerging almost as fast, it is not possible to cover every way that you might get hardcopy prints of your shots. This section will cover the fundamentals that aren't likely to change in the near future.

In the middle ground between the home devices featured in this section and the professional devices discussed in the next are various self-help kiosks and imaging stations that are beginning to appear everywhere from the community mall to the local "X-Mart." The complexity of your options increases further when you consider the availability of third-party enhancements to many of the most popular devices, including special inks for ink-jet printers that claim to be of archival quality, extending the life an image from the usual couple of years to an advertised 70-plus. Some of these issues are best evaluated over time, as your needs and knowledge mature with technologies. If you are interested in keeping up to date with emerging output technologies, look to the manufacturer and imaging magazine Web sites listed in the Appendix for places to start exploring.

What You'll Need

Much of this section is informative, but it is a good idea to try some of the things discussed, particularly when it comes to different paper and software settings. For starters, you'll need your printer. Make sure that you have the latest available driver software. Your best bet for practice at printing digital photographs is to start with a simple shot, perhaps a still life image with the original subject available for comparison. You will want to explore different paper and other substrates from as many manufacturers as possible. Your printer, its software and inks, and the substrate all interact to control the appearance of your final output. If you have the subject of the photo on hand as a check, you'll be able to see if the results are sufficiently true to life.

Printing Digital Photographs

Although you have many printing options available to you, there are some features that remain constant. For example, all printers currently work from the basis of 300dpi input resolution, no matter what their output resolution. This can be a source of confusion, because it may seem logical that if a printer advertises 600, 720, or even higher output resolution, you could get better results by using software to size your image accordingly. However, most of the current crop of printer drivers include Raster Image Processing (RIP or RIPing) to provide appropriate sizing no matter what the image's print resolution. What your high-resolution printer does is to sample the pixel information in your image and break it into finer, more controlled dots for printing. This means that you do not have to change your image resolution to use a high-resolution consumer printer.

Some output devices use *halftones,* also called screens, to produce their images, while others work in continuous tones. Halftone devices create an image by laying down discrete areas of color that, when viewed as a whole, create a total image. Continuous tone printers, such as some so-called "photo printers," use a process by which there is no separation between color elements or dots, and so the colors are continuous. Most consumer-level printers, including ink-jets and lasers, are halftone printers.

Conventional photographic prints are a common example of a continuous tone process, whereas color printing as in commercial catalogs or magazines uses a halftone process. If you examine a photograph in a magazine carefully, perhaps under a loupe or hand lens, you can see the tiny dots that make up

the halftone image. If you do the same with a conventional photographic print, you will not be able to see halftone dots. From a practical standpoint, you may be just as happy with one type of device as the other, but you should be aware that all other things being equal, continuous tone devices do produce the highest quality output. Furthermore, there may be more that can go wrong with halftone printing, including the problem called "out of register," where the different color screens that make up the image are not properly aligned with respect to one another and the image can appear cartoonish.

Devices also differ according to the color space they use for output. As a general rule, continuous tone printers use the RGB color space for printing, and halftone devices use the CMY color space—plus most add true Black (K) for what's known as CMYK printing. One of the factors that favors continuous tone output is the fact that RGB output naturally matches the human eye, and is the color space of the original digital photograph. To print in CMYK color space, the RIP software must convert the image to CMYK in what is known as *color separation.* Unfortunately, color separation is never perfect, and this can result in images that are less visually satisfactory. This morning's section titled "The Basics of Digital Color" covers different color spaces in greater detail.

◆ ◆

As a final word about selecting printers, be sure to avoid so-called "Win printers," which claim to be specifically designed for use with a Microsoft Windows operating system. Win printers take advantage of your computer's CPU and memory for all their computing needs rather than using their own. The result is that your computer system is essentially unavailable during the printing process, which in the case of large, high-resolution digital photographs can put your computer out of action for more than 10 minutes. These devices are a few dollars less expensive than printers that have the necessary computing power and memory to work in any environment, but you pay a prohibitive price in printer performance—for anything other than printing a quick memo, they are not very useful.

◆ ◆

Ink-Jet Printers

It is in keeping with the generally perverse nature of the universe that halftone CMYK ink-jet printers are most often used to print digital photos. Don't despair; the good news is that many newer ink-jets have been designed from the ground up for outputting digital photographs. The serious home and small-office user might decide to take the plunge and invest in a continuous tone device, but it is likely that an ink-jet will still be the daily workhorse for

most folks for a long time to come. The better ink-jet printers are so good, in fact, that while they may not be able to produce true photographic quality prints, they can turn out better images than even the latest crop of consumer-level megapixel digital cameras can provide, and so are probably going to be plenty good enough for you.

If you are looking to purchase a photo-optimized ink-jet printer, you've never had more choices than today. As long as you avoid Win printers, you can be sure that the latest models from the major manufacturers are going to give you solid output (see Figure 6.83). Be sure that the printer you are considering has a separate black ink cartridge and doesn't try to construct black from the subtractive CMY primaries. Blacks produced this way are inferior, and tend toward brown. One of the primary factors in producing high-quality digital photos on an ink-jet printer is how much ink the printer uses during processing, and for this reason some manufacturers have improved the quality of their printers' output by increasing the number of colors used for printing. These printers are still based on the CMYK color space, but lay down additional ink in one or more of the primaries to enhance output.

TIP

Look for a printer with six or eight colors and high resolution for the highest level of digital photographic output.

One of the most expensive elements in ink-jet printing is the consumables. If you do a lot of photographic output with your printer, you could easily spend more on ink in a year than the original purchase price of your printer. You may

Figure 6.83

Color ink-jet printers have become a ubiquitous accessory in homes and offices.

want to consider the costs of consumables when purchasing a printer, perhaps allocating a portion of your budget to allow for replacement ink cartridges (see Figure 6.84).

Paper

One of the most important components in a successful ink-jet print is the paper on which it appears (see Figure 6.85). The actual resolution of the print depends on the quality of the paper. In this case, *quality* does not simply refer to how well or poorly the paper is made but to the purpose for which it was made. Your wonderful linen-finish stationery will give you lousy photographs. Ink-jet printers require special coated paper, or even higher-quality glossy paper "film," for photographic work. Photographic quality ink-jet paper has more *tooth* than other types of paper, which means that it can support finer dot patterns and hold better color definition.

Figure 6.84

Ink cartridges and other consumable elements of the ink-jet printing equation have a significant impact on output quality—and cost.

Figure 6.85

Don't scrimp on the paper for your ink-jet. There are lots of paper options, including fun materials like stickers and iron-ons; use them for their intended purpose and you'll be pleased with the results.

Your printer manufacturer, perhaps not too surprisingly, will recommend that you use only its own brand of paper. This is probably not necessary, and in fact may not be desirable. Many companies that do not manufacture printers make fine paper for ink-jets. As the market expands, you will find more and more specialty paper for ink-jets, including stickers, cards, T-shirt appliqués, and perforated sheets that assist you in printing multiple smaller prints on a single sheet. The paper you select will have an impact on issues like color, so be sure to experiment with a new paper before jumping in and assuming that one paper is the same as another.

TIP

Price isn't everything when selecting paper. If you choose a third-party paper, perhaps for price or maybe the third party offers types of paper beyond what your printer manufacturer provides, be sure to consider the color issue. Most higher-end paper manufacturers include instructions with color settings for your printer with packs of paper. Be sure to consult the instruction manual before printing to avoid costly reprints while perfecting color settings.

You must handle photographic quality ink-jet paper carefully, as fingerprints on the paper prior to printing can degrade the final output. Moreover, the final prints are not water-fast and do not withstand direct sunlight well. If you handle them carefully and keep them reasonably well protected, you can expect them to maintain reasonable image quality for two or three years. If you hang a print on the wall where it receives direct sunlight, it may be noticeably degraded in a couple of months. Many hobby stores sell protective sprays that will make your prints water-fast. Some of these sprays will also help protect against damage from the sun (see Figure 6.86).

Figure 6.86

For long-lasting, water-fast results treat your ink-jet prints with a spray-on protectant.

Photographic ink-jet paper is expensive, and if you use a lot of it you should look for ways to reduce your costs. The savvy paper shopper buys paper by the square inch, or square foot, just as you compare packages of food in the grocery store by weight. You may find that the convenience of presized paper comes with a cost, and that you can save a substantial amount on your printing by buying a large size and ganging up multiple prints on a single page.

TIP

Cutting paper designed for large-format printers down to size may be the most inexpensive way to buy photo paper. Wear gloves If you expose paper to a lot of handling to avoid damaging the paper and reducing your savings.

Color

The most challenging thing about getting good photo prints is matching color. Consumer printers exacerbate this problem because they helpfully assume that you will be working in the RGB color space. Most of them do not let you control the conversion to CMYK printing yourself in software. Your best bet for good output is to experiment with a variety of settings and paper until you find what works well for you.

You can control the color of your image using image-editing software, which is fine if you only intend to use one output device and one kind of paper. However, remember the changes that you make to the file will be saved with the file, and so cannot be applied to other images, and may not work if you share the image with someone with a different printer. Fortunately, printers come with their own color controls that can be used to adjust output including brightness, intensity, and color (see Figure 6.87). Better printers include the ability to save settings, so you'll be able to instantly go to a setting like "Indoors with Kodak Photo Paper" or "Evening with Epson Photo Film."

Test your printer, paying close attention to color and brightness. The best starting point will be to use a digital shot of a simple inanimate object that you have on hand and you can compare to the print. It may take many tests, but you should be able to get the print to match the real object by adjusting your printer's software settings. Save the successful settings, and use them as the basis for future output. You may discover that your camera is predictably off in one color direction or another—and it's a good idea to figure this out now so you get consistently good prints despite the problem.

Laser Printers

With all the excitement today about ink-jet printers, you shouldn't overlook the utility of laser printers. While color lasers tend to be out of the price range of most home users and of too low quality to satisfy professional labs, mono-chrome laser printers can be useful to the digital photographer. Laser printers are fast, and consumables can cost well under a penny a page. Laser printers may not be up to all digital photo applications, but they are good enough for many. For example, if you need thumbnails of your images for reference, perhaps to include with a CD-R or other removal storage device, mono-chrome laser prints can be more than adequate for the job.

Other Photo Printers

Beyond the quality level of ink-jet printers are dye-sublimation and other similar devices that produce continuous-tone photographic prints from your digital photographs. These devices are not really suitable as general-purpose computer printers—they're designed solely for producing photographic prints, and so would be in addition to an ink-jet or laser printer.

Some of these devices, like the Olympus P-300 (see Figure 6.88), are designed to work in concert with a digital camera and can be directly connected to a camera to create prints without the use of a computer. This capability, which

Figure 6.87

Expect the printer driver for a photo-oriented ink-jet printer to include its own image controls and adjustments.

a handful of ink-jets share, greatly expands the imaging potential of a digital camera. The Olympus model has the added advantage that, if used with an Olympus digital camera, it will produce special proof sheets and other options that can allow you to use the camera and the P-300 as a stand-alone digital imaging unit.

Devices like the P-300 produce the very highest quality output possible from your digital camera. The principles of these devices are identical in essence to some of the professional devices that cost 10—or even 100—times as much. The home use devices are typically limited in their output size to the natural size of consumer digital cameras (something in the neighborhood of 3"×5") and are not capable of producing high volume output. Other than these limits, you can expect professional-quality output from these devices for about $500 and perhaps $1 per print in consumables.

Self-Help Commercial Printing

Some camera and print shops now offer self help access to professional output devices. Many of these shops require users to have detailed knowledge and experience using the software and devices, or they will impose a hefty consulting fee to instruct you in their use. Even if you have to pay the consulting fee once, being freed to use pro equipment may make it worthwhile in the long run, particularly if you plan an making frequent use of the shop.

Figure 6.88

The Olympus P-300 is an excellent small-format continuous-tone printer that can function as a computer printer or via direct connection to your digital camera.

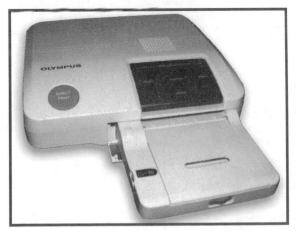

Perhaps the best of both the personal and professional world can be found in the digital imaging kiosks popping up these days (see Figure 6.89). A typical kiosk, such as the Kodak Image Station, will allow you to scan photos, access images on a floppy disk or CD-ROM, and some now will even allow you to read images directly from digital camera memory cards. Simple software, accessed with a touch screen, allows you to do basic image manipulation. However you load your images, the imaging kiosks include a professional-quality continuous-tone RGB printer that will create a high-end version of your photo while you wait.

Using Service Bureaus and Professional Labs

The information in this section is probably not for day-to-day use. For some folks, getting professional quality output may never be an option. But when the time is right and you want to get truly outstanding output or a special format for your favorite image, there is simply no reasonable alternative to using a service bureau. This is particularly true for small businesses, graphic artists, and other users of digital photography and digital imaging.

One reason that you probably won't be e-mailing your images off every weekend for professional output is that high-end quality does not come cheap. The devices used to process and output at the level discussed in this section start in the five-figure range, and many run into the mid-sixes. Add the usually

Figure 6.89

Digital-imaging kiosks, like this one from Kodak, include several ways to input your image. They also include editing software and an output device that will give you professional-quality continuous tone prints.

very high cost of consumables and the salary of the technicians and operators, and you begin to understand why it is that professional output of one digital photo will usually start at no less than $35 and can rapidly run into the hundreds for some processes. In fact, the equipment expense is one reason that in terms of professional output, conventional photography has an advantage over digital. You may be able to get a pro film lab to make you a high-quality 8×10 from a negative for $15 or $20; to get the same size from a continuous tone professional digital device could easily cost $50. Of course, compared to plunking down $30,000 in equipment, software, and training so you can generate the same output in your garage, $50 is a steal.

There are a number of types and styles of professional shops that might be willing to handle your images. *Service bureaus* are pro houses that are from day one designed to help folks output their files. A *pre-press facility* is a service bureau that specializes in preparing images to be sent to a printing press. Many pre-press houses today are fully digital, and many smaller houses might consider helping you prepare and output a file digitally. Similarly, small to medium-sized *printers* are typically fully equipped to help you to output your digital file. Many *film labs* and *copy centers* now offer digital services, including providing professional assistance with high-quality output. And of course, many professional *digital photographers* have a sideline assisting consumers with outputting their digital photographs—to help make back some of that $30,000 they plunked down.

Getting your file to the service bureau can be an issue, and don't expect while-you-wait service. If you live in or near a metropolitan area, you may be able to go to the actual shop that will do your work. If this is possible, you will get the best service by forming a relationship with the people there. If you have to deal with long-distance shops, many can accept files via the Internet, but if you are an analog modem user you might find the idea of transferring files that start at 4MB and can quickly run to 20MB or more to be prohibitive. This usually means putting your file on some form of large-format removable medium and shipping your file to the shop.

Most shops have very specific instructions for file format and preparation. Be sure that you understand these instructions and follow them to the letter. If you deliver a file that is in some way different from what the shop requires, it may either reject the job outright or charge you fees that typically run in excess

of $100 an hour to fix your file. Your best bet is to get the instructions in writing, confirm your understanding over the telephone or in person, and specify what should happen if the files are in some way other than what is required. The last point is important, because many pro shops are in the habit of automatically fixing files and charging appropriate fees without first notifying the customer. Developing a good relationship with a local shop can help you smooth over these upsets.

Making It Big in Digital Photography

Perhaps one of the most common reasons to turn to a service bureau is to get big output, maybe very big output (see Figure 6.90). While you may have your own ideas of what's big, for the purpose of this section big output is anything larger than a standard 11"×17" spread. There are a bunch of technologies out there that are capable of taking your images beyond this point, but we have never looked at covering an area beyond about 1,700 square feet with a digital image, so if you need anything larger than that you'll have to buy another book to find out how.

From a practical standpoint, there will be an upper limit as to how large you can take your digital photos and have them look reasonable. The technologies discussed in this section are all digital, and so you have the enormous advantage that pure digital processes, meaning from digital camera to output, tend to be of much higher quality than comparable hybrid techniques. If you will recall from the exercise on hybrid photography, digital photos easily compete with hybrid scans three or more times their file size.

How large you'll find acceptable is partly a function of how far you expect the viewer to be from your image. For shots designed to be seen from a distance

Figure 6.90

Three digital photographs of different sizes. A 4–foot square LaserMaster, an 11"×22" Iris, and an 8.5"×11" Fuji print.

of 4 feet or more, there are digital output devices that can take a consumer-level digital shot to 3'×4' and hold up pretty well. Of course, a lot also has to do with how much time you've spent preparing the file for output. The better the digital photograph to start with, the better the final product.

Most large-format digital printing actually uses an ink-jet process. A common example of large-format ink-jet is output from a device called a LaserMaster. Why they should all an ink jet printer a Laser, we may never know, but whatever the name it gets the job done. LaserMaster output can go to many feet by many feet, depending on the model. Costs for a LaserMaster print are typically about $6 a square foot, so for our example of a 3'×5' image, the cost would be about $90. You should add to the cost lamination or some other form of protection, because LaserMaster prints are not resistant to water and have an image life of perhaps five years.

Lambda prints are the newest and highest-quality very-large-format prints. Lambdas are continuous tone, with the potential quality that goes with it. Many Lambda prints are indistinguishable from conventional photographic prints, even at very large sizes. Expect to pay $16 a square foot or more for this extremely high-quality output. Lambdas are susceptible to water damage and should be protected from UV rays.

Smaller Formats

The large-format ink-jet and continuous tone processes have smaller and probably more widely available cousins. For output in the range one typically seeks for conventional photographic prints, consider these processes. Most of the devices used have a standard output paper size, and so the costs are the same for all images up to their standard size. While this may work against you if you are sending a 5"×7" image to an 8.5"×11" device, you can usually combine multiple images on a sheet for the single-page price. This means that you should be able to get two 5"×7" digital prints on a single 8.5"×11" page without having to pay anything extra.

Probably the most popular professional ink-jet system in use today is the Iris (see Figure 6.91). Irises come in a couple of sizes, the most common being 8.5"×11" and 11"×17". The usual use for Irises is to print what's called a color proof, a print that is used to determine if the colors in a digital file match the

Figure 6.91

The professional Iris ink-jet printer uses CMYK printing to produce medium-sized output, often as photographic proofs for use as color reference.

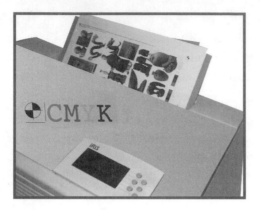

product. However, Irises can make terrific prints for other uses, and they can use special archival inks that are rated to last more than 70 years. As with all ink-jets, Iris prints must be handled with care and treated to protect them from water.

The Fujix Pictrography (see Figure 6.92) and the Kodak 8650 are two examples of professional quality continuous tone output devices. These devices produce true digital photographic prints and are among the highest-quality digital imaging devices ever constructed. If you ever want to see just how good your digital photos really are, have yourself an 8"×10" Fujix made of one of your best shots. You'll be amazed at what you see.

Slides and Other Film Output

It isn't necessary to limit yourself to paper prints; you can also run your images through a *film recorder,* a digital output device that "prints" a digital file to film, usually slides. This may seem a bit backwards at first, particularly when most of this book is about avoiding the use of film, but it turns out that there are times when only film will do. You probably already know if you are likely to face this. But if you are relatively new to the world of digital imaging, you may soon find yourself surprised at how much you depend on conventional film imaging without even realizing it.

Perhaps the most common reason to print film from a digital image is for slide shows. Even today, slides are the lowest common denominator for talks and

Figure 6.92

Continuous tone RGB devices like the Fujix Pictrography produce the inch-by-inch highest-quality digital output currently available.

presentations—unless you own it yourself, you can't count on having a computer-based projection system in every hall. Fortunately, film recorders were one of the earliest forms of digital output technology to become widely available, so you'll have plenty of options and often the ability to get 24-hour turn-around for about $5 a slide.

Film also comes in handy if you want to have a print made of an image, but either don't have a convenient digital service bureau or hope to save on expenses by having a negative made and prints then produced conventionally. This can be a very cost-effective way to produce large numbers of smaller prints, if you compare it to the high cost of professional digital output.

Some small businesses still find that sending conventional forms of photographs are the best way to communicate with other businesses, and so occasionally have to have film made of a digital image. This is often true when sending photographic communications about products and distributing press releases. Promotional companies, those that specialize in producing small gifts, pens, hats, shirts, and so on for businesses also often require artwork in conventional form.

Special Concerns When Outputting Digital Files

The sections today have covered quite a lot of information regarding outputting and sharing your digital photographs. This section goes back and summarizes the highlights of what you need to know, and to keep in mind, when preparing to send off your files. The recipient could be a Web page, your home

ink-jet printer, or a CD for a colleague. Each case has its own special concerns and keys to success. You can use this section as a quick reference when getting ready to share a digital photo electronically, for print, or if you plan on sending it off to a professional service bureau.

Electronic File Sharing

The first and most important thing to keep in mind when working with and outputting electronic versions of your images is to avoid compression whenever possible. Compression lessens the quality of your photos and introduces problems that can require a great deal of retouching to remove. Following this general principle, if you must compress, apply the least amount to achieve the required size goal. Nothing good ever came of unnecessary compression.

If you do a lot of file sharing, investing in programs like Conversions Plus or Debabelizer will make your life easier and your tasks more successful. This is especially true if you have to share files with folks who have different types of computers and use different software from what you use. Converting file formats and getting the file to a properly formatted medium can be an art unto itself, so be sure to give yourself some lead time and if possible verify your techniques before sending a file off.

Photographs intended for Web pages or other Internet applications should be sized appropriately. Be sure you know how long it will take your viewers to download an image, and then be brutally self-critical when evaluating if your image is worth that much time to view. Experiment with saving your photo in various ways, and try both GIF and JPEG formats before committing to a single form. The more experience you have in this area, the easier it will become to predict how a photo will hold up under the insults of compression and color indexing. Software packages like FireWorks and Debabelizer can help with this.

Printing Your Photographs

One of the first concerns with printing your images is to be sure that you have a feel for how your printer handles issues like color and brightness. It is a good idea to experiment with the various settings offered by your printer software to find what works best in common shooting situations. If your printer's software lets you save settings you like, be sure to use it—and keep a list of printer

Figure 6.93

Macromedia
FireWorks gives you
a preview of four
Web image options,
including useful
information like
estimated
download time
for each.

settings for common shooting scenarios. And as with all computer equipment, make it a point to regularly check with your printer manufacturer for new, enhanced, or patched driver software.

The substrate, usually paper, that you select for printing is one of the most important ingredients in successfully outputting digital photos. Try a variety of paper types and brands, and keep well stocked with your favorite varieties. No single paper will be best for all situations, so be sure to cast as wide a net as possible when considering your paper strategy.

The resolution, color space, and aspect ratio of your photograph with respect to your intended print can be critical to the quality of the output. Most printer software will handle these options for you, but try using your image-editing software to set them manually and compare the results with what the printer churns out. You may find that the few extra steps required to do it yourself can make a difference in your satisfaction with your images.

Professional Output

You may find yourself using service bureaus for high-quality output, large-format prints, or slides from your digital photos. Many of the elements for successfully working with a service bureau begin with the basics of electronic file sharing. You'll need to be certain that the file you send is properly formatted and prepared according to the instructions and requirements of the pro house with which you're working. Getting file issues right is the first and most important step in dealing with a bureau, and one where many folks have problems.

Be sure that the device being used to output your image is the right choice for your needs. Don't be afraid to ask questions, and be sure to be clear with the folks at the bureau about your hopes and intended use for the image. They'll be able to tell you if there's a better option, or if there are other special considerations or treatments that are advisable based on your specific goals. The best approach is to get the avenues of communication open as wide as you can, creating a working relationship with a shop if at all possible. Don't be afraid to pick up the phone or drive to a shop in this world of e-mail and nearly anonymous long-distance communication. A few moments of direct personal contact can go a long way to help you get things right.

Digital Photography Web Resources

This listing contains some of the many useful commercial Web sites available as resources for digital photography. There are far too many great sites to list them all here, so don't read anything into the presence or absence of something on this list. The omissions are mainly due to oversight and lack of room, and inclusion on this list is not an endorsement of the products or services the site offers. Surf on!

And don't ignore the noncommercial sites—they're not listed here, but there are far more of them than commercial sites. Use your favorite Web search engine to find some of the many great and informative noncommercial digital photography Web resources available.

Hardware

As with software, there are many players in the hardware market. Between digital cameras, their accessories, and peripheral products like printers, it may be that nearly all major electronics companies are involved in some way in the

manufacture of digital imaging hardware. Many of these sites do not stop at promoting products, but are also involved with education and increasing public knowledge and awareness of digital photography.

Agfa (www.agfahome.com): Photo manufacturer with full line of digital cameras, scanners, and output devices for the consumer and professional.

Alps (www.alps.com): Maker of color printers.

Canon (www.usa.canon.com): Camera and electronics manufacturer with a full line of digital imaging products.

Casio (www.casio.com): Electronics manufacturer with consumer digital imaging product line.

Eastman Kodak (www.kodak.com): Photo and imaging giant with a full line of consumer and professional digital cameras, PhotoCD products, imaging kiosks, and a line of photo-quality ink-jet paper products. Check out the online Digital Learning Center for terrific information about digital photography.

Epson (www.epson.com): Manufacturer of digital cameras and printers.

Fargo Electronics (www.fargo.com): Manufacturer of dye-sublimation printers, including the consumer-oriented PhotoFun printer.

Fuji Photo Film USA (www.fujifilm.com): Photo and electronics company with comprehensive consumer and professional digital-imaging product lines.

Harding Energy (www.hardingenergy.com): Maker of the excellent Quest battery system, ideal for digital cameras.

Hewlett-Packard (www.hp.com): Electronics and computer manufacturer with digital imaging products including cameras, scanners, and printers.

Imagek (www.imagek.com): Manufacturer of CMOS-based digital camera "film roll" used with conventional camera bodies.

Konica (www.konica.com): Manufacturer of scanners, printers, and digital cameras.

Leica (www.leica-camera.com): Camera manufacturer with professional digital products.

Lexar (www.lexar.com): Manufacturer of removable media for digital cameras.

MegaVision (www.mega-vision.com): Professional digital camera manufacturer.

Minolta (www.minolta.com): Camera company with full digital line.

Newcom (www.newcominc.com): Maker of digital cameras and personal digital photo printer based on cylithographic technology.

Nikon (www.nikonusa.com): Camera manufacturer with a full line of digital cameras and scanners.

Olympus (www.olympus.com): Camera manufacturer with digital cameras and other digital imaging products.

Panasonic Consumer Electronics (www.panasonic.com): Electronics manufacturer with digital camera products.

Polaroid (www.polariod.com): Photo manufacturer with line of digital cameras and software products.

Phase One (www.phaseone.com): Professional digital camera manufacturer.

Ricoh (www.ricoh-usa.com): Camera manufacturer with digital imaging line.

Samsung (www.samsung.com): Electronics and computer company with digital cameras and other digital imaging products.

Scitex (www.scitex.com): Manufacturer of professional digital imaging products, including scanners and digital cameras.

SinarBron Imaging (www.sinarbron.com): Professional camera manufacturer with line of digital cameras and special digital optics.

Sony (www.sony.com): Electronics company with line of digital cameras and other digital imaging products.

SoundVision (www.soundvisioninc.com): Manufacturer of digital cameras and CMOS innovator.

Tektronix (www.tek.com): Color laser printer manufacturer.

Toshiba (www.toshiba.com): Computer manufacturer with digital imaging products, including digital cameras.

UMAX (www.umax.com): Computer and electronics company with digital imaging line, including scanners and digital cameras.

Vivitar (www.vivitar.com): Camera manufacturer with digital line.

Yashica (www.yashica.com/yashica/index.html): Manufacturer of digital cameras.

Software Manufacturers

Multitudes of software vendors are jumping into the digital imaging market. This list contains a few that you might find interesting or useful, although this is such a dynamic field that you can expect constant changes.

Adobe (www.adobe.com): The main Web site of a software company that produces many professional and high-quality consumer-level digital imaging software products.

Alien Skin Software (www.alienskin.com): Software manufacturer of special effect plug-ins for image editing software.

Altamira Group (www.altamira.com): Manufactures high-compression, low-loss filters for digital images called fractal files.

Apple (www.apple.com): This giant of a computer manufacturer also makes many software imaging products.

ArcSoft (www.arcsoft.com): Has image editing and enhancement software.

Chroma Graphics (www.chromagraphics.com): Inexpensive editing and effects software packages.

Corel (www.corel.com): Major software producer of image editing packages.

DataViz (www.dataviz.com): Producer of file translation and transfer utilities.

Deneba (www.deneba.com): Maker of Canvas software.

Desktop Darkroom (www.desktopdarkroom.com): Maker of AutoPhoto processing software.

Equilibrium (www.equilibrium.com): Maker of Debabelizer image processing, editing, and conversion software.

Extensis (www.extensis.com): Producer of an extensive library of image plug-ins.

G&A Imaging (www.ga-imaging.com, www.photorecall.com): Maker of Photorecall image catalog software.

IXLA (www.ixla.com): Maker of IXLA Explorer, Digital Camera, and Web Easy software suites.

Jasc Software (www.jasc.com): Maker of Paint Shop Pro software.

Live Pix (www.livepix.com): Maker of the Live Pix family of digital photo products.

Macromedia (www.macromedia.com): This relative software giant produces many fine tools for the digital artist and Web production.

Metacreations (www.metacreations.com): Producer of the KAI line of software image tools.

MicroFrontier (www.microfrontier.com): Producer of Enhance and the very inexpensive Digital Darkroom software packages.

Micrographx (www.micrographx.com): Producer of Picture Publisher software.

MGI Software (www.mgisoft.com): This software company offers a powerful line of editing tools, plus home and personal use accessories like PC Wedding Kit.

Picture Works (www.pictureworks.com): Maker of Spin Panorama software to stitch multiple photos into a single panoramic shot.

Streetwise Software (www.swsoftware.com): Maker of effects software.

Ulead (www.ulead.com): This software company produces a full line software solutions and enhancements for digital imaging.

VideoBrush (www.videobrush.com): Panorama software.

XLSoft (www.xlsoft.com): Maker of StickerPix for printing photos to stickers.

Magazines

Many imaging-related periodicals have online counterparts. Here are a few where you'll find all sorts of tips, techniques, and resources to help you stay on top of the happenings in the world of digital photography.

Desktop Publisher's Journal (www.dtpjournal.com): Magazine of desktop publishing and digital imaging.

Mobile Computing (www.mobilecomputing.com): Laptop-oriented magazine that features uses of digital cameras.

New Media (www.newmedia.com): General resource for information pertaining to all of digital imaging, including digital photography.

PC Magazine (www.pcmag.com): Major computer magazine with frequent articles and reviews of digital cameras and other digital imaging products.

PC Photo (www.pcphotomag.com): Magazine specializing in the use of computers and cameras.

PHOTO>Electronic Imaging (www.peimag.com): Excellent general resource on digital imaging.

Professional Photographer Storytellers (www.ppa-world.org) Professional photographers' association magazine.

Web Imaging

At the moment, these resources are primarily hybrid photo services concerned with putting your conventional pictures on the World Wide Web. You can expect services for digital photographers to expand as demand increases.

E-Prints (www.eprints.com): A service primarily oriented toward sharing photos from an event such as a wedding online.

FujiFilm Net (www.fujifilm.net): Fuji's World Wide Web–based photo distribution site, featuring services such as online albums and global print delivery.

Kodak PhotoNet (www.kodak.photonet.com): Kodak's World Wide Web site for viewing, storing, and sharing digitized photos. Includes e-mail and reprint ordering services.

PhotoNet (www.photonet.com): This is a service bureau for many chain photo processors that allows you to view and share your photos online.

PICTRANET (www.pictranet.com): A service for publishing and sharing photos on the Web.

Pix (www.pix.com): Formerly called Picture Mall, this Web service is oriented toward creation and ordering of photo novelties and promotional items like calendars, T-shirts, and hats.

GLOSSARY

1-bit color. A monochromatic image.

4 color. The way images are represented and reproduced in most printing processes. The image is separated into each of the three CMY (cyan, magenta, yellow) subtractive colors and black.

8-bit color. Image color space comprising 256 colors. Not to be confused with 24-bit color, which has 8 bits per channel.

24-bit color. Image color space of 8 bits per RGB (Red, Green, and Blue) channel allowing representation of 16.7 million colors.

48-bit color. Image color space with 16 bits per color channel.

A

Achromatic. An image or region of an image having no color information or hue.

Additive colors. See *RGB*.

Algorithm. A process of logical steps, as in a computer program.

Aliasing. An image or digitization fault characterized by transition from one tone to another, without intervening steps or smoothing. Creates the "jaggies" in digital images.

Anti-aliasing. Smoothing the transition between tones; prevents the "jaggies" in an image.

Anti-blooming. Physical separation of pixels within a CCD to reduce the tendency for bloom. This also has the effect of decreasing the sensitivity of the overall CCD.

Aperture. The hole in the lens that allows light to pass to the camera's sensor. By changing the size of the aperture, you can increase or decrease the amount of light allowed on the sensor and thus change the speed of the exposure. Increased aperture means faster exposure times, but shallower depth of field.

Archive. System of storing and retrieving files.

Artifact. Fault in an image caused by any one of numerous processes. The fault is considered to be an artifact, or result, of the process.

Autofocus. Computer-controlled system on a camera that uses either passive contrast or active sensor information to focus the lens.

Autofocus override. Camera feature that allows the photographer to adjust or reject the solution offered by the auto focus system.

B

Banding. Image fault where smooth color gradations are broken into discrete bands of color. Most often noted in printed output.

Bit. Fundamental unit of digital information. A bit may be either "off" (0) or "on" (1).

Bitmap. An image represented in the form of an array of bits. Bitmaps are composed of discrete image information, and thus have specific resolutions. Digital and hybrid photographs are bitmaps, as opposed to vector images.

Blooming. An image fault caused by one or more pixels in a CCD becoming saturated and overexposing neighboring pixels.

BMP. Bitmap file format.

Brightness. The amount of light present in an image.

C

Calibrate. To adjust an instrument or device to conform to the attributes of either another device or a common standard. Monitors and printers can be calibrated so that colors are represented identically on both.

CCD (Charge Coupled Device). Type of light sensor most commonly used in digital cameras.

Center weighted meter. Type of camera light meter that uses information from about the central 1/4 to 1/3 of the image to determine exposure.

CD-R. Recordable compact disc format. Requires a special drive to write the disc, which can then be read by standard CD-ROM drives. Once written, data may not be erased, although some discs may have data written over their empty space in a multi-session process.

CD-ROM. Computer compact disc format that permits only reading of the disc.

CD-RW. Compact disc format that permits areas previously written to be erased or overwritten. Requires a special CD-RW drive to create, although the discs may be read by many newer CD-ROM drives. These drives do not work like traditional hard drives because data still must be written during a sustained session, as with CD-R.

Channel. A distinct piece or layer of information, such as color. RGB images have three channels of color information, while CMYK images have four. Channels may also represent luminosity and other image data.

Chroma. The color of an image datum. This is distinct from brightness, and so may be described as a pixel's deviation from white of the same brightness.

CMOS (Complementary Metal-Oxide Semiconductor). An integrated circuit that can be used both as a light sensor and computing device. Expected to emerge as a replacement for the CCD in many consumer-level digital cameras.

CMS (Color Management Software). computer software used to calibrate devices in a professional digital imaging workflow.

CMYK (Cyan, Magenta, Yellow, and Black). The three subtractive colors plus black, used in most printing processes. The three colors (CMY) are considered to be subtractive because when combined they create the absence of color, which is perceived as black. Black ink is used in the printed process instead of relying on the CMY subtractive combination because using black directly results in much higher-quality printing.

Color correction. Color adjustments made to a digital image so that the colors are represented in what is perceived as a more true-to-life manner.

Color gamut. The range of colors that can be represented by a device or program; the size of the color space. In some cases, the gamut may be changed or restricted for the purposes of calibration.

Color separation. The process of dividing an image's color data into different channels. Usually, this means moving from one color model to another, and is almost always used to refer to transforming an image from RGB to CMYK.

Color space. Also called color model, any system of representing colors according to divisions of primary colors, such as RGB or CMYK. Also can be used to mean the color bit depth of an image, as in "24-bit color space."

Compact flash card. Type of removable memory used in digital cameras.

Composite image. An image formed by merging elements from multiple images into one.

Compression. A reduction in file data resulting in smaller file size. Most forms of compression are regarded as lossy by some experts, even those forms that are officially considered to be lossless. Compression does not affect the image size, only the amount of computer memory required to store the image.

Compression artifact. An image artifact created by the process of compression. An image fault resulting from lossy compression.

Continuous tone. Image display, usually a printing method, where brightness is represented without interruption. Representation without the discrete elements found in methods such as ink-jet printing. Conventional photographic prints and digital prints from devices like the professional Fujix Pictrography are continuous tone.

Contrast (subjective and objective). The degree of dissimilarity between two objects, regions, or pixels in an image. Subjective or relative contrast is a function of human perception, and pertains to images seen together, while objective contrast refers to measurable differences without regard to perception.

Conventional photography. Photographic method that uses light-sensitive film to capture an image.

Copy artifact. Image fault that occurs as a result of copying or writing image data.

Cropping. A reduction in image size achieved by selecting only a part of the original image for use and discarding the rest.

Curve. Graphic representation of one or more channels of image data. Curves can typically be grabbed and manipulated in image-editing software, allowing controlled changes to the image.

D

Daylight. Light from the sun, or light of the color of light from the sun. For example, light from a photographic flash is considered to be of daylight quality.

Diffuse. Light that is spread across a wide area or scattered rather than concentrated in one place.

Diffusion dithering. A form of dithering using a random dot pattern.

Digital. Anything represented in the form of combinations of 1s and 0s.

Digital camera. A camera that uses an electronic light sensor and converts image information to digital data.

Digital image. Any image or graphic representation in digital form, including digital photographs, hybrid photographs, computer-generated animation, and vector illustration.

Digital photography. Method of photography that uses a digital camera to take pictures.

Digitize (or digitization). To convert or capture information from the real, analog world to digital representation. As with scanners, digital cameras, and digital drawing tablets.

Dithering. Applying a pattern of dots to represent a picture, typically used to approximate colors or other information that can not be directly represented by a device.

DPI (Dots Per Inch). An expression of file or output device resolution. A greater number of dots per inch tends to indicate higher quality, particularly if a device is not continuous tone.

Driver. Software that allows a computer to access or interface with a corresponding hardware device.

Drum scanner. A professional scanner that operates by spinning the subject past the sensor at a high rate of speed.

Dye sublimation. A thermal dye–based color printer that is capable of producing excellent digital photographic prints.

E

EPS (Encapsulated Postscript). digital file format that can contain both bitmap and vector information.

Export. A software process that transforms a file from the native format of the application to another format.

Exposure. The interaction of light, time, and sensor sensitivity that results in a photographic image. Aperture and shutter settings are the photographic controls of exposure.

Exposure compensation. A camera feature that offsets the exposure solution of the camera's light meter to result in greater or lesser exposure. This feature is usually expressed as a function of stops, or fractions of a stop, as in –0.5EV.

Exposure meter. Camera component that measures light reflected from the subject and proposes an exposure solution, including shutter speed and aperture setting.

F

File (or file format). The set of binary data that comprise a digital image. A file is in a standard or proprietary format that tells software how to interpret the data to display the image.

Filter. Either a piece of optics that is attached to the camera's lens for an effect, or software designed to process an image for the same purpose.

Film recorder. An output device used to create film negatives or transparencies from a digital file.

Finder. Also called a viewfinder. The little window on your camera through which you see the camera's view of the subject. A finder may be a single lens reflex (SLR) that provides a through the lens (TTL) view, or a dual lens model which means that you see the image through a lens other than the one the camera uses to take the picture.

Flash memory. A type of removable storage used by digital cameras.

Flash sync. Camera feature that permits one or more camera flashes to fire in synchronization with the exposure.

FlashPix. File format emerging in the consumer digital marketplace.

Flatbed scanner. Type of scanner that features a flat glass scanning surface upon which the subject is placed.

Fluorescent. Type of lighting that is usually cooler, or more blue, in color than daylight.

Focus. Process of moving lens elements, done automatically by the camera in auto focus models, so that the subject appears clear and sharp.

G

Gamma. A measurement of the ability of a monitor or other device to display contrast.

Gamut. See Color gamut

GIF (Graphics Interchange Format). An indexed color image file format used in many applications, including widely on the World Wide Web.

Gray level. Digital measurement of a pixel's brightness information.

Gray scale. Either literally a scale representing the range from white to black with intervening grays, or a mode of representing a digital image without color information but with multi-bit tonal information.

H

Halftone. Simulation of a continuous tone image with a pattern of dots that represent the tonal range.

Hard copy. Any form of output that forms a tangible representation—hardcopy output—of the image.

High key. A photograph with tones mostly in the white or bright end of the spectrum.

Histogram. A graphic representation of the distribution of image information for a given channel or channels.

HTML (Hypertext Markup Language). File format used in the World Wide Web to instruct browser software what to display and how to display it.

Hue. A color, either a pure primary of one of the color spaces or a combination of any primaries.

Hybrid photography. A method of photography that incorporates conventional image capture and subsequent scanning of the photograph to result in a digital image.

I

Image PAC. File format used on PhotoCD discs; also called PCD.

Import. A software process that loads a file of another format and converts it to the native format of an application.

Ink-jet. Output device that creates a hardcopy representation of an image using a spray of ink dots.

Intensity. The amount of light in an image.

Internet. Global network of computers used for data storage and retrieval, and as a medium of communication.

Interpolate. A method of digitally expanding the size of a bitmap file by approximating multiple pixels from fewer pixels; digital enlargement.

J

JPEG (Joint Photographic Experts Group). File format that uses varying levels of compression to represent images of up to 24-bit depth. Can be very lossy.

K

Kiosk. A stand-alone computing station, usually designed to deliver a specific product, service, or information.

L

Laser printer. Output device that creates hard copy of images by transferring charged inks to paper.

Layer. An element of a digital image that is independent of other elements, or layers. One layer can have properties and be processed independent of other layers.

LCD (Liquid Crystal Display). The type of data display used on digital cameras and other electronic devices.

Lossless. A process that does not cause a loss of information or a degradation of image quality. For digital images this is most often applied to compression schemes that theoretically reproduce the image in a form indistinguishable from the original.

Lossy. A process that causes a loss of information. In digital files, this is typically loss of image information that corresponds to a reduction in digital information.

LPI (Lines Per Inch). An expression of file or output device resolution similar to DPI.

Luminance. A physical measure of the brightness information in an image.

M

Manual focus. Camera feature that allows the photographer to directly adjust lens focus without input from an auto focus system. Often necessary for certain types of photography, as in low light conditions.

Marquee. Image-editing software tool used to select regions of an image for processing.

Mask. Image-editing software tool that designates some portion of an image as either active and subject to processing or covered and protected from processing.

Megapixel. Digital camera with a sensor that has an active image area comprising more than 1 million pixels. Some digital cameras have raw sensor sizes greater than a million pixels but do not use the entire sensor for imaging, and so should not be considered megapixel units. A megapixel camera is the lowest sensor size capable of yielding reasonable image quality.

Moiré. Image fault caused by scanning or digitally photographing subjects with patterns. Commonly caused by scanning subjects with halftone dot patterns rather than continuous tone originals.

N

Negative. A photographic image that is in reversed form. The term is often reserved for negative film designed to produce photographic prints in conventional photography.

Neutral density filter. A filter that serves to reduce the intensity or brightness of light without affecting color information. If it is a physical filter used during a photographic session, it can reduce the tendency for CCD bloom and permit long exposures for motion effects during bright daylight.

Noise. Image fault resulting in a grainy appearance to the image. Similar to an artifact, but noise is typically evenly distributed throughout the image rather than concentrated in one place. Often the result of inadequate exposure.

Normal. Lens focal length that results in an image approximating the view a person would get from the same location.

O

On-camera flash. Photographic flash unit built into a camera, or a separate flash unit directly attached to the camera body.

Overscan. The process of capturing more image data than is required. In the extreme, this refers to deliberately capturing more digital information than the available photographic information.

P

Palette. A subset of the colors available in a given color space.

PCMCIA (Personal Computer Memory Card International Association). A computer hardware device interface commonly found on laptops and used to add peripheral devices to the computer.

Perspective. The relationship of distance and size in an image. Often used in particular reference to the tendency of parallel lines to converge in an image as distance from the viewer increases.

PhotoCD. A format of compact disc designed for the storage and retrieval of hybrid photographs.

Photo realistic. Representation of an image that can casually pass for a photograph, but is not quite of photographic quality.

PICT. Macintosh bitmap file format.

Pixel. The smallest element in an image or sensor.

Pixelated. Image fault, typically caused by interpolation, where individual pixels can be seen.

Polarizer. Filter that only permits the passage of light in a single plane. Used to reduce specular effects and CCD bloom.

Positive. Representation of an image in standard form with tonal range that matches the original.

Posterize. Photographic special effect that replaces regions of continuous tone with single colors, resulting in a reduced image gamut.

Postscript. A page description language that allows images to be processed and output at independent resolutions.

R

Raster. A bitmap image representation.

Rasterize. To convert a vector or EPS image to a bitmap.

Rastery. A colloquial term for an aliasing type image fault.

Reflectance. A measurement of the amount of light information being reflected from the subject.

Resolution. In an image or device, the number of elements used to represent the image.

Revert. To restore the image to a version prior to processing.

RGB (Red, Green, Blue). The color space that corresponds to the human visual system by use of the three additive primaries. The space is considered additive because the three primaries sum to produce white, which is the sum of all color.

RIP (Raster Image Processor). Software that converts image data to a form for use by an output device. A RIP engine can include color separation in addition to basic formatting and translation.

S

Saturation. A measure of the strength of a color in an image.

Scanner. Any device used to digitize conventional images.

Sharpen. A process of increasing the contrast in an image to make it appear to be in better focus.

Shutter. Camera feature used to precisely control the times of exposure.

Shutter speed. The time that the shutter is open, exposing the sensor to light.

Service bureau. A commercial graphics house that offers professional quality outputting.

Slide scanner. A scanner designed specifically to scan transparent media of the size of photographic film.

SLR (Single Lens Reflex). A style of camera that projects the view of the subject through the lens to the camera's finder.

Smart Media. Format of removable image storage used in digital cameras.

Specular. Region of an image where light reflectance is complete, resulting in pure white with no other data. Often occurs off of shiny surfaces, glass, and the surface of water.

Spot meter. Camera feature that allows the photographer to select a small area of the total subject for use by the camera's exposure system.

Subtractive color. See CMYK.

T

Telephoto. Lens that gives the effect of making the subject appear closer, a telescopic effect. Telephoto lenses also have the effect of diminishing depth of field and creating flatter images.

Thermal wax transfer. Color output device that uses heated wax to produce the image. Many devices called "color laser printers" are actually thermal wax transfer devices.

Thumbnail. A reduced version of an image used to allow a quick review.

TIFF (Tagged Image File Format). A nearly universal image file format commonly used for its cross-platform compatibility and high resolution. Typically uncompressed, although one form does offer a small degree of compression.

Tone. Any image color or gray that posses density.

Transparency. A positive photographic representation in a transparent hardcopy form. Slides are a common example of transparencies. In digital images, transparency refers to a region of the image that does not contain image information and so will permit underlying images to show through.

TTL (Through The Lens). Any camera feature or view that functions through the main body lens used to capture the picture.

Tungsten. Common incandescent lighting, warmer in color than daylight.

TWAIN. Computer interface protocol commonly used for direct connection between digital cameras and computers.

U

Unsharp mask. The general form of image sharpening that allows user control over the primary sharpening settings.

V

Vector image. A digital image that uses mathematical formulae to store and reproduce pictures. These files are created in drawing or illustration programs, and have no set resolution, so they can be scaled to fit any device used. These files also are small, as the information stored is a set of equations, rather than a map of bits as in a bitmap image.

W

Wide angle. Camera lens that approximates the view from a distance farther from the subject than the camera's position.

White balance. Camera feature that compensates for the ambient light color when it is other than daylight.

World Wide Web. Portion of the Internet devoted to transmission of information using the Hypertext Transfer Protocol (HTTP), which permits visually rich presentations to users.

Z

Zoom. Type of camera lens that allows multiple focal lengths, including wide, normal, and telephoto, from a single lens.

INDEX

24-bit color, 236–237

A
AC adapter, 36, 117, 193
action shots, 15, 29, 30, 146–155
active autofocus, 26
Adams, Ansel, 72
adapters
 AC, 36, 117, 193
 lens, 23
 video, 49
additive color space, 234, 239
Adobe PhotoDeluxe
 applying color effects with, 258–266
 basic image processing with, 211–221
 color correction with, 238, 240–242
 contrasted with professional-level packages, 48
 correcting or distorting perspective with, 295–298
 creating Web images with, 325–335
 outlining with, 279–282
 sharpening digital photographs with, 227, 229–231
 styling effects, 246–247, 253–257
Adobe Photoshop
 changing backgrounds with, 286–294
 color correction with, 238, 242–246
 contrasted with Adobe PhotoDeluxe, 48

 correcting perspective with, 298–299
 lighting effects with, 268–274
 native file format, 323
 outlining with, 283–285
 recommended book on using, 309
Advanced Menu, Adobe PhotoDeluxe, 211–212
Airbrush tool, Adobe Photoshop, 293, 294, 310–311
alien death ray, 26
Alien Skin, 300–301
alkaline batteries, 35, 173
ambient light, 141, 142
Amount option, Adobe PhotoDeluxe, 231
angles
 extreme camera, 79
 shooting at different, 160–162
animals, photographing, 90–98, 183
aperture, 28, 138
architecture, photographing, 83–90
archiving, 197–198
area autofocus mode, 26
artifacts
 compression, 40, 43, 232–233
 copy, 196
artificial features, removing from photographs, 97
aspect, 138
audio feature, digital camera, 37

"auto enhance" filter, 228
autofocus cameras, 25–26, 159, 180

B

back lighting, 70
backgrounds, changing, 285–294
backups, 196–198
batteries, digital camera, 3, 35–36, 173
bit depth, 201–202, 236
bitmap files, 317–318
black-and-white photographs, 235
bloom, CCD, 81, 166–173
blurring, 71, 139, 148–149, 150, 152–154, 217
BMP files, 317–318
books, photography, 174
bracketing, exposure, 110, 186
bright-light conditions, 14–15, 28
brightness, 235–236, 261
buildings, photographing, 83–90, 128–135
burst mode feature, 15, 37, 103
business presentations, 312

C

cable, transferring images via, 193–195
cables, serial *vs.* USB, 35
camera shops, 53–54
cameras. *See* digital cameras.
candid photographs, 121, 124
canvas, software, 214–216
Canvas Size tool, Adobe PhotoDeluxe, 215–216
capture back, 16
cars, photographing, 105–111
Cartoon effect, MGI PhotoSuite, 249–250
CCD bloom, 168–173
CCD chips, 19–20
CD-R drives, 50, 197
CD-ROM image storage, 50, 206–209
center-weighted metering, 27–28
CGM (Computer Graphics Metafile), 318
Charge Coupled Device, 19–20, 169
children, photographing, 99–104, 120–121, 126–127

chips, digital camera, 18–20
Circle of Light effect, Adobe Photoshop, 270–271, 272
circular polarizing filter, 23, 165
Clone tool, image-editing software, 217–218
close focusing, 27
close-up photography, 81–82, 130, 143–145, 159–160
CMOS technology, 20
CMYK color, 223, 234–235, 238, 341
color, digital, 233–237
color accuracy, 44, 133–135
Color Balance, Adobe PhotoDeluxe, 240–242, 264, 266
color correction
 with Adobe PhotoDeluxe, 238, 240–242
 with Adobe Photoshop, 238, 242–246
 basics, 237–240
color depth, 201–202
color effects, 258–266
color printers, 50
color scanning, 205–206
color screens, 336
color separation, 337
color space, 234–235, 238–239, 341–342
Color Wand, Adobe PhotoDeluxe, 279–281
compact flash cards, 31
complementary colors, 238–239
compositing, 93
composition, photographic, 72–76, 121
compressed files, 32–33, 39–43, 193, 223–224, 350
compression artifact, 40, 43, 232–233
computer
 CD-ROM drive, 208
 hardware and software manufacturers on the Web, 353–357
 system requirements, 49–50, 203
 transferring digital photographs to, 33–34, 192–196
Constrain Proportions option, image-editing software, 224
continuous tone printers, 336, 348, 349
contrast, 226, 236, 261

conversion software, 46, 313, 314, 316–317, 350

Conversions Plus, DataViz, 313, 314, 316–317, 350

Copy and Paste commands, 217

copy artifact, 196

Corel Photo-Paint, 286, 301

cost considerations, digital photography, 6, 15, 21, 42, 52, 197, 345

Crackle effect, Adobe PhotoDeluxe, 256, 257

cropping, 213, 325–326

cross-platform file sharing, 314–317

D

DataViz Conversions Plus, 313, 314, 316–317, 350

Debabelizer Pro, 46, 313, 350

deleting images, 112

depth-of-field problem, 143–145

digital back, 16

digital cameras

 cost considerations, 6, 15, 21, 42, 52

 evaluating, 38–45

 features

 audio, 37

 burst mode, 37

 chips, 17–20

 exposure system, 27–28

 file formats, 32–33

 finder, 24–25

 flash, 29–30, 132

 focus options, 25–27

 image storage, 30–32

 interface, 33–34

 lenses, 21–23

 power considerations, 35–36

 scripting, 37–38

 tripod mount, 37

 how and where to buy, 52–55

 ISO ratings, 138

 megapixel, 42

 professional *vs.* consumer-level, 11–12, 14–17

 renting, 54

 stabilizing, 50–51, 184

digital color, 233–237

digital imaging, 4–5

digital information (contrasted with photographic information), 199–200

digital photographs

 backing up, 196–198

 changing background, 285–294

 correcting or distorting perspective, 295–299

 editing tools, 191

 enhancing

 with color effects, 258–266

 with lighting effects, 267–274

 with styling effects, 246–257

 enlarging, 322, 346–347

 printing, 335–344, 350–352

 sharpening, 226–232

 transferring to computer, 192–196

 using on Web pages, 12, 13, 73, 312, 324–335

digital photography

 applications, 11–14, 73, 84, 100, 105

 contrasted with other types of imaging, 4–5, 137

 planning your shots, 59–60, 117

 pros and cons, 5–10

 software tools, 45–48

 specialized hardware, 49–52

 Web resources, 353–358

digital zoom, 23, 169–170

digitally tuned optics, 16

diopter correction, 24

direct media transfers, 195–196

direction, of faces, 121

Distort tool, Adobe PhotoDeluxe, 295, 297–298, 299

distortion, when shooting through glass, 162

drivers

 advanced printer, 237–238

 output device, 48

 TWAIN, 46, 194, 201, 300

drop shadows, 302

droppers, black and white, 204–205, 244

drum scanner, 210

dual lens cameras, 17, 19

dynamic range, 44

E

Eastman Kodak
 CMOS cameras, 20
 PhotoCDs, 206–210, 322
editing software, 47–48
Emboss effect, MGI PhotoSuite, 248–249
enlarging digital photographs, 322, 346–347
EPS (Encapsulated Postscript) file, 318–320
Equilibrium Software, 46, 313
Eraser tool, image-editing software, 218, 219
errors, copy and compression. *See* artifacts.
Essential Photoshop 5 Book, The, 309
EV (Exposure Value) setting, 110
exercises
 indoor photography
 action and motion shots, 146–152
 building interiors, 128–135
 metals and reflective objects, 166–173
 people, 118–127
 shooting through glass, 156–166
 still life, 136–145
 outdoor photography
 action shots, 152–155
 architecture, buildings, and structures, 83–90
 cars, trucks, and other vehicles, 105–111
 landscapes and scenery, 72–83
 people, children, and portraits, 99–104
 pets and other animals, 90–98
 sunrises and sunsets, 65–72
exposure bracketing, 110, 186
exposure compensation, 28, 64–65, 68, 81, 109–111, 122, 181
exposure system, digital camera, 27–28
external flash units, 29–30, 51, 52, 132
Eye Candy 3.0, 300–304
Eye Candy 2.1 LE, 301
eyedropper tools, 204–205, 244

F

fences, shooting through, 96–97
file acquisition and transfer software, 46

file formats, 32–33, 193, 195, 313
file sharing, 314–317, 350
file transfer options, 33–34, 192–196, 313–317
fill cards, 140–141
fill flash, 29, 110–111
film back, 16
film grain, 6, 170
film holder, 16
film labs, 344–346
film recorder, 348–349
film scanner, 200, 202–203, 205
film sensitivity ratings, 136–139
filters
 image-editing
 "auto enhance," 228
 MGI PhotoSuite, 248–253
 Sharpen effect, 229–232
 lens, 23, 165
finder, 17, 24–25
Fire filter, Eye Candy, 302–303
FireWorks, Macromedia, 324
fireworks, photographing, 185–186
Five Lights Down effect, Adobe Photoshop, 273–274
flash
 freezing motion with, 149, 151, 153
 mini-slave, 166, 182
 for nighttime photography, 180–183
 on-camera, 131–132, 140
 recommendations for shooting through glass, 162–164
flash cards, 31
flash modes, 29
flashlight, as accessory for nighttime photography, 183
Flashlight effect, Adobe Photoshop, 268–270
FlashPix, 33
flatbed scanner, 16, 200
Floodlight effect, Adobe Photoshop, 268–270, 271
floppy disks, storing images on, 30
fluorescent light, 134–135
focal length, 23
focus-free cameras, 25, 159
focusing through glass, 159

FPX (FlashPix) files, 321
Free Resize tool, Adobe PhotoDeluxe, 213–214
frozen motion, 138–139, 149, 150, 151, 153
f-stop, 138
Fuji
 digital cameras, 45
 Web site, 354
Fujix
 Pictrography continuous tone output device, 348, 349

G

gadget bags, 51–52
gamut, 236
Gaussian blur, 307
Gibbons, Bob, 174
GIF (Graphics Interchange Format) files, 237, 321, 324, 330–334
glare, 23, 60–61, 165
glass
 shooting pictures through, 156–166
 as synonym for lens, 138
Glass effect, MGI PhotoSuite, 251
Glowing Edges effect, Adobe PhotoDeluxe, 255, 256
graphic artists, 209
gray shift, 80
Green Fog effect, Adobe PhotoDeluxe, 261

H

halftone printing, 312, 336–337
halo effect, 69
hardware, digital photography, 49–52, 353–355.
 See also computer; digital cameras.
Hedgeco, John, 174
highlights, 44
histogram tool, 204–205
horizon, placement of, 74
houses, photographing, 84
hue, 235, 261
hybrid photography
 defined, 5
 pros and cons, 6–10
 scanning basics, 199–206

I

IF (internally focusing) lens, 159
Image Composer, Microsoft, 301
image density, 204
image files
 backing up, 196–198
 file transfer options, 33–34, 192–196, 313–317
 popular file formats, 32–33
 sharing, 314–317, 350
image information (contrasted with digital information), 199
image processing. See image-editing software; specific techniques.
image size
 changing with Adobe PhotoDeluxe Photo Size command, 216–217
 contrasted with image resolution, 221–222
 impact on image quality, 39–43, 60, 199–200
 rules of thumb
 for scanned images, 202
 for Web pages, 326–329, 350
image stations, Kodak, 201
image-cataloging software, 47
image-editing software. See also specific programs.
 advanced techniques, 277, 283
 basic tools and techniques, 210–221
 color effects/color correction with, 237–238, 258
 outlining with, 283
 packaged with digital cameras, 191
 plug-ins and macros, 300
 professional vs. consumer, 47–48
images
 choosing best photographic and production methods, 7–10
 deleting, 112
 factors affecting quality of, 39–45
 printing, 7–8, 312, 350–352
 sharpening
 with image-editing software, 226–232
 during scanning, 206
 storing and retrieving, 13–14, 30–32, 40, 47
 transferring to computer, 192–196
 transmitting electronically, 8

imaging, digital, 4–5
Imspace Systems, 47
incidental reflection, 161, 163
indexed color images, 330
indoor photography
 contrasted with outdoor, 118
 exercises
 action and motion shots, 146–152
 building interiors, 128–135
 metals and reflective objects, 166–173
 people, 118–127
 shooting through glass, 156–166
 still life, 136–145
 planning your shots, 117
infrared port, 34
ink-jet printers, 50, 224, 237–238, 337–342, 348
inside masking, 303
instant cameras, 11
interface options, digital camera, 33–34
interiors, photographing, 128–135
interlaced GIFs, 332
International Standards Organization, 136
Internet. *See* World Wide Web.
interpolated resolution, scanner, 202
interpolation, 20
Iomega Jaz drive/disks, 197
Iomega ZIP drive/disks, 49–50, 197
IrDA ports, 34
Iris ink-jet printer, 348
ISO, 136, 137
IZ (internally zooming) lens, 159

J

jaggies, 322
Jaz drive/disks, Iomega, 197
JPEG (Joint Photographic Experts Group) files,
 32–33, 321–322, 324, 334–335

K

Kai Software, 47–48
Kodak 8650, 348

Kodak DC-120, 166
Kodak DC-220, 38
Kodak DC-260, 19
 burst mode, 103
 CCD bloom and, 171
 color accuracy, 44
 compression ratio, 223
 cost with accessories, 30
 external flash synch, 30, 145
 for close-up photos, 160
 IrDA port, 34
 off-camera flash, 166
 scripting feature, 38
 shadow detail, 44–45
 shooting through glass with, 166
 shutter speeds, 28
 testing image quality, 39–45
 white balance feature, 134
Kodak DCS-520, 11
Kodak Image Station, 344
Kodak PhotoNet Web site, 198, 358
Kodak Picture Easy, 227, 228
Kodak Picture Maker kiosks, 198
Kudo image-cataloging software, 47, 48

L

Lambda large-format prints, 347
landscapes, photographing, 72–83
large objects, photographing, 83
large prints, 14, 322, 346–347
laser printers, 342
LaserMaster large-format prints, 347
layers, 285, 288–289, 295, 304
LCD finders, 24–25
Leaf DCB, 39
Leaf Digital Camera Back, 20
lens mounts, 23
lenses
 accessories for, 23
 glass *vs.* plastic, 21
 IF contrasted with IZ, 159

interchangeable, 16
role in digital camera's exposure system, 138–139
telephoto, 21–22, 23, 82–83, 89, 97
wide-angle, 21–22, 23, 88–89
zoom *vs.* fixed, 21–23
light, color of, 132
light cards, 51, 52
light sensors, digital camera, 136
lighting considerations
dealing with bright light, 14–15, 28
indoor photography, 118, 122, 128, 133–134, 136, 140
outdoor photography, 60–61
lighting effects, digital photograph, 267–274
lights, photographing, 187
Line tool, image-editing software, 219
Liquid Crystal Display (LCD), 24–25
long exposures, 184–187
lossy compression, 32, 40, 193
lossy processes, 9
low-light photography
challenges of, 177, 178–180
dealing with dark images, 72
equipment and camera features for, 178
external flash, 29–30
focus considerations, 26
shutter speeds, 28
slow exposure and, 64–65

M

MacDrive 98, Media4, 317
Macintosh-to-PC file transfers, 313–317
macro focusing, 27
Macromedia FireWorks, 324
Macromedia xRes, 48
macros, image-editing software, 300
magazines, digital photography, 357–358
Magnifying Glass, Adobe PhotoDeluxe, 212–213
mail-order camera stores, 54
manual exposure, 28
manual-focus cameras, 26

manufacturers, hardware and software, 353–357
marching ants, 279–280, 285
Master, PhotoCD, 208
matrix metering, 27–28, 68
Media4 MacDrive 98, 317
megapixel cameras, 42
memory, personal computer, 49, 203
metafile, 318
metals and reflective objects, photographing, 166–173
meter, light, 27–28, 68, 132, 171, 185
MGI PhotoSuite, 191, 247
Micrographx Picture Publisher, 286
Microsoft Image Composer, 301
mini-slave flash, 166, 182
Mirage effect, MGI PhotoSuite, 250
35mm photography
image size, 143
quality issues, 9–10, 17
scanning considerations, 202–203
monitor, personal computer, 49
monopod, 51
moon, photographing, 184–185
morphing, 210
Mosaic effect, MGI PhotoSuite, 251, 252
motion
creating sense of, 74–76, 106–107
photographing objects in, 146–155
Motion Trail filter, Eye Candy, 304
multi-frame mode, 103
multimedia presentations, 312
must-have list, digital camera, 55

N

NASA Web site, 305
nature photography, 94–98, 183
Negative effect, MGI PhotoSuite, 248, 249
negative space, 75, 107
negatives, producing prints from, 9–10
neutral gray, 80
Ni-Cd batteries, 35
Night & Low-Light Photography, 174

nighttime photography. *See also* low-light
photography.
 basic types
 long exposures, 184–187
 shooting with flash, 180–183
 challenges of, 177–180
Nikon
 digital cameras, 45
 Super Coolscan LS-1000, 205
 Web site, 355
NiMH batteries, 35, 36
nocturnal animals, photographing, 183
normal perspective lens, 21

O

objects, photographing, 136–145
Olympus Digital Vision, 194
Olympus D-600L, 15, 18
 for close-up photos, 159–160
 color accuracy, 44
 external flash, 30
 shadow detail, 44–45
 shutter speeds, 28
 testing image quality, 39–45
Olympus P-300 printer, 343
opacity, 288
optical finder, 24
optical resolution, scanner, 202
optics, digitally tuned, 16
Orientation Tab, Adobe PhotoDeluxe, 219
outdoor photography
 dealing with bright light, 14–15, 28
 exercises
 action shots, 152–155
 architecture, buildings, and structures, 83–90
 cars, trucks, and other vehicles, 105–111
 landscapes and scenery, 72–83
 people, children, and portraits, 99–104
 pets and other animals, 90–98
 sunrises and sunsets, 65–72
 planning your shots, 59–60
 preparing for, 60–61

outlining, 277–289
 with Adobe PhotoDeluxe, 279–282
 with Adobe Photoshop, 283–285
output-devices
 hardware, 50, 312
 software, 48
overexposed images, 81, 110, 120, 122
overscanning, 10, 43, 202, 203, 236

P

Page Curl effect, Adobe PhotoDeluxe, 255, 257
panning, 153–155
paper, printer, 339–340, 351
parallax, 17, 159, 160
passive autofocus, 26, 180
PC (personal computer). *See* computer.
PCD (PhotoCD) files, 322
PCMCIA memory cards, 31–32
PC-to-Macintosh file transfers, 313–317
PCX files, 322
Pen tool, Adobe Photoshop, 283–284
people, photographing, 99–104, 118–119, 181–182
perspective, 83–86, 88
 correcting, 295–299
Peterson, Bryan, 174
pets, photographing, 90–94
photo bags, 51–52
Photo CD Image PAC, 208
photo printers, 336, 343
Photo Size command, Adobe PhotoDeluxe, 216–217
PhotoBubbles, 47–48
PhotoCD, 206–209, 322
PhotoDeluxe. *See* Adobe PhotoDeluxe.
Photographer's Handbook, The, 174
photographic composition, 72–76, 121
**photographic information (contrasted with digital
information),** 199–200
photographs, digital. *See* digital photographs.
photography. *See also* digital photography.
 conventional contrasted with digital, 5
 recommended books on, 174
PhotoNet Web site, Kodak, 198

Photo-Paint, Corel, 286, 301
photo-realistic output, 50
Photoshop. *See* Adobe Photoshop.
PhotoSuite, MGI, 191, 247
pickers, 244
PICT files, 323
Picture Maker kiosks, Kodak, 198
Picture Publisher, Micrographx, 286
Pink Skies effect, Adobe PhotoDeluxe, 266
pixels
 defined, 6
 quality issues, 9, 222
 saturation of, 170
planning, importance of, 59–60, 117
plug-ins, image-editing software, 300–302
point-and-shoot cameras, 11, 15
polarizing filter, 23, 165
Polaroid, contrasted with digital photography, 137
Polygon tool, Adobe PhotoDeluxe, 282
Portfolio II, PhotoCD, 208
portraits, outdoor, 99–104
Posterize effect, image-editing, 264–265
Postscript files, 318–320
power considerations, digital camera, 35–36
prefocusing, 94
pre-press facility, 345
prescan, 201
preview image, 201
print quality issues, 9–10, 14, 17
print shops, 7–8, 312, 344
print size, 222, 223
printers, 50, 224, 237–238, 336–344
Pro Master, PhotoCD, 208
production methods, photographic, 8–9
professional film labs, 344–346
professional photographers, 15–17
Professional Photographer's Guide to Shooting Nature and Wildlife Photos, The, 174
proprietary file formats, 193, 195
PSD (Adobe Photoshop) files, 323
Purple Haze effect, Adobe PhotoDeluxe, 263–264

Q

quality issues, image, 9–10, 17, 39–45
quantum potential, 170
Quick Mask Mode, Adobe Photoshop, 287

R

Radius option, Adobe PhotoDeluxe, 231
RAM, 49, 203
Randomize effect, MGI PhotoSuite, 252–253
raw files, 32, 222
rechargeable batteries, 35
Recordable Compact Disk (CD R), 197
red-eye reduction/removal, 29, 124–126, 310–311
reflections
 avoiding, 158, 161, 163, 165
 photographing, 72, 106, 108, 109, 166–173
reflective materials, 200
removable storage media, 30–32, 49–50, 197, 206
rental, digital camera, 54
Resample option, image-editing software, 224
Resize tool, Adobe PhotoDeluxe, 213–214, 224
resolution
 image, 32, 38, 221–225
 scanner, 202, 208
resource fork, 317
retouching, 210. *See also* image-editing software.
RGB color, 223, 224, 234–235, 341
Ripples effect, MGI PhotoSuite, 251, 252
Rotate Left tool, image-editing software, 220
rule of thirds, 73–74

S

saturation, 235–236, 261
scanners, 16, 200, 201, 202–203, 210, 236
scanning
 basics, 199–206
 capture back contrasted with scanning back, 16
 commercial/professional, 206, 209–210
 defined, 6
 equipment and software, 200, 201

scenery, photographing, 72–83

Scitex, 323, 355

scripting feature, digital camera, 37–38

SCSI interface, 33

SCT (Scitex Continuous Tone) files, 323

Selections menu, Adobe PhotoDeluxe, 279

sensitivity ratings, film, 136–139

Sepia effect, Adobe PhotoDeluxe, 259–261

serial interface, 34, 35

service bureaus, 344–346, 351–352, 358

shadow detail, 44

Sharpen effect filters, Adobe PhotoDeluxe, 229–232

sharpening images

 with image-editing software, 226–232

 during scanning, 206

shiny surfaces, photographing, 72, 106, 108, 109

shutter, 138

shutter speed, 28, 102–103, 138–139

signal-to-noise ratio, 20

silhouettes, 69, 70, 88

Sinar p2, 39

single lens reflex (SLR) cameras, 17–18

Size Tab, Adobe PhotoDeluxe, 212, 213

Size tool, Adobe PhotoDeluxe, 216–217

Sketch effect, Adobe PhotoDeluxe, 255

skin tones, warm *vs.* cool, 101

sky, photographing the, 66–67, 72, 79

slides/slide shows, 312, 348–349

slow exposure, 64–65

SLR cameras, 17–18

smart cards, 31

Smudge tool, image-editing software, 217–218

snow scenes, photographing, 80

Soft Spot effect, Adobe Photoshop, 271–272

software, 45–48, 356–357. *See also* image-editing software.

Solarize effect, Adobe PhotoDeluxe, 264–265, 266

special effects. *See* styling effects, digital photograph.

spectrum, color, 234

speed, film, 136

Spherize effect, MGI PhotoSuite, 253, 254

sporting events, photographing, 101–103

spot focus, 26, 109

spot meter, 28, 132, 171, 185

Spotlight effects, Adobe Photoshop, 273–274

stars, photographing, 186–187

still life photography, 136–145

structures, photographing, 83–90

styling effects, digital photograph, 246–247

 with Adobe PhotoDeluxe, 253–257

 with MGI PhotoSuite, 248–253

subtractive color space, 234, 239

sun

 creating long shadows, 71–72

 photographing sunrises and sunsets, 61–63, 65–72

 shooting toward, 69–71

 twilight shooting and, 68–69

supplies, printer, 339–340

Surreal Landscape effect, Adobe PhotoDeluxe, 261

T

telephoto lens, 21–22, 23, 82–83, 89, 97, 124

tethered shooting mode, 46, 117

tethering, image transfer via, 193

text editing, 221

Text tool, 220–221

thirds, rule of, 73–74

Three Lights Down effect, Adobe Photoshop, 273–274

Threshold option, Adobe PhotoDeluxe, 231

through the lens (TTL) view, 17

thumbnail images, 47

TIFF (Tagged Image File Format) files, 32, 193, 232, 321, 323–324, 325

tips

 action shots, alternatives to, 152

 digital cameras

 buying tripod for, 50

 determining finder's percent coverage, 24

 importance of exposure compensation, 28

 stocking up on removable storage media, 30

 support for standard file formats, 33

 taking advantage of software offers, 45

 try-before-you-buy options, 54

using AC adapter when transferring images, 193

using picture information utility, 112

how to get the most out of this book, 3

image-editing software

adding drop shadows to images, 302

editing digital photographs, 227

finding images on the Web, 305

importance of saving images frequently, 220

recommended book on using Adobe Photoshop, 309

indoor photography

best time to photograph public facilities, 158

dealing with low-light conditions, 138

dealing with red eye, 126

preventing overexposure with gauze curtains, 120

tricks for minimizing reflections, 161

using spot meter to improve picture quality, 132

when to use video or conventional camera instead of digital, 121

nighttime/low-light photography

dealing with low-light conditions, 72

using a flashlight when photographing nocturnal animals, 183

outdoor photography

dealing with low-light conditions, 72

getting good vehicle shots, 106

metering off the ground vs. the sky, 67

software solution to back lighting, 70

using tripod to capture partial shots in sequence, 90

printers

choosing paper for, 340, 341

most important features for digital photographic output, 338

scanning

flatbed vs. drum scanners, 210

improving quality of scanned images, 204

trade-off between image size and quality, 60

using tethered shooting mode, 46

tone, image, 204, 235

Tools Tab, Adobe PhotoDeluxe, 217–219

tooth, paper, 339

Trace tool, Adobe PhotoDeluxe, 281

transparent GIFs, 332, 333

Trim option, Adobe PhotoDeluxe, 213, 325–326

Triple Spotlight effect, Adobe Photoshop, 273

tripod mount, 37

tripods, 50–51, 65, 90, 139, 184

trucks, photographing, 105–111

TTL (through the lens) view, 17

tungsten light, 134–135

TWAIN, 46, 194–195, 201, 300

twilight photography, 61–62, 64

U

Ultimate Photoshop Web site, 305, 306

uncompressed files, 32, 223, 232

underexposed images, 81, 178–180

Understanding Exposure, 174

Undo tool, image-editing software, 220

Unsharp Mask filter, Adobe PhotoDeluxe, 230–232

USB interface, 34, 35

UV Haze filter, 23

V

value, 235

Variations, Adobe PhotoDeluxe, 262, 263

vehicles, photographing, 105–111

vibrations, 184

video adapter, 49

video port, 34

videotape, contrasted with digital photography, 137

viewfinder, 17, 24–25

virtual lights, 267

W

warping, 210

washed out images, 122

water, shooting objects in, 164–166

Water Drops effect, Eye Candy, 303

Web. *See* World Wide Web.

white balance feature, 134

wide-angle lens, 21–22, 23, 88–89

wild animals, photographing, 98

Wilson, Peter, 174

"Win printers," 337

Windows bitmap files, 317–318

winter scenes, photographing, 80

World Wide Web

 digital photography resources, 353–358

 getting digital photography software from, 45, 191, 208, 268

 image storage and distribution services, 198

 using digital photographs on, 12, 13, 73, 105, 312, 324–334

X

xRes, Macromedia, 48

Z

ZIP drive/disks, Iomega, 49–50, 197

zoom, digital, 23, 169–170

Zoom feature, Adobe PhotoDeluxe, 212–213

Zuckerman, Jim, 174

Incredible Pictures.
Incredible Choices.

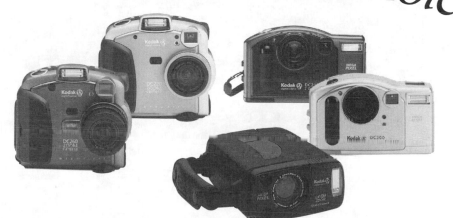

KODAK Digital Cameras

• A range of megapixel digital cameras offering outstanding image quality, full of features and bundled with everything you need to get started right away • KODAK Picture Easy Software, the fast, easy way to download, view and print your pictures (included with all KODAK Digital Cameras)

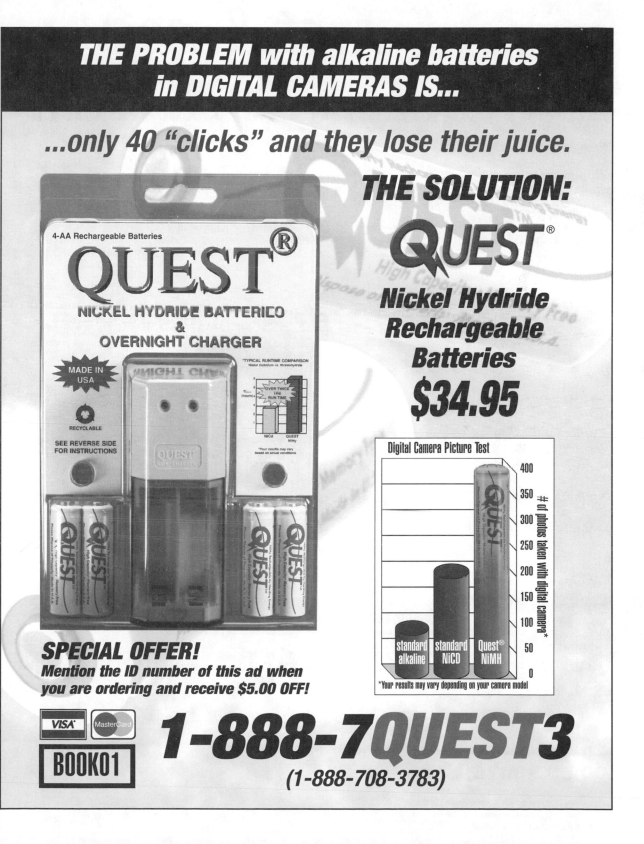